故宫博物院藏品大系

COMPENDIUM OF COLLECTIONS
IN THE PALACE MUSEUM

故宫博物院藏品大系

玉器编

1

新石器时代

故宫博物院 编

紫禁城出版社

时代出版传媒股份有限公司

安徽美术出版社

图书在版编目（ＣＩＰ）数据

故宫博物院藏品大系. 玉器编. 1，新石器时代/故宫博
物院编.—北京：紫禁城出版社；合肥：安徽美术出版社，
2011.1
　ISBN 978-7-5398-2621-9

Ⅰ. 故… Ⅱ. 故… Ⅲ. ①故宫博物院－历史文物－
北京市－图集②古玉器－中国－新石器时代－图
集 Ⅳ. ①K870.2② K876.82

中国版本图书馆CIP数据核字（2010）第225477号

故宫博物院藏品大系

玉器编 Ⅰ 新石器时代

故宫博物院　编

		出版领导小组	
主　　编：张广文		主　任：王亚非　王亚民	
编　　委：徐　琳　赵桂玲　许晓东		副 主 任：田海明　林清发	
杨　捷		委　员：郑　可　赵国英　唐元明	
摄影统筹：冯　辉		丁怀超　贾兴权	
摄　　影：刘明杰　胡　锤　冯　辉			
刘志岗		项目实施小组	
翻　　译：宋玲平		主　任：林清发	
编辑统筹：陈丽华　王亚民　赵国英		副 主 任：武忠平	
责任编辑：万　钧　郑　可		成　员：谢育智　陈　涛　马晓芸	
装帧设计：北京颂雅风文化艺术中心		黄　伟　姚　健　刘　辉	
责任校对：司开江　史春霖		陈连营	
英文校对：张楚武　陈芳芳			
责任印制：马静波　李建森　徐海燕			

出　　版：紫 禁 城 出 版 社
　　　　　时代出版传媒股份有限公司
　　　　　安 徽 美 术 出 版 社

发　　行：安徽美术出版社总经销
社　　址：合肥市政务文化新区翡翠路 1118 号出版传媒广场 14 层
邮　　编：230071
营 销 部：0551-3533604　0551-3533607

印　　刷：北京雅昌彩色印刷有限公司
开　　本：787 毫米 ×1092 毫米　1/8
印　　张：39
版　　次：2011 年 1 月第 1 版第 1 次印刷
印　　数：1~2,000 册
书　　号：ISBN 978-7-5398-2621-9
定　　价：600.00 元

COMPENDIUM OF COLLECTIONS
IN THE PALACE MUSEUM

JADE

1

Neolithic Age

Edited by the Palace Museum

The Forbidden City Publishing House

Time Publishing and Media Co., Ltd.
Anhui Fine Arts Publishing House

总目

Contents

总序

郑欣淼

故宫博物院既是明清紫禁城建筑群与宫廷史迹的保护管理机构，也是以明清皇室旧藏文物为基础的中国古代文化艺术品的收藏、展示和研究机构。故宫博物院以其颇具皇家文化特色的文物藏品，在中国以及世界博物馆界占有特殊的重要地位。

一　故宫博物院藏品的来源

故宫博物院的文物藏品品类丰富，体系完备，可划分为陶瓷、绘画、法书、碑帖、青铜、玉石、珍宝、漆器、珐琅、雕塑、铭刻、家具、古籍善本、文房用具、帝后玺册、钟表仪器、武备仪仗、宗教文物等，共 25 大类、69 小项，计 150 多万件（套），截至 2006 年底，占中国文物系统博物馆藏品总量的 11.5％；其中一级文物 8 273 件（套），占中国文物系统博物馆藏品一级文物的 1/6。

在故宫博物院的 150 多万件（套）文物藏品中，有 130 多万件（套）是清宫旧藏和遗存，占藏品总数的 85％，其余 20 多万件（套）为建院以来的新收藏，占藏品总数的 15％。清宫旧藏和遗存主要来自以下四个方面：

【一】历代皇家收藏的承袭。中国历代宫廷都收藏有许多珍贵文物，到宋徽宗时，收藏尤为丰富。《宣和书谱》、《宣和画谱》、《宣和博古图》，就是记载宋朝宣和内府收藏书画鼎彝等珍品的目录。清代帝王重视文物收藏，特别是乾隆皇帝，更使宫廷收藏达到了极盛。《西清古鉴》、《西清续鉴》、《宁寿鉴古》、《石渠宝笈》、《秘殿珠林》、《天禄琳琅》和《四库全书总目》等，是清乾隆时期编辑的宫中所藏古铜器、书画、图书的目录。见于著录中的很多古代文物早已散失，

但也有不少珍品几经聚散,历尽沧桑,保存到今天。例如,晋王珣《伯远帖》、隋展子虔《游春图》、唐韩滉《五牛图》、五代顾闳中《韩熙载夜宴图》等著名书画,都曾载在《宣和书谱》、《宣和画谱》或《石渠宝笈》中,现仍藏在故宫。这部分藏品是中国皇家收藏传统的延续。

【二】宫廷制作。为了满足皇室对宫廷日用器皿及各种工艺品的需要,清宫内务府一直设有造办处,从全国各地选拔技艺高超的工匠,在宫廷内制作各种物件,均不惜工本,精益求精。乾隆二十年(1755年)前,造办处曾设立有匣作、裱作、画作、广木作、穿珠作、皮作、绣作、镀金作、银作、玉作、累丝作、錾花作、镶嵌作、牙作、砚作、铜作、做钟处、玻璃厂、舆图房、弓作、鞍甲作、珐琅作、画院处、木作、漆作等38作,后将一些活计相近的合并,共为15作,后又有所调整。这是一个规模很大的综合性的手工业工场,常年按照御旨制作独具清代皇家风范的艺术品、工艺品和各种精美的日用品。还有些器物由造办处设计画样,或拨蜡样或做木样,交苏州、扬州、南京、浙江、江西、广东等地相关部门,由当地最优秀的匠人制作。遗留至今的很多精美绝伦的工艺品,如玉器、珐琅器、钟表、文玩等,其中不少都是当年造办处制造的。造办处的档案保存至今。故宫所藏清代工艺美术品有许多仍可以在档册中找到作者是何人,是某年月日开始设计画样、做模型,某日完成,以及陈设地点等。

【三】进呈及查抄没收物品。专制时代帝王一家天下,逢年过节、万寿大典或外出南巡,臣工往往多有贡献,其中又以进书画、文玩较为讨喜。乾隆皇帝在《石渠宝笈续编·序文》中说:"自乙丑至今癸丑,凡四十八年之间,每遇慈宫大庆、朝廷盛典,臣工所献古今书画之类及几暇涉笔者又不知其凡几。"《石渠宝笈三编》嘉庆皇帝的上谕中也说:"朕自丙辰受玺以来,几暇怡情,惟以翰墨为事,阅时既久……至内外臣工,祝嘏抒诚,所献古今书画亦复不少。"清宫书画,臣工所献占一大部分。书画如此,其他珍宝也进献不少。除国内进献外,还有藩属国贡品、外国礼品等。这些所进之物,往往与重大的政治事件有密切关系。查抄没收物品也是重要来源。如康熙初期权臣明珠藏书数万卷,宋元版及名贵抄本尤多,其藏书处所为"谦牧堂"。明珠去世后,其子因罪被追夺官位,削谥抄家,家藏古书名画等尽入内府。嘉庆二年(1797年)重辑《天禄琳琅书目续编》时,原"谦牧堂"书便是入选的重要对象。又如高士奇、毕沅,都身居高位又精鉴赏,家藏书画古帙甚富,后也均被抄没入内府。

【四】清宫编刻书籍。清宫藏书是以明代皇宫秘籍为基础,又经过数百年的搜求,加上清宫的编纂刊刻、抄写各类图籍,其收藏之富,超越以前各代。在清代,特别是清前期,内务府

主持编纂、刊行和抄写了许多大部头的图书。这些图书不仅在中国图书史上占有极为重要的位置，同时也成为清宫藏书的重要来源。康熙时把武英殿作为清代内府专门的修、刻书机构。康、雍、乾三朝，内府编刊了大量图书。由于康、乾二帝崇尚书法，内府抄写书籍亦极为盛行，其抄写之精、装帧之美、数量之大，均可与内府刊本书相媲美。这些内府刊本与内府抄本，都成为以后故宫博物院的文物藏品。

故宫保存了大量清宫衣食住行的用品，当时并不是收藏品，而是实用之物，但在今天看来，同样是宫廷历史的见证，具有重要的历史价值、认识价值；又由于是皇室日常生活用品，制作都十分讲究，也有着相当高的艺术价值。这批物品种类繁多，数量庞大，例如宫灯、乐器、车马轿舆、明清家具、戏衣道具、服饰衣料、地毯以及金银器、锡器、铜器，甚至梳妆具、玩具、茶叶、药材、药具等，都是清宫典制及文化娱乐活动的反映，具有文物的意义。

清宫旧藏，至乾隆年间最为丰盛，以后随着国力衰败，外患频仍，收藏日渐式微，特别是近代以来，清宫文物珍藏更是多次遭到劫掠或毁损。比较大的厄难有三次：第一次是 1860 年英法联军对圆明园的野蛮劫掠和焚毁；第二次是 1900 年八国联军对皇室财宝的抢劫与破坏；第三次是清逊帝溥仪"小朝廷"时期对宫廷文物的盗运，以及 1923 年建福宫花园大量文物珍宝的付之一炬。1924 年底驱逐溥仪出宫后，清室善后委员会及以后成立的故宫博物院，对清宫物品进行了初步点查，整理出版《清室善后委员会物品点查报告》，共六编 28 册，计有文物 94 000 余号，117 万件之多。这些文物就成为于 1925 年成立的故宫博物院的藏品。当然，清宫旧藏及遗存的数量远不止这些，当时有些殿堂尚未清点，清点过的一些物品，因计算方法的原因与实际数量亦有不少出入。文物清理也就成了故宫博物院一项多次进行的工作。据估计，当年故宫博物院成立时，清宫旧藏及遗存最少在 700 万件以上。

为防止日本侵略者的掠夺，1933 年，故宫博物院的数十万件文物迁移到中国南方，抗日战争中又转运西南。在 20 世纪 40 年代末，其中 1/4 送往台湾，共约 60 万件，其中书画器物约 5 万件，典籍近 17 万册，文献档案约 38 万件，1965 年在台北成立了故宫博物院。

中华人民共和国成立后，在各方支持下，故宫博物院努力充实文物藏品，经过数十年积累，古老的皇宫不仅重现昔日收藏颇丰的盛况，而且补充了更多的过去皇宫所没有的精美艺术品，使其成为世界上收藏中国文化艺术品最为宏富的宝库。

充实文物的渠道主要有以下三个方面：

【一】政府拨交。20 世纪五六十年代，故宫博物院接收政府部门和各地博物馆拨交的文物达 16 万件（套），有许多是原清宫旧藏后来流失出去的，如当年溥仪抵押给盐业银行的玉器、瓷器、珐琅器、金印、金编钟等。50 年代初，中央政府先后从香港买回著名的"三希"中王珣《伯远帖》、王献之《中秋帖》，以及韩滉《五牛图》、顾闳中《韩熙载夜宴图》、董源《潇湘图》、赵佶《祥龙石图》等一大批瑰宝，交故宫存藏。在国家文物局和全国各地博物馆的支持下，众多的国家级珍贵文物调拨到故宫博物院，使得故宫藏品更加丰富、系统。

【二】文物征购。从 20 世纪 50 年代以来，故宫博物院确定了以清宫流失出去的珍贵文物为主、兼及中国历代艺术珍品的文物收购方针，国家在资金上给予支持，购回了大量珍贵文物。收购的途径主要有文物商店、古玩铺、文物收藏者和拍卖公司等。50 年代至 60 年代初，是故宫博物院购藏文物的高峰期。当时社会上流散文物较多，琉璃厂一带的古董店得到一件珍贵文物后，首先是送故宫，这就为故宫博物院创造了一个大量购进珍贵文物的极好机会。截至 2006 年 12 月底，共购得文物 53 971 件，其中一级文物 1 764 件。这些文物，品类众多，特别是书画珍品，如隋人书《出师颂》，以及唐代周昉、颜真卿，宋代王诜、刘松年、马和之、夏圭、马远、张先、欧阳修、苏轼、米芾，元代顾安、钱选、赵孟頫、迺贤，明代吴伟、唐寅、沈周、董其昌、祝允明，清代原济、赵之谦等名家的作品。

【三】接受捐赠。截至 2006 年 12 月底，故宫博物院共接受捐赠文物及文物资料约 33 900 件（套），捐赠人员 696 人次。捐赠者中，有党政军领导人，有社会各方面专家、学者、艺术家，有港澳台同胞、海外华侨和国际友人，有故宫博物院的领导、专家等。毛泽东主席先后将友人赠送的王船山手迹《双鹤瑞舞赋》、钱东壁临写的《兰亭十三跋》以及张伯驹赠他的唐李白《上阳台帖》，转交故宫。张伯驹先生捐献的有西晋陆机《平复帖》，隋展子虔《游春图》，唐杜牧《张好好诗》，宋黄庭坚《诸上座帖》、蔡襄《自书诗册》、范仲淹《道服赞卷》，元赵孟頫《千字文卷》等法书巨迹。孙瀛洲先生捐献各类文物精品 3 000 余件，以陶瓷珍品最为重要。郑振铎先生捐赠文物 657 件，尤多雕塑精品。陈叔通先生捐献的《百家画梅》，凡 102 家，109 幅，有唐寅、陈录、王綦、邵弥、原济及扬州八怪等明清诸家的杰作。新加坡华侨韩槐准先生捐献了他毕生收集到的中国古代外销瓷器，填补了故宫陶瓷藏品中的缺门。香港叶义先生捐献的 81 件犀角雕刻品，全是明清犀角雕刻精品。

20 世纪 50 年代中期，故宫博物院的业务及机构也作了一些调整，主要是档案馆划出故宫

博物院。明清档案在故宫文物藏品中占有重要位置。1955 年 2 月，故宫档案馆移交国家档案局；1969 年底，又交归故宫博物院；1980 年 4 月，藏品已逾 800 多万件的故宫博物院明清档案部再次划归国家档案局，改称中国第一历史档案馆。故宫博物院图书馆长期以来是个重要的业务部门。1949 年以后，先后将一批宋元善本、明清旧籍和清代殿本书中的"重复本"15 万余册拨交给北京图书馆、中国人民大学图书馆、吉林省图书馆等 16 家单位。其中仅 1958 年拨给北京图书馆的宋、元、明善本书即有 69 510 册。至此，清代宫中藏书再一次分散于全国各地。

故宫博物院原有数量不多的宋元版书虽已拨交给国家图书馆，但现存的明清抄、刻本，品种及数量众多，包括内府修书各馆在编纂过程中产生的稿本，呈请皇帝御览、待刻之书的定本，从未发刻的清代满、蒙、汉文典籍，为便于皇帝阅览或携带而重抄的各式书册，以及为宫内外殿堂陈设而特制的各种赏玩性书册，此外还有翰林学士、词臣自撰的未刊行书籍，各地藏书家进呈之书，一大批宫中戏本和档案，帝后服饰和器物小样，建筑图样和烫样、舆图等特藏文献，以上共计 195 000 册（件）。另有 23 万块精美的武英殿"殿本"的原刻书版。这些构成了故宫善本特藏的特色。

从 1949 年至 1980 年前，故宫博物院藏品的充实得到社会各界的支持，同时也先后把 84 000 余件文物调拨给不少博物馆、图书馆及其他机构。例如，故宫博物院曾把包括《乾隆南巡图》、虢季子白盘等在内的 3 781 件珍贵文物拨给了 1959 年成立的中国历史博物馆，把一部分官窑瓷器赠给了一些古窑址博物馆。在一些寺院和我驻外使馆等，都有被调去或借用的故宫文物。也有一些清宫文物被赠送国外博物馆，例如 1957 年赠给苏联东方博物馆清代瓷器、玉器、漆器、珐琅器、织绣等文物 550 件。此外，南迁文物尚有 10 万余件滞留在南京博物院。

二　故宫博物院藏品的价值

故宫博物院的文物藏品丰富多彩，品质精美，具有经典性、系统性与完整性，有着非常重要的历史、文化价值。

故宫文物具有国宝的意义。中国皇室收藏有着悠久的历史。皇室收藏具有强烈的政治与文化的象征意义。皇室收藏文物，不仅因其是稀有的珍宝或是有重要价值的艺术品，而是更重视这些文物所寓有的某种至高德行的含义，认为它的聚集是天命所归的象征。因此，新的王朝接收前朝的旧藏，表示着它继承前朝的天命。清代皇室收藏为历代之顶峰，也是历代皇室收藏的

总结。在反对帝制复辟背景下成立的故宫博物院，把清宫藏品视为文化传统的结晶、整个民族的瑰宝，把对它及故宫博物院的维护与坚持民主共和政体等同起来。在以后艰苦卓绝的文物南迁中，故宫藏品的国宝形象进一步得到提升和加强。文物南迁，开始也有许多人反对，但大家最后认识到失去的领土可以收复，而几千年的文明，作为文化传统的结晶，得之不易，能否保存下去，关乎民族根基的坚持与民族精神的传扬。最终，民众达成了尽力保护国宝的共识。在故宫列入世界文化遗产名录后，随着人们对故宫价值以及故宫作为文化整体的意义的深刻认识，国宝不只是故宫的一件件具体的文物，整个故宫就是一个巍然挺立、价值无比的国宝，是民族文化传统最有代表性的象征。

故宫是世界上最丰富、最重要的中国古代艺术品的宝库。在故宫150万件（套）文物中，论时代，上自新石器时代，下至宋元明清直至近现代；论范围，囊括了古代中国各个地域的文明精华，包容了汉族和古代许多少数民族的艺术精粹；论类别，包含了中国古代艺术品的所有门类。故宫庋藏的各主要类别文物，其本身就完整地记录了该类文物从萌生、发展到辉煌的文化链。以书法为例，故宫的藏品涵盖了从契刻到书写进而发展成为一门独立的书法艺术的历程，藏品从甲骨文、钟鼎文，直至晋朝开始形成书法艺术，此后，历朝各代的名家流派，几乎一应俱全。再以陶瓷为例，从新石器时代的黑陶、彩陶，直到两宋的五大名窑，元代青花瓷，明代白瓷、釉里红、斗彩等，清代的粉彩和珐琅彩等。其他如玉器、铜器和许多工艺品等，也是如此。为了这条历史文化长河永远奔腾流淌、润泽后代，故宫还在收藏现当代的艺术精品。因此，故宫是一部浓缩的中华五千年文明史。中华民族绵延不断的历史文化在故宫博物院的各类文物藏品里均得到了充分的印证。

故宫藏品与故宫古建筑都是旷世之宝。故宫藏品的一个重要特点是与故宫古建筑的不可分割，二者的结合构成了故宫无与伦比的价值以及故宫博物院的丰富内涵与崇高地位。故宫是世界文化遗产。故宫的文物藏品因此也是世界文化遗产的重要组成部分，它不仅是中国的，同时也是全人类的共同财富。

故宫是明清两代皇宫，在长达491年的历史时期，它是封建国家的政治中枢和24位皇帝的居所。保存至今的大量宫廷旧藏及其遗存，不仅与故宫不可分割，而且与中国历史尤其是明清两代的宫廷历史紧密相联。文物藏品、古建筑以及历史上宫廷发生的人和事，三者是一个文化整体，从而形成了一个新的学科——故宫学。从故宫学的视野看待故宫的文物藏品，它们不仅在文化史、艺术史上占有特殊地位，而且见证了王朝的治乱兴衰，具有重要的历史价值。

三　出版《故宫博物院藏品大系》的意义

整理和出版《故宫博物院藏品大系》具有多方面的意义。

文物藏品是博物馆赖以存在和开展业务的基础，藏品质量的高低和数量的多少是衡量一个博物馆地位及其作用的主要条件。故宫博物院曾进行过多次文物清理，由于宫廷藏品的数量庞大、种类复杂，长期以来，一些底数还不很清楚。只有彻底弄清故宫博物院藏品的种类和确切数量，才能有效实施保护，才能对它的内涵、特点和价值有更为全面、准确的认识。这是博物院的基础建设，是一项重要的业务工作。基于以上认识，故宫博物院多年来坚持清理文物藏品的工作，并制定实施了《2004～2010年文物清理规划》，取得了显著的成绩。《故宫博物院藏品总目》及《故宫博物院藏品大系》就是文物清理工作的成果体现，是几代故宫人努力的结果，对于让世人了解故宫藏品的奥妙及全貌，更好地为人们的鉴赏、研究等不同需要服务，发挥博物馆的社会教育功能，具有积极的作用。

故宫博物院曾整理出版了《故宫博物院藏文物珍品全集》（60卷），以及书画、陶瓷、青铜器、玉器、建筑等多种图录，但出版面世的文物数量仍然相当少，绝大多数不为世人所知。人们难以欣赏到中华文物精粹的灿烂与辉煌，专家学者难以充分利用故宫的藏品资源进行研究，故宫博物院大量藏品的重要历史价值、科学价值和艺术价值，难以得到有效的发挥。出版《故宫博物院藏品大系》，可使大量"养在深闺人未识"的文物藏品，以先进的制版印刷工艺、高品质的图书形式，系统、完整地呈现在人们的眼前，真正成为社会公众共享的文化资源。

如前所述，60万件故宫文物被运往台湾，并出现了北京、台北两个故宫博物院同时存在的现状。两岸故宫的文物都主要来自清宫旧藏，同根同源，具有很强的互补性，应该把它们作为一个整体来看待。《故宫博物院藏品大系》的出版，不仅有助于人们对两岸故宫藏品状况的了解，有助于人们对故宫文化整体的深刻认识，尤为重要的是，它会使人们更为全面地领略中华文明的源远流长、光辉灿烂以及一脉相承。

瑰宝聚集，来之不易；沧海桑田，文明永续。《故宫博物院藏品大系》的出版，是一项重大的文化建设工程，是21世纪出版史上的一件盛事。我们相信，这套丛书的出版，对于故宫文化内涵的发掘，对于故宫的整体保护，对于故宫学研究的深入，都会有所促进。

General Preface to

Compendium of Collections in the Palace Museum

Zheng Xinmiao

The Palace Museum is not only an administrative organization for the preservation of the Forbidden City architectural complex of the Ming and Qing dynasties and its historical palaces, it is also an institution for storing, exhibiting, and researching collections of Chinese cultural artifacts and ancient works of art, the core of which came from the imperial courts of the Ming (1368-1644) and Qing (1644-1911) dynasties. The Palace Museum, with its almost unique collection of artifacts of dynastic imperial culture, occupies an important position among museums in China and in the world.

I. Sources of the Palace Museum's collection

The cultural artifacts in the Palace Museum feature a wide variety of types and are remarkably complete. They can be divided into twenty-five categories and sixty-nine sub-categories, which include ceramics, paintings, calligraphic works, stele rubbings, bronze, jade, jewelry, lacquer, enamel, sculpture, inscriptions, furniture, rare editions of ancient books, scholar's items, seal books of emperors and empresses, clocks and watches, military and parade equipment, and religious artifacts. There are altogether over 1.5 million artifacts (or sets of artifacts) in the Museum according to the statistics at the end of 2006, which represents eleven and a half percent of the objects in all of China's museums. Of these cultural artifacts, there are 8,273 items (or sets) of the First Rank, which amounts to one sixth of all First-Rank artifacts in Chinese museums.

Of the entire Palace Museum collection of a million and a half artifacts, eighty-five percent, or 1.3 million artifacts, are from the imperial court of the Qing dynasty. The other more than two hundred thousand (fifteen percent of the total) were acquired after the Palace Museum was founded in 1925. The cultural artifacts from the Qing imperial court primarily came from the following sources:

(1) The collections of former imperial dynasties. It was a long-standing tradition for Chinese imperial courts to collect precious cultural artifacts. For example, during the reign of Emperor Huizong of the Song dynasty, the collection was especially large. *Calligraphic Catalogue of Xuanhe Period* (*Xuanhe shu pu*), *Painting Catalogue of Xuanhe Period* (*Xuanhe hua pu*), and *An Illustrated Book Compiled during the Years of Xuanhe on Ancient Bronzeware* (*Xuanhe bogu tu*), are in fact catalogues of the treasures and curios, such as calligraphic works, paintings and bronze vessels, collected by the Song Court during the

Xuanhe's reign. The emperors of the Qing dynasty also attached great importance to cultural collecting. Emperor Qianlong, in particular, expanded the imperial collections to its peak. *Catalogue of the Qing Imperial Bronze Collection (Xi qing gu jian), Sequel Catalogue of the Qing Imperial Bronze Collection (Xi qing xu jian), Imperial Bronze Collection in the Palace of Tranquil Longevity (Ningshou jian gu), Precious Collection of Stone Moat (Shiqu baoji), Treasured Collections of Mysterious Halls (Midian zhulin), Treasured Rare Books of the Qing Court (Tianlu linlang)* and *General Catalogue of the Complete Library of the Four Treasuries* are all catalogues compiled under the Qianlong's reign concerning ancient bronze vessels, calligraphic works, paintings, and books collected by the imperial court. Although many of them are no longer extant, some treasures have been preserved in spite of the turbulent ages and vicissitudes they went through, among which there are famous calligraphic works or paintings such as *Manuscript Beginning with Boyuan* by Wang Xun of the Jin dynasty, *Spring Excursion* by Zhan Ziqian of the Sui dynasty, *Five Oxen* by Han Huang of the Tang dynasty, and *Night Revels of Han Xizai* painted by Gu Hongzhong of the Five Dynasties. All these works of art now in the Palace Museum were recorded in *Calligraphic Catalogue of Xuanhe Period, Painting Catalogue of Xuanhe Period* or *Precious Collection of Stone Moat*. They are evidence of the long tradition of collecting at Chinese imperial courts.

(2) Articles made by imperial courts. In order to meet the needs of the imperial family, articles of daily use and handicrafts of various kinds were made by highly skilled craftsmen from all over the country under the supervision of the Qing Imperial Workshop, a branch of the Imperial Household Department. No expense was spared to improve the quality of those articles needed inside the imperial palace. Before 1755, thirty-eight different jobs were listed in the Imperial Workshop, which included box making, mounting of painting and calligraphy, painting, Guangdong-style woodworking, bead threading, leatherwork, embroidery, gilding, silversmithing, jade carving, filigreeing, chiseling, inlaying, ivory and horn carving, ink-stone making, bronze manufacture, clock making, glass blowing, drawing, bow making, armory forging, enamel making, wood working, and lacquering. Later they were rearranged into fifteen workshops. This was a comprehensive handicraft workshop of a very large scale. Its regular work was to make works of art, handicrafts, and articles for daily use, all characterized by imperial splendor. Other articles were made by the best local craftsmen of Suzhou, Yangzhou, Nanjing, Zhejiang, Jiangxi, and Guangdong according to design drawings, or models made of wax or wood, provided by the Imperial Workshop. Many consummate handicraft articles handed down, such as jades, enamelware, clocks, and curios, were all made by this workshop. The archives of the workshop, which have been preserved, provide detailed information on many exquisite works of art and handicrafts in the Palace Museum, such as their makers, the dates when they were designed, when their design drawings or models were made, and when they were completed, as well as the locations where the items were stored.

(3) Tributes presented to the court or objects confiscated. Under the autocratic system of dynastic China, the ruler viewed the whole country as his family. On the occasions of festivals, birthday celebration ceremonies of the emperors or inspection tours, it was a common practice for officials to present gifts, of which calligraphic works, paintings and curios were most to the emperors' liking. Emperor Qianlong wrote in *Preface to the Sequel of Precious Collection of Stone Moat*, "Over the past forty-eight years, whenever there was a grand ceremony, calligraphic works and paintings, ancient and modern, pre-

sented by ministers and those created by myself were numerous." And in an imperial edict on *The Third Sequel to Precious Collection of Stone Moat*, Emperor Jiaqing wrote, "Ever since I ascended the throne, my chief pastime has been calligraphy and painting... Ministers in and out of court have presented ancient and recent paintings and calligraphy as well ." Calligraphic works and paintings collected by the Qing imperial court were mostly gifts from officials, as was the case with other treasures. Besides those from domestic sources, there were others presented by vassal states and other countries. All of these tributes tended to be closely associated with major political events. Confiscated articles were another important source. A case in point is Mingzhu, a powerful official during the early years of the Kangxi's reign, who collected in his private library, Qianmu Hall, tens of thousands of volumes, of which many were rare editions of the Song and Yuan dynasties. After Mingzhu died, his son, having been convicted of certain crimes, was deprived of his position and noble title; his home was searched and all rare books and famous paintings were confiscated by the Qing court. In 1797, when *The Sequel of Treasured Rare Books of the Qing Court* was compiled, a selection of books from the Qianmu Hall, were important entries. There were other high-ranking officials such as Gao Shiqi and Bi Yuan who were outstanding collectors and authenticators. Their large collections of calligraphic works, paintings, and copies of ancient books were confiscated by the Qing court.

(4) Books compiled and printed by the Qing imperial court. Based on the book collection inherited from the Ming imperial court, the Qing court searched for and accumulated books for more than two centuries, added, compiled, transcribed, and printed books of various kinds; they managed to amass a book collection that surpassed all previous dynasties. During the Qing dynasty, especially during its early years, the Imperial Household Department oversaw the compilation, printing, and hand copying of many enormous books. These books are not only of great importance in the history of Chinese printing, they are also another important source of the book collection of the Qing palace. During the Kangxi's reign, the Hall of Martial Valor (Wuying dian) became the site for compiling texts and carving woodblocks under the Imperial Household Department, who, through the Kangxi, Yongzheng, and Qianlong reigns, compiled and published a vast number of books. Because the Kangxi and Qianlong emperors especially liked calligraphy, it was also a common practice for the Department to transcribe books. These manuscripts, due to the quality of calligraphy, beauty of their bindings, and their sheer quantity, can compare with the printed books published by the Imperial Household Department. These printed and hand-copied books are all in the Palace Museum.

The Palace Museum also has many articles of daily use from the Qing imperial court. At that time, they were not items for collection, but for practical use. However, as evidence of the history of the imperial court, they have significant historical value and are worth studying today. Because they were made with exquisite workmanship for imperial family members, they also have artistic value. These articles, various in type and large in number, include palace lamps, musical instruments, carts, sedans, furniture of both the Ming and Qing dynasties, opera costumes and stage props, clothing, carpets, silverware, gold, tin, and bronze objects, even dressing and makeup boxes, toys, tea leaves, herbs, and medical tools. They all provide useful information concerning the customs, and cultural and recreational activities of the Qing dynasty court.

The imperial collection of the Qing dynasty reached its peak during the Qianlong's reign. Thereafter, as a result of the

continuous weakening of China and frequent invasions of foreign countries, its scale gradually shrank. Still more unfortunately, many cultural artifacts and treasures of the Qing imperial court suffered repeated barbarous looting or damage. There were three major disasters: the first one was in 1860 when the Anglo-French Allied Forces looted and wantonly set fire to the Garden of Perfect Brightness; the second was in 1900 when the Allied Forces of the Eight Powers looted and destroyed the imperial treasures; the third instance was during the period of the "reduced court" of the abdicated emperor, Puyi, when quantities of cultural artifacts and treasures were smuggled out of the palace and others were incinerated in the conflagration of the Garden of Established Happiness in 1923. After Puyi was expelled from the palace at the end of 1924, the Qing Palace Reparation Committee and the Palace Museum were established soon after, made a rough count of the articles left in the Qing palace and published *Report of the Qing Palace Reparation Committee* in twenty-eight sections in six volumes. According to the report, there were more than 1.17 million cultural artifacts, which were handed over to the Palace Museum that was established in 1925. Of course, this number is much smaller than the actual number, because the contents of some of the palaces were not included and because of discrepancies in the counting methods. As a result, the inventorying of artifacts has been a continuing job conducted many times. It is estimated that, when the Palace Museum was established, the artifacts passed down from the Qing court numbered at least seven million.

In order to prevent these objects from falling into the hands of Japanese invaders, in 1933, hundreds of thousands of them were crated and moved to South China. During the War of Resistance, they were moved further inland to the southwest. At the end of 1940s, one fourth of these artifacts, about 600,000 items, were transported to Taiwan, which included about fifty thousand calligraphic works, paintings and objects, nearly 170,000 copies of classic books, about 380,000 documents and archives. In 1965, the Palace Museum of Taipei was established.

After the founding of the People's Republic of China in 1949, with support from many sides, the Palace Museum has endeavored to enlarge its collection. After several decades of acquisitions, the imperial palace not only has a collection as abundant as before, but also has added exquisite works of art that the imperial palace collections never had. The Palace Museum in Beijing has become the greatest treasury of Chinese cultural artifacts and works of art.

Additionally acquired artifacts had three main avenues:

(1) Cultural artifacts handed over by the government or other museums. In the 1950s and 1960s, the Palace Museum received as many as 160,000 cultural artifacts (sets) from relevant government departments and other museums. Many of them were items that formerly had been in the Qing palace collection, but which were lost. For example, there were jade articles, ceramics, enamel objects, gold seals, and gold bells given to the Yien Yieh Commercial Bank as collateral. In the early 1950s, the Central Government bought back a large number of rare treasures, which included two of the famous Hall of Three Rarities manuscripts, i.e., the *Manuscript Beginning with Boyuan* by Wang Xun and the *Mid-Autumn Festival Manuscript* by Wang Xianzhi, as well as some uniquely important ancient paintings such as *Five Oxen* by Han Huang, *Night Revels of Han Xizai* by Gu Hongzhong, *Xiang River* by Dong Yuan, and *Auspicious Dragon Rock* by Zhao Ji. These were turned over to the Palace Museum. Supported by the State Administration of Cultural Heritage and museums across the country, many

precious cultural artifacts under state-level protection were transferred to the Palace Museum, thereby making the collections larger and more comprehensive.

(2) Cultural artifacts purchased by the Palace Museum. Since the 1950s, under the guideline of "giving priority to buying back valuable cultural artifacts originally in the Qing palace collection and taking into account fine works of art of dynastic China," and with the financial support of the government, the Palace Museum has purchased many rare artifacts. These purchases have been conducted mainly through cultural relic stores, curio stores, collectors, and auction houses. During the 1950s and the early 1960s, when a fairly large number of cultural artifacts were in private hands, such purchases were at their peak. When an antique store in Liulichang obtained a rare item, they would present it to the Palace Museum for first refusal, which gave the Museum valuable opportunities to purchase rare cultural artifacts. By the end of 2006, altogether 53,971 cultural artifacts had been purchased, of which 1,764 were designated First Rank. These artifacts are of many kinds. Especially worth mentioning are the great paintings and calligraphic works such as *Ode to the Army Which Is About to Be Sent Out* by an unknown calligrapher of the Sui dynasty, and works by such great artists as Zhou Fang and Yan Zhenqing of the Tang dynasty, Wang Shen, Liu Songnian, Ma Hezhi, Xia Gui, Ma Yuan, Zhang Xian, Ouyang Xiu, Su Shi and Mi Fu of the Song dynasty, Gu An, Qian Xuan, Zhao Mengfu, and Naixian of the Yuan dynasty, Wu Wei, Tang Yin, Shen Zhou, Dong Qichang, and Zhu Yunming of the Ming dynasty, Yuanji and Zhao Zhiqian of the Qing dynasty.

(3) Donated cultural artifacts. By the end of 2006, the Palace Museum had accepted about 33,900 cultural artifacts from 696 donors, among whom were leaders from the party, government and military services, experts from all walks of life, scholars, and artists, compatriots from Hong Kong, Macao and Taiwan, overseas Chinese, international friends, leaders and experts of the Palace Museum. Chairman Mao donated to the Palace Museum *Prose Poem on Two Auspiciously Dancing Cranes* written by Wang Chuanshan, *Thirteen Inscriptions for the Orchid Pavilion* transcribed by Qian Dongbi, and the *Ma- nuscript of Shangyang Terrace* by Li Bai of the Tang dynasty, which Zhang Boju had given him as a present. Zhang Boju donated great paintings and calligraphic works such as the *Ping Fu Manuscript* by Lu Ji of the Western Jin dynasty, *Spring Excursion* by Zhan Ziqian of the Sui dynasty, *Poem on Zhang Haohao* composed and written by Du Mu of the Tang dynasty, *The Seating Controversy* transcribed by Huang Tingjian of the Northern Song, *Personally-written Poetry Album* by Cai Xiang of the Northern Song, *Ode to Taoist Costumes* written by Fan Zhongyan of the Song, and *Thousand-Character Classic* written by Zhao Mengfu of the Yuan dynasty. Sun Yingzhou donated over 3,000 fine cultural artifacts of various kinds, of which the exquisite ceramics are the most important. Zheng Zhenduo donated 657, of which there are many fine sculptures. Chen Shutong donated his collection of 109 great paintings of plum blossoms by 102 famous painters of the Ming and Qing dynasties, including Tang Yin, Chen Lu, Wang Qi, Shao Mi, Yuanji, and the Eight Eccentrics of Yangzhou. Han Huaizhun, a Singaporean Chinese, donated his collection of Chinese export ceramics that he had assembled over his lifetime, thereby enriching the Museum's inadequate collection in this area. Ye Yi, from Hong Kong, donated 81 rhinoceros horn carvings, all fine works of art of the Ming and Qing dynasties.

In the mid 1950s, the Palace Museum adjusted its operations and organizational structure. The Archives was separated

from the Museum. The archives of the Ming and Qing dynasties once occupied an important place among the collec-tions in the Museum. In February 1955, the Archives of the Palace Museum were turned over to the State Archives Administration and, at the end of 1969, were returned to the Museum. In April 1980, the Ming and Qing Archives Department of the Palace Museum, whose items amounted to over eight million, was once again turned over to the State Archives Administration and renamed the First Historical Archives of China. For a long time, the Museum Library had been an important department of the Museum. After 1949, many rare editions of Song and Yuan dynasty books, ancient books of Ming and Qing and "dupli-cate copies" of books of Qing altogether 150,000 of them were transferred in many batches to sixteen other libraries such as the Beijing Library, the Library of People's University of China, and Jilin Provincial Library. For instance, in 1958, a selection of rare editions of the Song, Yuan and Ming dynasties (totaling 69,510 folios) were sent to the Beijing Library (now the National Library). After the completion of these transfers, the books collected in the Qing palace once again are distributed across the country.

Although early rare editions were transferred to the National Library, the Palace Museum still possesses a large number of Ming and Qing dynasty hand-written and printed books of various kinds, which include the various book manuscripts generated during the Qing court's process of compilation, the finalized manuscripts submitted to the emperors for inspection and authorization before printing, classical texts in Manchu, Mongolian, and Chinese which have never been printed, books of different types recopied for the convenience of the emperors' reading or carrying, special ornamental books for halls in and outside the imperial palace. There are also specially preserved items such as books by imperial academicians or poetry officials that have never been published, books presented by book collectors across the country, many opera scripts and records, samples of the fabrics of the emperors' and empresses' clothes and articles for practical use, architectural drawings and models of buildings, and Chinese traditional maps. These above-mentioned articles add up to 195,000 albums. In addition, there are 230,000 exquisite original woodblocks for the books published in the Hall of Martial Valor. All these books endow the Museum's collection of rare editions of books with distinctive characteristics.

During the period from 1949 to 1980, while the Palace Museum collections were enriched with the support of all soci-ety, the Museum also transferred over 84,000 cultural artifacts to other museums, libraries and organizations. For example, the Palace Museum transferred 3,781 rare cultural artifacts, including a painting scroll of *The Qianlong Emperor's Southern Inspection Tour* and the famous Western Zhou ritual bronze vessel with an eight-line inscription (*Guo jizi bai pan*) to the History Museum of China established in 1959. In addition, some of the finest official porcelains were sent to museums at the sites of ancient kilns. For some selected monasteries and Chinese embassies in other countries, artifacts were transferred or lent by the Palace Museum. Some cultural artifacts of the Qing palace were given to foreign museums as presents. For exam-ple, in 1957, 550 cultural artifacts of the Qing dynasty, including porcelain, jade, lacquer, enamel, and embroidery, were given to the Museum of Oriental Art of the former Soviet Union. In addition, in the Nanjing Museum, there are still about 100,000 artifacts of the Palace Museum, which remained there after they were moved from Beijing to South China to avoid Japanese invaders.

II. The value of the Palace Museum's collection

The Palace Museum's collection, which is rich in variety and of excellent quality, is classic, systematic and complete, with tremendous historical and cultural value.

The collection is a national treasure. In China, the practice of collecting by a royal house has a long history and is highly symbolic, both politically and culturally. Artifacts were assembled not only because of their rarity or artistic value, but also because of their implications of supreme virtue, and because their assembly was symbolic of receiving the mandate of heaven. A new dynasty's taking over the collection of a previous one indicated the takeover of heaven's mandate. Such collecting culminated in the Qing dynasty, which had effectively taken over the collections of all previous dynasties. Founded at a time when the restoration of the monarchy was opposed, the Palace Museum regards the Qing court's collection as the essence of the cultural tradition and a treasure of all the people, and sees the preservation of the treasures and of the palace as an integral to safeguarding democracy and the republic. The image of the collection as a national treasure was enhanced during the arduous efforts to ship it to the South. Although such efforts were objected to at first, it was soon realized that while lost territory could be regained, the national tradition and spirit would be at stake if treasures representing thousands of years of civilization were destroyed. Finally, a consensus was reached to protect as much of the national patrimony as possible. With the Forbidden City being designated a World Cultural Heritage Site, thanks to the enhanced understandings of its value and cultural significance, not only are its collections regarded as national treasures, but the entire Forbidden City itself is considered an unparalleled treasure that best represents the cultural traditions of China.

The Palace Museum is the richest and most important treasury of ancient Chinese works of art. Its one million and a half artifacts (or sets of artifacts) date from the Neolithic era to the Song, Yuan, Ming, and Qing dynasties and to modern times. They represent the essence of ancient culture of every region of China and that of the Han and the ethnic minorities. They include all the categories of ancient Chinese art. The artifacts in the major categories are complete records of the inception, development, and apex of their respective categories. Taking calligraphic works for example. Those in the museum's collection cover the process from engraving to writting and to the development of calligraphy as an independent art, ranging from oracle bones, bronze inscriptions, early calligraphic works of the Jin dynasty, and works of major schools of various periods. Or consider ceramics. The collection includes black pottery and painted pottery of the Neolithic, products of the five famous kilns of the Song dynasty, blue and white porcelain of the Yuan dynasty, white porcelain, under-glaze red porcelain, and porcelain with contending colors of the Ming dynasty, and *famille rose* and colored enamel porcelain of the Qing dynasty. This is also true of jade, bronze, and handicrafts. The museum is also collecting modern and contemporary works for the sake of cultural continuity and for the benefit of posterity. Therefore, the Palace Museum can be said to represent a condensed history of the five millennia of Chinese civilization. The museum's collection fully attests to the continuity of Chinese history and culture.

Both the collection and the historical buildings of the museum are peerless treasures. A major characteristic of the for-

mer is its inextricable link with the latter. Their combination constitutes the Forbidden City's unrivaled value and the museum's rich significance and high prestige. As the Forbidden City is a site of world cultural heritage, so is its collection. It belongs not only to China, but also to the world.

The Forbidden City was the imperial palace in the Ming and Qing dynasties, having been the political center of the dynastic empire and the residence of twenty-four emperors over 491 years. The quantity of collections and related items that were handed down bear inextricable links not only to the Forbidden City, but also to Chinese history, especially to that of the Ming and Qing dynasties. The collection, the historical buildings and the figures and events related to the court form a whole that has given rise to a new discipline- Gugong Studies. From the point of view of Gugong Studies, the museum's collections are not only of special cultural and artistic importance, but, having witnessed the rise and fall of dynasties, are also of tremendous historic value.

III. The significance of the publication of the *Compendium of Collections in the Palace Museum*

The compilation and publication of this compendium is significant in more ways than one.

Collections are the basis for the existence and operation of a museum, whose importance is mainly judged by its quality and quantity. Though the cultural artifacts of the Forbidden City have been inventoried several times, little is known about some of them due to the enormous number and variety of the court collection. Effective protection and a more comprehensive and accurate understanding of the collection's significance, features and value would not be possible without a thorough inventory of the types and numbers, which is a fundamental task for the museum. In light of that, the Palace Museum has been continuously inventorying the Collection over recent decades, and the implementation of *The Plan for Inventorying Cultural Artifacts in 2004-2010* has produced remarkable results, which, along with the efforts of several generations of museum staff, are embodied by the *General Catalogue for the Collections in the Palace Museum* and *Compendium of Collections in the Palace Museum.* They are useful in presenting, in a comprehensive way, the wonders of the museum's collection, in meeting the needs for appreciation and research, and in enlightening society.

The Palace Museum has published *The Complete Collection of Treasures of the Palace Museum* (in sixty volumes) and a number of catalogues on paintings and calligraphy, ceramics, bronze, jade, and architecture. However, the number of cultural artifacts presented in publications is still rather small, and the vast majority remains unknown. It is difficult for people to appreciate the splendor of Chinese cultural artifacts, and for experts and scholars to make full use of the museum's resources. The historical, scientific and artistic value of a large proportion of the collection is yet to be realized. The publication of *Compendium of Collections in the Palace Museum,* which is beautifully printed with advanced technology, presents such artifacts in a systematic, comprehensive way and turns them into cultural resources truly shared by the public.

As noted above, 600,000 artifacts were shipped to Taiwan and now there are two Palace Museums, one in Beijing and the other in Taipei. The collections of both were primarily inherited from the Qing court and are mutually complementary,

and should therefore be regarded as a whole. The publication of the *Compendium* helps to familiarize people with the collections on both sides of the straits and facilitates a deeper understanding of the museum's culture as a whole. More importantly, it makes for a more comprehensive appreciation of the age, splendor, and continuity of Chinese civilization.

The collection of so many treasures, which has been an arduous process, signifies the continuity of civilization. The publication of *Compendium of Collections in the Palace Museum* is a major cultural project and a great event in the history of publication of the twenty-first century. We believe that it will be beneficial for further revealing the cultural significance of the Forbidden City, for its overall protection, and for the development of Gugong Studies.

凡例

一　本大系为中英文对照的资料性图录，力求以图片形式展示故宫博物院藏品的总体面貌，除文物号、名称、时代、尺寸、造型及纹样等基本要素外，概不做考释。

二　本大系以藏品质地、功用为据分为不同编；编下各册原则上按历史时序排列。每编首册设总目、总序、凡例、分论、图版目录、图版及图版索引，其余各册只设总目、图版目录、图版和图版索引。

三　选取标准以全面展示故宫博物院的藏品为主旨，同时兼顾藏品自身的历史价值和艺术价值。大系所选藏品约占故宫博物院藏品总数 150 万件（套）中的 10%。

四　"故"字号藏品均于 1949 年 9 月 30 日前入藏故宫博物院，绝大多数为清宫旧藏。"新"字号均为 1949 年 10 月 1 日之后故宫博物院通过拨交、征购以及接收各界捐赠等途径新征集之藏品。

五　藏品定名以通行的质地、纹样、器形三要素为主。对个别传承有绪、社会影响较大的重器，尽量沿用旧名，存在争议的则以当前的研究水平为准。

六　中国文物的时代均采用传统纪年方法；外国文物使用公元纪年。度量衡按照中华人民共和国法定单位书写。

七　有明确考古出土地点的藏品均予注明。

Guide to the Use of the Compendium

I. As Chinese-English informative volumes, this compendium presents a comprehensive view of the Palace Museum's collections. There are no explanatory notes apart from such basic information as each item's inventory number, title, date, dimensions, shape, and decorative pattern.

II. The compendium is divided into parts according to the materials and functions of collected items. Each part is in principle divided into chronologically arranged volumes, and the first volume of each part contains the Preface, Guide to the Use of the Compendium, an essay on its contents, list of plates, plates and index, while the other volumes only contain list of plates, plates and index.

III. The criterion for selection is a comprehensive survey of the Palace Museum's collection as well as the historic and artistic value of the items. The selected items account for about 10% of the total of 1.5 million (sets).

IV. Items whose numbers begin with the word "Gu (old)" were collected before September 30, 1949, and the vast majority of them were taken over from the Qing court. Those whose numbers begin with the word 'Xin (new)' were collected through purchase, transfer, or donation after October 1, 1949.

V. The items are mainly named according to material, decorative pattern and shape, the generally acknowledged three essentials. Old names are still used for certain influential ones that were handed down in a systematic way. Controversial ones are named according to the latest reliable results of research.

VI. Chinese artifacts are dated in the traditional way, while "common era" is used for foreign ones. The PRC's legal units are used for weights and measures.

VII. Sites of excavation are specified where appropriate.

前言

张广文

　　故宫博物院收藏有 3 万件以上的玉器，这些玉器组成了世界上最大最精美的中国古代玉器群，其中不乏各时代的代表作品，较为全面地反映了中国古代玉器的面貌。人们若想了解中国古代玉器、研究中国古代玉器，就应该关注故宫博物院收藏的这部分藏品。

　　故宫博物院收藏的玉器大致可分为清代宫廷收藏的古玉器、清代宫廷使用的玉器、博物院收藏的传世玉器、博物院收藏的考古发现玉器 4 个类别，其中传世玉器占多数。它们中的许多在流传过程中或器形被改变或加染颜色，与考古发掘的玉器有一定的差别。

　　故宫博物院藏新石器时代玉器有较多为宫廷收藏。清以前，人们对石器时代的社会状态及玉器使用认识不清，商代以前的玉器真实的制造年代几乎不被人知，仅少量所谓"蚩尤环"被认为是早于商代的作品，其他玉器，尤其是直方类几何形玉器，多被认为是西周玉礼器，且用《周礼》的记述解释其用途、名称。故宫博物院所藏清宫存新石器时代玉器，有红山文化、龙山文化、良渚文化、石家河文化、齐家文化及其他新石器文化玉器，其中许多为乾隆时期的收藏。乾隆皇帝对这些玉器非常喜爱，许多玉器上带有乾隆题诗或御识文字，以良渚文化、齐家文化玉器所带文字为多。在故宫博物院新收玉器中，最重要的部分是安徽省含山县凌家滩出土的新石器时代玉、石器，约 104 件，其中的玉龟板，为玉龟背甲及玉腹甲间再加玉板，板上有图案，或是巫师占卜所用法器；玉勺则与现代用勺极为相似，精致至极。这批藏品为极重要的现代考古玉器发现。

　　商周时期是古代玉器的成熟期，故宫博物院藏有商周玉器的 4 个主要类别：礼仪用玉，主要有璧、琮、圭、璋、璜；佩带用玉，有各式环、璜、珩、冲牙、坠饰；玉动物人物，有鸟、兽、蝉、蚕、蛹、虫及人物；玉用具。多数为故宫博物院建院后所藏，清代宫廷所遗作品中亦有精品，

个别作品还附有乾隆题诗。

春秋战国玉器历来是玉器收藏的重点，这一时期的玉器制造精细，器物边线简练而准确。多为片状，厚度均匀，表面平整，或为满而密的单元花纹组合，或为对动植物图案进行删减和主体部位的夸张。饰有图案的作品多，图案精细的作品多，一般来看，春秋玉器上的纹饰多含有变形的小兽面纹或窃曲纹，一些图案在玉器的表面微微突起，图案突起圆润者为好。战国玉器图案以几何状的谷纹、蒲纹、勾云纹为主，图案凸起以明锐者为好。其中一些玉器的玉质较佳，有较多的白玉、青白玉作品。

故宫博物院收藏的春秋战国玉器约有 1 400 件，其中一级品约 180 件，二级品约 950 件。较为重要的作品是清代宫廷遗存的玉人首，作品所用玉料似为新疆产透闪石玉，造型带有石家河文化玉人首特点，表面饰有春秋玉器特有的隐起勾云纹，又在流传过程中被染颜色，作品为石家河文化玉器，花纹为春秋时期加工，染色约为清代，表现出古代玉器在长期流传过程中的不同时期特点。故宫博物院收藏的战国玉器，一部分为清代宫廷收藏，多为珩、璜、觽类佩玉，一些作品非常精美，曾在乾隆收藏玉器的百什件箱内存放，是乾隆时期玉器收藏的重要作品。清宫存留的战国玉灯，玉色青白，上部为圆形灯盘，饰勾云纹，其下灯柱，上端为花蕾状，灯柱下为圆形柿蒂纹座，是战国玉器精品。故宫博物院成立后入藏的战国龙凤玉璧，玉色白而泛青，孔中有一兽身龙，璧表面饰云纹，两侧轮廓外各雕一凤，也是非常难得的玉器精品。

故宫博物院还收藏有少量经考古发掘出土的战国玉器，其中重要的有安徽长丰县杨公乡出土玉器。杨公乡战国墓群同楚王墓相距约 5 千米，属王室贵族墓地，发掘墓葬 11 座，出土玉器 80 余件，故宫收藏有其中的 27 件。这些玉器同未入藏故宫的作品，在所用玉料、艺术风格、使用方式上有明显特点，是研究楚文化玉器及文化状态的重要资料。

故宫博物院收藏的汉代玉器约有 1 150 件，其中宫廷遗存约 750 件，与收藏的春秋战国玉器数量相近。汉代的用玉制度，史书中记载得并不多，但汉代大型墓葬中玉器的使用量很大，且有较为统一的风格，除了少量葬玉外，多数都是入葬者生前使用或收藏的作品。汉代玉器在品种上较春秋战国玉器有很大的发展，动植物造型与纹饰的使用，丧葬玉器、玉文具、佩玉、陈设摆件之中出现了一些新品种，故宫博物院收藏有汉代这些类别玉器的精品。如动物造型中的玉马、玉羊、玉鸠、玉辟邪、玉兽首，文具用具中的玉砚滴、玉洗、玉樽，还有"长乐"铭玉璧、"益寿"铭玉璧等，都是清代宫廷收藏的汉代玉器中非常罕见的艺术珍品。汉代玉辟

邪是对后世影响极大的作品，唐以后到明清玉辟邪多取其制造特点，现代又有大量仿制。但是真正的汉代作品数量非常少，其中的辟邪玉镇，除汉墓考古发现的几件外，能够确定的传世作品不过 10 件，故宫博物院藏清宫遗存 4 件，有一件尚需研究，其余 3 件特点明确，为此类玉器的典型。

三国、两晋、南北朝时期的玉器，延续了汉代玉器的风格，但使用量很小，考古发掘仅发现少量作品，传世作品也很少，传世玉器的确认方法仍在探索中。故宫博物院收藏的这一时期的玉器有玉佩、玉剑饰、玉杯、小玉兽，以清代宫廷收藏为主。其中的凤鸟纹玉佩与考古发现的北朝玉佩样式、花纹基本相同；白玉虎纹璜尚不见有相似作品发表于文献；玉剑璏则多饰云水纹；玉辟邪具有张口、凸颊、鼓胸、短肢、羽翅的特点，延续了汉代玉辟邪的风格；玉杯则具有汉代玉器皿风格且有变化。多年来，故宫博物院研究人员对这一时期玉器的确认采取了谨慎的方式，可能藏品中还有一些此时期玉器尚未被确定。

南北朝以来玉器风格的渐变，最终引起剧变，其中又有中亚艺术的影响，唐代玉器以全新的面貌展现于世。目前已经发现的唐代玉器，主要有玉杯、玉兽、玉佩件、玉梳具。故宫博物院藏唐代玉器，包括了唐代玉器的主要品种，且多为精品，白玉人物纹舟形杯、青玉云柄瓜棱杯、白玉云柄杯，造型、花纹皆为典型的唐代风格，在已知的为数极少的唐代玉杯中占有很重要的位置。唐代至五代时期，妇女使用的玉头饰，多用上好白玉制造，非常精致，故宫博物院收藏的这一时期的玉簪饰、玉梳、玉梳背，可以作为这一类玉器的代表作品。另外还收藏有不同尺寸、花纹的玉带板，品种也很丰富。唐代玉器中玉人非常少，故宫博物院藏有一批人物题材玉器，长袖于手前下折，舞状，面部表情丰富，头戴幞头，同唐、五代墓葬所出舞人木俑风格类似，应为同一时期的作品。

故宫博物院藏宋、辽、金、元玉器约 960 件，尚未计算镶嵌于盖、盒、家具等器物上的作品，是目前所知收藏这类玉器最多的单位。这一时期，玉器在民间已广泛使用，汉以前存在的士以下无制度性佩玉的传统已不复存在，古玉收藏、研究与玉器市场的发展，推动了仿古玉器和时样玉器的发展，玉器数量大，品种多，风格多变化。目前有较多的作品流传于世，相对而言，这一时期玉器的考古发现与研究略显不足。故宫博物院所藏这一时期玉器多为清宫遗存，是清宫数百年的搜存积累，虽然经过与考古发掘玉器的比对及艺术风格的研究，确定了其中的典型作品，但目前的总体认识是粗略的，且尚有未被认识的作品。

故宫曾是明、清两代的皇宫，故宫博物院藏宫廷遗物中有大量的明代玉器，这些玉器多为明代宫廷遗存及清代宫廷的收集。目前，故宫博物院玉器库所藏明代玉器约5 000件，其他类文物库房还有藏品，是最大规模的明代玉器收藏。同一些田野考古、明代古建筑考古中发现的明代玉器一样，明代玉器往往同元以前玉器不易区别，相互混杂，但主体脉络清楚，主要为礼器、陈设器、用具、佩带玉、文玩、仿古器几个类别。同以前的玉器相比，明代玉器中器皿所占比例较大，故宫博物院藏明代玉中有较多的瓶、尊、壶、杯、炉、盒、碗、洗，其中有较多的仿古样式。玉礼器主要为圭、璧，故宫博物院所藏明代素璧为礼器用璧，螭纹璧则多为珍玩。所藏明代佩带玉以玉带为多，分为素玉带、透雕玉带、刻花玉带。《明宫史》记载，明代使用玉带，冬用光素、夏用玲珑、春秋用顶桩，应为此三种。陆子刚是明晚期苏州的著名治玉大师，其字号延续使用数百年，明代玉器、清代玉器、现代玉器中多有子刚款作品。故宫博物院藏有数十件明代制造的子刚款玉器，其中一些为陆子刚亲手所制。

　　清代宫廷玉器是故宫博物院藏玉中的最重要部分，又分为宫廷藏玉和用玉。宫廷收藏，历来就有，宋、明宫廷收藏见于文献，所见实物不是很多。清代宫廷收藏的基本面貌，在故宫博物院有较完整的保存。宫廷对玉器的收藏，包括古玉器，也包括时样玉器，收藏过程可分为入宫、鉴选、分类、刻字、存储、利用等步骤。一些玉器还被拾掇、捆饬，因而宫廷遗存古玉器多有改刀、染色，其实，这也是当时社会收藏中存在的普遍现象。

　　清代宫廷玉器使用的玉料，主要有三种，一为透闪石玉，主要来自新疆，宫廷多称为和田玉。清宫遗玉上，很多都刻有乾隆咏和田玉及器的诗句，玉料有山料和籽料的区别，籽料产于河中。二为辉石类的翡翠，产于缅甸，明代已见使用，清宫廷称其为云南玉。有较多的作品，如宫廷造办处档案记：乾隆三十六年五月十八日，交彰宝呈进的云南玉佛手洗一件。目前故宫博物院藏清代翡翠器700余件，有许多精品。三为蛇纹石玉。多为清晚期的作品，有学者称其为石器，但故宫博物院藏有一件带乾隆款的蛇纹石玉，一面刻有"虑俿玉尺"，虽然为仿古作品，但还是作为玉器定名。由于蛇纹石玉易于染色，乾隆以后的许多宫廷仿古作旧玉器，都是用蛇纹石玉制造的。故宫博物院收藏的清代宫廷玉器，数量大，品种多，成系统，是目前收藏这类作品最多的单位。玉器品种多种多样，包括了顺治到光绪各朝的作品，尤其是收藏的清宫廷所用成组玉磬、大玉山、大玉瓮、玉屏风，目前在故宫博物院以外尚难见到，收藏的宫廷所用大玉瓶、壶亦属罕见。作品的多样化超过任何时期的玉器，自典章用器到医疗保健应有尽有，进入了社

会生活的方方面面，其设计内容对现今玉器行业仍有指导意义。

 故宫博物院还藏有大量的古代彩石雕刻，有与玉器加工方式相同的水晶、玛瑙、珊瑚、青金石、绿松石等作品，也有手工雕刻的寿山石、鸡血石、青田石、端石、松花石等各类名石作品，丰富多彩。尤其是所藏清初雕刻家杨玉璇、周彬（尚均）等名家的作品用材精良、雕刻精湛、设计奇妙，造型生动准确，是各艺术家的代表性作品。

 故宫博物院，是古代玉石器的艺术宝库，研究者、爱好者、探奇者、惑而不解者纷沓而来，似潮之往复，他们在这里都能得到满足。为了这些藏品能够得到更好的保护和利用，为了更好地满足广大读者的需要，我们编辑了《故宫博物院藏品大系·玉器编》，凡 10 册，录作品 3 000 余件，尽量选择有代表性的作品、精品及个别有待探索品，因篇幅有限，又因时间仓促，遗漏甚多，不足之处，恳请指正。

Foreword

Zhang Guangwen

There are more than 30,000 jade articles in the collections of the Palace Museum, which constitute the largest and most exquisite array of Chinese ancient jade in the world. Many of them are masterpieces of their respective periods. The collection provides a survey of the entire history of Chinese jade processing. These remarkable works of art are an excellent resource for those who wish to learn about or research the history of Chinese jade artefacts.

The jade artefacts in the Palace Museum may be roughly grouped into the following four types: ancient jade artefacts from the Qing Dynasty (1644-1911) court collection, jade artefacts made for use at the Qing court, jade artefacts collected after the Museum was established in 1925,which were handed down generation after generation, and jade artefacts archaeologically discovered and collected by the museum after its establishment. Most of them were handed down generation after generation, therefore many such jade artefacts over the centuries were altered or enhanced with colour stain, they are distinctively different from those recovered from archaeological excavations.

A fairly large number of jade artefacts of the Neolithic Age in the Museum were once in the collections of former imperial courts. Before the Qing Dynasty, people were not so clear about the social usage of jades in the Neolithic Age; they had only the vaguest notion of the time when the pre-Shang Dynasty jade artefacts were made. Only a few "Chiyou Rings" were thought to be from that early period. The rest, especially those of straight and square shapes, were generally deemed to be ritual jade artefacts made during the Western Zhou Dynasty. Their uses were interpreted and their names specified in accordance with relevant records in Rites of the Zhou Dynasty. The Palace Museum's collection of Neolithic jade formerly in the Qing court include jades from sites such as Hongshan, Longshan, Liangzhu, Shijiahe, Qijia, and other Neolithic cultures. Many of them were collected by Emperor Qianlong who liked them so much that he had his poems or calligraphic works incised on them. Those with the most inscriptions are jades of the Liangzhu and Qijia cultures. Among the jade artefacts recently added to the Palace Museum, the most important are those from the Neolithic site at Linjiatan, Hanshan County, Anhui Province. A multitude of jade artefacts were excavated at the site and 104 of them are in the Museum's collection. Among them there is a jade tortoise shell which consists of the upper and lower tortoise plastrons, and a jade plate between them carved with patterns. This may have been an instrument used by medicine men during divination. There is an exquisite jade spoon which closely resembles modern spoons. This group of jade artefacts are extremely important in recent archaeological discoveries.

During the Shang and Zhou dynasties the craft of jade processing attained its maturity. In the collections of the Palace Museum, Jade artefacts of that period are of four major types: 1) ritual jades which predominantly are bi (a round jade with a hole in the centre), cong (a rectangular jade with round hole), gui (an elongated tablet of jade), zhang (a jade resembling a half of gui), huang (a jade pendant of semi-circular shape); 2) jades for personal ornament which include circular jades, semi-circular jades, jade bodkins of various shapes; 3) jade animals and statuettes which include jades in the form of birds, beasts, cicadas, silkworms, pupas, insects as well as jade human figures; 4) jade utensils, most of which came into the collections after the Palace Museum was established. Some jade artefacts from the Qing court collection are also fine works of art, with a few of them inscribed with poems by the Qianlong Emperor.

The jade artefacts of the Spring and Autumn period and the Warring States period would be highlights of any jade collection because of their extremely delicate patterns. In some cases, the jade artefacts are uniformly covered with a dense array of similar patterns; in other cases, they are ornamented by carved patterns of animals or plants with some parts omitted or the major motif exaggerated. Of the jade artefacts from this period, many are excellent works of art ornamented with fine carvings and with simple but precise border lines. Most of them are jade disks of even thickness and smooth surface. Generally speaking, on jade artefacts of this period there are deformed small beast face patterns or qiequ patterns (literally "stealthily twisted pattern", usually an array of S-shaped patterns), some of which are in low relief, and those that are smoothly rounded are regarded as superior. Jades of the Warring States period often feature regular geometric patterns of grain, cattails, and whirling clouds. Those with clearly articulated patterns are considered the finest. Of those made from relatively high quality jade, there are slightly more artefacts of fine white or of pale grey-white jade.

About 1,400 jade artefacts of the Spring and Autumn and the Warring States periods are in the Palace Museum collection, of which about 180 are ranked in the First Grade and about 950 are designated Second Grade. Among them, the Jade Human Head once in the Qing court collection is especially worth mentioning. Made of a special jade resembling the raphi-lite jade produced in Xinjiang and ornamented on its surface with bas-relief whirling cloud patterns characteristic of the Spring and Autumn era, this fine work of art bears the distinctive features of Shijiahe jade articles. As a Shijiahe jade whose pattern was carved during the Spring and Autumn era and to which colour was imparted during the Qing Dynasty, it bears features of different periods of Chinese jade history. Jade artefacts of the Warring States period in the Palace Museum come partly from the Qing court collections, most of which are heng (an ornamental jade at the top of a jade pendent), huang or xi (a jade bodkin). Some of these jade artefacts are exquisite works of art. They were once kept by Emperor Qianlong in his Hundred-treasure Box for the jade collection. Among the emperor's favourite jade artefacts was a jade lamp of the Warring States period. Made of grey-white jade, the lamp is composed of an upper round oil tray ornamented with whirling cloud patterns and a lamp stem whose top is in the shape of a petal and whose base is carved with persimmon stem patterns, a masterpiece of its time. The Dragon-and-Phoenix Bi, another rare jade article of the Warring States era, was added to the collection after the Palace Museum was established. It is a piece of white jade tinged with traces of grey. Ornamented with cloud patterns on its surface, it has a beast-bodied dragon in the central hole and a phoenix-like ornament attached to the main round shape at each of its two sides.

Also in the Palace Museum collection are a small number of jade artefacts of the Warring States period from archaeological excavations, of which the most important are those unearthed at Yanggong Township, Changfeng County, Anhui

Province. The Warring States period tombs at Yanggong, about five kilometres from the Mausoleum of the King of the State of Chu, belong to a cemetery of former noble families. More than eighty jade artefacts were excavated from eleven tombs, of which twenty-seven are now in the Museum. These jade artefacts have distinctive characteristics in terms of materials, artistic styles, and uses and thus provide important information for studies on the jade artefacts and culture of Chu.

There are about 1,150 jade artefacts of the Han Dynasty in the Palace Museum, of which about 750 once belonged to the Qing imperial collection, comparable to the number of jade artefacts from the Spring and Autumn and Warring States periods. Only scanty information can be found in historical records concerning the social function of jade artefacts during the Han Dynasty. However, a large number of jade artefacts have been found in large-scale tombs of that time and all of them are of nearly identical styles. Except for a few exceptions, all of these jades were once used by or collected by the deceased when alive. Compared with those of the Spring and Autumn and the Warring States periods, these works were much more diversified. Many new shapes and patterns were adopted; many new types of jade artefacts appeared in categories such as funerary jades, jade writing implements, jade pendants, and jade ornaments. The Palace Museum has some excellent Han Dynasty jade artefacts in these categories, including animal-shaped jades such as horses, sheep or goats, owls, BiXie (mythical), beast heads, and jade implements such as water droppers for inkstones, brush washers, and drinking vessels. All these jade articles, together with the round jades inscribed with chang le (Everlasting Happiness), yi shou (longevity), are all rare works of art from the Qing Dynasty court collection. Jade Bixie of the Han Dynasty had tremendous influence on its kind of later ages. This explains why jade Bixie from the Tang to the Qing Dynasty all have similar features. Even today they are often copied. However, authentic jade Bixie of the Han Dynasty are now very rare. Except the Bixie jade ballast and the few discovered in tombs of the Han Dynasty, among the objects which were handed down generation after generation, no more than ten jade Bixie, were confirmed authentic Han. Of the four in the collection of the Qing court and now in the Palace Museum, one remains to be authenticated and the other three are typically Han Dynasty objects with distinctive features.

Jade artefacts made during the Three Kingdoms, the Eastern and Western Jin Dynasties and the Northern and Southern Dynasties inherited the style of Han Dynasty jade artefacts. During that period, jades were less frequently used, only a small number of jades of this period have been archaeologically excavated or survived above ground. Methods of verifying them have yet to be established. Jade artefacts of this period in the Palace Museum include pendants, ornaments on the sword, cups, and small-size beasts, most of which were in the Qing court collection. Among these works of art, the jade pendant ornamented with phoenix patterns is strikingly similar in terms of design and patterns with those excavated from the Northern Dynasty. However, no records or descriptions concerning semi-circular tiger-patterned white jade pendants have been found. Jade Zhi(slotted fitting attached to sword-scabbard) are mostly ornamented with curved wave-line cloud or water patterns. Jade Bixie of this time followed the characteristics of Han Dynasty such as open mouth, protruding cheeks, convex chest, short legs, and feathered wings. Jade cups also share some common features with Han Dynasty jade vessels but a few changes were made. For many years, Palace Museum researchers have maintained a cautious attitude before deciding that a jade object was made in the period between the Han and Tang dynasties.

Different in style from those of the Warring States period and of the Han Dynasty, jade artefacts of the Tang Dynasty took on a brand-new look. The gradual change in style beginning during the Southern and Northern Dynasties, coupled with influences from central Asian art, eventually resulted in a drastic revolution. Jade artefacts of the Tang Dynasty discovered to

date may be grouped into the following major types: cups, beasts, pendants, and combs. Those in the Palace Museum include representative jade artefacts of all these types and many of them are excellent works of art. For example, judging from shapes and patterns, all of the following are typical Tang Dynasty jade artefacts: the boat-shaped white jade cup with human figure, the grey jade cup with a cloud-shaped handle and melon ridges, and the white jade cup with a cloud-shaped handle. They are the finest of those few jade artefacts confirmed as works datable to the Tang Dynasty. During the tenth century, following the Tang Dynasty, it was common for women to wear exquisite head ornaments made of fine white jade. The jade hairpins, jade combs and jade comb backs in the Palace Museum are masterpieces of this type. In addition, some jade belt discs and hooks of various sizes and with different patterns are also in the collection. Jade statuettes are rarely seen among Tang Dynasty jade artefacts. However there is a collection of jades depicting human figures in the Museum. With their long sleeves dangling over their hands, the turban-wearing dancers represented in these works of art have various facial expressions. Since they are similar in style to the wood dancer figurines unearthed from Tang Dynasty and Five Dynasties tombs, they must have been created during that period.

About 960 jade artefacts (not including those attached to covers, cases, furniture, etc.) of the Song, Liao, Jin, and Yuan dynasties are in the Palace Museum. This is the largest collection of jade artefacts of this period, during which jade objects were widely used in ordinary families. The traditional sumptuary laws of the pre-Han period restricting the wearing of jade to aristocrats had long been abolished. Jade collecting, research on jades, and a flourishing jade market stimulated the development of both antiquarian-styles and newly-designed jade articles. Jade articles, of different types and styles, were produced in large numbers, many of which have survived. Comparatively speaking, archaeological finding and research concerning jade artefacts of this period are somewhat inadequate. The Palace Museum's collection of jade artefacts of this period is largely based on the collection accumulated over several hundred years by the Qing court. Though some representative jade artefacts of this period have been selected through comparison with archaeologically excavated examples and research on their artistic styles, we only have a general knowledge at present and further study is needed.

The Forbidden City was the imperial palace of the Qing and Ming dynasties. Therefore many jade artefacts of the Ming Dynasty have survived. Most of them were once kept by the Ming court or were collected by the Qing court. At present there are about 5,000 jade artefacts of the Ming Dynasty in the jade storage of the Palace Museum. Jades kept in other departments are not included in this number. The Museum's collection of Ming Dynasty jade artefacts is by far the largest of its kind. As with Ming Dynasty jades archaeologically excavated or found in architectural contexts, it is difficult to distinguish them from those made before the Yuan Dynasty. However, their categorisation is clear. Jade artefacts of the Ming may be assigned to the following categories: ritual, decorative, utensils, waist belt ornaments, scholar's implements, and ancient-style articles. Compared with jade artefacts of earlier times, vessels make up a larger proportion. Of the Palace Museum's Ming Dynasty jade artefacts, a significant number are flasks, goblets, kettles, cups, stoves, cases, bowls, and brush washers. Many are copies of ancient jade articles. Ritual jades of the Ming Dynasty consist mainly of gui tablets and bi disks. Those bi disks without decor are ritual jades, while those carved with designs of young hornless dragons (chi) are primarily curios. Most of the jades for personal adornment of this period in the Palace Museum are jade belt tablets, which can be further divided into belts without carved decor, belts with openwork, and belts with carved patterns. These may be the three kinds of belts recorded in the History of Ming Court Dynasty: guang su, ling long and ding zhuang which were said to have been used respectively in win-

ter, in summer, and in spring and autumn. Lu Zigang was a well-known master of jade carving who lived in Suzhou during the late Ming Dynasty. His name became synonymous with jade artefacts for several hundred years. Many of jade artefacts made during the Ming and Qing dynasties and morden times are branded with "Zigang". The Palace Museum has scores of Zigang-inscribed jade artefacts made in the Ming Dynasty, some of which were made by Lu Zigang himself.

As the most important collection of jade artefacts in the Museum, the jades of the Qing Court are further categorised into those collected by the court and those used at the court. It was a long-standing tradition for imperial courts to collect jade articles. Although some historical documents record and describe jade artefacts collected by the imperial courts of the Song and Ming dynasties, the actual objects that can be seen today are relatively few. The Qing court collection, on the other hand, has been preserved nearly intact. During the Qing Dynasty, court-collected jade artefacts, ancient ones included, had to undergo the following various steps before they were accepted into the collection: presented to the court, authenticated and appraised, categorized, inscription incised, storage assigned or put into use. Some jades were reprocessed or modified. Therefore a large proportion of those ancient jade artefacts from the Qing court collection were altered and had colours embellished. The same was the case with non-imperial collections.

The Qing court jade artefacts are mainly of the following three materials. The first is raphilite from Xinjiang (also known as Hetian jade). The second is the brilliantly green jadite from Burma (also known as Yunnan jade), and the third is serpentine jade. Jade artefacts of nephrite are often inscribed with Emperor Qianlong's poetic lines praising Hetian nephrite and the objects made from this. Even Hetian nephrite may be further divided into two different kinds: mountain jade and river jade. The Burmese jadite, or Yunnan jade, already in use during the Ming Dynasty, constitute a fairly large part of the Qing court jade collection. There is a document in the files of the Imperial Household Office that records, "On the eighteenth day of the fifth month in the thirty-sixth year of the Qianlong reign [1771], a Buddha hand vessel of Yunnan jade was presented through Zhang Bao (a high official) to the Emperor." At present there are over seven hundred jadite objects from the Qing Dynasty in the Palace Museum, many of which are rare works of art. From the Qing court there are also a fairly large number of serpentine jade objects, most of which were made during the latter Qing Dynasty. Some scholars have referred to the serpentine artefacts as "stone". However, one of them bearing the Emperor's name Qianlong has four characters reading "Lühu Jade Ruler" inscribed on one side and has been catalogued as jade object. After the Qianlong reign, the imperial court made many ancient-style jade articles, which were all of serpentine jade.

The Museum's collection of Qing Dynasty court jade artefacts, characterised by its quantity and diversity, is the largest of its kind. It includes jade artefacts made from the beginning to the end of the Qing Dynasty. Court jade artefacts made earlier and later also must be extant. Items used at the court, such as jade chime stones, large jade boulders, large jade jars, and jade screens. No similar jade artefacts have been found besides the Palace Museum. Large jade flasks and teapots are also rarely seen. Jade artefacts of the Qing Dynasty are more diversified than those of any other historical period. Widely used in social life, they can be seen among scholar implements and in the field of medical care. Their designs are still significant for the present jade industry.

In addition, the Palace Museum also has large quantities of ancient carvings in various colourful stones. The techniques used to create jade articles are similar for the creation of works out of crystal, agate, coral, lapis lazuli, and turquoise. There are

also diverse and colourful hard-to-carve stones such as Shoushan stone, bloodstone, azurite, Duan stone and Songhua stone. Especially worth mentioning are those by early Qing sculptors such as Yang Yuxuan and Zhou Bin, courtesy name Shang jun. Because of their fine materials, excellent carving, wonderful designs, and vivid representations, these extraordinary works of art are masterpieces representing the greatest achievements of the artists.

Jade artefacts in the Palace Museum constitute a treasury that has never failed to attract art connoisseurs, researchers, those investigating the unusual and those seeking answers. They come in droves into the Museum and have their needs met. In order to protect and utilise our resources better, and to meet the demands of the reader, we have compiled this Compendium of Jade Artefacts in the Palace Museum, in ten volumes which records information about over there thousand jade articles, with efforts focused on representative examples, masterpieces, and extraordinary pieces about which further study is needed. Because of limitations of space and time, there are no doubt lacunae. We welcome your comments and advice.

图版目录

List of Plates

图版

Plates

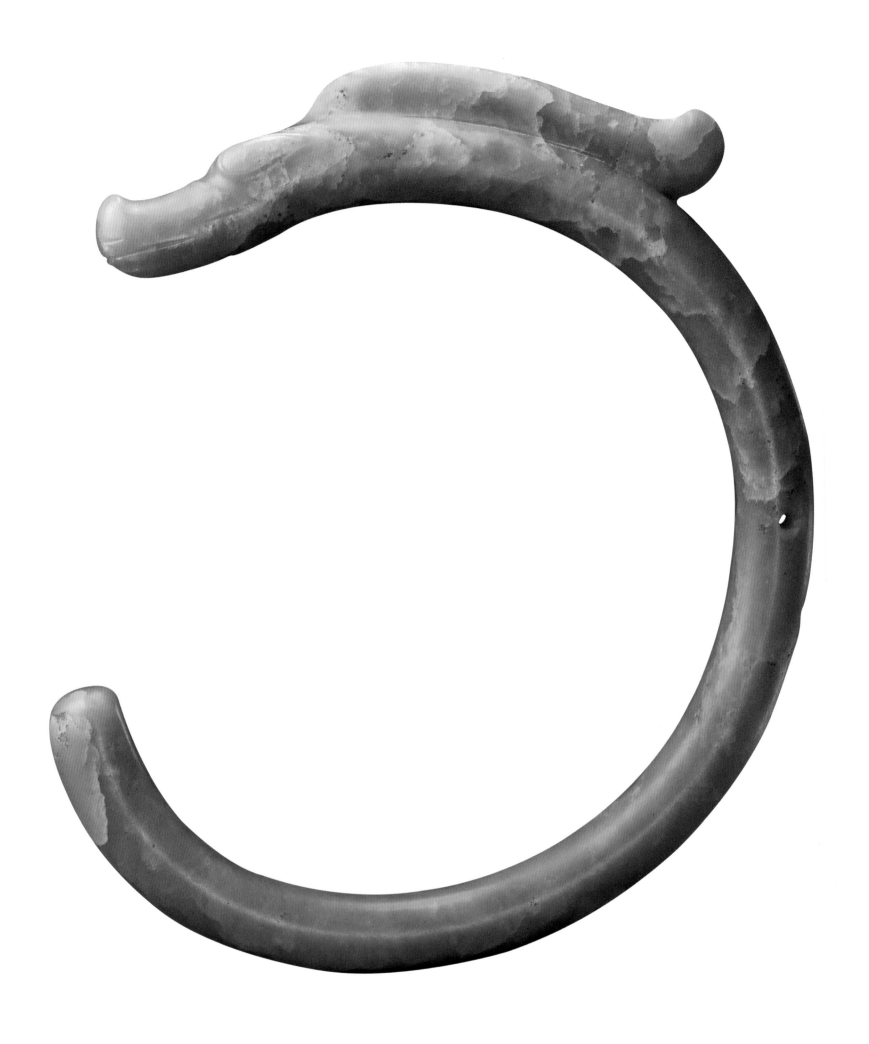

新200399
玉龙
红山文化
高25.5厘米　宽20.1厘米　首厚2.4厘米

I

Xin 200399
Jade dragon
Hongshan Culture
Height: 25.5 cm　Width: 20.1 cm
Head thickness: 2.4 cm

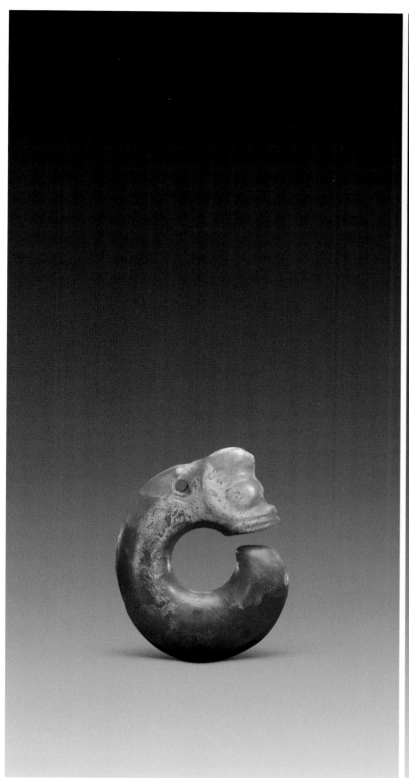

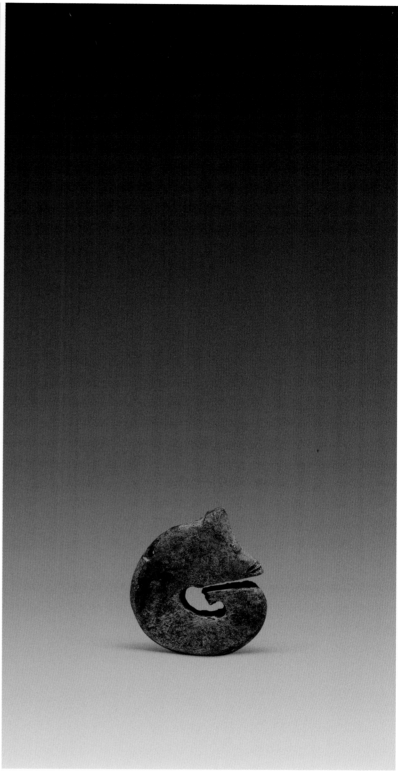

新178369

玉龙
红山文化

2 径5.9×4.4厘米 厚0.5厘米

Xin 178369

Jade dragon
Hongshan Culture

Diameter: 5.9×4.4 cm
Thickness: 0.5 cm

新74538

玉龙
红山文化

3 径3.8×3.3厘米 厚0.6厘米

Xin 74538

Jade dragon
Hongshan Culture

Diameter: 3.8×3.3 cm Thickness: 0.6 cm

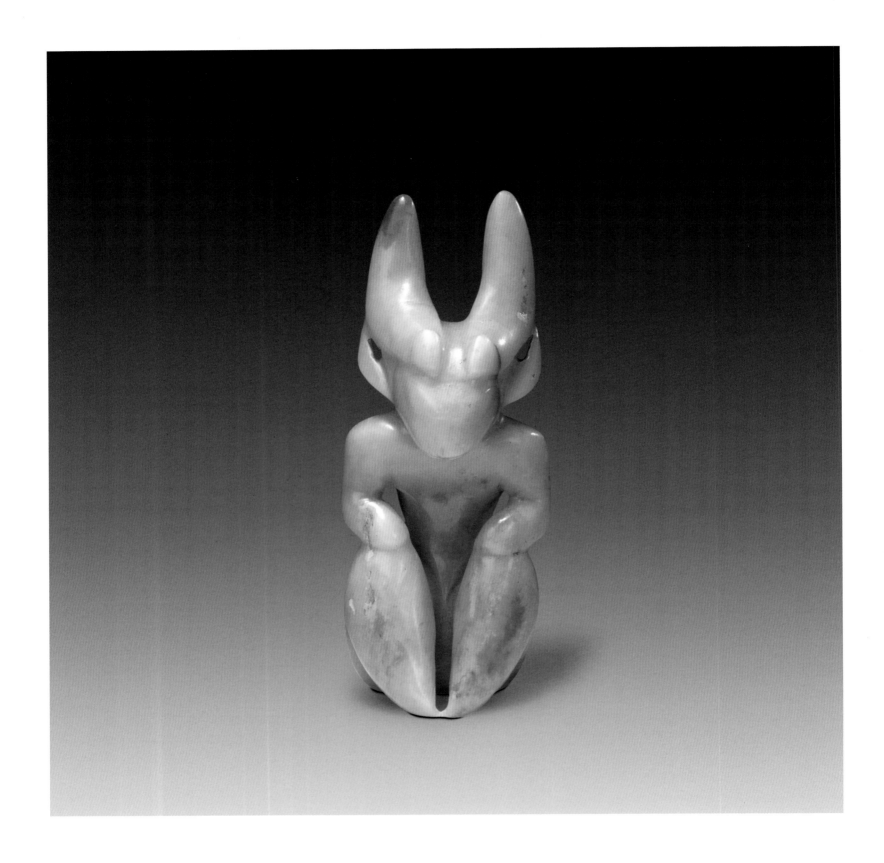

新194773
玉坐人
红山文化

4　高14.5厘米　宽5.7厘米　厚4.7厘米

Xin 194773
Jade seated figure
Hongshan Culture
Height: 14.5 cm Width: 5.7 cm
Thickness: 4.7 cm

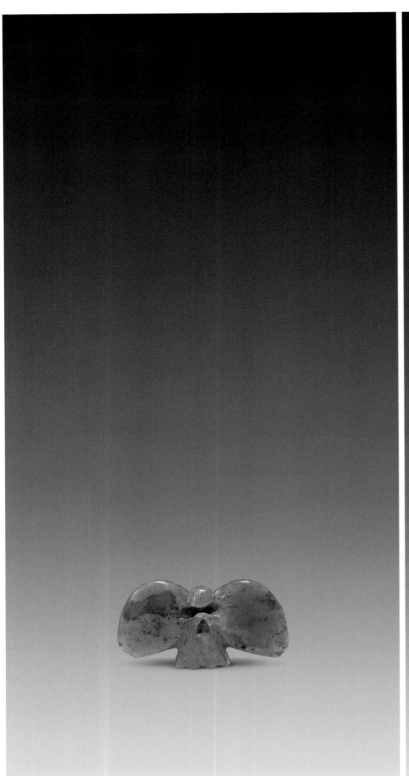

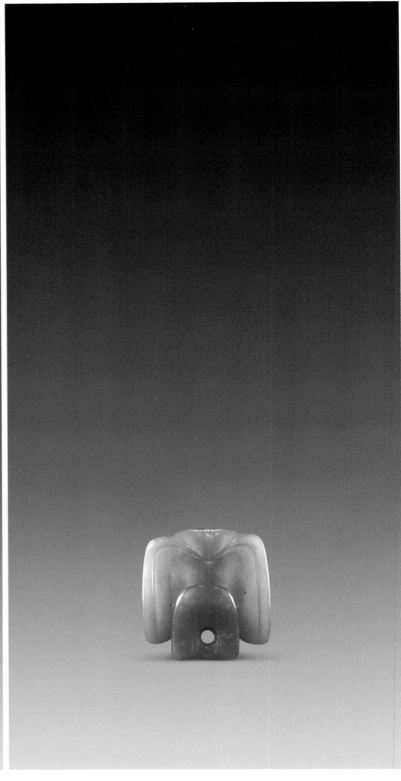

新116124

玉鸮

红山文化

5 | 高2.5厘 宽4.6厘米 厚0.4厘米

Xin 116124

Jade owl
Hongshan Culture

Height: 2.5 cm Width: 4.6 cm
Thickness: 0.4 cm

新200401

玉鸮

红山文化

6 | 高3.7厘米 宽3.5厘米 厚1.3厘米

Xin 200401

Jade owl
Hongshan Culture

Height: 3.7 cm Width: 3.5 cm
Thickness: 1.3 cm

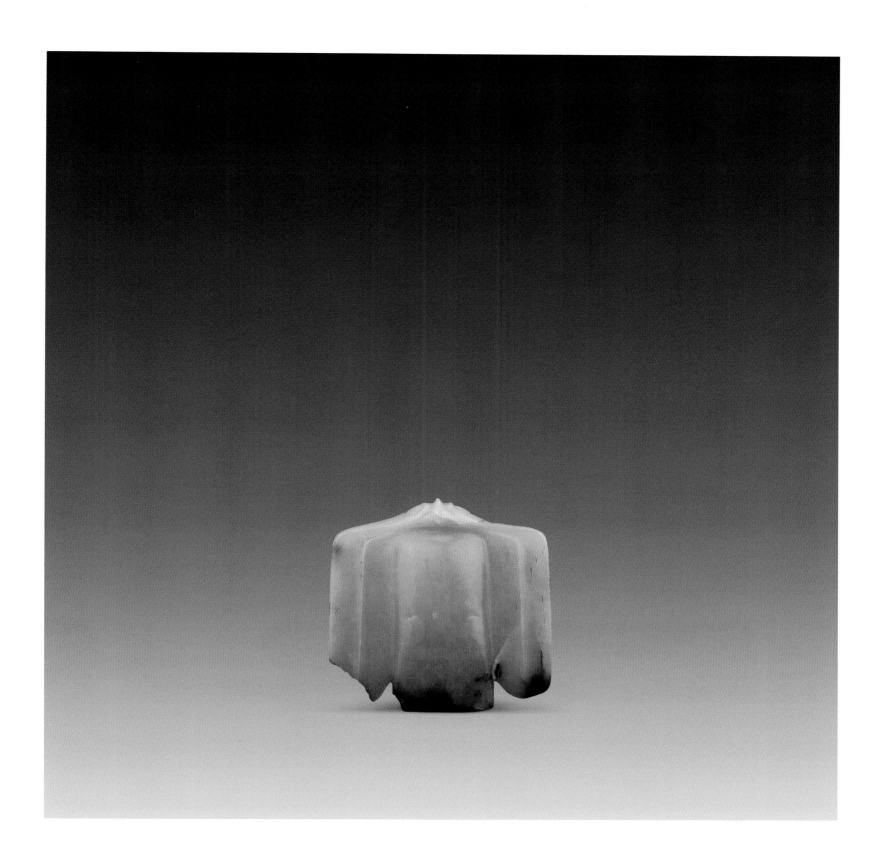

新43041

玉鸮

红山文化

高7.5厘米 宽8厘米 厚1.5厘米

备注：残

7

Xin 43041

Jade owl

Hongshan Culture

Height: 7.5 cm Width: 8 cm
Thickness: 1.5 cm

Incomplete

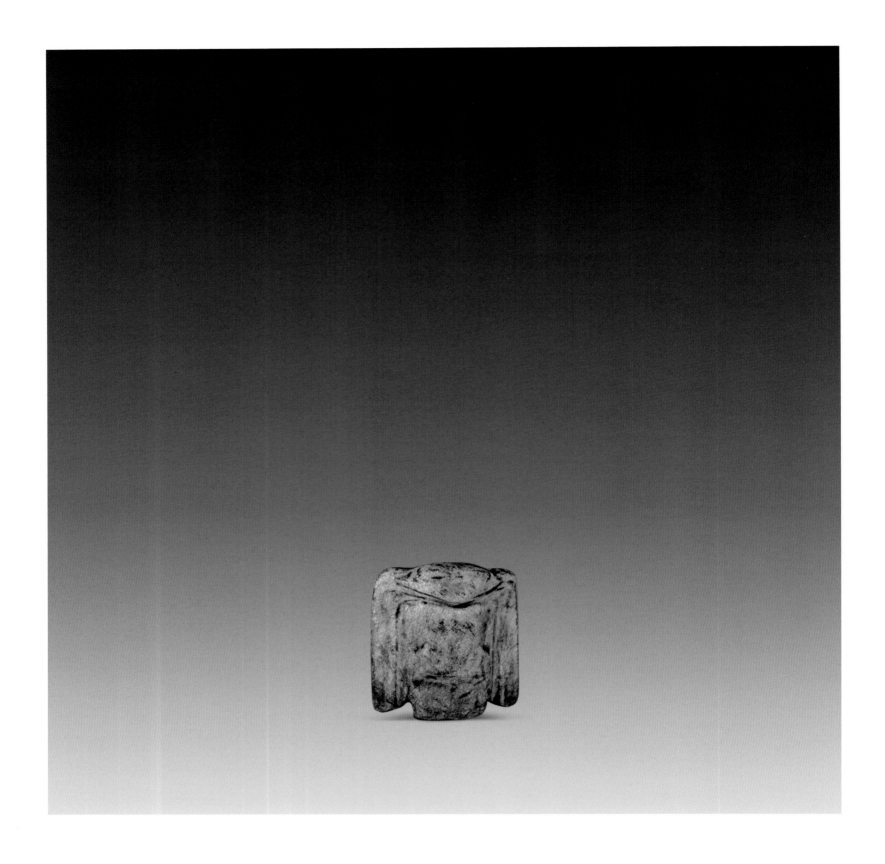

故84717

玉鹰

红山文化

8 | 高3.5厘米 宽3.5厘米 厚1厘米

Gu 84717

Jade eagle
Hongshan Culture
Height: 3.5 cm Width: 3.5 cm
Thickness: 1 cm

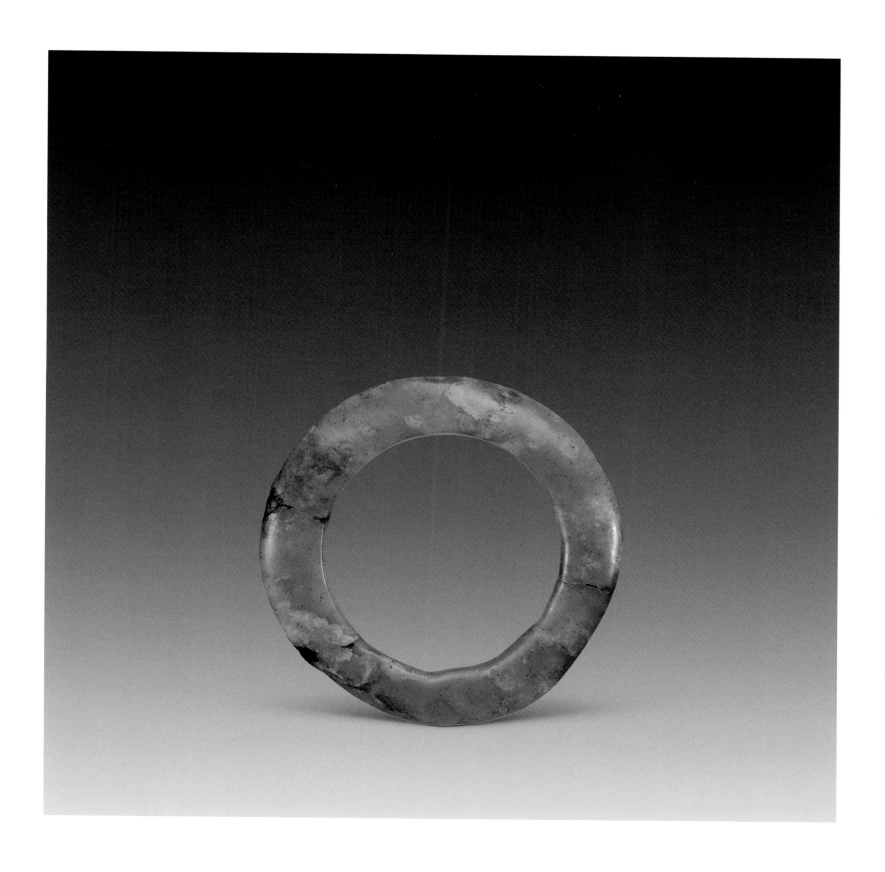

新196664
玉环
红山文化

9 径9.7厘米 孔径6.5厘米 厚0.4厘米

Xin 196664
Jade ring
Hongshan Culture
Diameter: 9.7 cm Internal diameter: 6.5 cm
Thickness: 0.4 cm

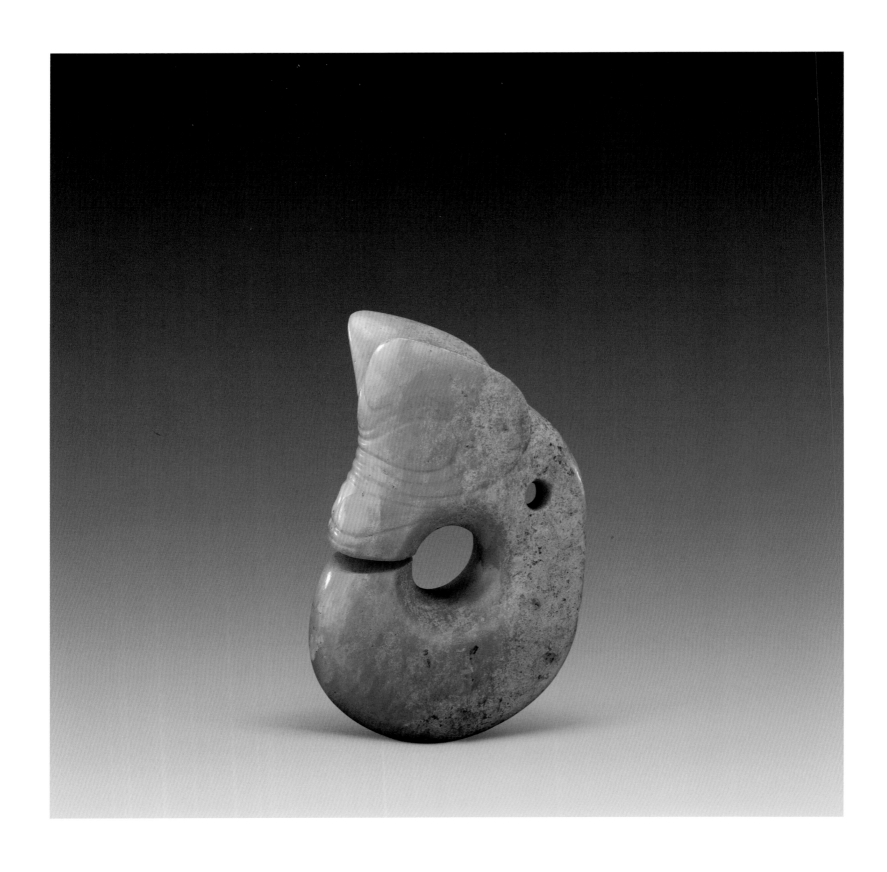

新156776
玉兽头玦
红山文化
10　高12厘米　宽7.6厘米　厚4.2厘米

Xin 156776
Jade Jue in the shape of animal-head
Hongshan Culture
Height: 12 cm　Width: 7.6 cm　Thickness: 4.2 cm

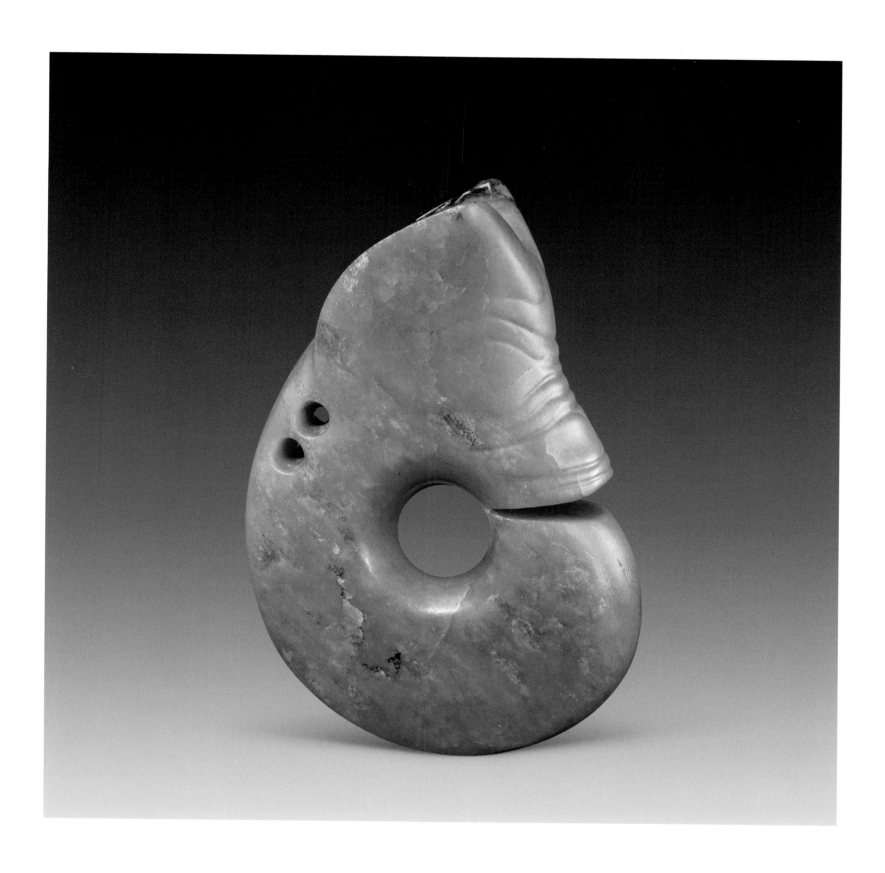

故103952

玉兽头玦

红山文化

高15.4厘米 宽10.5厘米 厚4.2厘米

Gu 103952

Jade Jue in the shape of animal-head
Hongshan Culture
Height: 15.4 cm Width: 10.5 cm Thickness: 4.2 cm

11

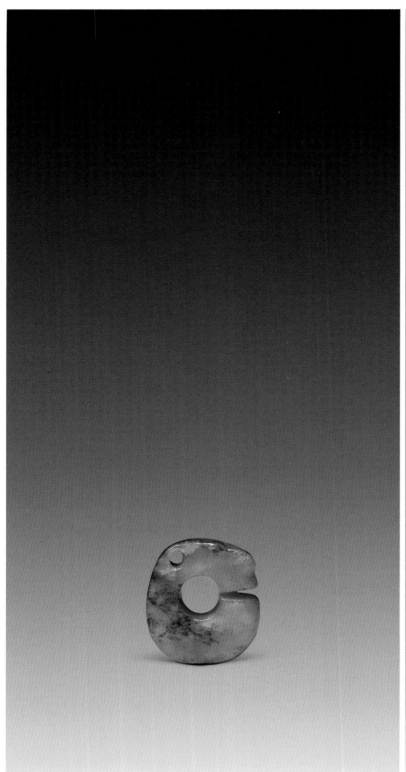

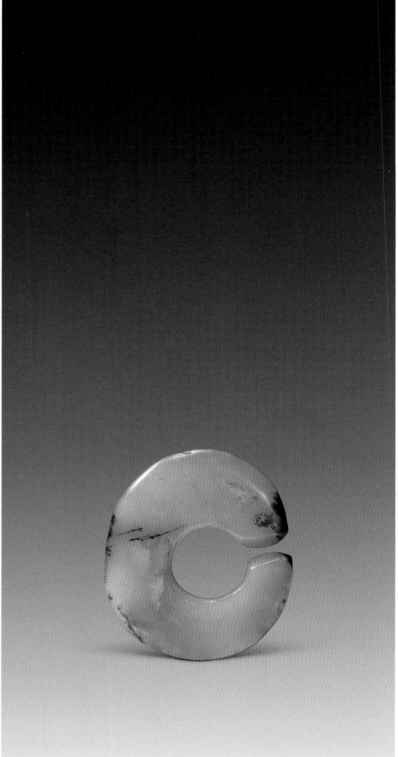

新116052

玉玦

红山文化

12 | 径3.5厘米 孔径0.9×0.8厘米 厚0.7厘米

Xin 116052

Jade Jue

Hongshan Culture

Diameter: 3.5 cm Internal diameter: 0.9×0.8 cm
Thickness: 0.7 cm

故94359

玉玦

红山文化

13 | 径5厘米 孔径2×2.2厘米

Gu 94359

Jade Jue

Hongshan Culture

Diameter: 5 cm
Internal diameter: 2×2.2 cm

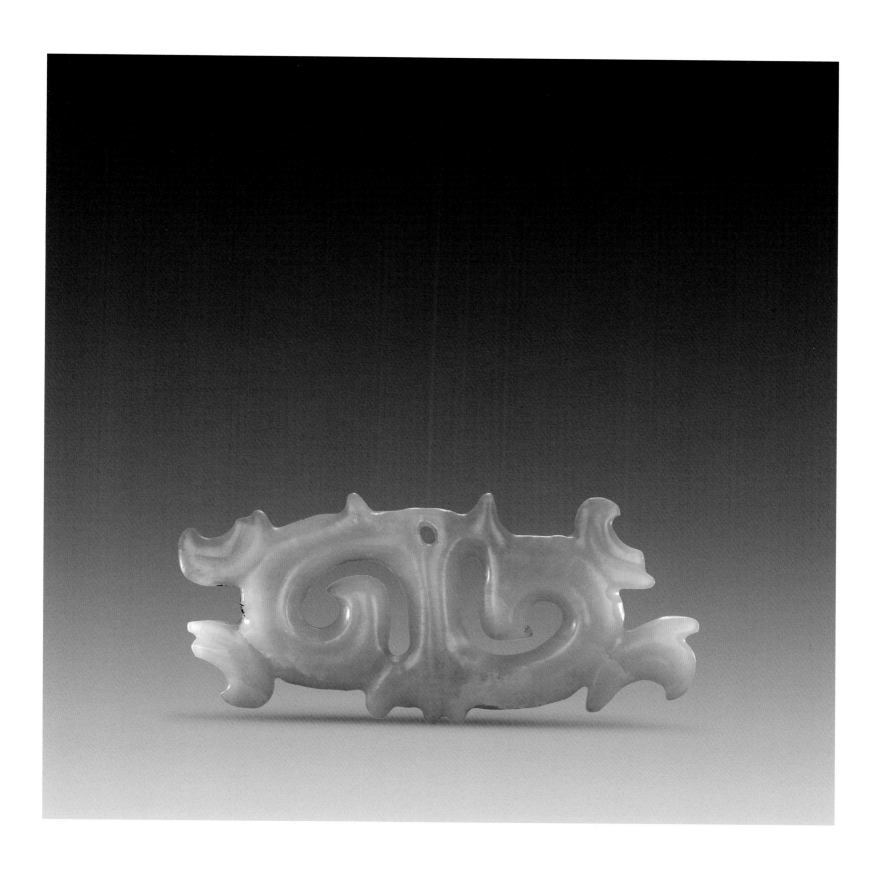

新200400
玉勾云形佩
红山文化

14 | 长13.7厘米　宽6.4厘米　厚0.75厘米
Xin 200400
Cloud-shaped jade pendant
Hongshan Culture
Length: 13.7 cm　Width: 6.4 cm　Thickness: 0.75 cm

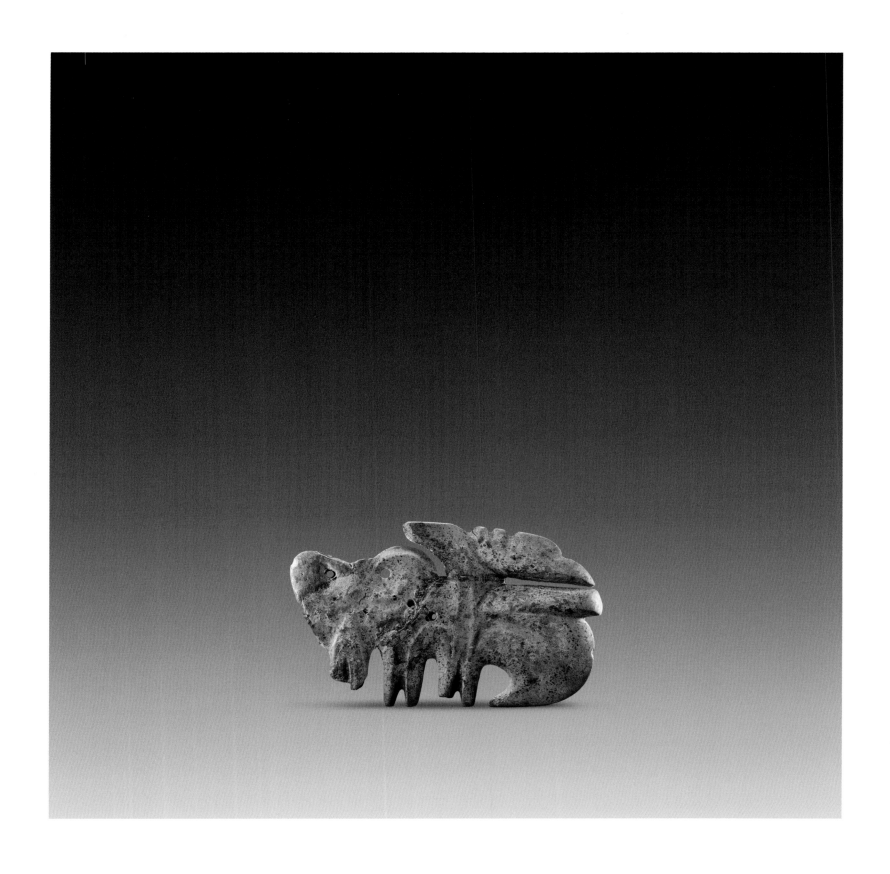

新141648

玉兽面纹饰件
红山文化

长8.3厘米 宽4.9厘米 厚0.3厘米

备注：残

Xin 141648

Jade pendant with animal-face design
Hongshan Culture

Length: 8.3 cm Width: 4.9 cm Thickness: 0.3 cm
The pendant is incomplete

故95791

玉角形饰件
红山文化

长20.2厘米 宽12.5厘米 厚0.7厘米

备注：后修改，清代配座

Gu 95791

Horned-shaped jade ornament
Hongshan Culture

Length: 20.2 cm Width: 12.5 cm
Thickness: 0.7 cm
*Re-shaped and with a support equipped in the Qing
Dynasty*

15

16

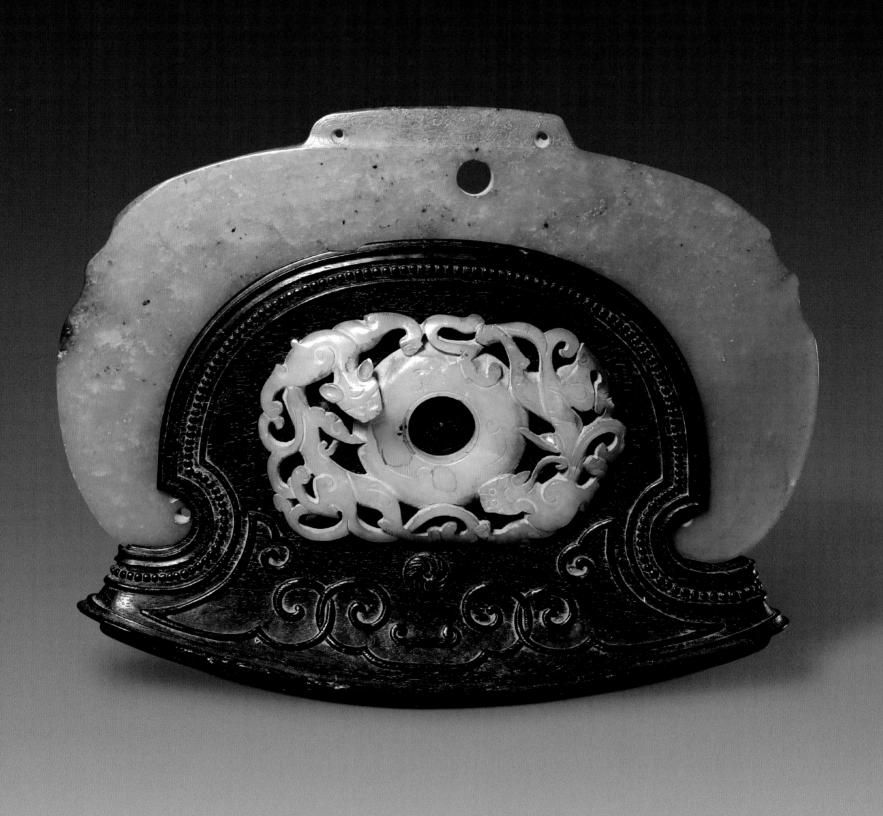

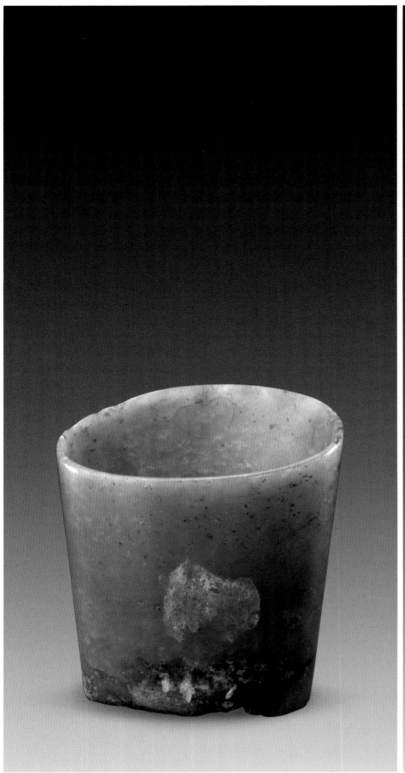

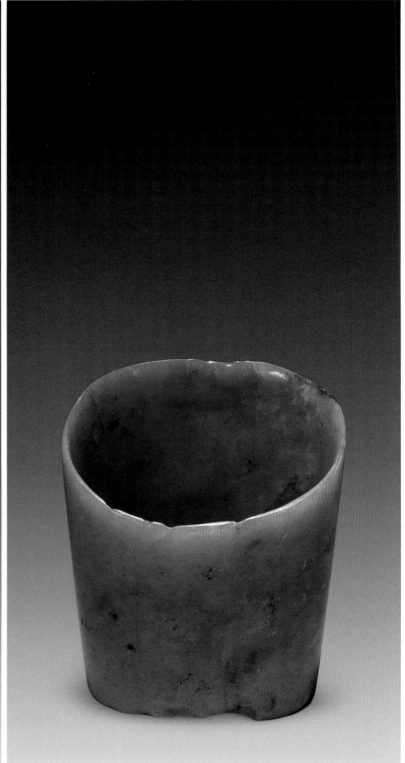

新96961
玉马蹄形器
红山文化
17 高9.5厘米 口径9×7.1厘米 底径6.9×5.5厘米
Xin 96961
Jade object in the shape of horse-hoof
Hongshan Culture
Height: 9.5 cm Mouth diameter: 9×7.1 cm
Bottom diameter: 6.9×5.5 cm

新111962
玉马蹄形器
红山文化
18 高9.9厘米 口径7.8厘米 底径6.6厘米
Xin 111962
Jade object in the shape of horse-hoof
Hongshan Culture
Height: 9.9 cm Mouth diameter: 7.8 cm
Bottom diameter: 6.6 cm

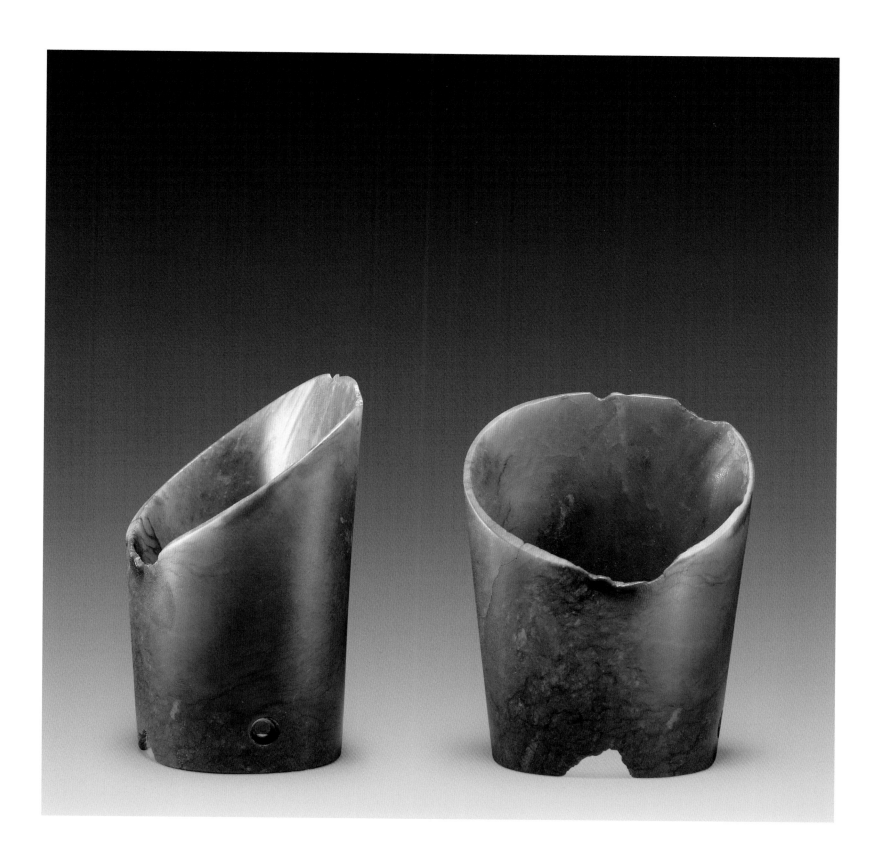

新178421
玉马蹄形器
红山文化
19 | 高11.7厘米 口径7厘米 底径6厘米
Xin 178421
Jade object in the shape of horse-hoof
Hongshan Culture
Height: 11.7 cm Mouth diameter: 7 cm
Bottom diameter: 6 cm

新51589

玉马蹄形器

红山文化

20

高17.2厘米　口径10×6.1厘米　底径7.2×5.9厘米

Xin 51589

Jade object in the shape of horse-hoof
Hongshan Culture

Height: 17.2 cm　Mouth diameter: 10×6.1 cm
Bottom diamter: 7.2×5.9 cm

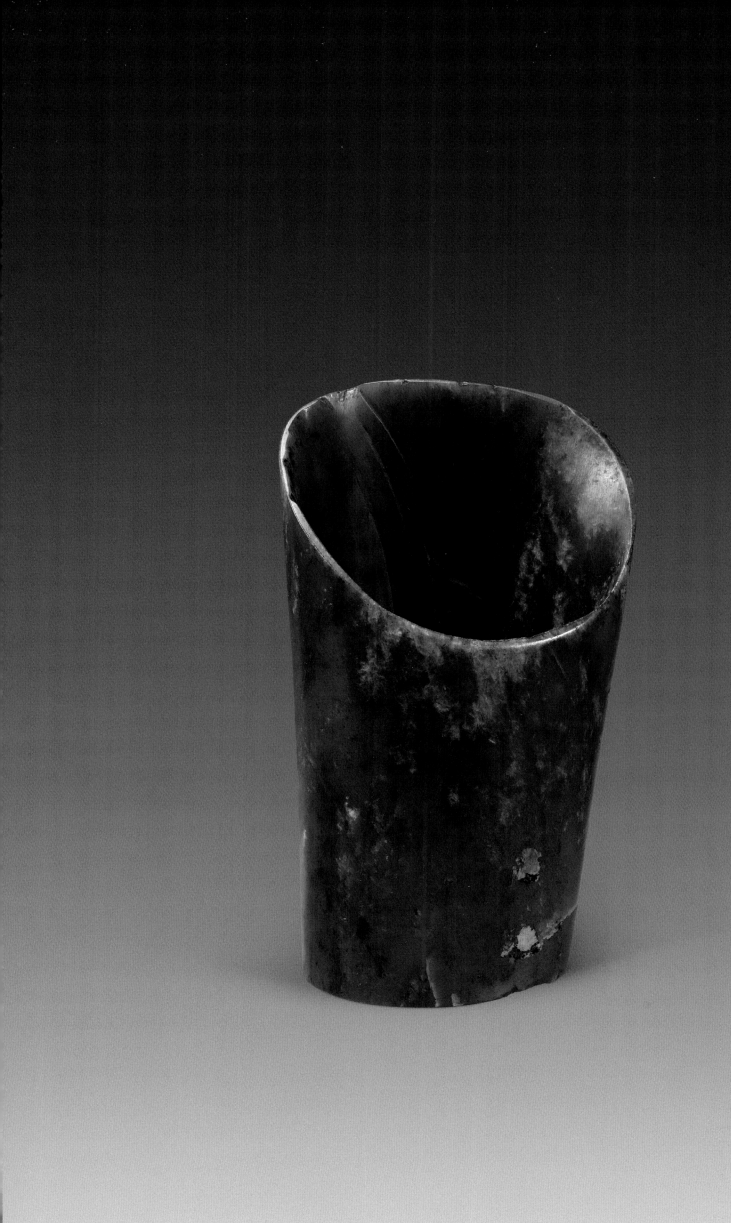

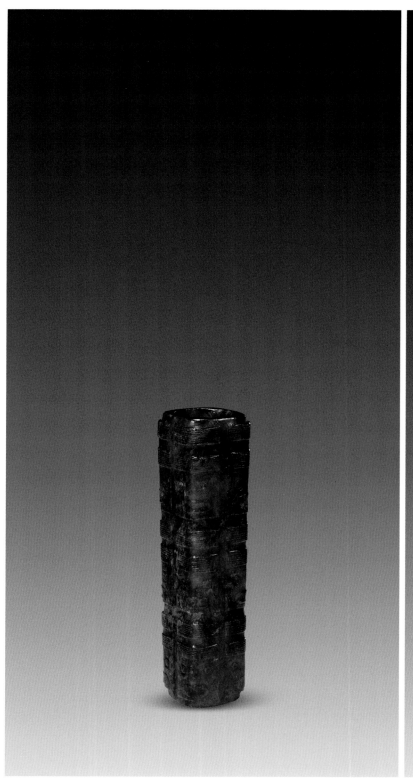

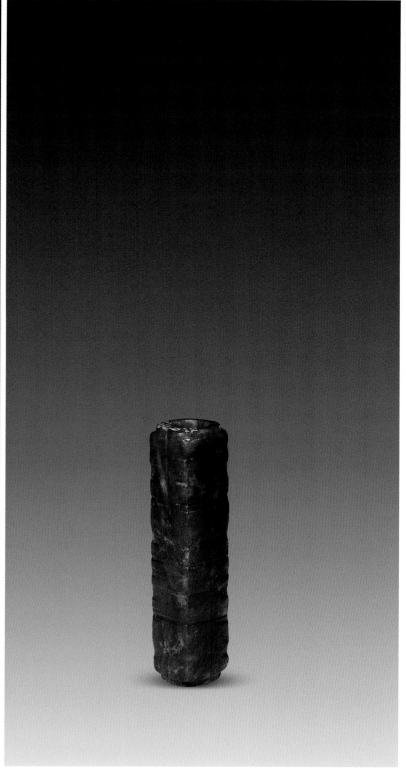

故84935
玉三节琮
良渚文化
21 | 高8.2厘米 宽1.8厘米 口径2.2厘米
Gu 84935
Jade Cong
Liangzhu Culture
Height: 8.2 cm Width: 1.8 cm
Mouth diameter: 2.2 cm

故83956
玉四节琮
良渚文化
22 | 高7.4厘米 宽1.7厘米 口径1.6厘米
Gu 83956
Jade Cong
Liangzhu Culture
Height: 7.4 cm Width: 1.7 cm
Mouth diameter: 1.6 cm

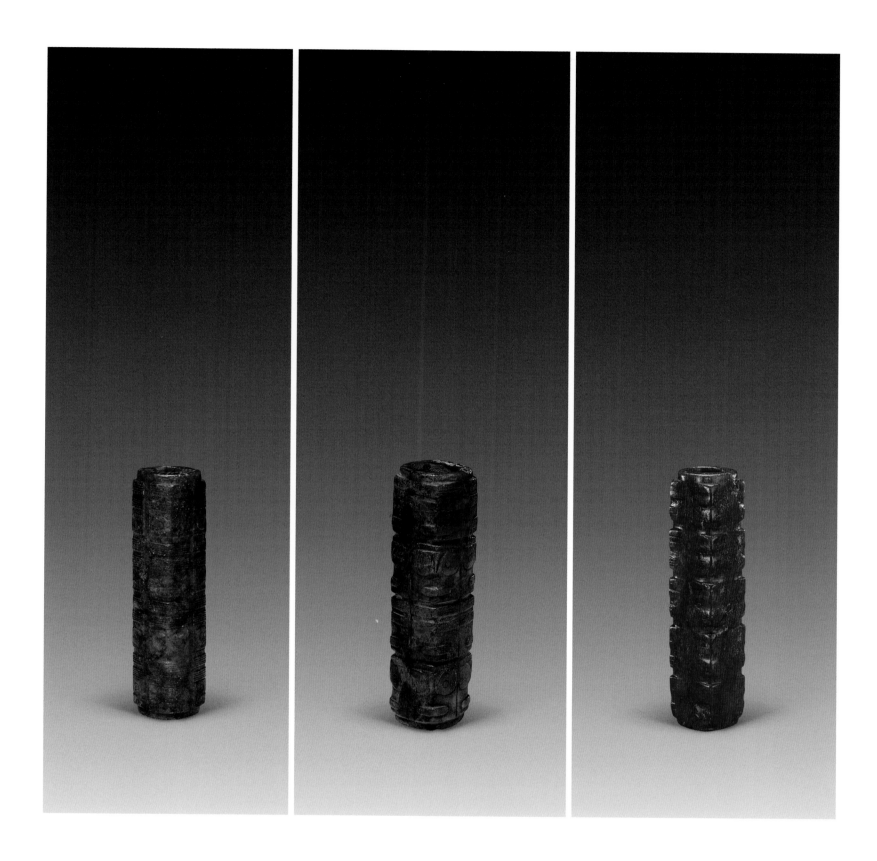

故84686
玉四节琮
良渚文化
23 | 高7厘米 口径1.6厘米
—————
Gu 84686
Jade Cong
Liangzhu Culture
Height: 7 cm Mouth diameter: 1.6 cm

故83957
玉四节琮
良渚文化
24 | 高7.4厘米 口径1.8厘米
—————
Gu 83957
Jade Cong
Liangzhu Culture
Height: 7.4 cm Mouth diameter: 1.8 cm

故83931
玉五节琮
良渚文化
25 | 高7.3厘米 口径1.5厘米
—————
Gu 83931
Jade Cong
Liangzhu Culture
Height: 7.3 cm Mouth diameter: 1.5 cm

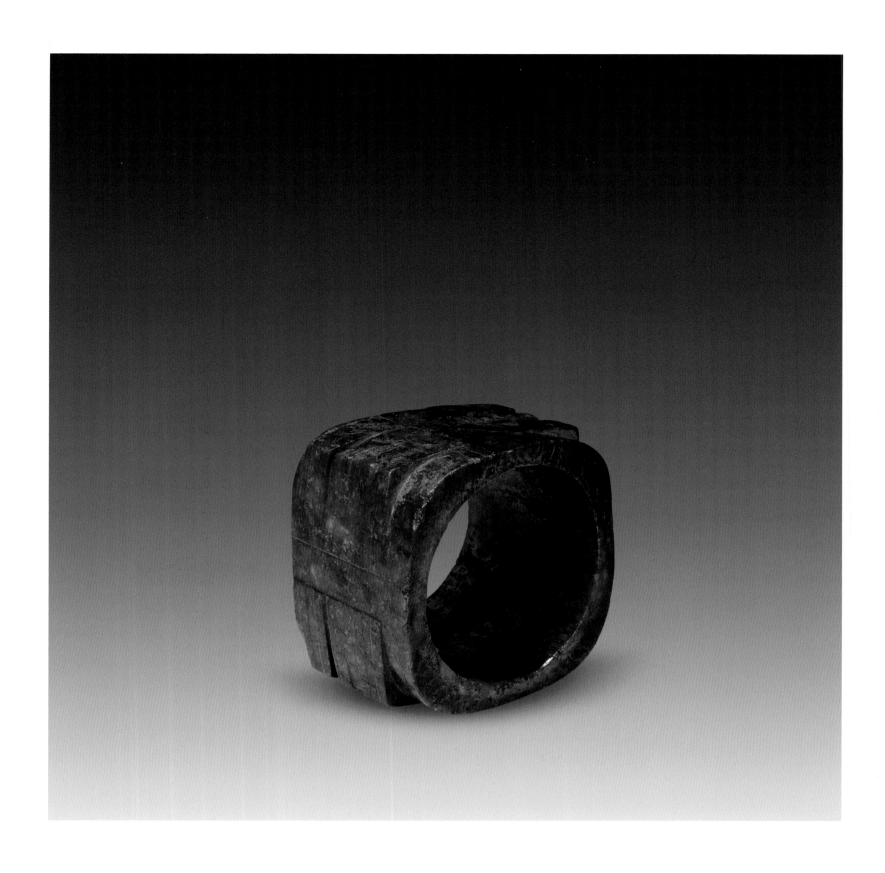

故83951
玉两节琮
良渚文化
高4.9厘米　口径6.9厘米
备注：清代配铜胆

26 Gu 83951

Jade Cong
Liangzhu Culture
Height: 4.9 cm　Mouth diameter: 6.9 cm
With a copper liner equipped in the Qing Dynasty

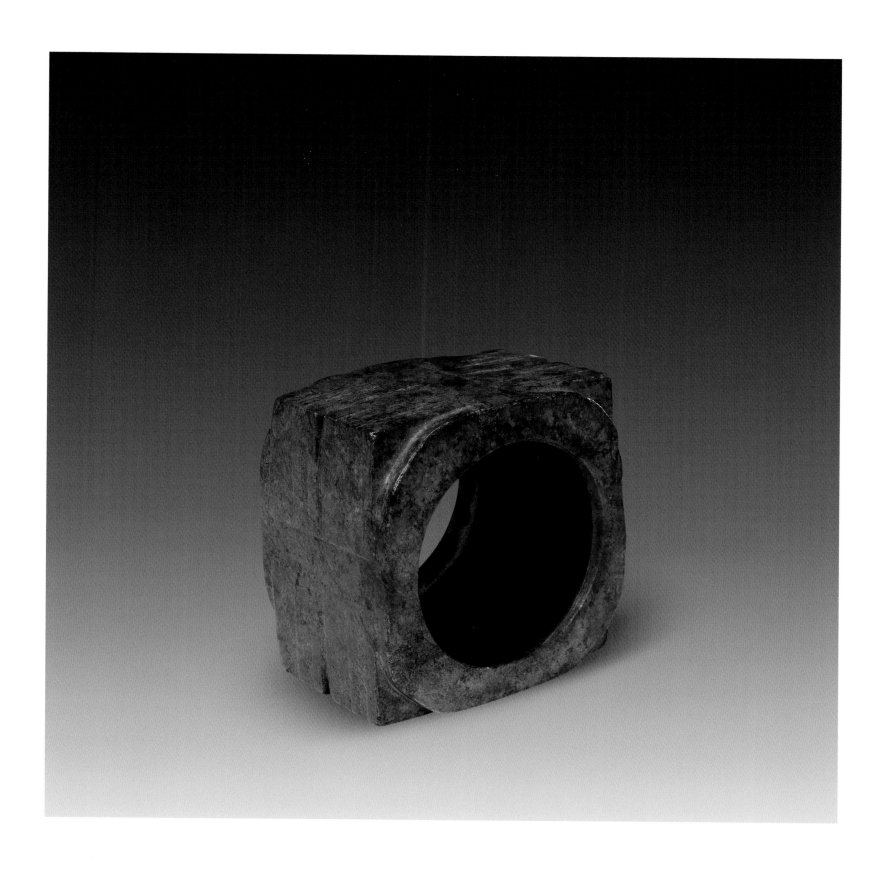

故96005

玉两节琮

良渚文化

高5.5厘米 口径8厘米

备注：清代配铜胆

27

Gu 96005

Jade Cong

Liangzhu Culture

Height: 5.5 cm Mouth diameter: 8 cm

*With a copper liner equipped in the Qing
Dynasty*

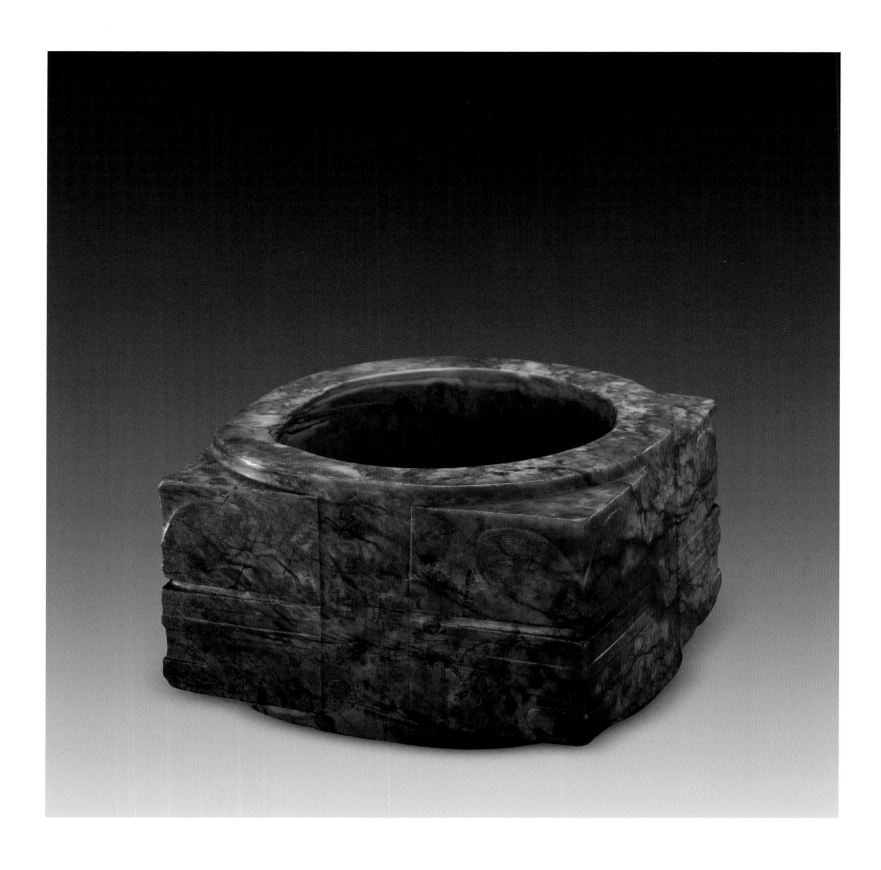

新117975

玉两节琮
良渚文化
高6.7厘米 口径11.7厘米

28 备注：经改动，染色，后刻御题诗

Xin 117975
Jade Cong
Liangzhu Culture
Height: 6.7 cm Mouth diameter: 11.7 cm
Re-shaped, dyed and inscribed later with an imperial poem

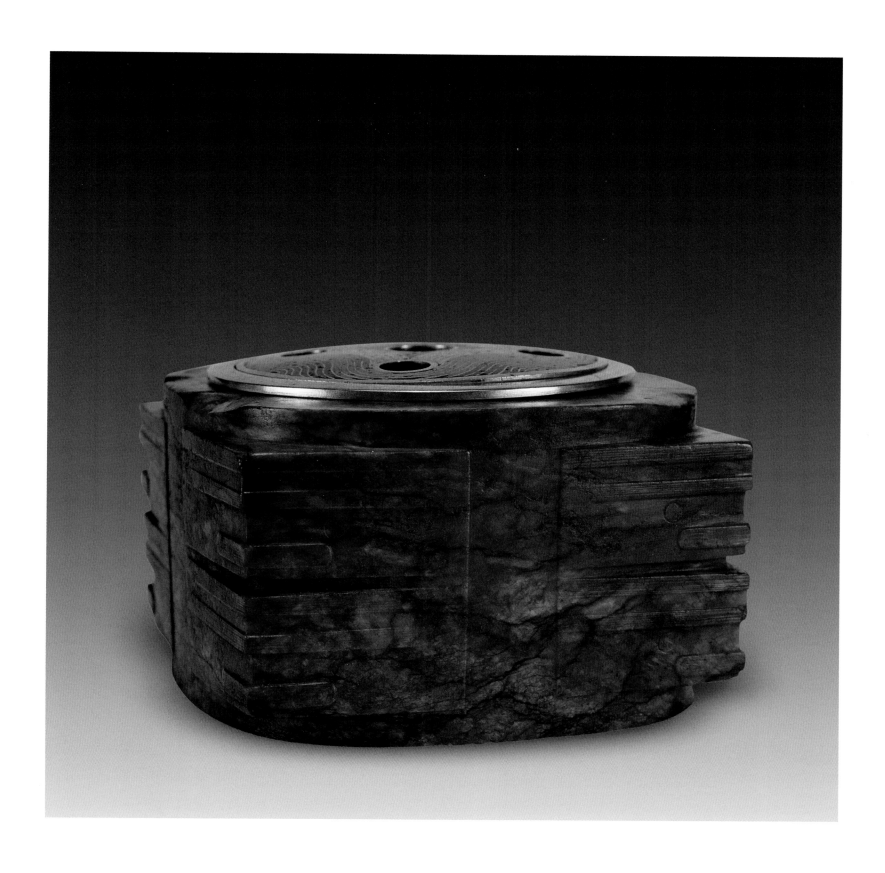

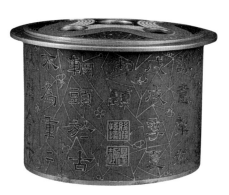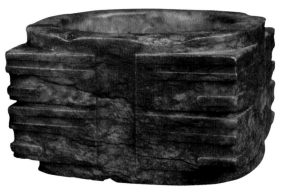

新117974

玉两节琮

良渚文化

高7.5厘米 口径11.7厘米

备注：孔后扩，孔壁刻乾隆御题诗，有染色：清代配铜胎珐琅胆，也有乾隆御题诗

Xin 117974

Jade Cong

Liangzhu Culture

Height: 7.5 cm Mouth diameter: 11.7 cm

With a copper liner equipped in the Qing Dynasty and inscribed with a poem by Emperor Qianlong on the Cong and the copper liner

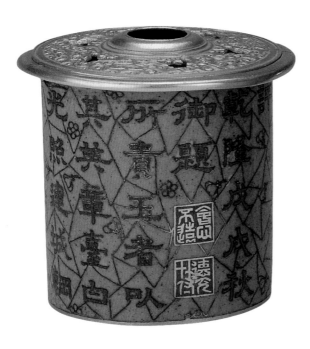

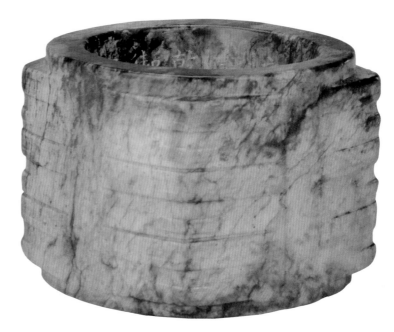

故103956

玉三节琮
良渚文化
高6.7厘米 口径8.2厘米
备注：内壁后刻乾隆御题诗；清代配铜胎珐琅
胆，也有乾隆御题诗

30

Gu 103956
Jade Cong
Liangzhu Culture
Height: 6.7 cm Mouth diameter: 8.2 cm
A poem by Emperor Qianlong was inscribed inside the jade Cong, and a copper liner equipped in the Qing Dynasty and a poem by Emperor Qianlong was inscribed on it

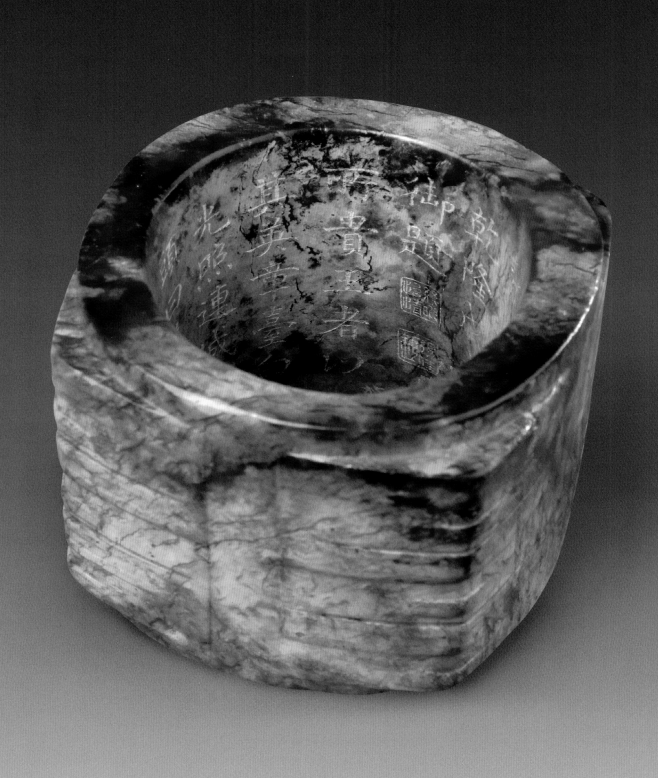

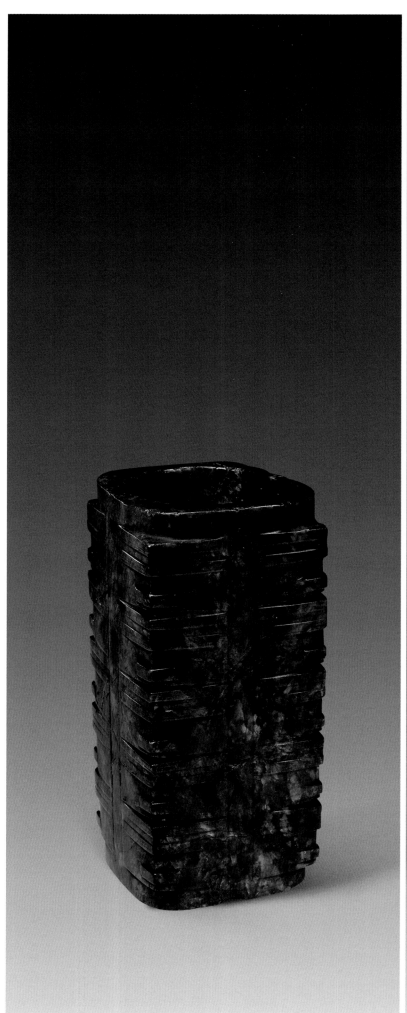

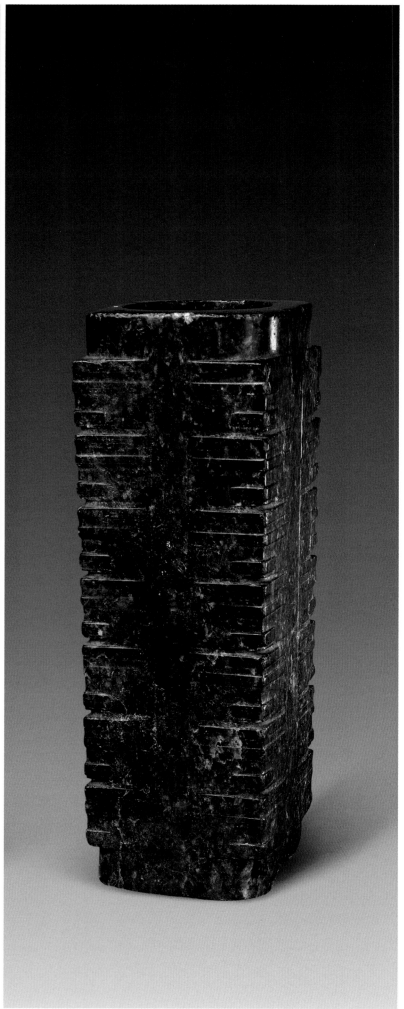

新136935

玉五节琮
良渚文化

31 | 高14.8厘米　口径6.9厘米

Xin 136935

Jade Cong
Liangzhu Culture

Height: 14.8 cm
Mouth diameter: 6.9 cm

新93170

玉七节琮
良渚文化

32 | 高22.6厘米　口径9.1厘米　底径8.6厘米

Xin 93170

Jade Cong
Liangzhu Culture

Height: 22.6 cm　Mouth diameter: 9.1 cm
Bottom diameter: 8.6 cm

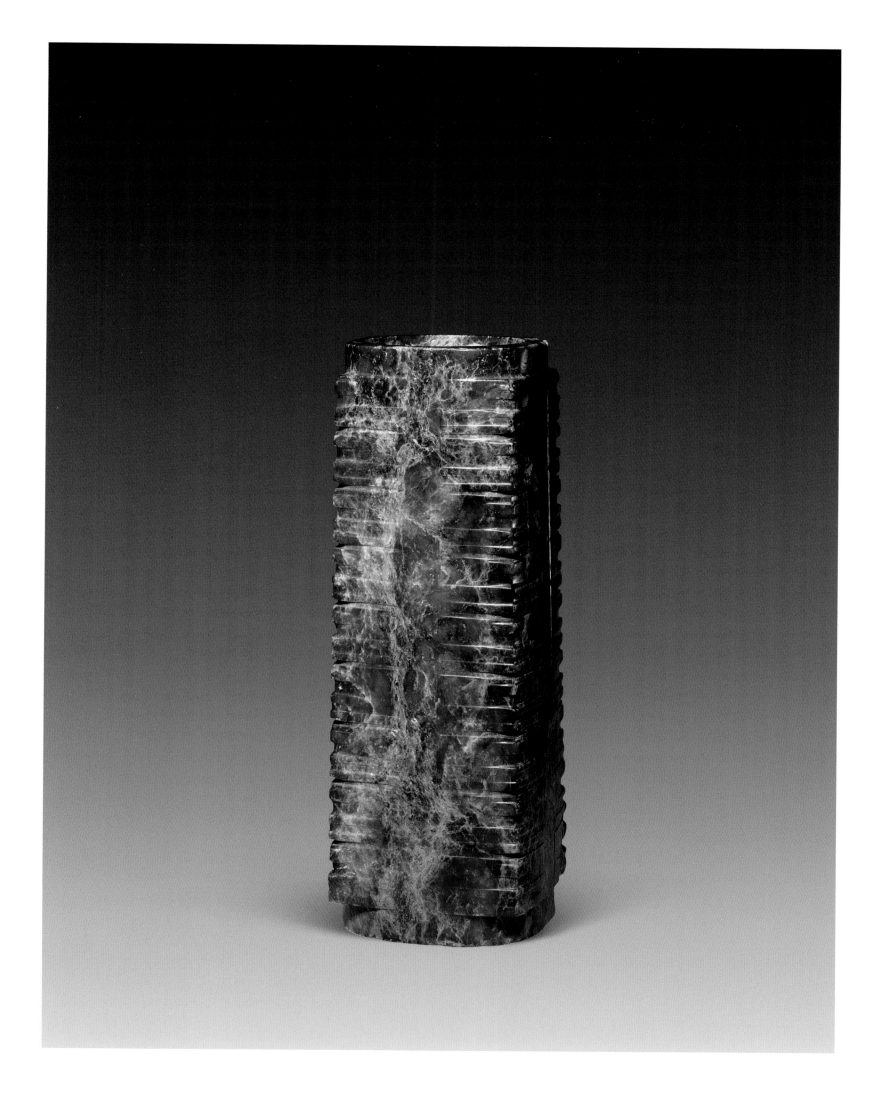

新155420
玉九节琮
良渚文化

33 高22.1厘米 口径7.8厘米 底径7.6厘米

Xin 155420
Jade Cong
Liangzhu Culture

Height: 22.1 cm Mouth diameter: 7.8 cm
Bottom diameter: 7.6 cm

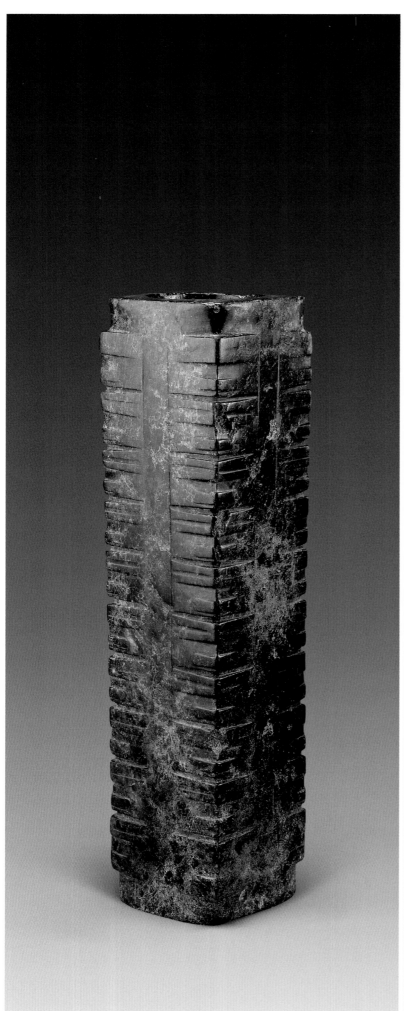

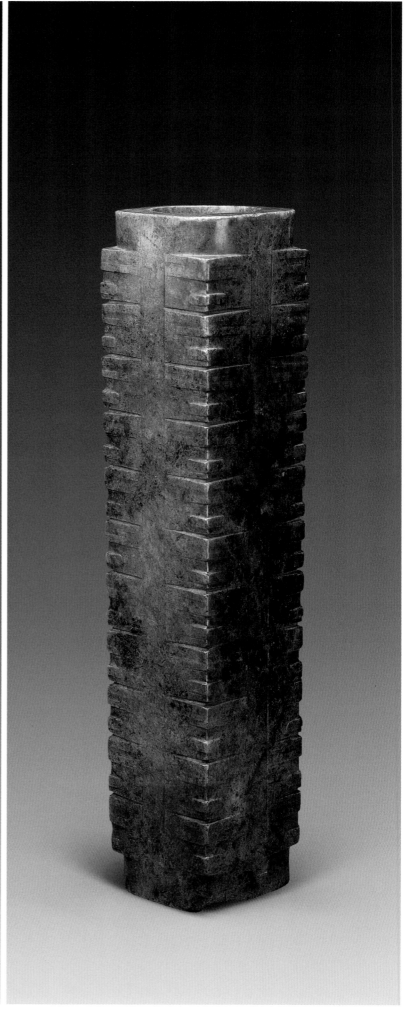

新63137

玉十节琮

良渚文化

34 高27.7厘米　口径7.2厘米　底径6.4厘米

Xin 63137

Jade Cong
Liangzhu Culture

Height: 27.7 cm　Mouth diameter: 7.2 cm
Bottom diameter: 6.4 cm

故103955

玉十一节琮

良渚文化

35 高31.9厘米　口径7.2厘米　底径6.3厘米

Gu 103955

Jade Cong
Liangzhu Culture

Height: 31.9 cm　Mouth diameter: 7.2 cm
Bottom diameter: 6.3 cm

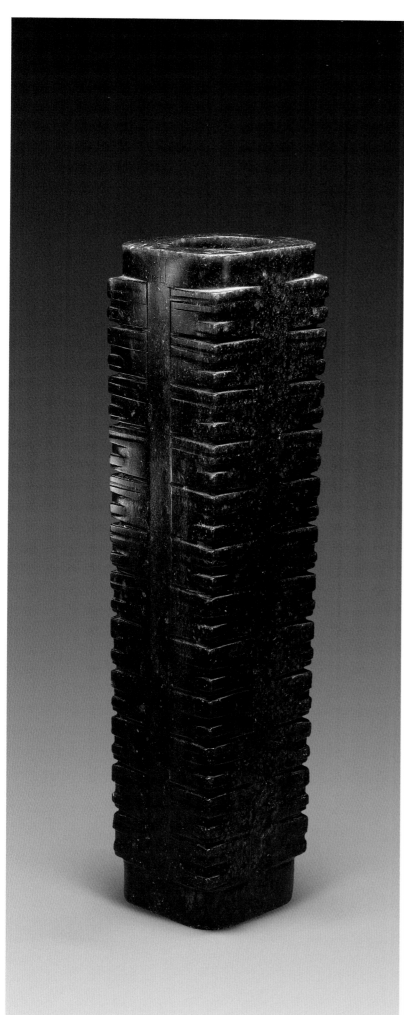

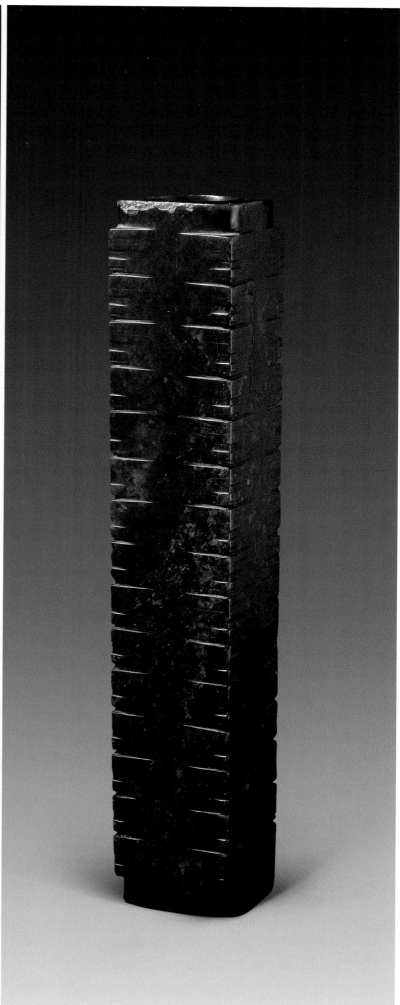

故96000

玉十二节琮
良渚文化

36 | 高30.9厘米 口径7.5厘米 底径6.5厘米

Gu 96000

Jade Cong
Liangzhu Culture

Height: 30.9 cm Mouth diameter: 7.5 cm
Bottom diameter: 6.5 cm

故83949

玉十五节琮
良渚文化

37 | 高34.8厘米 口径6.5厘米 底径5.6厘米

Gu 83949

Jade Cong
Liangzhu Culture

Height: 34.8 cm Mouth diameter: 6.5 cm
Bottom diameter: 5.6 cm

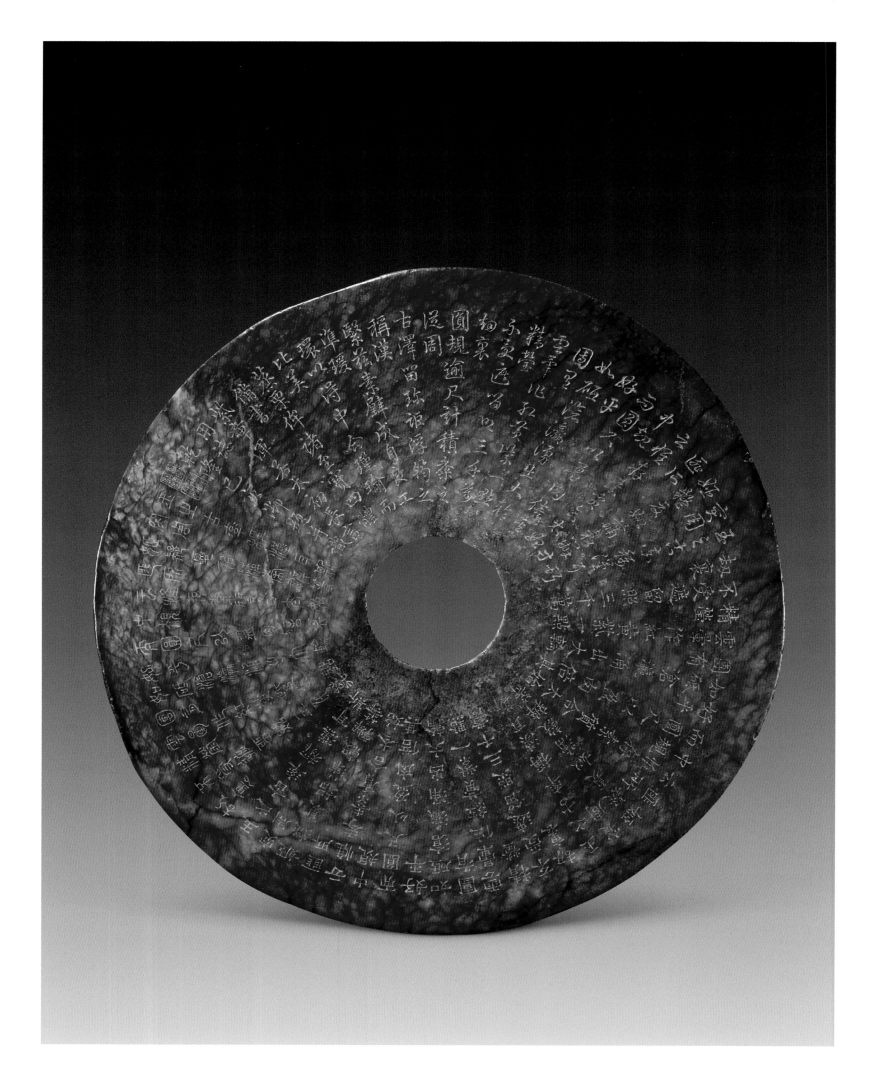

故103954
玉璧
良渚文化
径31.6厘米 孔径6.5厘米 厚1.1厘米

备注：后刻乾隆御题诗

38

Gu 103954
Jade Bi
Liangzhu Culture
Diameter: 31.6 cm Internal diameter: 6.5 cm
Thickness: 1.1 cm
Inscribed with a poem by Emperor Qianlong

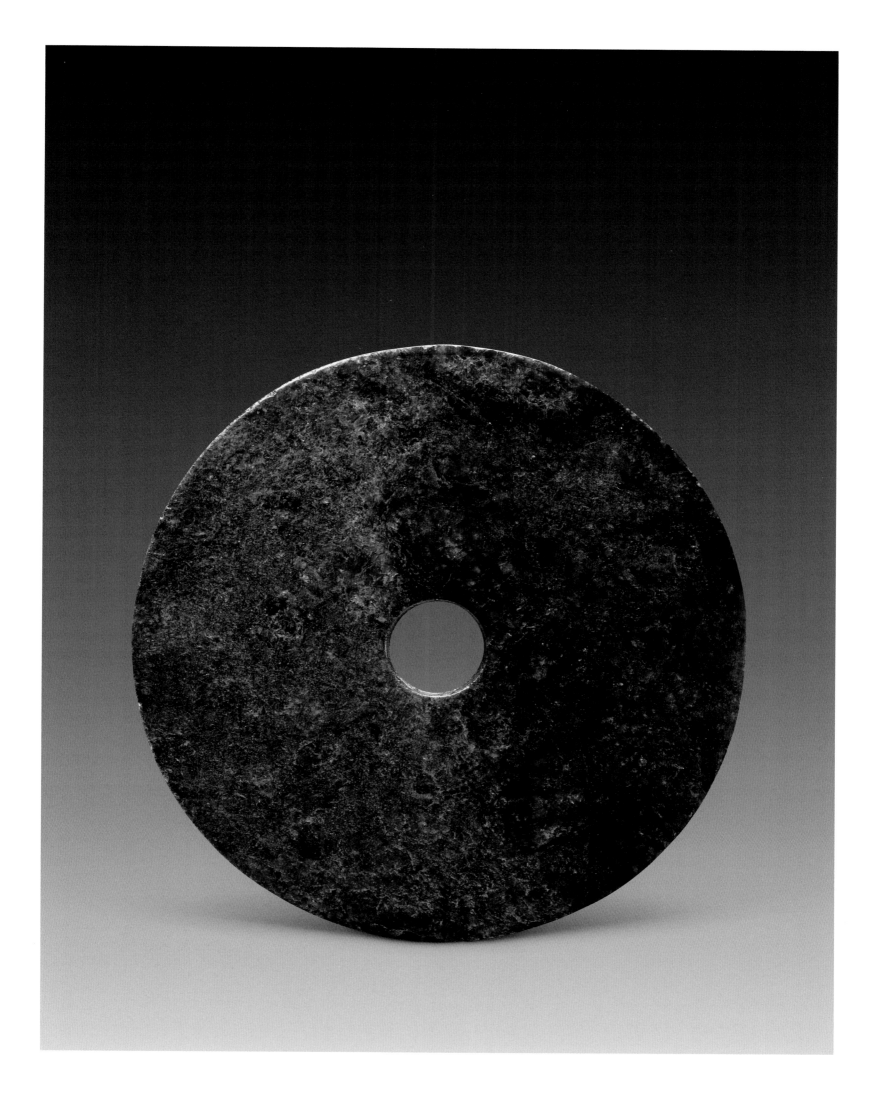

故83946

玉璧
良渚文化
径27.9厘米 孔径4.4厘米 厚1.2厘米
备注：外壁有一周凹槽
39
Gu 83946
Jade Bi
Liangzhu Culture
Diameter: 27.9 cm Internal diameter: 4.4 cm
Thickness: 1.2 cm
With a flute circled around the external edge

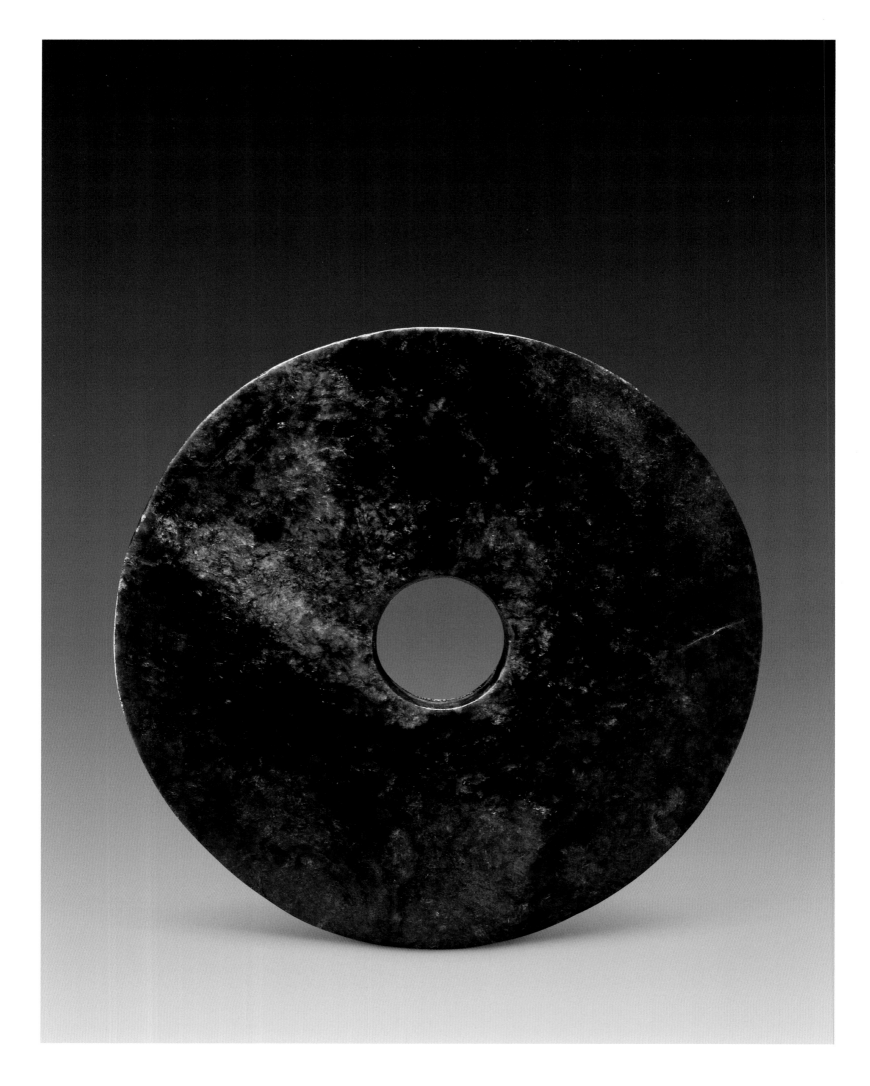

故83998
玉璧
良渚文化
40 径22.2厘米　孔径4.7厘米　厚1厘米
Gu 83998
Jade Bi
Liangzhu Culture
Diameter: 22.2 cm Internal diameter: 4.7 cm
Thickness: 1 cm

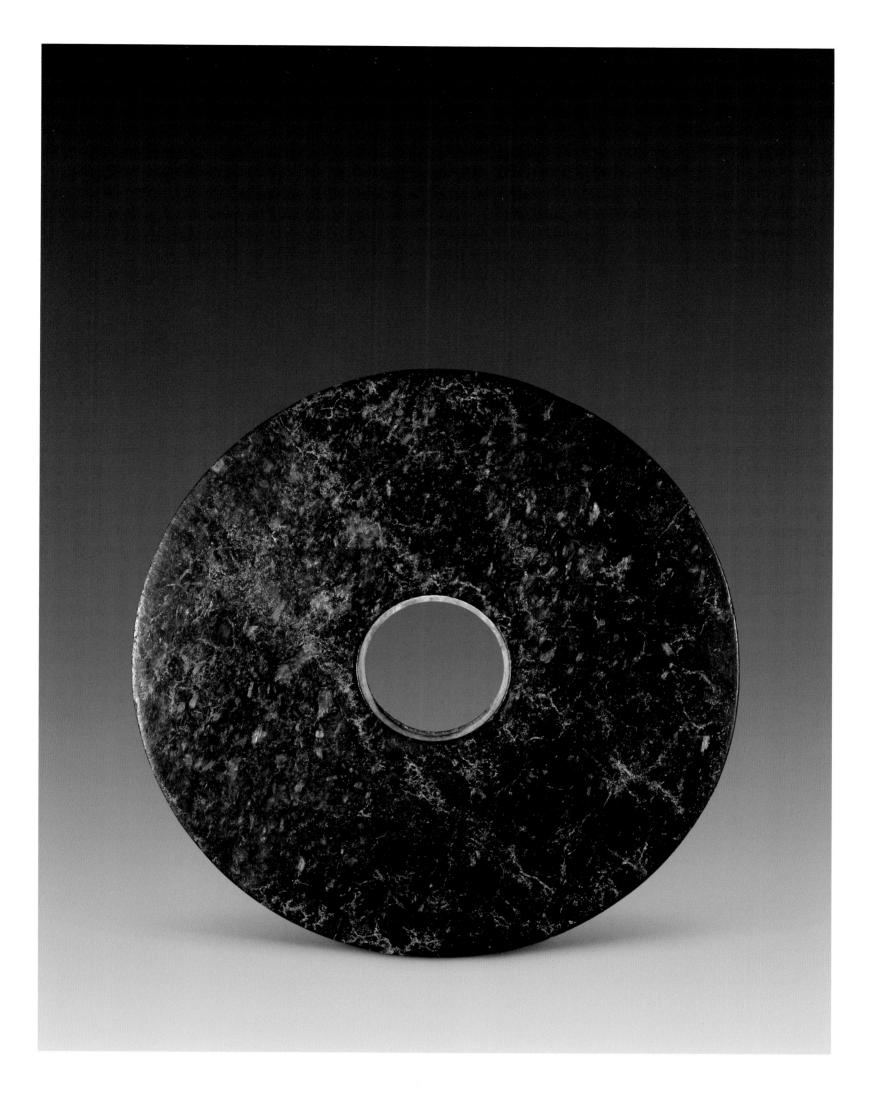

新127481

玉璧
良渚文化

41 径20.1厘米 孔径4.7厘米 厚1.1厘米

Xin 127481

Jade Bi
Liangzhu Culture

Diameter: 20.1 cm Internal diameter: 4.7 cm
Thickness: 1.1 cm

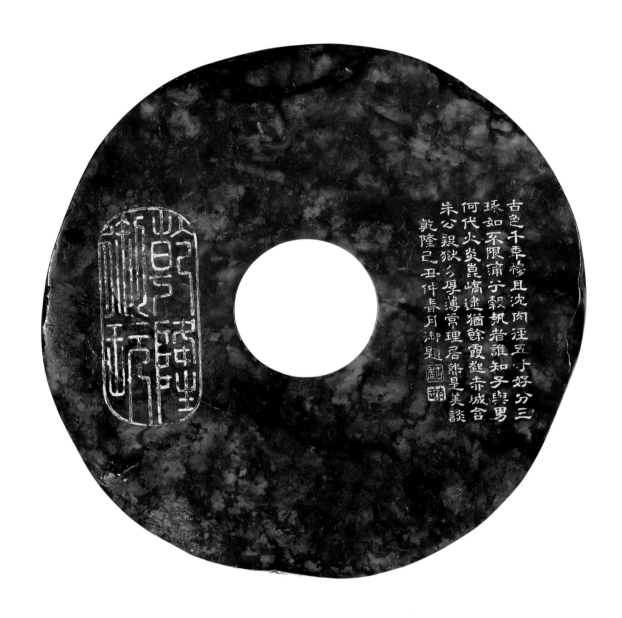

新9611

玉璧
良渚文化
径14.8厘米 孔径3.9厘米 厚1.4厘米
备注：后刻乾隆《咏汉玉素璧》诗

42

Xin 9611
Jade Bi
Liangzhu Culture
Diameter: 14.8 cm Internal diameter: 3.9 cm
Thickness: 1.4 cm
Inscribed with a poem "Yong Han Yu Su Bi" (Ode to the
Han jade Bi) by Emperor Qianlong

古色千秋樸且沈肉徑五寸好分三

琢如不限庸兮穀執者誰知子與男

何代火炎崑崎建猶餘霞起赤城舍

朱公嶽分厚薄常理君然是美談

乾隆己丑仲春月御題

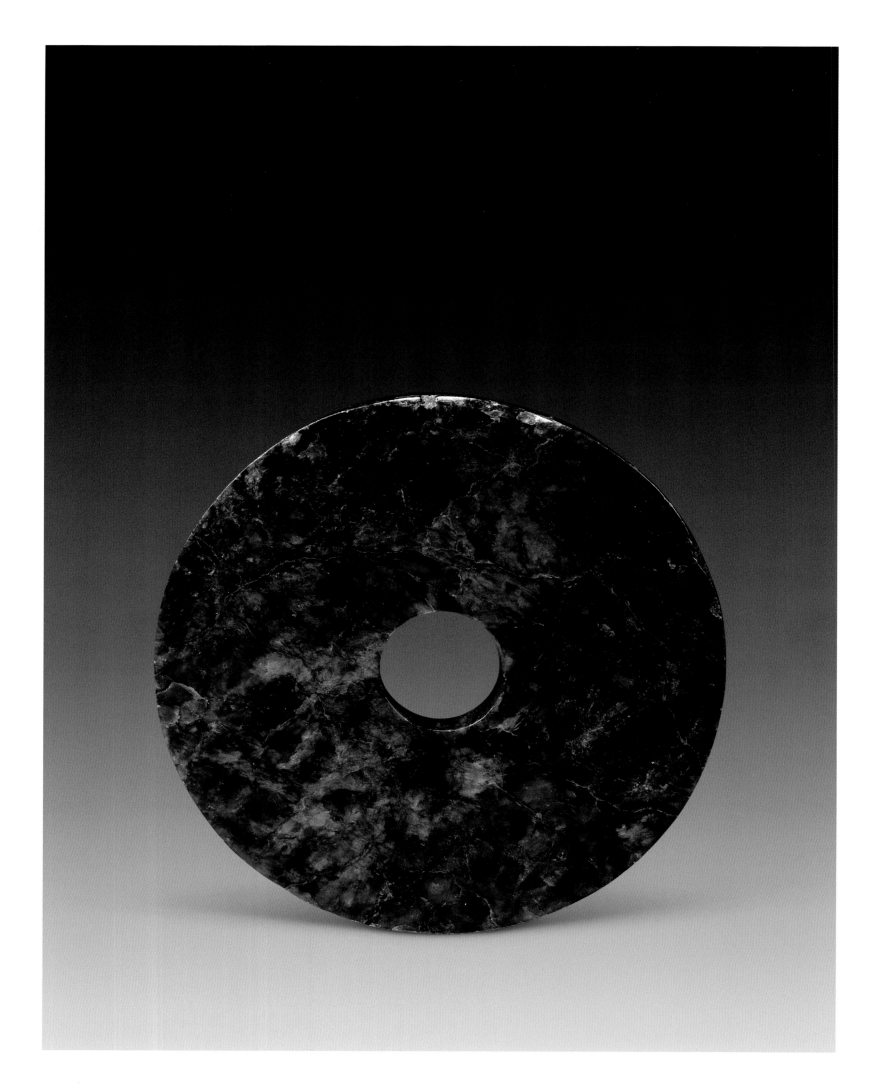

故83948

玉璧

良渚文化

43 径19.5厘米　孔径4厘米　厚2.1厘米

Gu 83948

Jade Bi
Liangzhu Culture

Diameter: 19.5 cm Internal diameter: 4 cm
Thickness: 2.1 cm

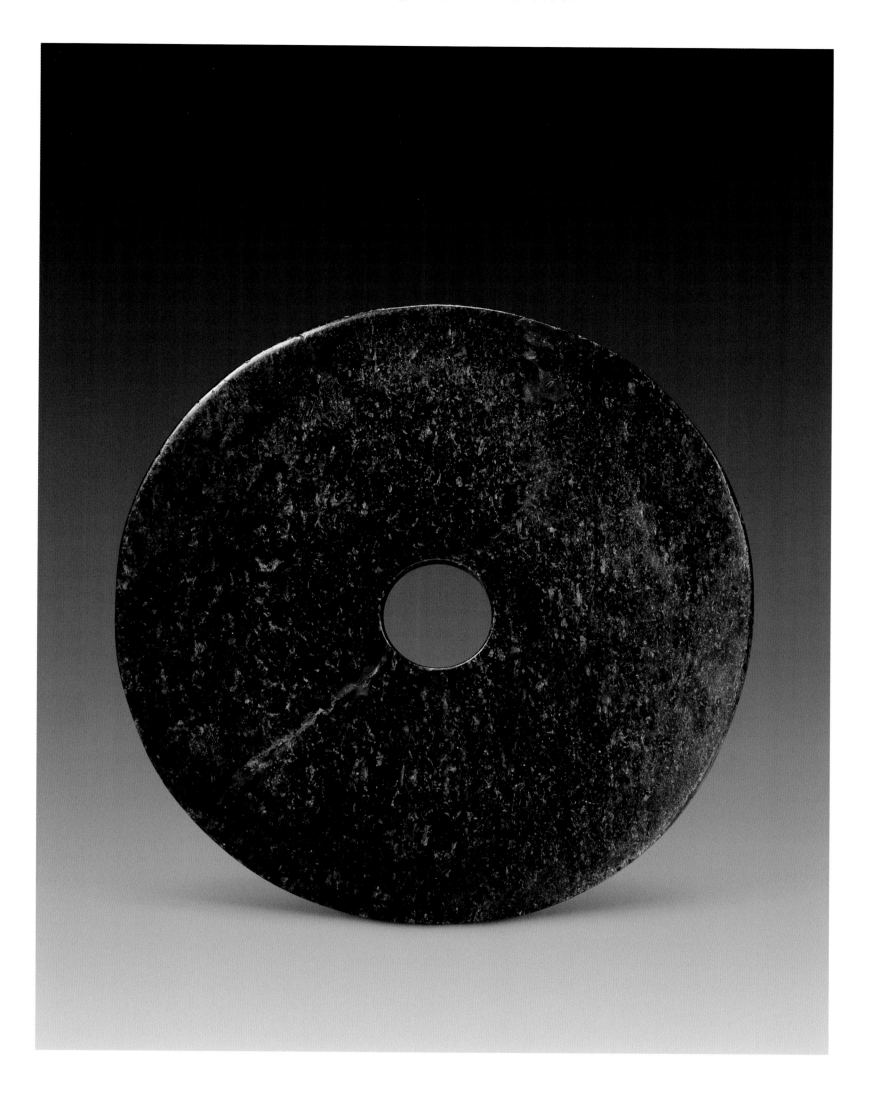

新127860

玉璧
良渚文化

44 径27.1厘米　孔径4.7厘米　厚1.1厘米

Xin 127860
Jade Bi
Liangzhu Culture
Diameter: 27.1 cm　Internal diameter: 4.7 cm
Thickness: 1.1 cm

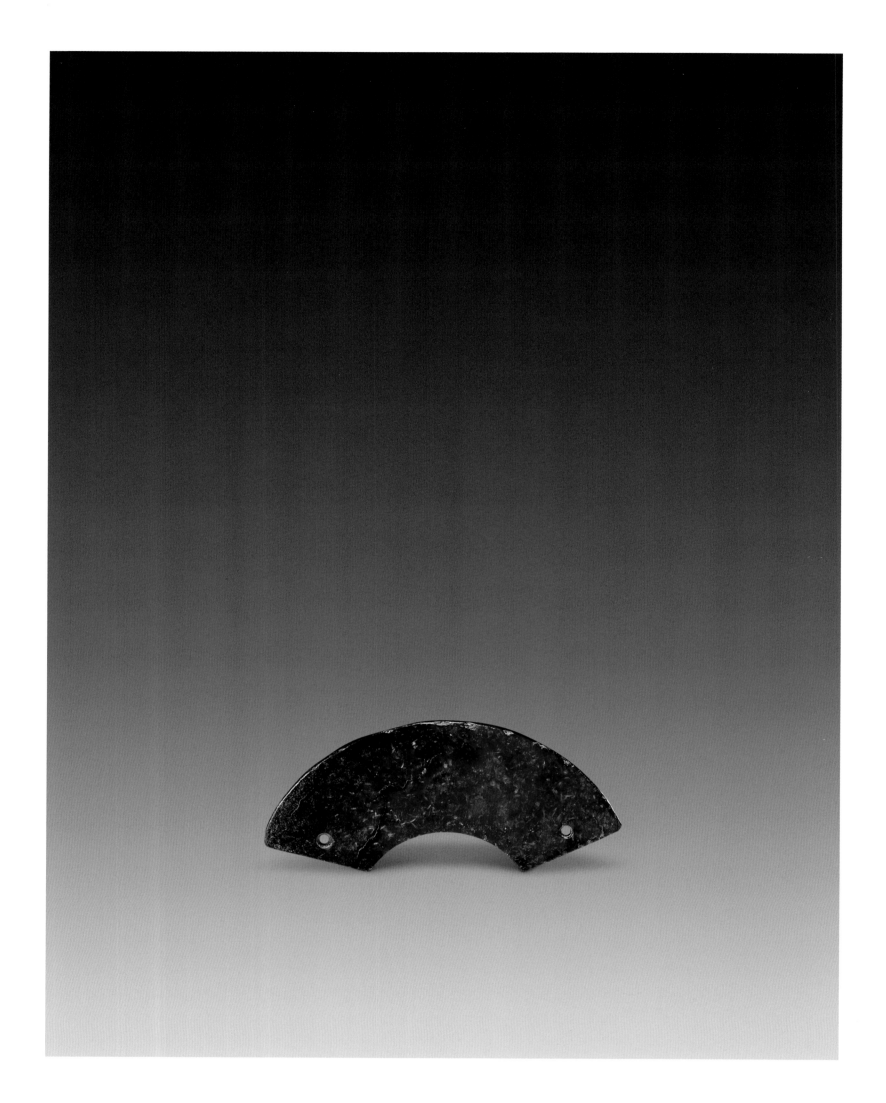

故95074

玉璜

良渚文化

长9.5厘米　宽3厘米　厚0.4厘米

备注：后改动，有染色

45

Gu 95074

Jade Huang

Liangzhu Culture

Length: 9.5 cm　Width: 3 cm　Thickness: 0.4 cm

Re-shaped and dyed

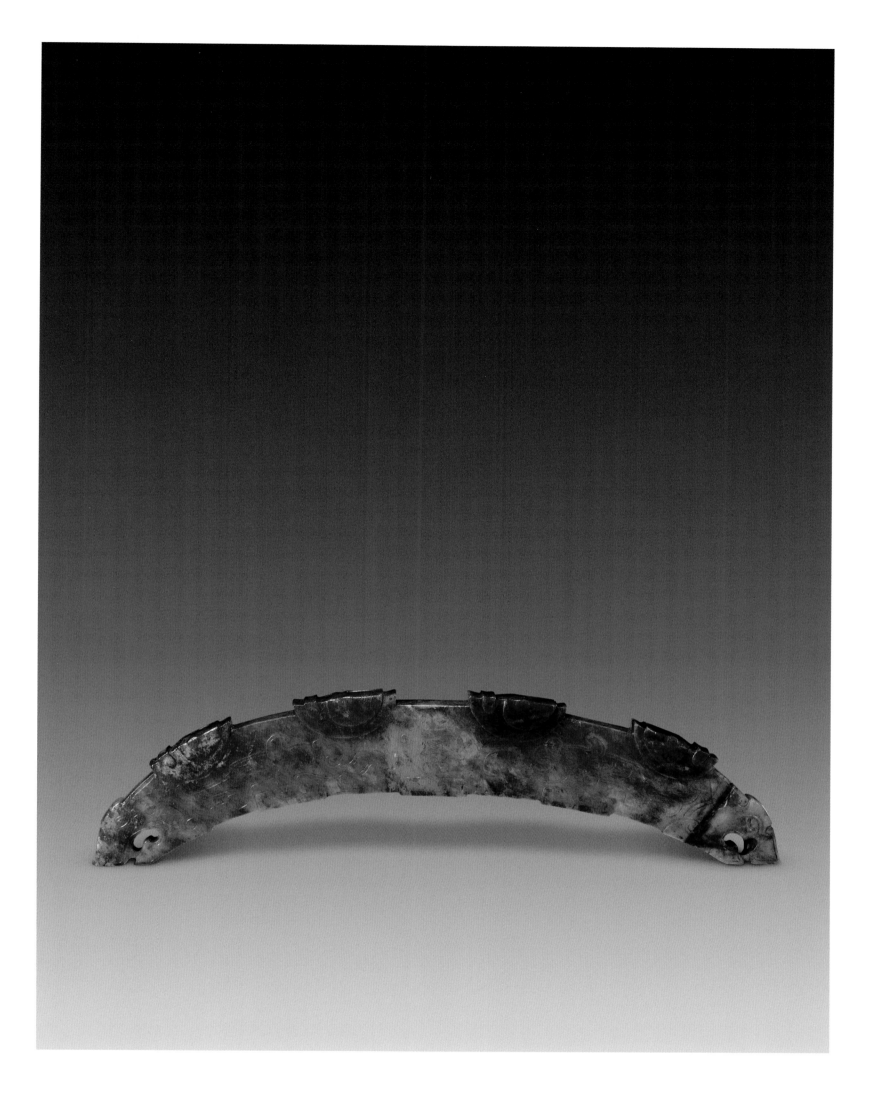

故84491

玉兽面纹璜
良渚文化
长19.5厘米 宽2.7厘米 厚0.8厘米
备注：后改制
46
Gu 84491
Jade Huang with animal-face design
Liangzhu Culture
Length: 19.5 cm Width: 2.7 cm Thickness: 0.8 cm
Re-shaped

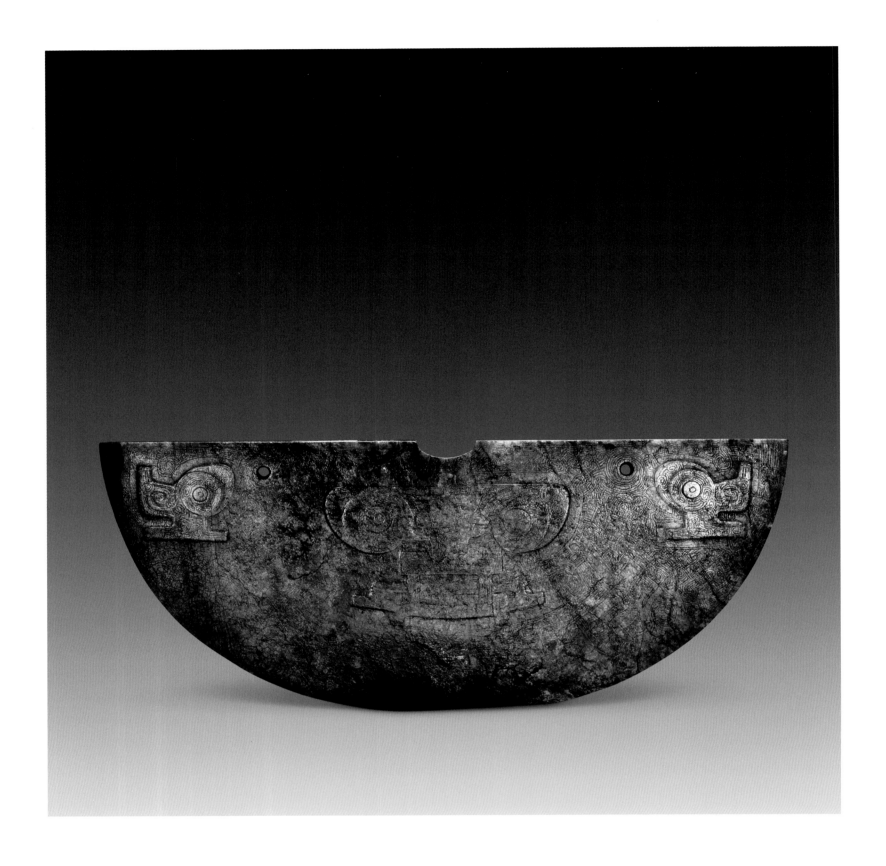

故84042

玉兽面纹璜
良渚文化

47 长20.8厘米　宽8.3厘米　厚0.6厘米

Gu 84042
Jade Huang with animal-face design
Liangzhu Culture
Length: 20.8 cm Width: 8.3 cm Thickness: 0.6 cm

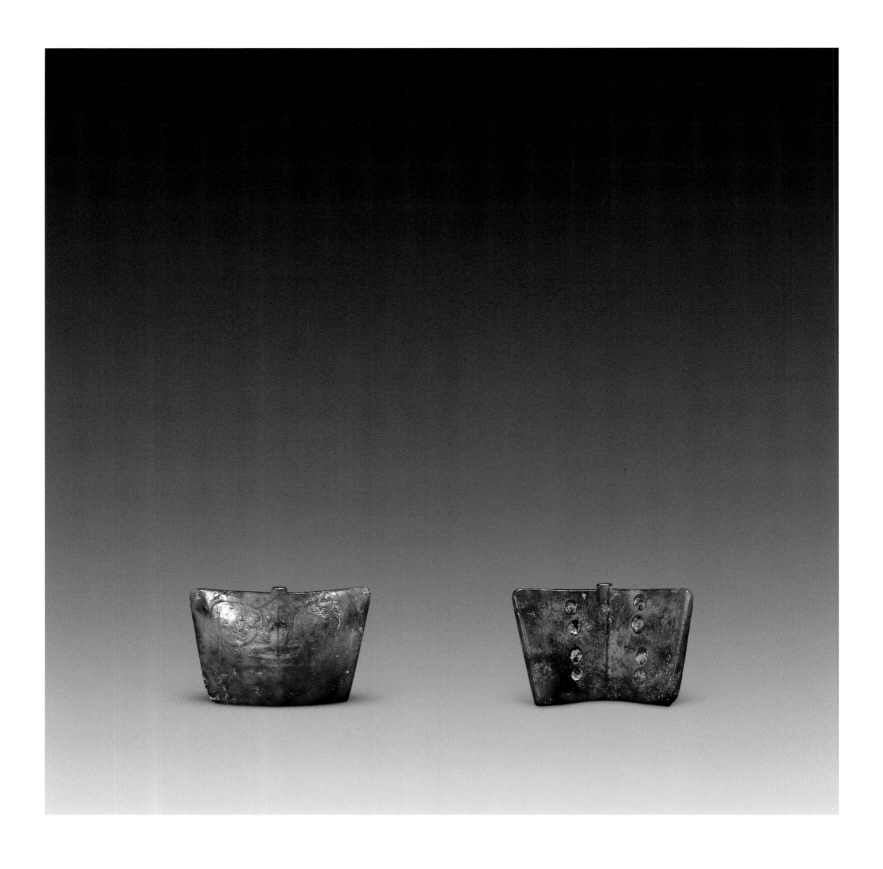

新200403

玉兽面纹饰
良渚文化

48 长3.2厘米　宽4.8厘米　厚0.7厘米

Xin 200403

Jade pendant with animal-face design
Liangzhu Culture

Length: 3.2 cm　Width: 4.8 cm　Thickness: 0.7 cm

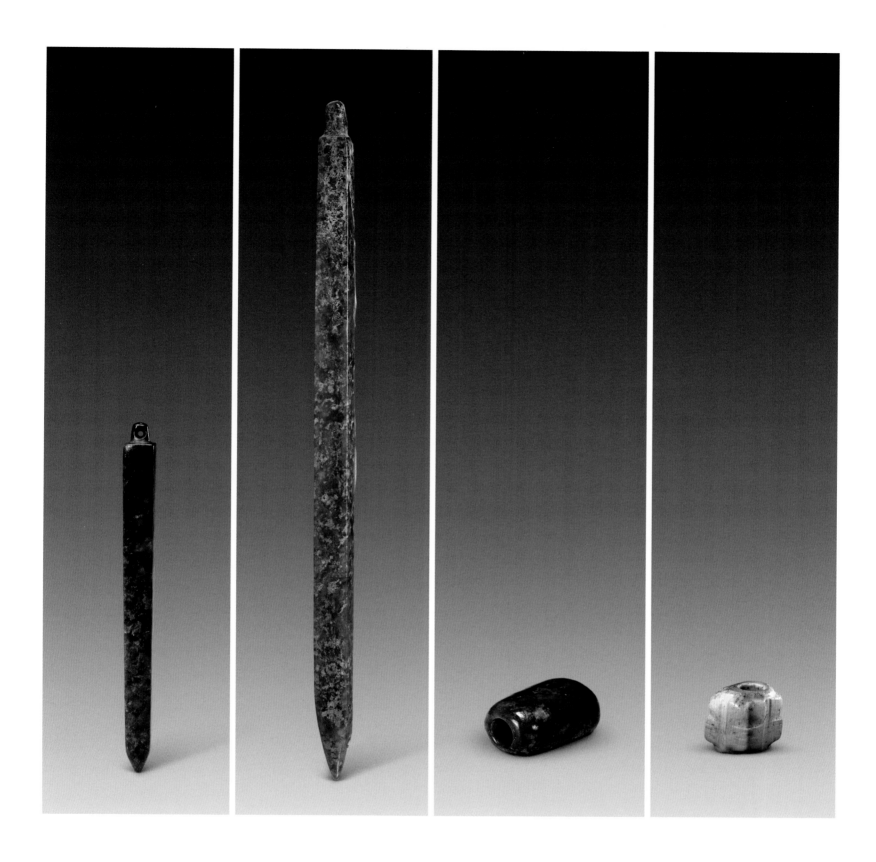

新196059

玉锥形器
良渚文化

49　长9.6厘米　宽0.8厘米　厚0.7厘米

Xin 196059

Awl-shaped jade object
Liangzhu Culture

Length: 9.6 cm　Width: 0.8 cm
Thickness: 0.7 cm

新97512

玉锥形器
良渚文化

50　长18.6厘米　宽1厘米　厚1厘米

Xin 97512

Awl-shaped jade object
Liangzhu Culture

Length: 18.6 cm　Width: 1 cm
Thickness: 1 cm

故84823

玉管
良渚文化

51　长2.5厘米　径1.5×1.2厘米

Gu 84823

Jade tube
Liangzhu Culture

Length: 2.5 cm　Diameter: 1.5×1.2 cm

新201492

玉两节琮
新石器时代

高2厘米　宽1.6厘米　口径0.9×0.8厘米
备注：1979年安徽省潜山县永岗村出土

52

Xin 201492

Jade Cong
Neolithic Age

Height: 2 cm　Width: 1.6 cm
Mouth diameter: 0.9×0.8 cm
Unearthed at Yonggang village, Qianshan County,
Anhui Province in 1979

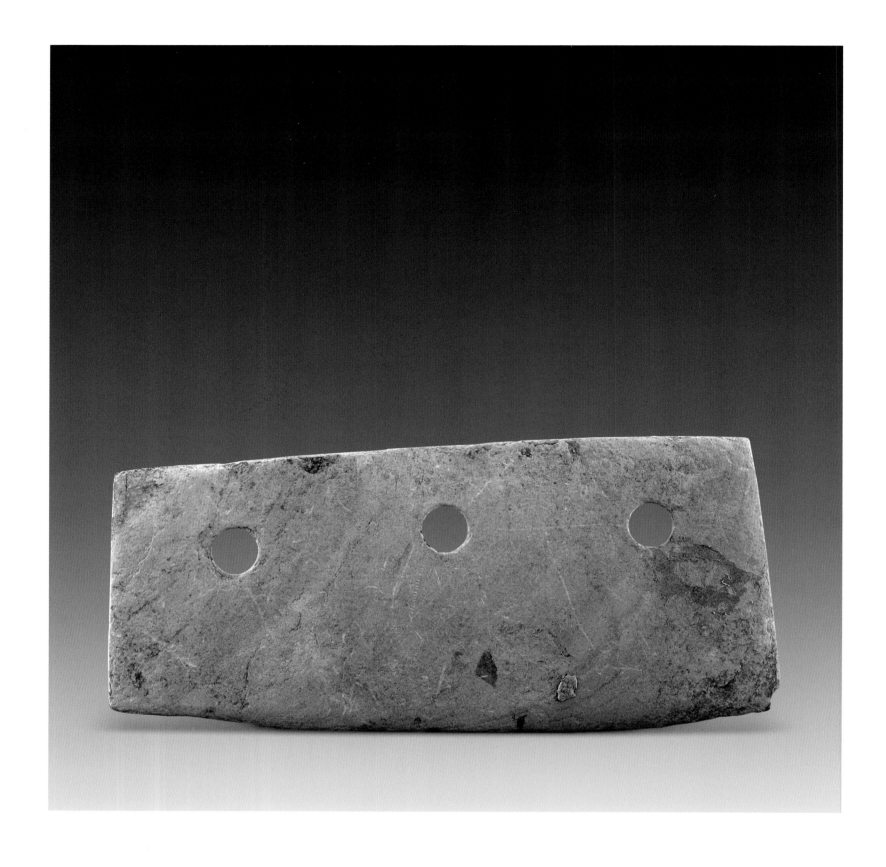

新201603
石三孔刀
新石器时代
长20.8厘米 宽9.4厘米 厚0.6厘米

备注：1979年安徽省潜山县永岗村出土

53

Xin 201603
Stone knife with three holes
Neolithic Age

Length: 20.8 cm Width: 9.4 cm Thickness: 0.6 cm
*Unearthed at Yonggang village, Qianshan County, Anhui
Province in 1979*

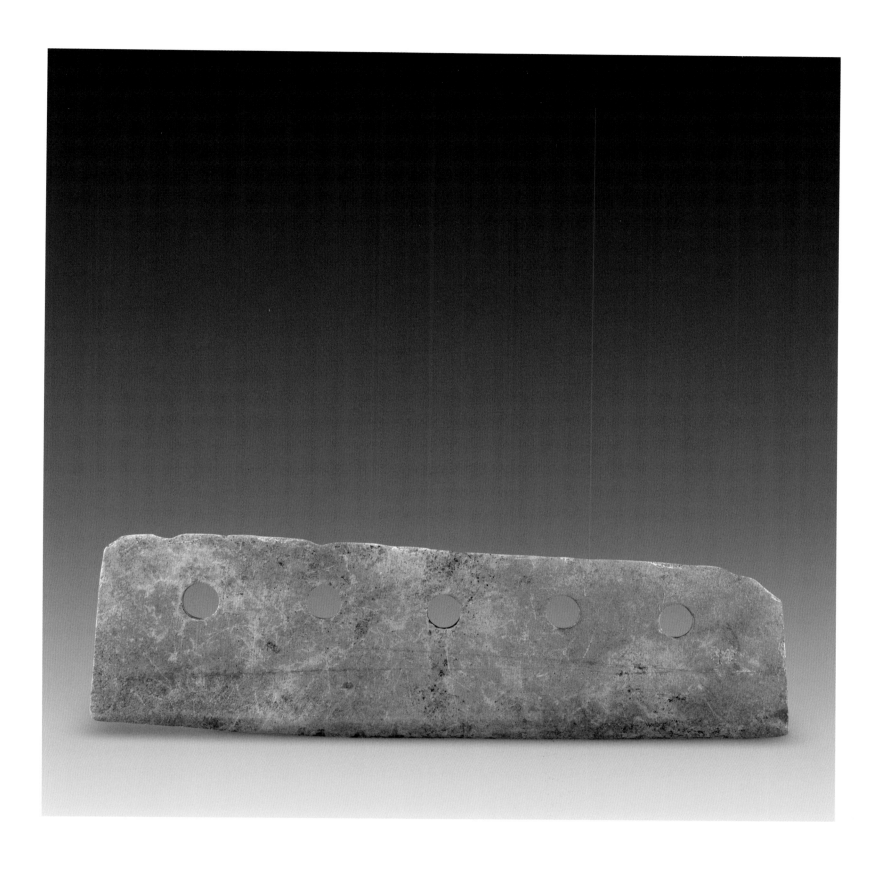

新201604
石五孔刀
新石器时代
长27.1厘米 宽7.9厘米 厚0.5厘米
备注：1979年安徽省潜山县永岗村出土

54

Xin 201604
Stone knife with five holes
Neolithic Age
Length: 27.1 cm Width: 7.9 cm Thickness: 0.5 cm
Unearthed at Yonggang village, Qianshan County, Anhui Province in 1979

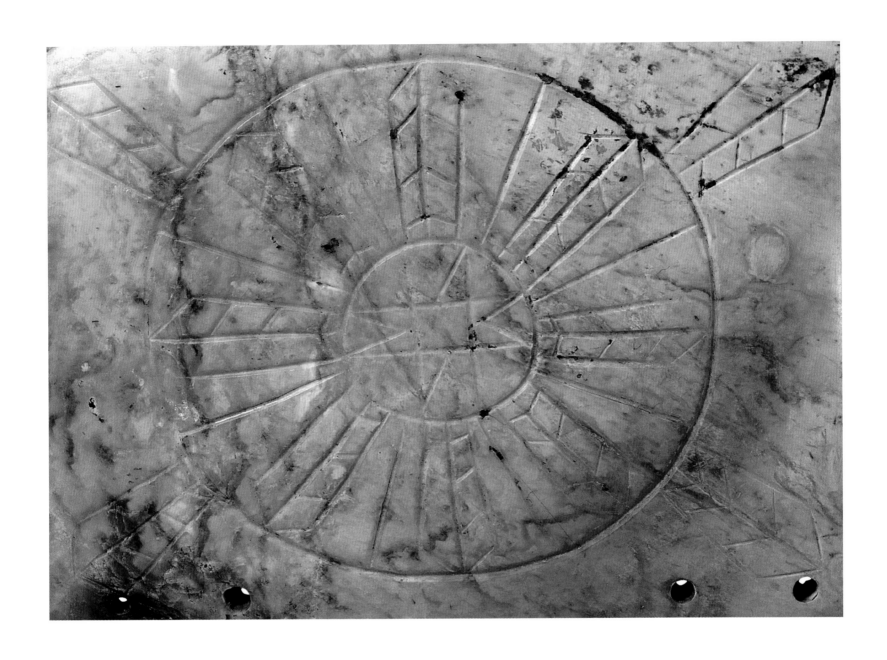

新201476

玉刻图长方板
新石器时代

长11.4厘米 宽8.3厘米 厚0.7厘米

备注：1987年安徽省含山县凌家滩出土

55

Xin 201476
Rectangular jade plate with engraved design
Neolithic Age
Length: 11.4 cm Width: 8.3 cm Thickness: 0.7 cm
Unearthed at Lingjiatan, Hanshan County, Anhui Province in 1987

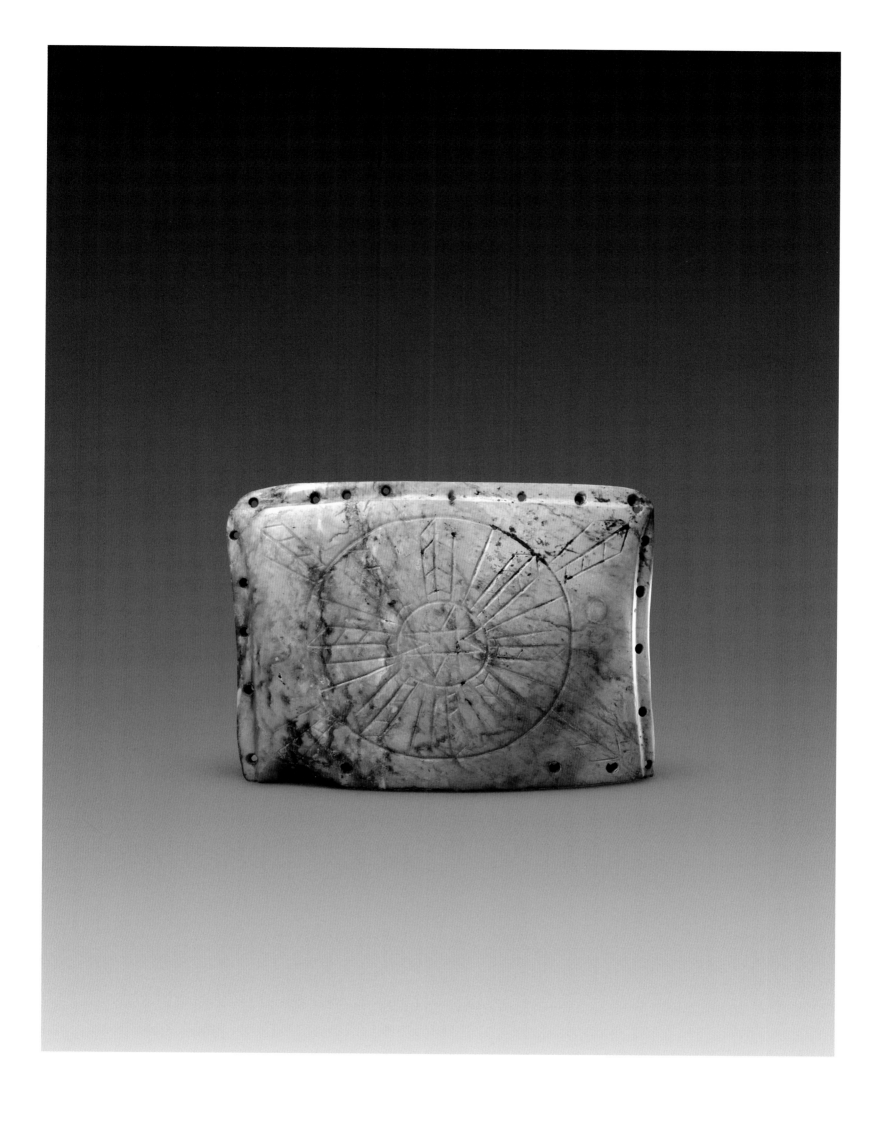

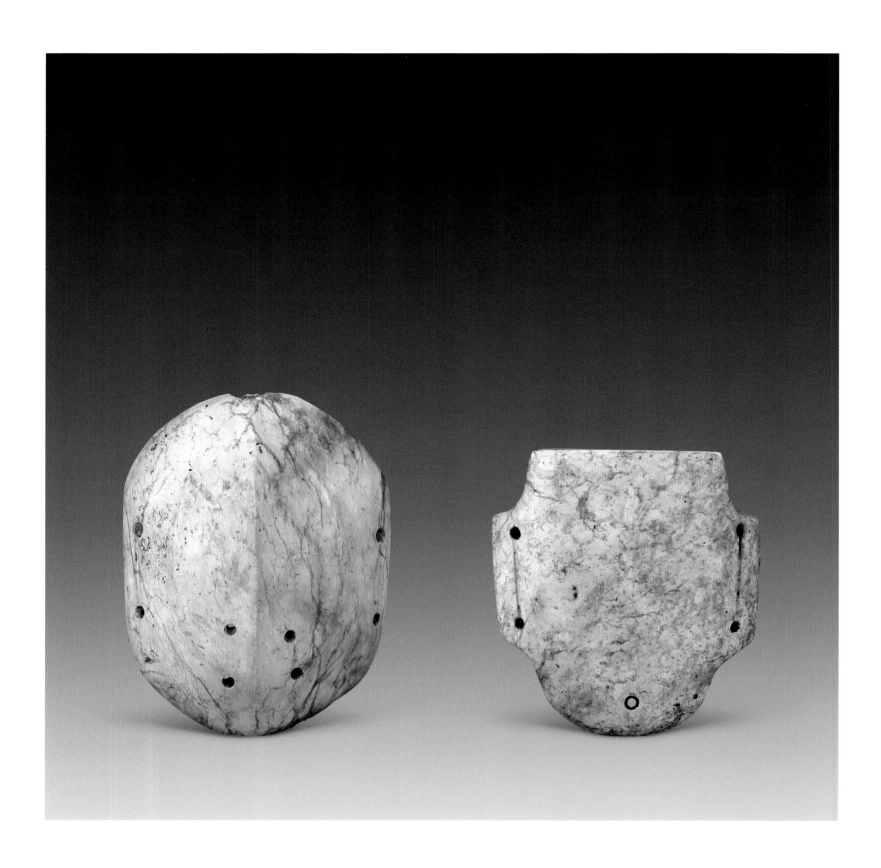

新201477
玉龟壳
新石器时代
背甲 长9.4厘米 宽7.6厘米 厚0.8厘米
腹甲 长7.9厘米 宽7.5厘米 厚1.3厘米
备注：1987年安徽省含山县凌家滩出土

56

Xin 201477

Jade tortoise-shell
Neolithic Age

Back length: 9.4 cm Width: 7.6 cm Thickness: 0.8 cm
Belly length: 7.9 cm Width: 7.5 cm Thickness: 1.3 cm
Unearthed at Lingjiatan, Hanshan County, Anhui Province in 1987

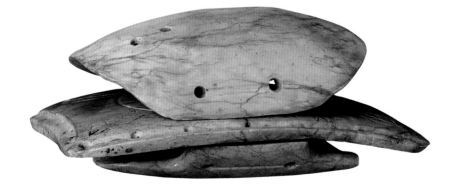

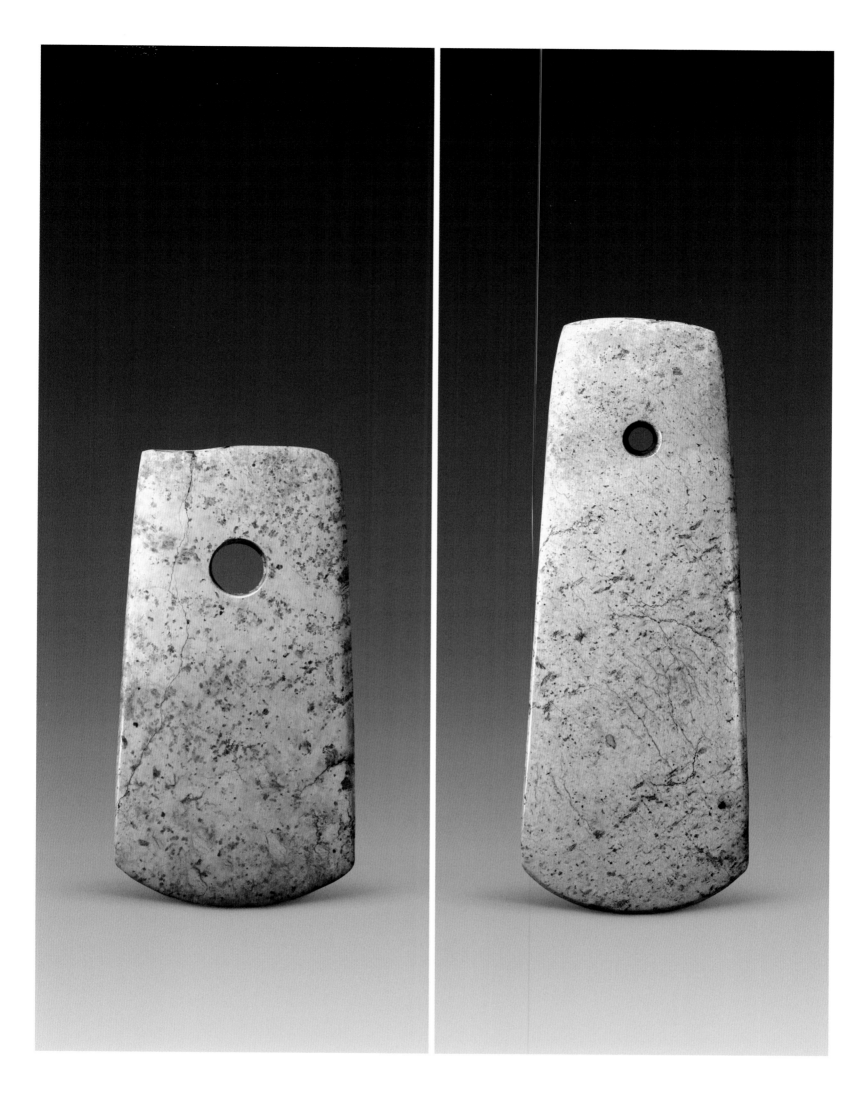

新201493
玉斧
新石器时代
长17厘米 宽8.5厘米 厚1厘米
57 备注：1987年安徽省含山县凌家滩出土
Xin 201493
Jade axe
Neolithic Age
Lenght: 17 cm Width: 8.5 cm Thickness: 1 cm
Unearthed at Lingjiatan, Hanshan County, Anhui Province in 1987

新201486
玉斧
新石器时代
长23.7厘米 宽8.7厘米 厚1厘米
58 备注：1987年安徽省含山县凌家滩出土
Xin 201486
Jade axe
Neolithic Age
Length: 23.7 cm Width: 8.7 cm
Thickness: 1 cm
Unearthed at Lingjiatan, Hanshan County, Anhui Province in 1987

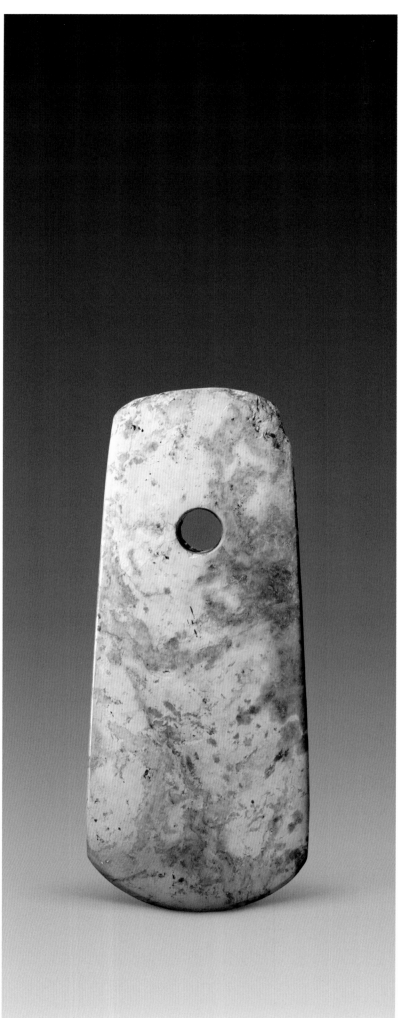

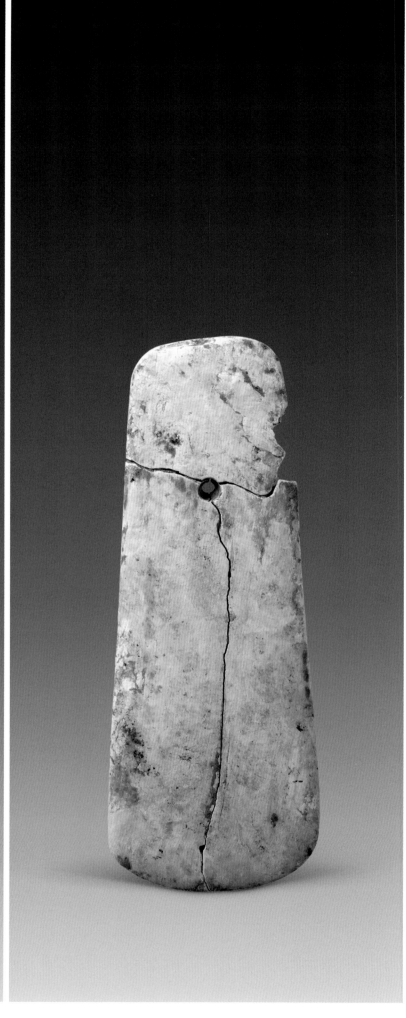

新201498

玉斧

新石器时代

长19.3厘米　宽8厘米　厚0.8厘米

备注：1987年安徽省含山县凌家滩出土

59

Xin 201498

Jade axe

Neolithic Age

Length: 19.3 cm　Width: 8 cm

Thickness: 0.8 cm

Unearthed at Lingjiatan, Hanshan County,

Anhui Province in 1987

新201582

玉斧

新石器时代

长20.2厘米　宽7.7厘米　厚1.6厘米

备注：1987年安徽省含山县凌家滩出土

60

Xin 201582

Jade axe

Neolithic Age

Length: 20.2 cm　Width: 7.7 cm

Thickness: 1.6 cm

Unearthed at Lingjiatan, Hanshan County,

Anhui Province in 1987

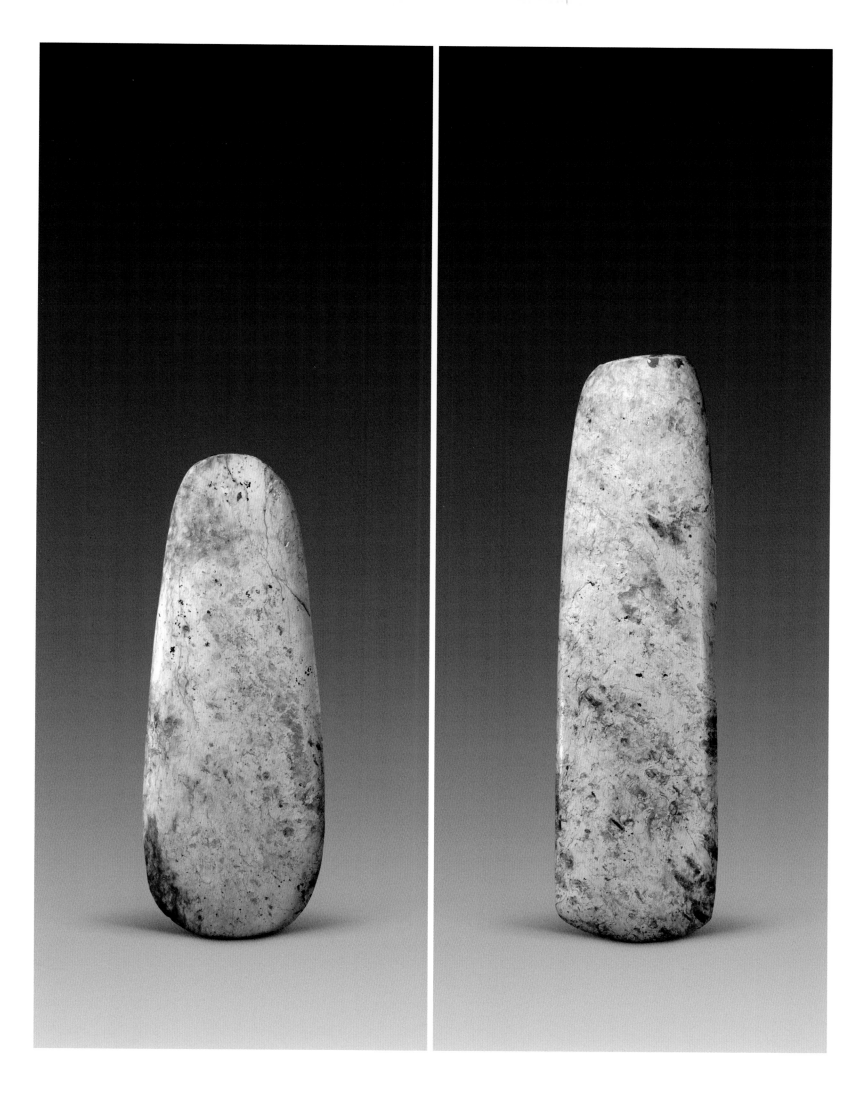

新201495
玉斧
新石器时代
长18.2厘米 宽6.6厘米 厚1.4厘米
备注：1987年安徽省含山县凌家滩出土

61

Xin 201495
Jade axe
Neolithic Age
Length: 18.2 cm Width: 6.6 cm
Thickness: 1.4 cm
Unearthed at Lingjiatan, Hanshan County,
Anhui Province in 1987

新201494
玉斧
新石器时代
长24厘米 宽6.5厘米 厚1.7厘米
备注：1987年安徽省含山县凌家滩出土

62

Xin 201494
Jade axe
Neolithic Age
Length: 24 cm Width: 6.5 cm
Thickness: 1.7 cm
Unearthed at Lingjiatan, Hanshan County,
Anhui Province in 1987

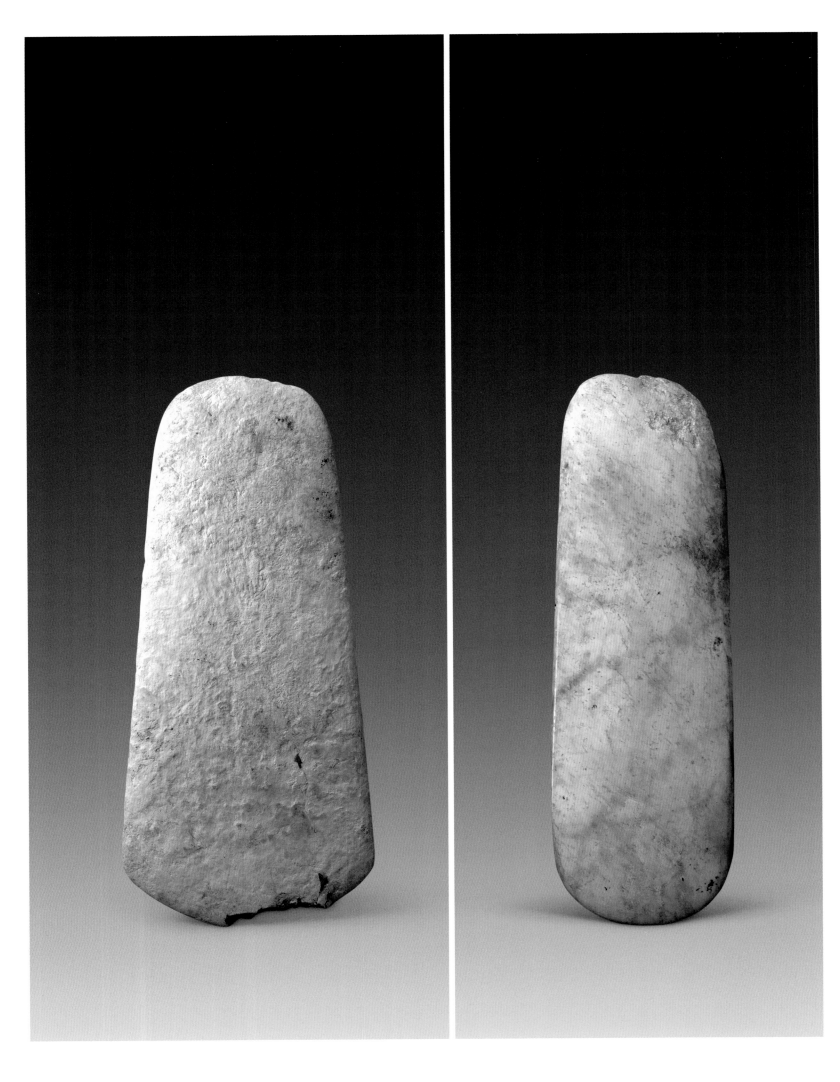

新201583
玉斧
新石器时代

长19.5厘米 宽8.7厘米 厚1.2厘米

63 | 备注：1987年安徽省含山县凌家滩出土

Xin 201583

Jade axe
Neolithic Age

Length: 19.5 cm Width: 8.7 cm
Thickness: 1.2 cm
Unearthed at Lingjiatan, Hanshan County,
Anhui Province in 1987

新201520
玉斧
新石器时代

长19.5厘米 宽6.3厘米 厚1厘米

64 | 备注：1987年安徽省含山县凌家滩出土

Xin 201520

Jade axe
Neolithic Age

Length: 19.5 cm Width: 6.3 cm
Thickness: 1 cm
Unearthed at Lingjiatan, Hanshan County,
Anhui Province in 1987

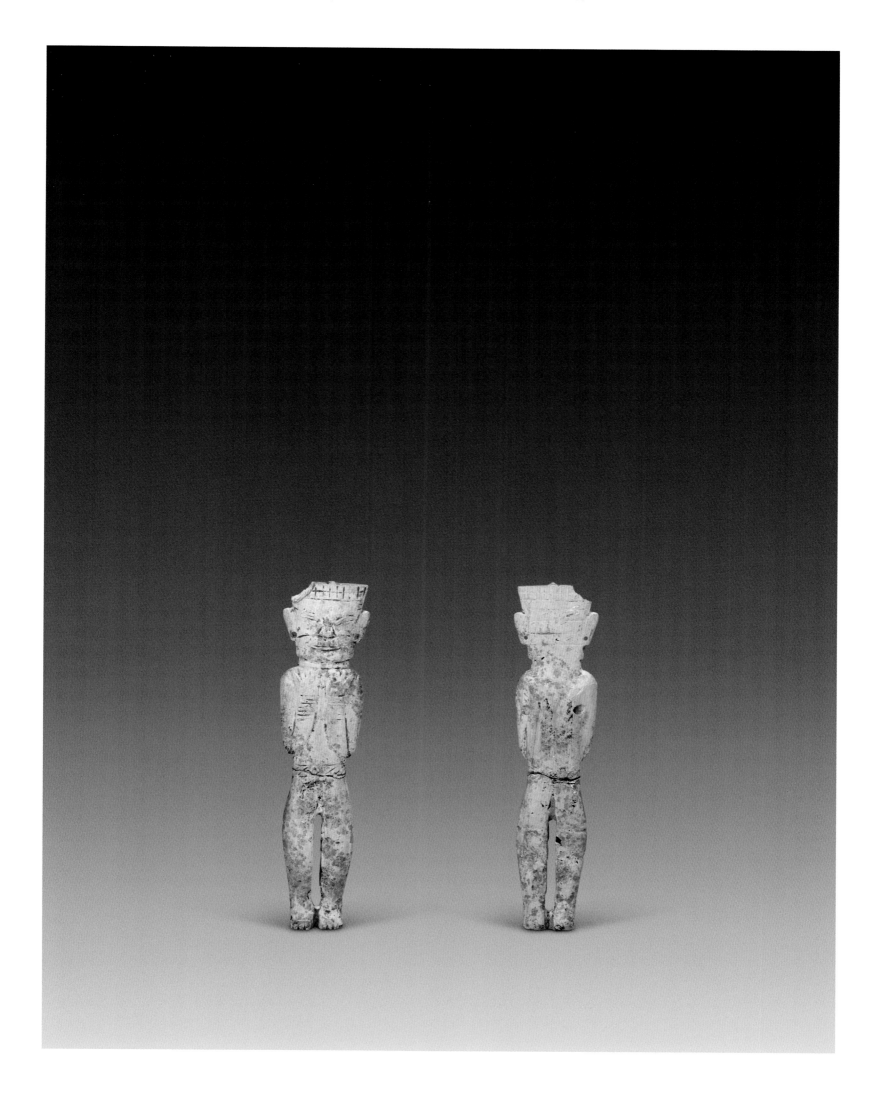

新201475

玉人
新石器时代

高9.6厘米 宽2.3厘米 厚0.8厘米

备注：1987年安徽省含山县凌家滩出土

65

Xin 201475

Jade figure
Neolithic Age

Height: 9.6 cm Width: 2.3 cm
Thickness: 0.8 cm
*Unearthed at Lingjiatan, Hanshan County, Anhui
Province in 1987*

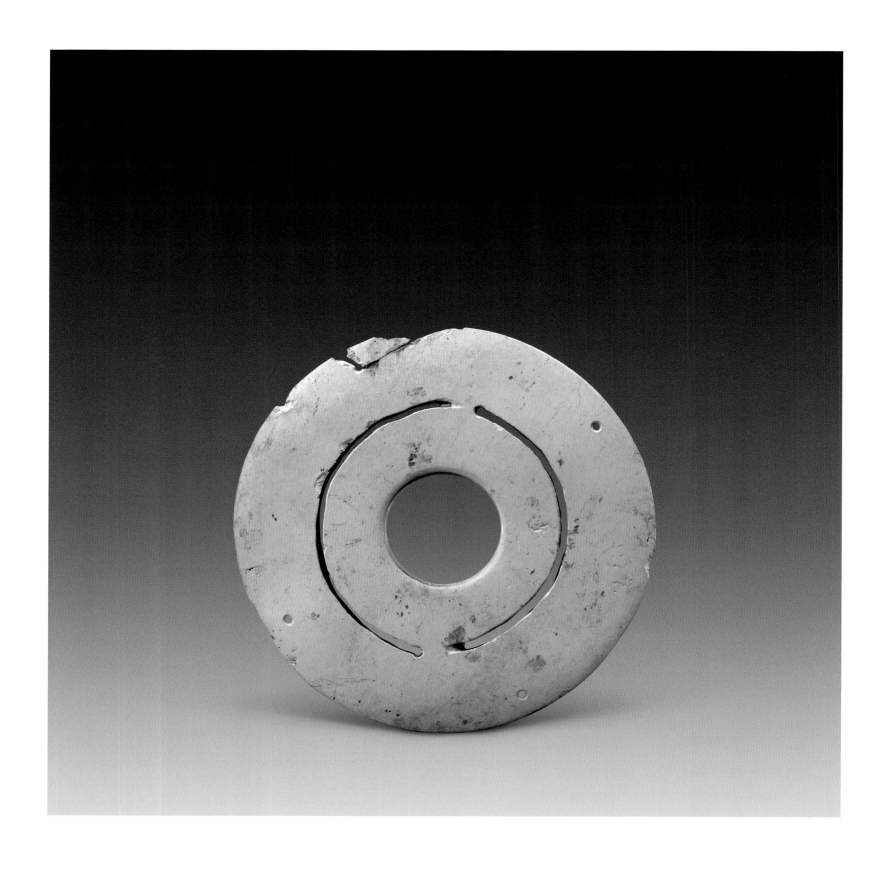

新201610

玉重环璧
新石器时代

径11.2厘米　孔径2.9厘米　厚0.5厘米

备注：1987年安徽省含山县凌家滩出土

66

Xin 201610

Jade double-ring Bi
Neolithic Age

Diameter: 11.2 cm　Internal diameter: 2.9 cm
Thickness: 0.5 cm
Unearthed at Lingjiatan, Hanshan County,
Anhui Province in 1987

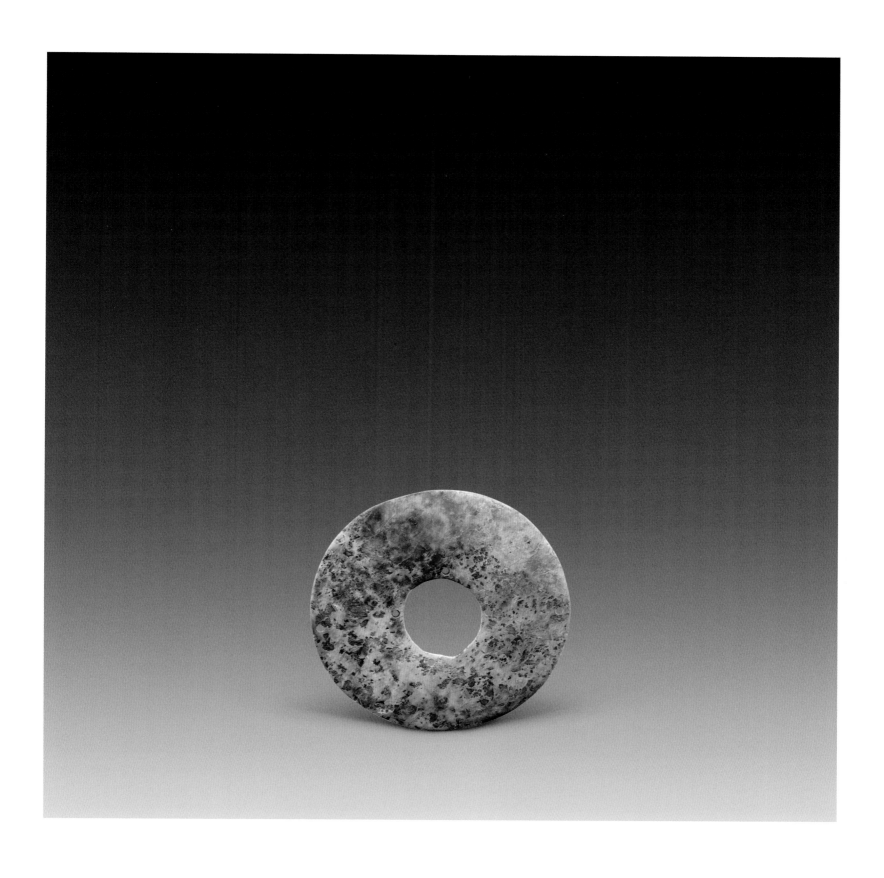

新201496
玉璧
新石器时代
径6.9厘米 孔径2.2厘米 厚0.2厘米
备注：1987年安徽省含山县凌家滩出土

67

Xin 201496
Jade Bi
Neolithic Age
Diameter: 6.9 cm Internal diameter: 2.2 cm
Thickness: 0.2 cm
Unearthed at Lingjiatan, Hanshan County, Anhui
Province in 1987

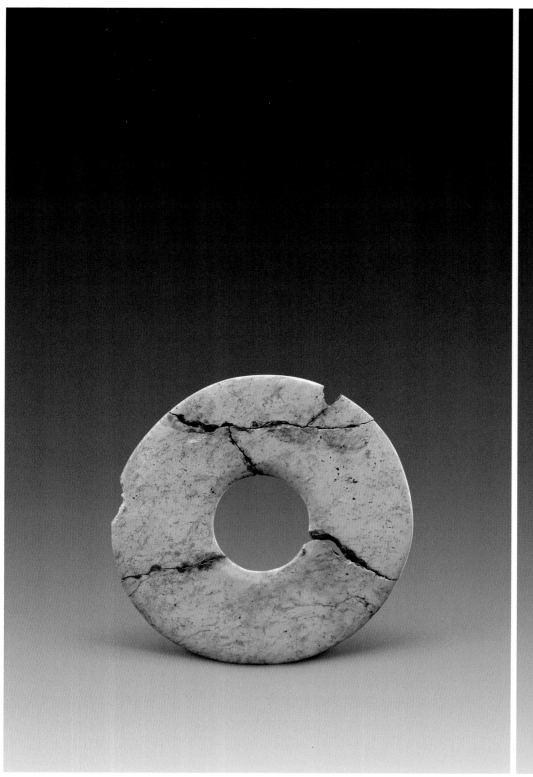

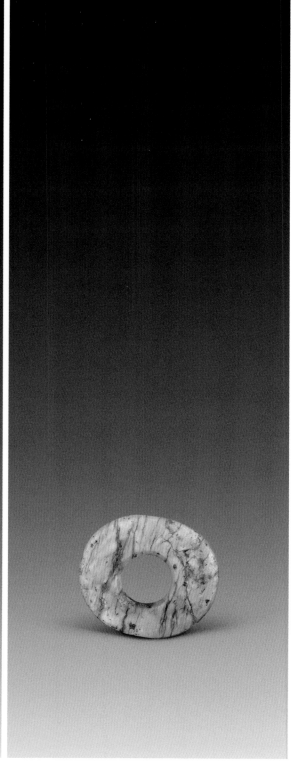

新201559

玉璧
新石器时代

径8.9×8.7厘米 孔径2.6厘米 厚0.2厘米

备注：1987年安徽省含山县凌家滩出土

68

Xin 201559

Jade Bi
Neolithic Age

Diameter: 8.9×8.7 cm Internal diameter: 2.6 cm
Thickness: 0.2 cm
*Unearthed at Lingjiatan, Hanshan County, Anhui Province in
1987*

新201530

玉环
新石器时代

径3.8×3.3厘米 孔径1.3厘米 厚0.5厘米

备注：1987年安徽省含山县凌家滩出土

69

Xin 201530

Jade ring
Neolithic Age

Diameter: 3.8×3.3 cm Internal diameter: 1.3 cm
Thickness: 0.5 cm
*Unearthed at Lingjiatan, Hanshan County, Anhui Province in
1987*

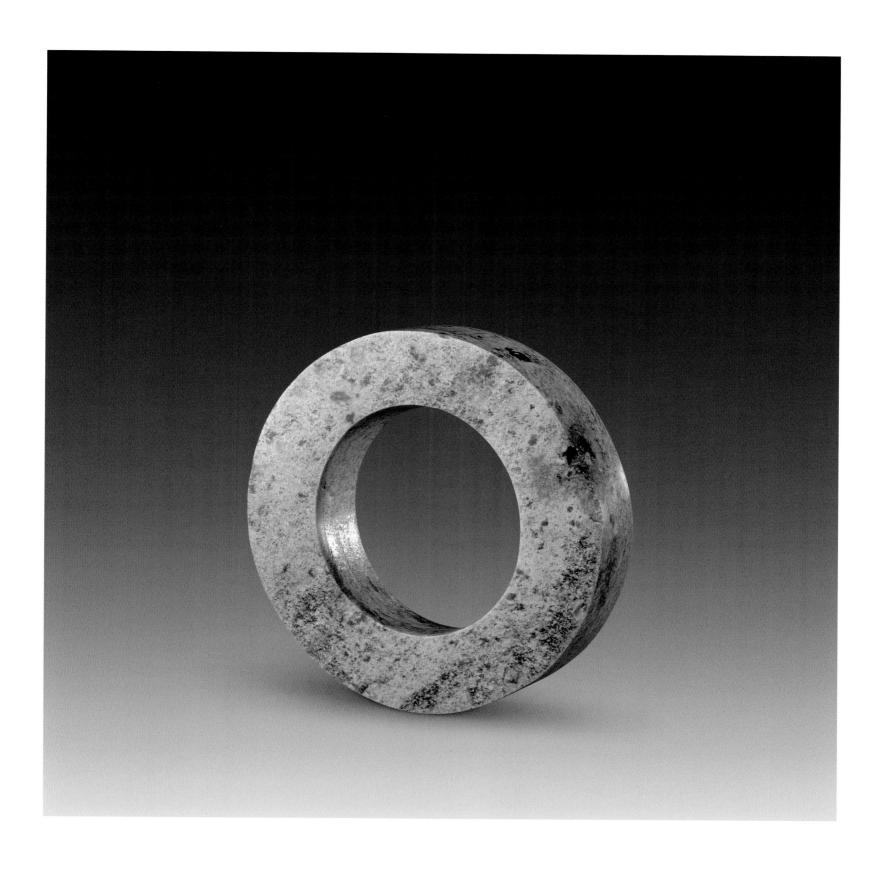

新201487

玉环

新石器时代

径11厘米 孔径6.5厘米 厚2.6厘米

备注：1987年安徽省含山县凌家滩出土

70

Xin 201487

Jade ring
Neolithic Age

Diameter: 11 cm Internal diameter: 6.5 cm
Thickness: 2.6 cm
Unearthed at Lingjiatan, Hanshan County, Anhui Province in 1987

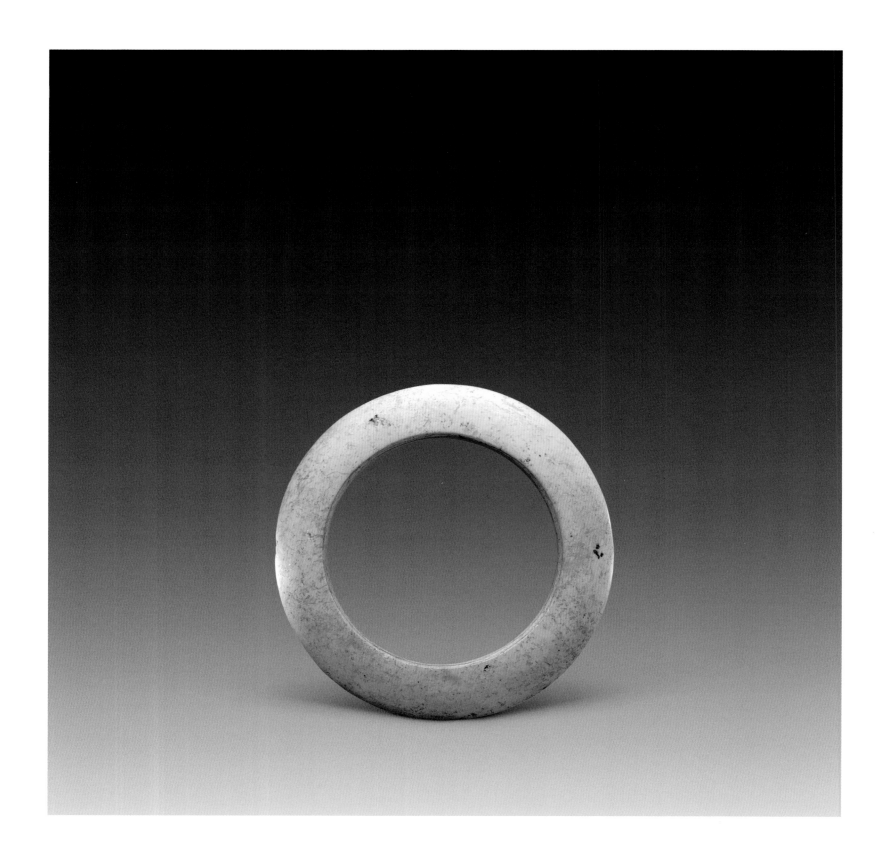

新201485

玉环
新石器时代
径9厘米 孔径6.2厘米 厚1.3厘米

71 | 备注：1987年安徽省含山县凌家滩出土

Xin 201485
Jade ring
Neolithic Age
Diameter: 9 cm Internal diameter: 6.2 cm
Thickness: 1.3 cm
Unearthed at Lingjiatan, Hanshan County, Anhui
Province in 1987

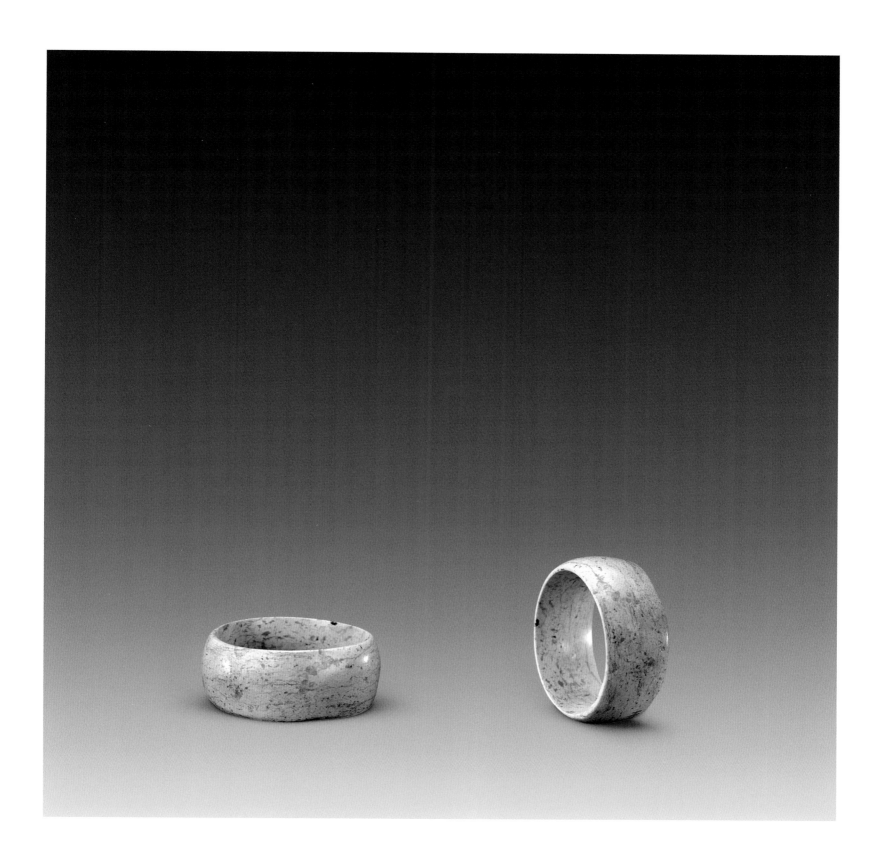

新201497

玉镯

新石器时代

径4.5厘米　孔径3.7厘米　厚0.3厘米

备注：1987年安徽省含山县凌家滩出土

72

Xin 201497

Jade bracelet

Neolithic Age

Diameter: 4.5 cm Internal diameter: 3.7 cm
Thickness: 0.3 cm
Unearthed at Lingjiatan, Hanshan County,
Anhui Province in 1987

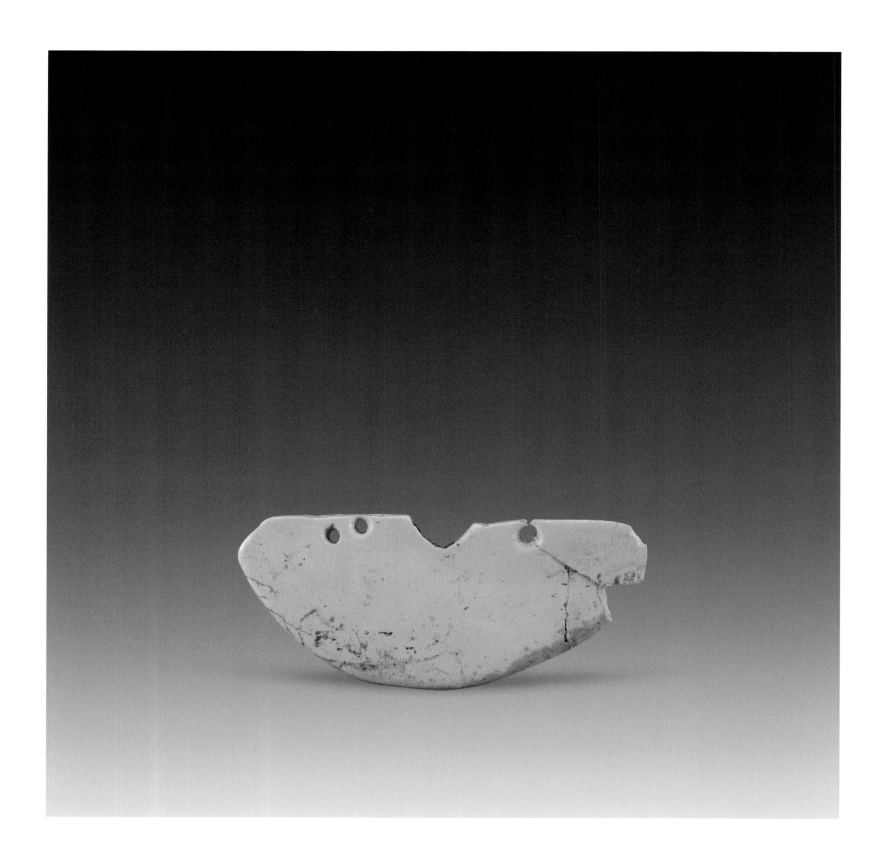

新201578

玉璜
新石器时代

长10.8厘米　宽4.5厘米　厚0.6厘米

备注：1987年安徽省含山县凌家滩出土

73

Xin 201578

Jade Huang
Neolithic Age

Length: 10.8 cm　Width: 4.5 cm
Thickness: 0.6 cm
Unearthed at Lingjiatan, Hanshan County,
Anhui Province in 1987

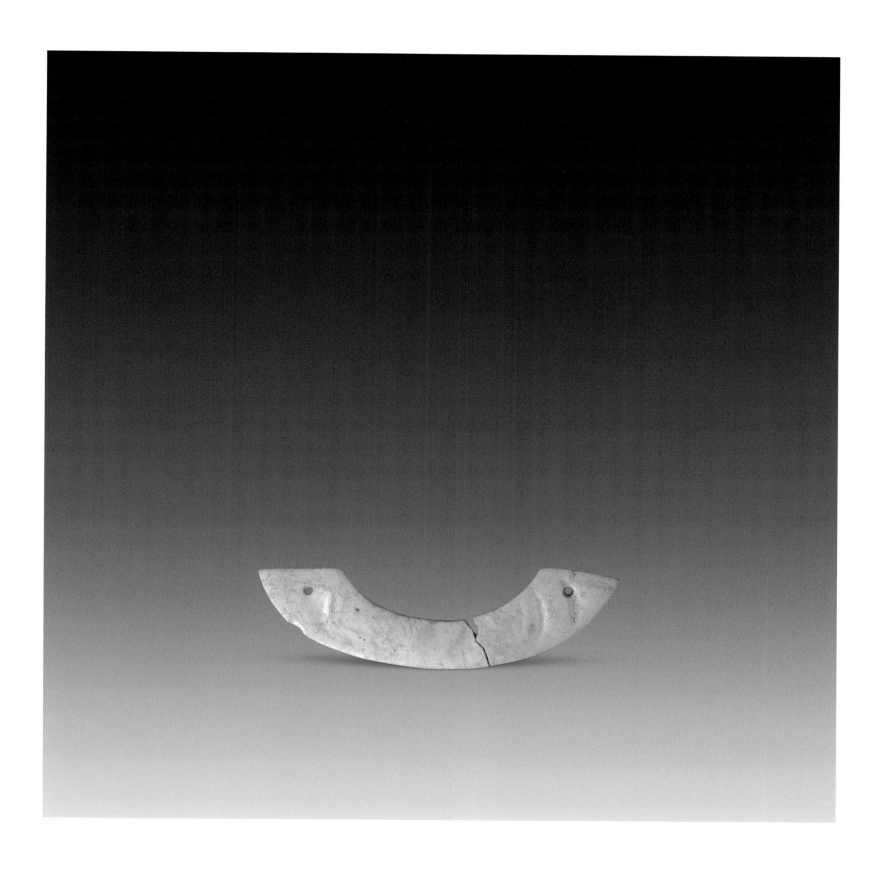

新201527

玉璜

新石器时代

长9.6厘米 端宽2.2厘米 厚0.2厘米

备注：1987年安徽省含山县凌家滩出土

74

Xin 201527

Jade Huang
Neolithic Age

Length: 9.6 cm End width: 2.2 cm
Thickness: 0.2 cm
Unearthed at Lingjiatan, Hanshan County,
Anhui Province in 1987

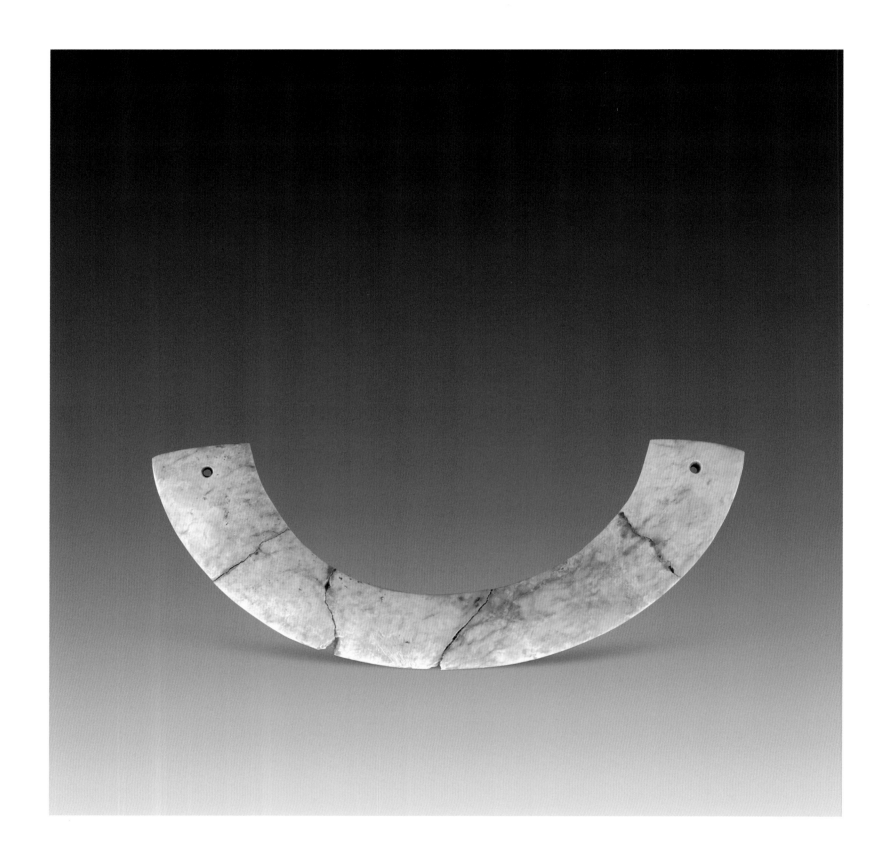

新201525

玉璜
新石器时代

长15.7厘米 端宽2.6厘米 厚0.5厘米

75 备注：1987年安徽省含山县凌家滩出土

Xin 201525
Jade Huang
Neolithic Age

Length: 15.7 cm End width: 2.6 cm
Thickness: 0.5 cm
Unearthed at Lingjiatan, Hanshan County,
Anhui Province in 1987

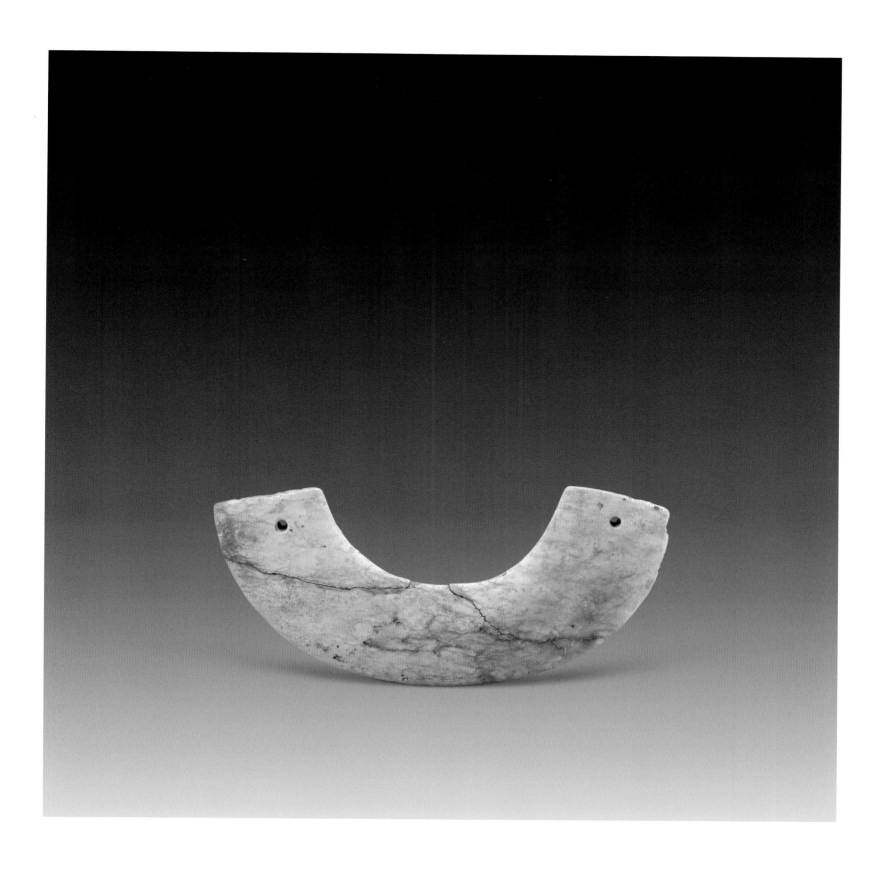

新201524
玉璜
新石器时代
长12厘米 端宽2.9厘米 厚0.6厘米
备注：1987年安徽省含山县凌家滩出土

Xin 201524
Jade Huang
Neolithic Age
Length: 12 cm End width: 2.9 cm
Thickness: 0.6 cm
Unearthed at Lingjiatan, Hanshan County,
Anhui Province in 1987

76

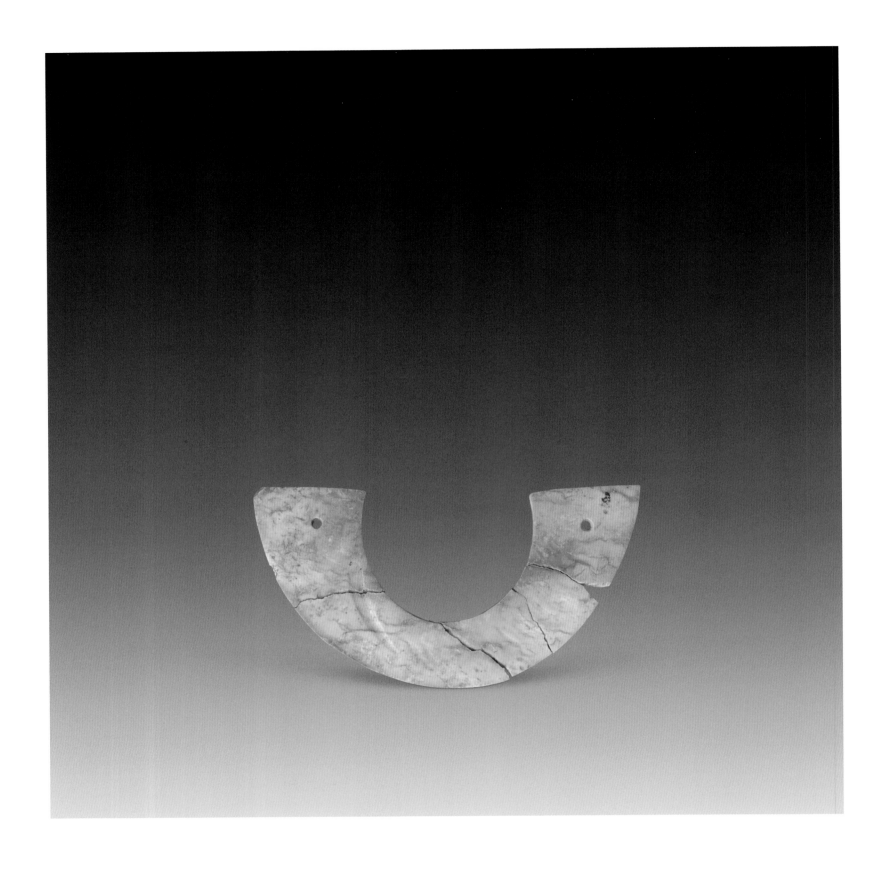

新201553

玉璜
新石器时代
长10.3厘米 端宽2.8厘米 厚0.2厘米

备注：1987年安徽省含山县凌家滩出土

77

Xin 201553

Jade Huang
Neolithic Age

Length: 10.3 cm End width: 2.8 cm
Thickness: 0.2 cm
*Unearthed at Lingjiatan, Hanshan County,
Anhui Province in 1987*

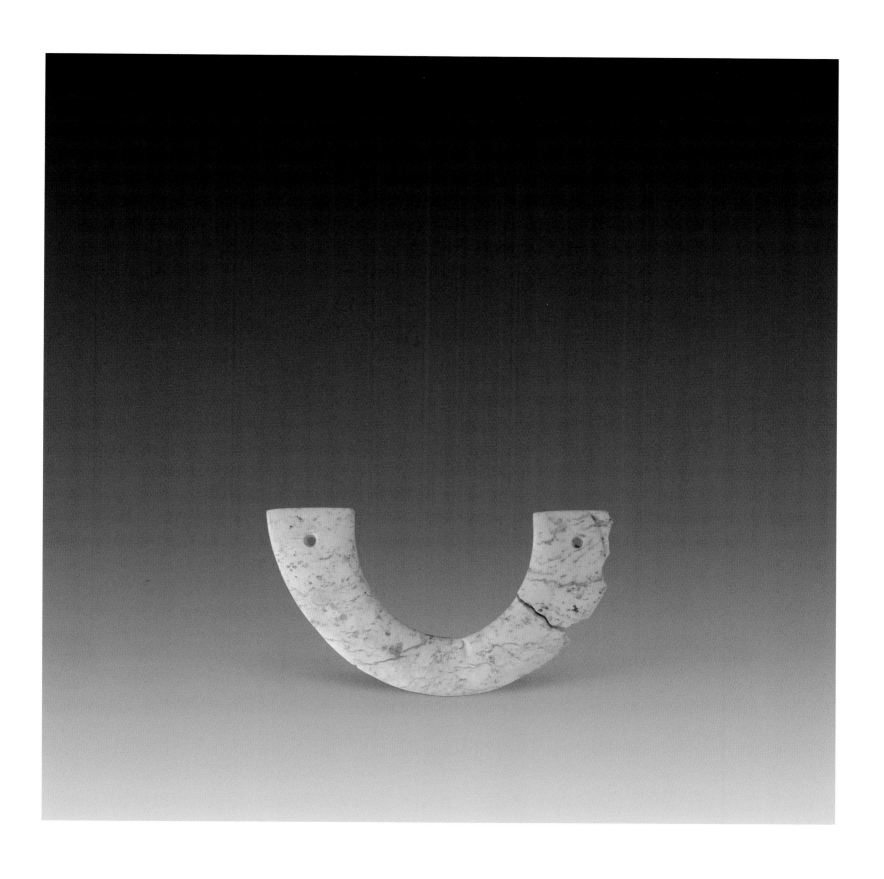

新201554

玉璜
新石器时代
长9.2厘米 端宽2.2厘米 厚0.3厘米
备注：1987年安徽省含山县凌家滩出土

78

Xin 201554
Jade Huang
Neolithic Age
Length: 9.2 cm End width: 2.2 cm
Thickness: 0.3 cm
Unearthed at Lingjiatan, Hanshan County,
Anhui Province in 1987

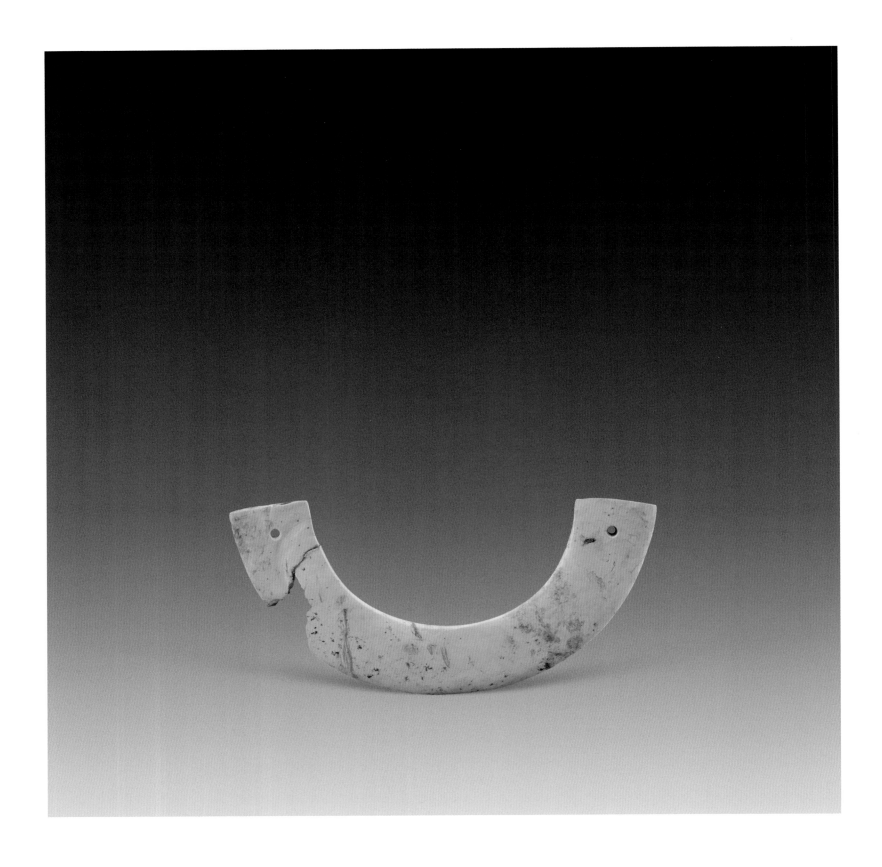

新201555

玉璜
新石器时代
长11.2厘米 端宽2.1厘米 厚0.3厘米
备注：1987年安徽省含山县凌家滩出土

79

Xin 201555
Jade Huang
Neolithic Age
Length: 11.2 cm End width: 2.1 cm
Thickness: 0.3 cm
Unearthed at Lingjiatan, Hanshan County,
Anhui Province in 1987

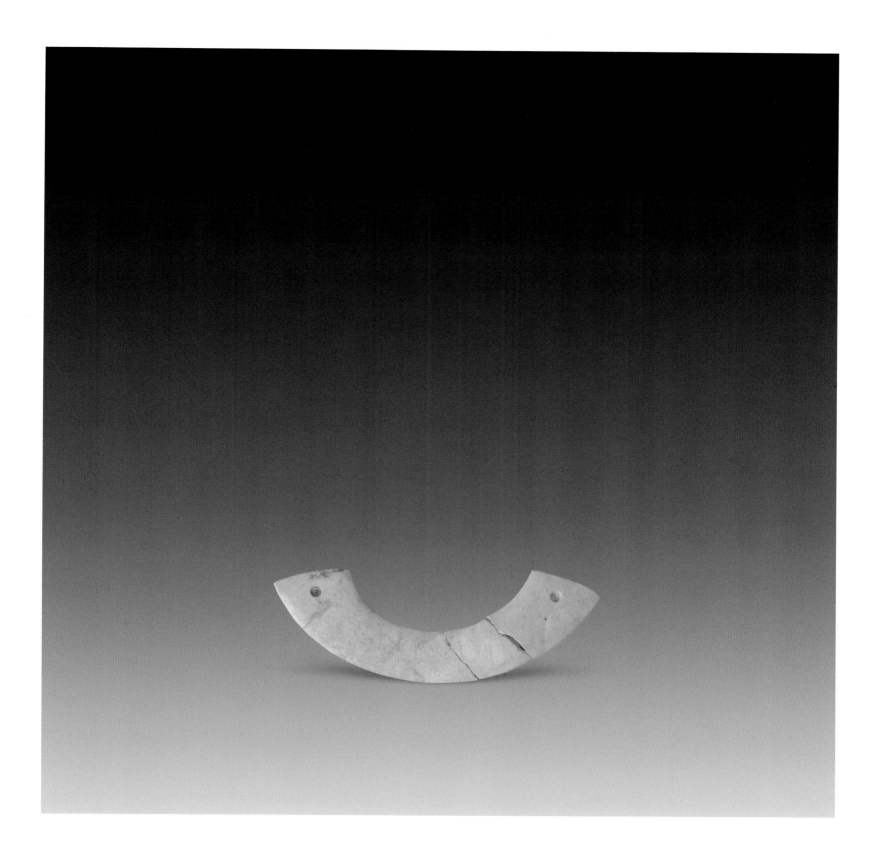

新201556

玉璜
新石器时代
长8.7厘米 端宽2厘米 厚0.2厘米
备注：1987年安徽省含山县凌家滩出土

80

Xin 201556
Jade Huang
Neolithic Age
Length: 8.7 cm End width: 2 cm
Thickness: 0.2 cm
Unearthed at Lingjiatan, Hanshan County,
Anhui Province in 1987

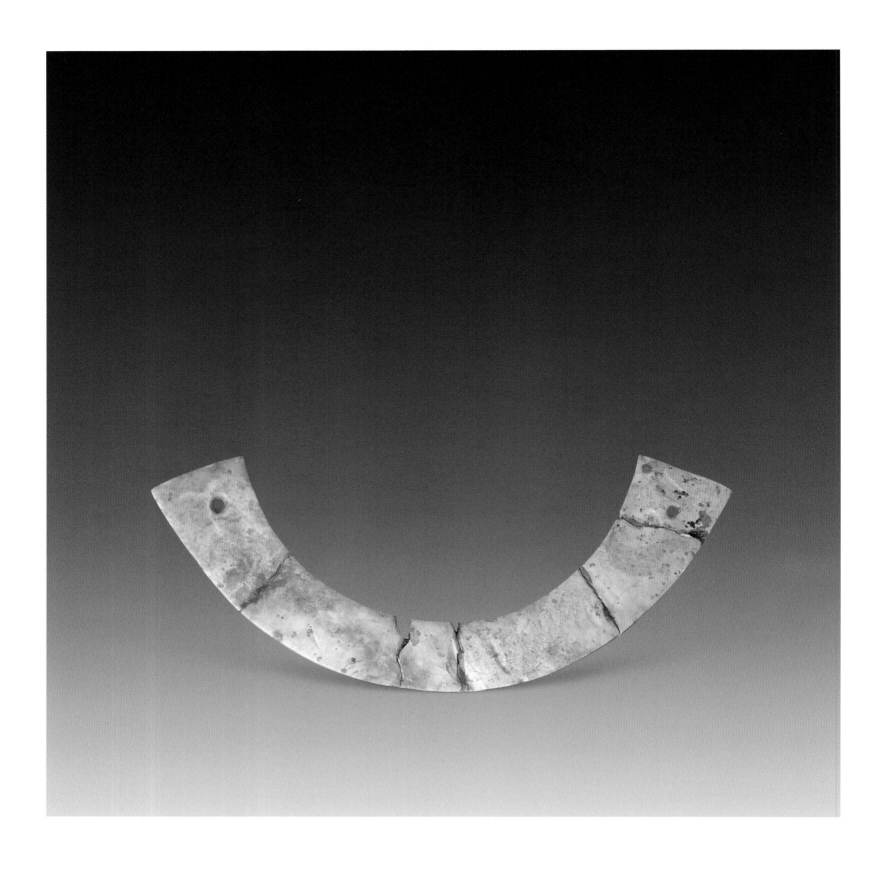

新201557

玉璜
新石器时代

长15.3厘米 端宽2.6厘米 厚0.3厘米

备注：1987年安徽省含山县凌家滩出土

81

Xin 201557

Jade Huang
Neolithic Age

Length: 15.3 cm End width: 2.6 cm
Thickness: 0.3 cm
*Unearthed at Lingjiatan, Hanshan County,
Anhui Province in 1987*

新201528

玉璜
新石器时代

长11厘米 端宽2.6厘米 厚0.2厘米

备注：1987年安徽省含山县凌家滩出土

82

Xin 201528

Jade Huang
Neolithic Age

Length: 11 cm End width: 2.6 cm
Thickness: 0.2 cm
Unearthed at Lingjiatan, Hanshan County,
Anhui Province in 1987

新201523

玉璜

新石器时代

长11.1厘米 端宽2.1厘米 厚0.3厘米

备注：1987年安徽省含山县凌家滩出土

83

Xin 201523

Jade Huang
Neolithic Age

Length: 11.1 cm End width: 2.1 cm
Thickness: 0.3 cm
Unearthed at Lingjiatan, Hanshan County,
Anhui Province in 1987

新201482
玉璜
新石器时代
长23厘米　端宽2.2厘米　厚0.6厘米
备注：1987年安徽省含山县凌家滩出土

84

Xin 201482
Jade Huang
Neolithic Age
Length: 23 cm End width: 2.2 cm
Thickness: 0.6 cm
Unearthed at Lingjiatan, Hanshan County,
Anhui Province in 1987

新201526

玉璜
新石器时代

长21.3厘米 端宽4.1厘米 厚0.2厘米

85 | 备注：1987年安徽省含山县凌家滩出土

Xin 201526
Jade Huang
Neolithic Age

Length: 21.3 cm End width: 4.1 cm
Thickness: 0.2 cm
Unearthed at Lingjiatan, Hanshan County,
Anhui Province in 1987

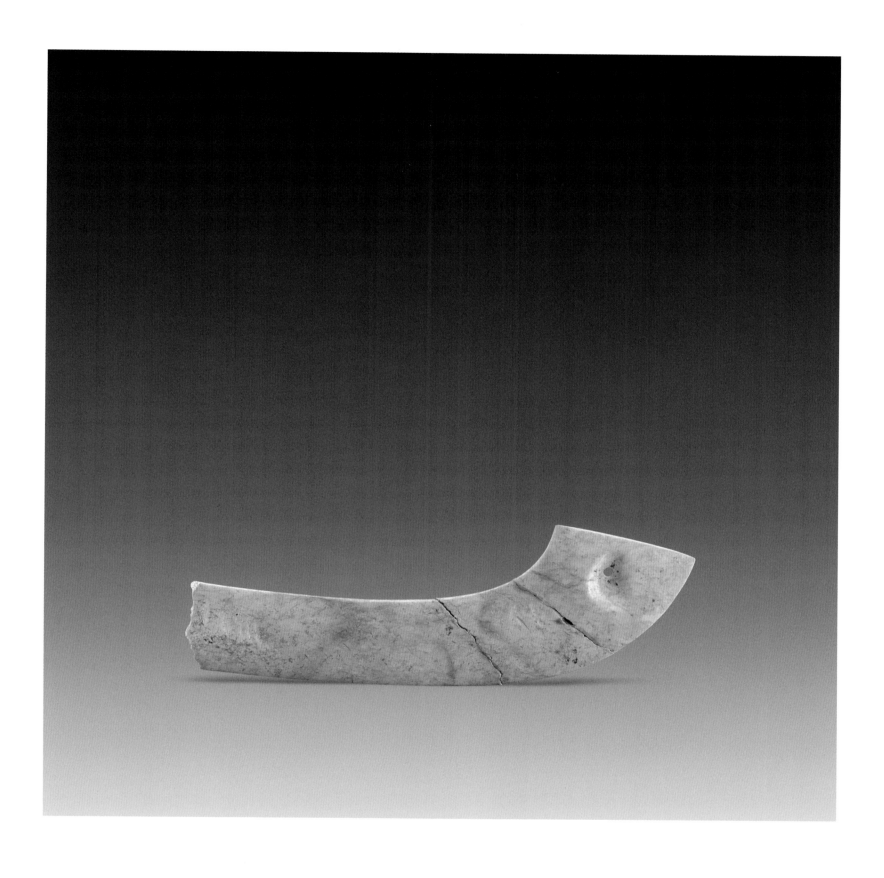

新201558

玉璜

新石器时代

长13.8厘米 端宽4厘米 厚0.2厘米

备注：残，1987年安徽省含山县凌家滩出土

86

Xin 201558

Jade Huang
Neolithic Age

Length: 13.8 cm End width: 4 cm
Thickness: 0.2 cm
*Incomplete and unearthed at Lingjiatan, Hanshan
County, Anhui Province in 1987*

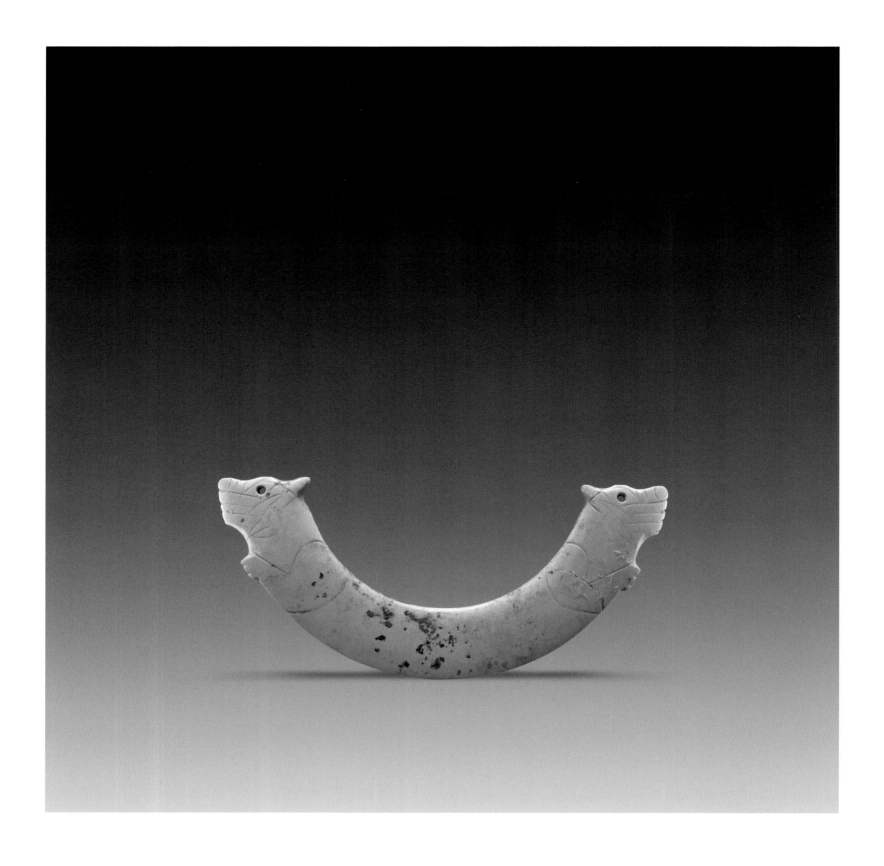

新201480
玉双虎首璜
新石器时代
长11.9厘米 端宽2.5厘米 厚0.4厘米
87 | 备注：1987年安徽省含山县凌家滩出土

Xin 201480
Jade Huang with double-tigerhead design
Neolithic Age
Length: 11.9 cm End width: 2.5 cm Thickness: 0.4 cm
Unearthed at Lingjiatan, Hanshan County,
Anhui Province in 1987

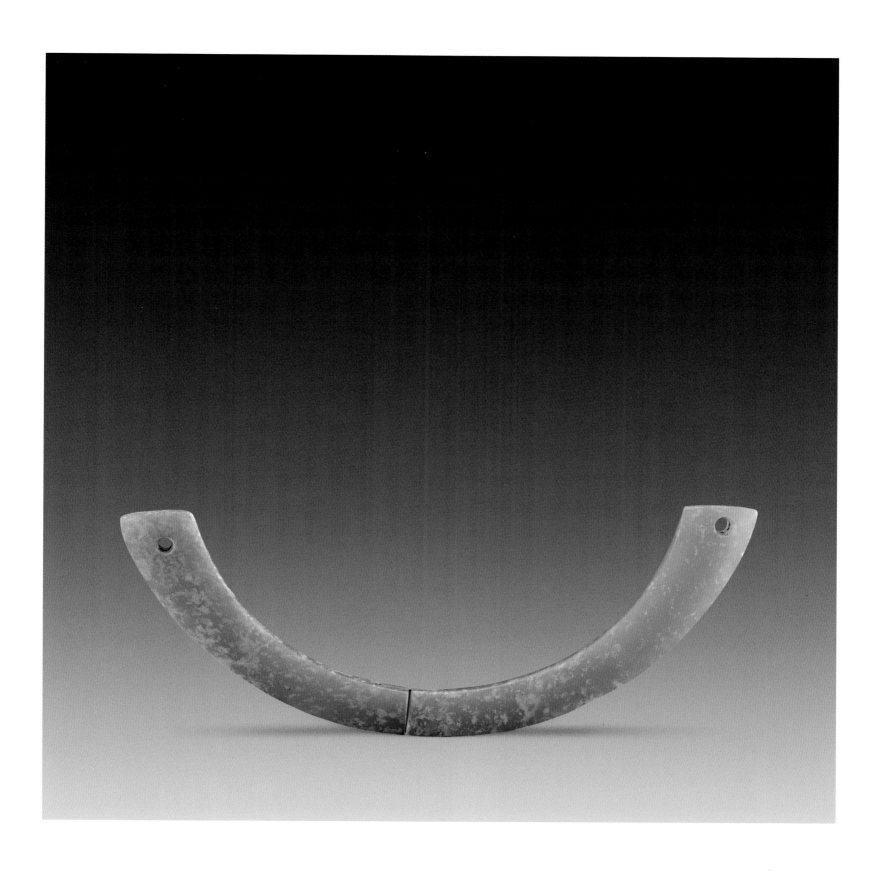

新201479

玉对接璜

新石器时代

长16.9厘米　端宽1.9厘米　厚0.6厘米

备注：1987年安徽省含山县凌家滩出土

88

Xin 201479

Jade Huang

Neolithic Age

Length: 16.9 cm End width: 1.9 cm

Thickness: 0.6 cm

Unearthed at Lingjiatan, Hanshan County,

Anhui Province in 1987

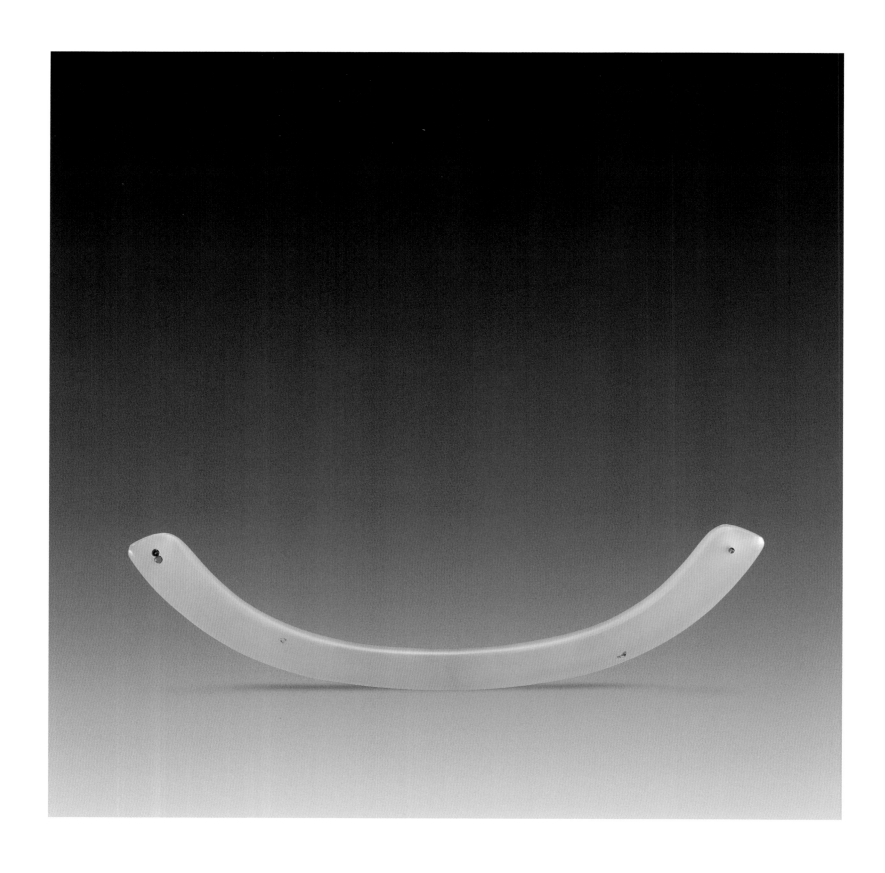

新201483
玛瑙璜
新石器时代
长19.2厘米 端宽1.5厘米 厚1厘米

89 备注：1987年安徽省含山县凌家滩出土

Xin 201483
Agate Huang
Neolithic Age
Length: 19.2 cm End width: 1.5 cm
Thickness: 1 cm
Unearthed at Lingjiatan, Hanshan County,
Anhui Province in 1987

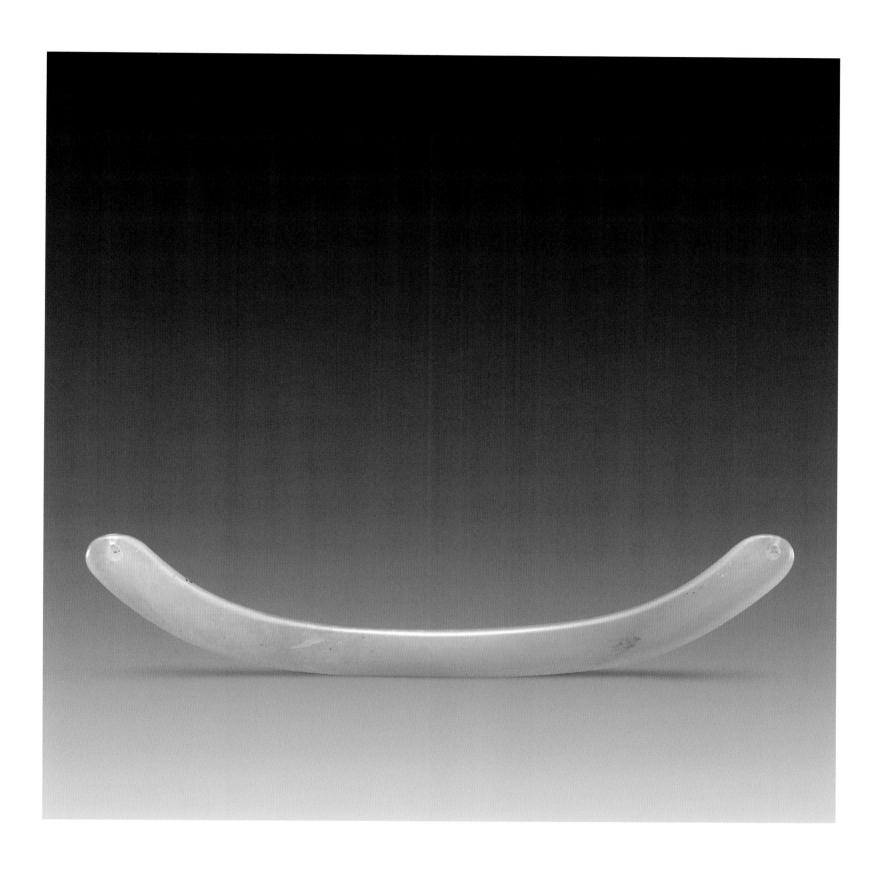

新201484
玛瑙璜
新石器时代
长18.8厘米 端宽1.4厘米 厚0.9厘米
备注：1987年安徽省含山县凌家滩出土

90

Xin 201484
Agate Huang
Neolithic Age
Length: 18.8 cm End width: 1.4 cm
Thickness: 0.9 cm
Unearthed at Lingjiatan, Hanshan County,
Anhui Province in 1987

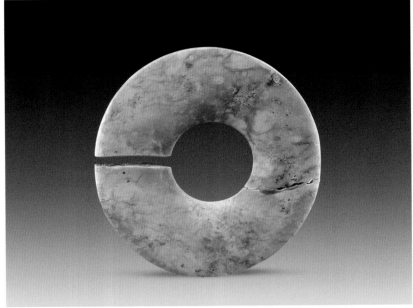

新201529
玉玦
新石器时代
径6厘米 孔径2.1厘米 厚0.4厘米
备注：1987年安徽省含山县凌家滩出土

91

Xin 201529
Jade Jue
Neolithic Age
Diameter: 6 cm Internal diameter: 2.1 cm
Thickness: 0.4 cm
Unearthed at Lingjiatan, Hanshan County,
Anhui Province in 1987

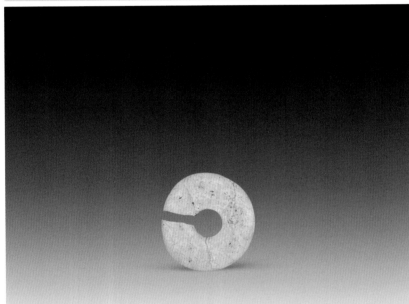

新201532
玉玦
新石器时代
径2.7×2.5厘米 孔径0.7厘米 厚0.3厘米
备注：1987年安徽省含山县凌家滩出土

92

Xin 201532
Jade Jue
Neolithic Age
Diameter: 2.7×2.5 cm Internal diameter: 0.7 cm
Thickness: 0.3 cm
Unearthed at Lingjiatan, Hanshan County,
Anhui Province in 1987

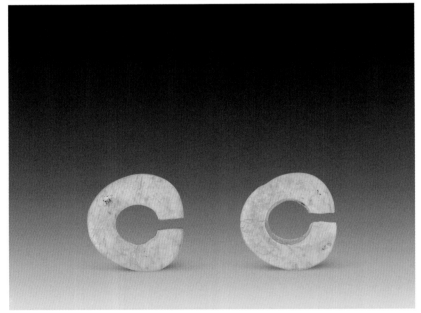

新201536
玉玦
新石器时代
径2.7厘米 孔径1.1厘米 厚0.4厘米
备注：1987年安徽省含山县凌家滩出土

93

Xin 201536
Jade Jue
Neolithic Age
Diameter: 2.7 cm Internal diameter: 1.1 cm
Thickness: 0.4 cm
Unearthed at Lingjiatan, Hanshan County,
Anhui Province in 1987

新201537
玉玦
新石器时代
径2.5×2.2厘米 孔径0.6厘米 厚0.5厘米
备注：1987年安徽省含山县凌家滩出土

94

Xin 201537
Jade Jue
Neolithic Age
Diameter: 2.5×2.2 cm Internal diameter: 0.6 cm
Thickness: 0.5 cm
Unearthed at Lingjiatan, Hanshan County,
Anhui Province in 1987

新201538
玉玦
新石器时代
径2.7厘米　孔径0.9厘米　厚0.3厘米
备注：1987年安徽省含山县凌家滩出土

95

Xin 201538

Jade Jue
Neolithic Age
Diameter: 2.7 cm Internal diameter: 0.9 cm
Thickness: 0.3 cm
Unearthed at Lingjiatan, Hanshan County,
Anhui Province in 1987

新201539
玉玦
新石器时代
径2.5厘米　孔径0.8厘米　厚0.4厘米
备注：1987年安徽省含山县凌家滩出土

96

Xin 201539

Jade Jue
Neolithic Age
Diameter: 2.5 cm Internal diameter: 0.8 cm
Thickness: 0.4 cm
Unearthed at Lingjiatan, Hanshan County,
Anhui Province in 1987

新201560
玉玦
新石器时代
径2.3 厘米　孔径0.7厘米　厚0.5厘米
备注：1987年安徽省含山县凌家滩出土

97

Xin 201560

Jade Jue
Neolithic Age
Diameter: 2.3 cm Internal diameter: 0.7 cm
Thickness: 0.5 cm
Unearthed at Lingjiatan, Hanshan County,
Anhui Province in 1987

新201561
玉玦
新石器时代
径2.2厘米　孔径0.8厘米　厚0.4厘米
备注：1987年安徽省含山县凌家滩出土

98

Xin 201561

Jade Jue
Neolithic Age
Diameter: 2.2 cm Internal diameter: 0.8 cm
Thickness: 0.4 cm
Unearthed at Lingjiatan, Hanshan County,
Anhui Province in 1987

新201563

玉玦

新石器时代

径2.6厘米 孔径1厘米 厚0.5厘米

99 | 备注：1987年安徽省含山县凌家滩出土

Xin 201563

Jade Jue
Neolithic Age

Diameter: 2.6 cm Internal diameter: 1 cm
Thickness: 0.5 cm
Unearthed at Lingjiatan, Hanshan County,
Anhui Province in 1987

新201564

玉玦

新石器时代

径2.4厘米 孔径0.8厘米 厚0.4厘米

100 | 备注：1987年安徽省含山县凌家滩出土

Xin 201564

Jade Jue
Neolithic Age

Diameter: 2.4 cm Internal diameter: 0.8 cm
Thickness: 0.4 cm
Unearthed at Lingjiatan, Hanshan County,
Anhui Province in 1987

新201565

玉玦

新石器时代

径2.4厘米 孔径0.9厘米 厚0.4厘米

101 | 备注：1987年安徽省含山县凌家滩出土

Xin 201565

Jade Jue
Neolithic Age

Diameter: 2.4 cm Internal diameter: 0.9 cm
Thickness: 0.4 cm
Unearthed at Lingjiatan, Hanshan County,
Anhui Province in 1987

新201566

玉玦

新石器时代

径2.6厘米 孔径0.8厘米 厚0.4厘米

102 | 备注：1987年安徽省含山县凌家滩出土

Xin 201566

Jade Jue
Neolithic Age

Diameter: 2.6 cm Internal diameter: 0.8 cm
Thickness: 0.4 cm
Unearthed at Lingjiatan, Hanshan County,
Anhui Province in 1987

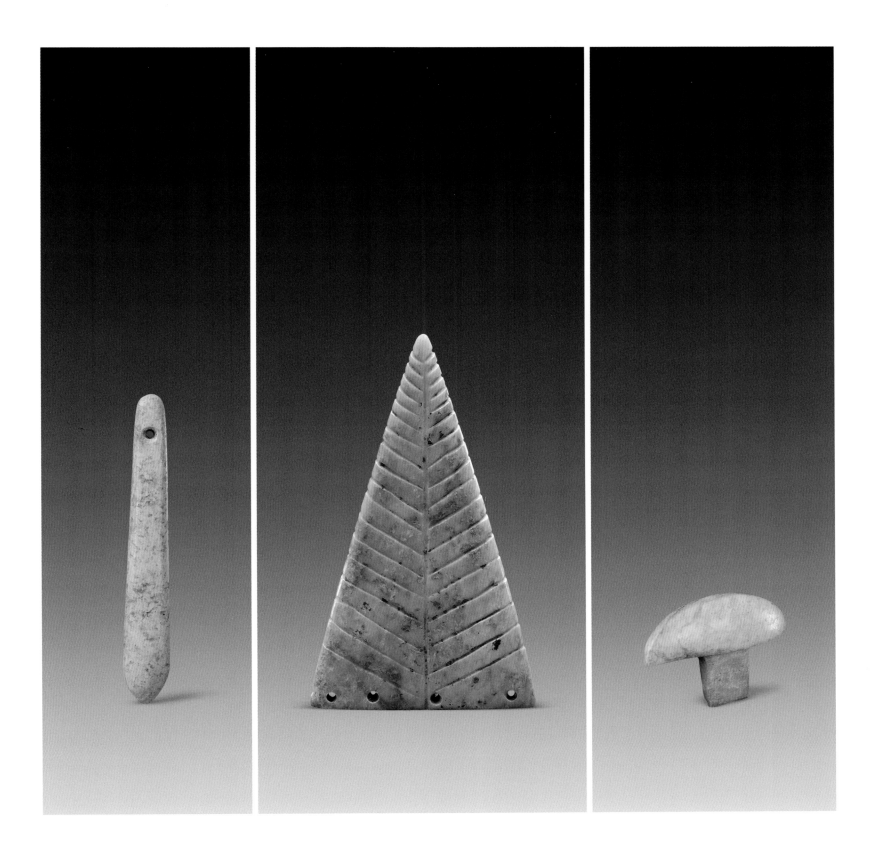

新201522
玉坠
新石器时代
长8.5厘米 宽1.2厘米 厚0.7厘米
备注：1987年安徽省含山县凌家滩出土

103

Xin 201522
Jade pendant
Neolithic Age
Length: 8.5 cm Width: 1.2 cm Thickness: 0.7 cm
Unearthed at Lingjiatan, Hanshan County,
Anhui Province in 1987

新201478
玉条纹三角形饰
新石器时代
长10.3厘米 宽6厘米 厚0.5厘米
备注：1987年安徽省含山县凌家滩出土

104

Xin 201478
Jade triangle ornament with stripe design
Neolithic Age
Length: 10.3 cm Width: 6 cm Thickness: 0.5 cm
Unearthed at Lingjiatan, Hanshan County,
Anhui Province in 1987

新201531
玉丁形饰
新石器时代
高3.2厘米 宽4.6厘米 厚1.5厘米
备注：1987年安徽省含山县凌家滩出土

105

Xin 201531
T-shaped jade ornament
Neolithic Age
Height: 3.2 cm Width: 4.6 cm
Thickness: 1.5 cm
Unearthed at Lingjiatan, Hanshan County,
Anhui Province in 1987

新201548
玉饰
新石器时代
径2.1厘米　厚0.4厘米
备注：1987年安徽省含山县凌家滩出土

106

Xin 201548
Jade ornament
Neolithic Age
Diameter: 2.1 cm Thickness: 0.4 cm
Unearthed at Lingjiatan, Hanshan County,
Anhui Province in 1987

新201550
玉饰
新石器时代
径2厘米　厚0.5厘米
备注：1987年安徽省含山县凌家滩出土

107

Xin 201550
Jade ornament
Neolithic Age
Diameter: 2 cm Thickness: 0.5 cm
Unearthed at Lingjiatan, Hanshan County,
Anhui Province in 1987

新201551
玉饰
新石器时代
径1.8厘米　厚0.6厘米
备注：1987年安徽省含山县凌家滩出土

108

Xin 201551
Jade ornament
Neolithic Age
Diameter: 1.8 cm Thickness: 0.6 cm
Unearthed at Lingjiatan, Hanshan County,
Anhui Province in 1987

新201552
玉饰
新石器时代
径2.1厘米　厚0.9厘米
备注：1987年安徽省含山县凌家滩出土

109

Xin 201552
Jade ornament
Neolithic Age
Diameter: 2.1 cm Thickness: 0.9 cm
Unearthed at Lingjiatan, Hanshan County,
Anhui Province in 1987

新201569
玉饰
新石器时代
径2.1厘米 厚0.4厘米
备注：1987年安徽省含山县凌家滩出土

110

Xin 201569
Jade ornament
Neolithic Age
Diameter: 2.1 cm Thickness: 0.4 cm
Unearthed at Lingjiatan, Hanshan County,
Anhui Province in 1987

新201570
玉饰
新石器时代
径1.7厘米 厚0.8厘米
备注：1987年安徽省含山县凌家滩出土

111

Xin 201570
Jade ornament
Neolithic Age
Diameter: 1.7 Thickness: 0.8 cm
Unearthed at Lingjiatan, Hanshan County,
Anhui Province in 1987

新201571
玉饰
新石器时代
径2.3厘米 厚0.4厘米
备注：1987年安徽省含山县凌家滩出土

112

Xin 201571
Jade ornament
Neolithic Age
Diameter: 2.3 cm Thickness: 0.4 cm
Unearthed at Lingjiatan, Hanshan County,
Anhui Province in 1987

新201572
玉饰
新石器时代
径0.9厘米 厚0.6厘米
备注：1987年安徽省含山县凌家滩出土

113

Xin 201572
Jade ornament
Neolithic Age
Diameter: 0.9 cm Thickness: 0.6 cm
Unearthed at Lingjiatan, Hanshan County,
Anhui Province in 1987

新201573
玉饰
新石器时代
径0.9厘米　厚0.6厘米
备注：1987年安徽省含山县凌家滩出土

114
Xin 201573
Jade ornament
Neolithic Age
Diameter: 0.9 cm　Thickness: 0.6 cm
Unearthed at Lingjiatan, Hanshan County,
Anhui Province in 1987

新201575
玉饰
新石器时代
径1厘米　厚0.6厘米
备注：1987年安徽省含山县凌家滩出土

115
Xin 201575
Jade ornament
Neolithic Age
Diameter: 1 cm　Thickness: 0.6 cm
Unearthed at Lingjiatan, Hanshan County,
Anhui Province in 1987

新201576
玉饰
新石器时代
径0.9厘米　厚0.5厘米
备注：1987年安徽省含山县凌家滩出土

116
Xin 201576
Jade ornament
Neolithic Age
Diameter: 0.9 cm　Thickness: 0.5 cm
Unearthed at Lingjiatan, Hanshan County,
Anhui Province in 1987

新201577
玉饰
新石器时代
径1厘米　厚0.4厘米
备注：1987年安徽省含山县凌家滩出土

117
Xin 201577
Jade ornament
Neolithic Age
Diameter: 1 cm　Thickness: 0.4 cm
Unearthed at Lingjiatan, Hanshan County,
Anhui Province in 1987

新201544 新201545 新201546 新201547
玉饰
新石器时代
长2.3～2.6厘米 宽2～2.7厘米 厚0.6～0.9厘米
备注：1987年安徽省含山县凌家滩出土

Xin 201544, Xin 201545, Xin 201546, Xin 201547
Jade ornaments
Neolithic Age
Length: 2.3-2.6 cm Width: 2-2.7 cm
Thickness: 0.6-0.9 cm
Unearthed at Lingjiatan, Hanshan County,
Anhui Province in 1987

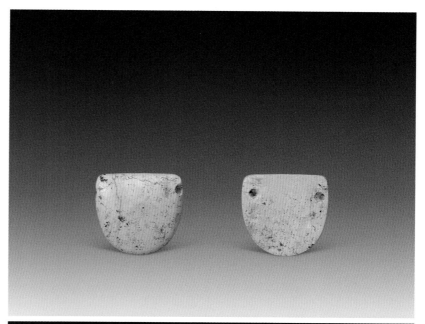
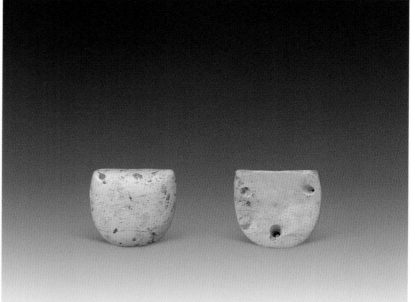
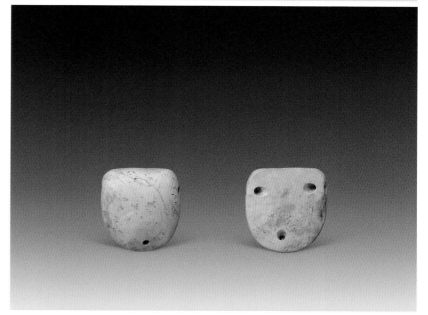
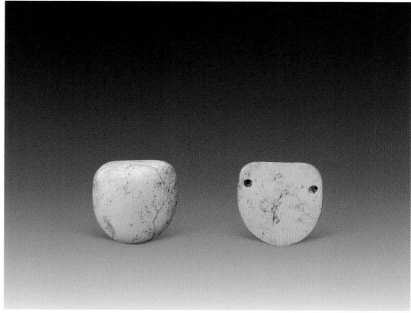

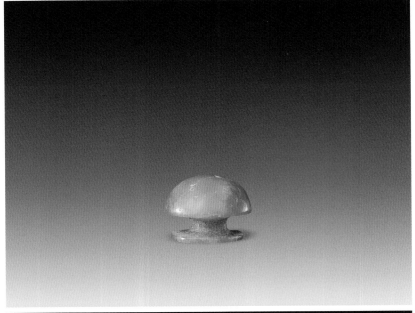

新201574
玉饰
新石器时代
高1.7厘米 底径1.9厘米
备注：1987年安徽省含山县凌家滩出土

119

Xin 201574
Jade ornament
Neolithic Age
Height: 1.7 cm Bottom diameter: 1.9 cm
Unearthed at Lingjiatan, Hanshan County,
Anhui Province in 1987

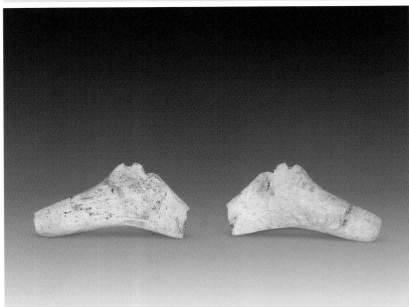

新201567
玉饰
新石器时代
长4.2厘米 宽1.8厘米 厚0.4厘米
备注：1987年安徽省含山县凌家滩出土

120

Xin 201567
Jade ornament
Neolithic Age
Length: 4.2 cm Width: 1.8 cm
Thickness: 0.4 cm
Unearthed at Lingjiatan, Hanshan County,
Anhui Province in 1987

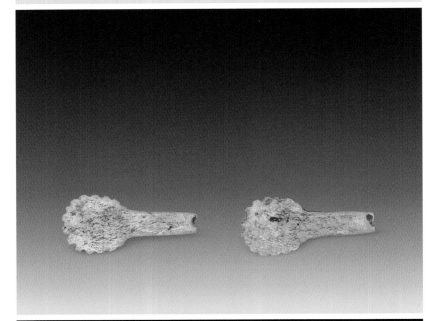

新201568
玉饰
新石器时代
长3.6厘米 宽1.6厘米 厚0.3厘米
备注：1987年安徽省含山县凌家滩出土

121

Xin 201568
Jade ornament
Neolithic Age
Length: 3.6 cm Width: 1.6 cm
Thickness: 0.3 cm
Unearthed at Lingjiatan, Hanshan County,
Anhui Province in 1987

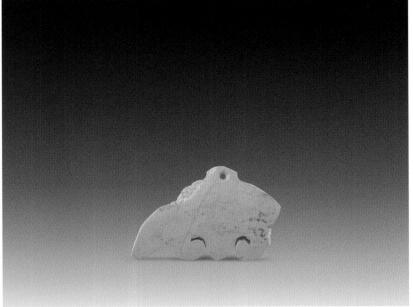

新201579
玉饰
新石器时代
长4厘米 宽2.5厘米 厚0.4厘米
备注：残，1987年安徽省含山县凌家滩出土

122

Xin 201579
Jade ornament
Neolithic Age
Length: 4 cm Width: 2.5 cm Thickness: 0.4 cm
Incomplete, unearthed at Lingjiatan, Hanshan County,
Anhui Province in 1987

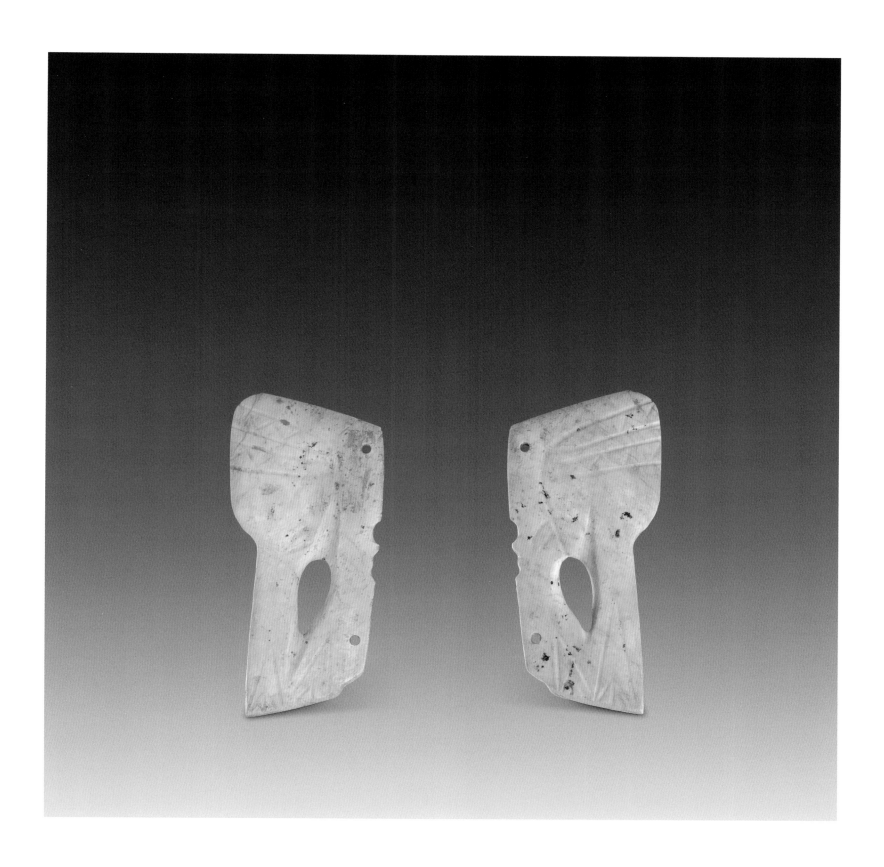

新201481
玉多边形片
新石器时代
长8.9厘米 宽4.1厘米 厚0.2厘米
备注：1987年安徽省含山县凌家滩出土

123

Xin 201481
Jade polygonal flake
Neolithic Age
Length: 8.9 cm Width: 4.1 cm Thickness: 0.2 cm
Unearthed at Lingjiatan, Hanshan County,
Anhui Province in 1987

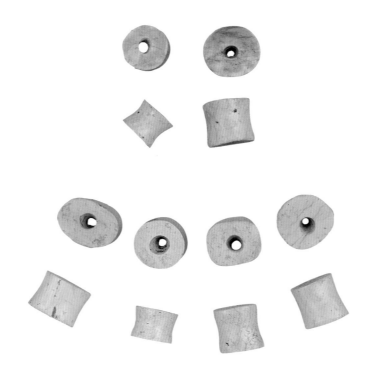

新201533 新201534 新201535
新201540 新201541 新201542
玉管形器（6 件）
新石器时代
高1.5厘米 径1.3～1.4厘米
备注：1987年安徽省含山县凌家滩出土

124

Xin 201533, Xin 201534, Xin 201535
Xin 201540, Xin 201541, Xin 201542
Jade tubes (six pieces)
Neolithic Age
Height: 1.5 cm Diameter: 1.3-1.4 cm
Unearthed at Lingjiatan, Hanshan County,
Anhui Province in 1987

新201521
玛瑙管
新石器时代
长5.8厘米 径1.5厘米
备注：1987年安徽省含山县凌家滩出土

125

Xin 201521
Agate tube
Neolithic Age
Length: 5.8 cm Diameter: 1.5 cm
Unearthed at Lingjiatan, Hanshan County,
Anhui Province in 1987

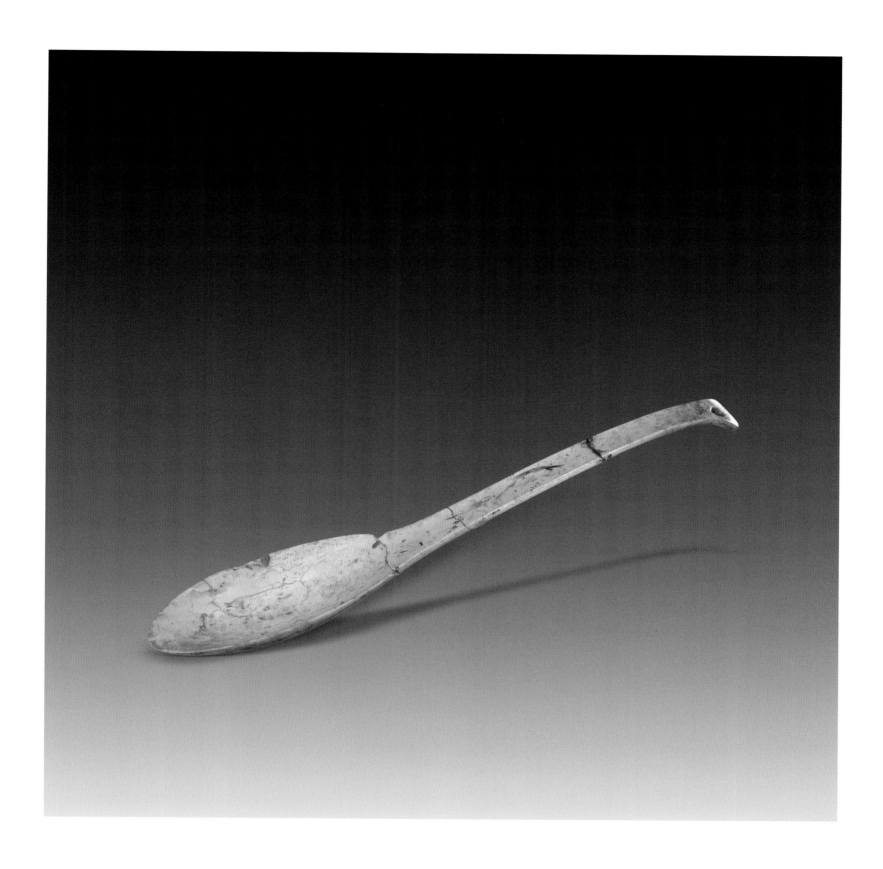

新201474
玉勺
新石器时代
长16.5厘米 宽2.8厘米
备注：1987年安徽省含山县凌家滩出土

126

Xin 201474
Jade spoon
Neolithic Age
Length: 16.5 cm Width: 2.8 cm
Unearthed at Linjiatan, Hanshan County, Anhui Province in 1987

新201584

玉石料
新石器时代

高7.5厘米 宽9.5厘米 厚4.5厘米

备注：1987年安徽省含山县凌家滩出土

127

Xin 201584

Jade stone
Neolithic Age

Height: 7.5 cm Width: 9.5 cm Thickness: 4.5 cm
Unearthed at Lingguatan, Hanshan County, Anhui
Province in 1987

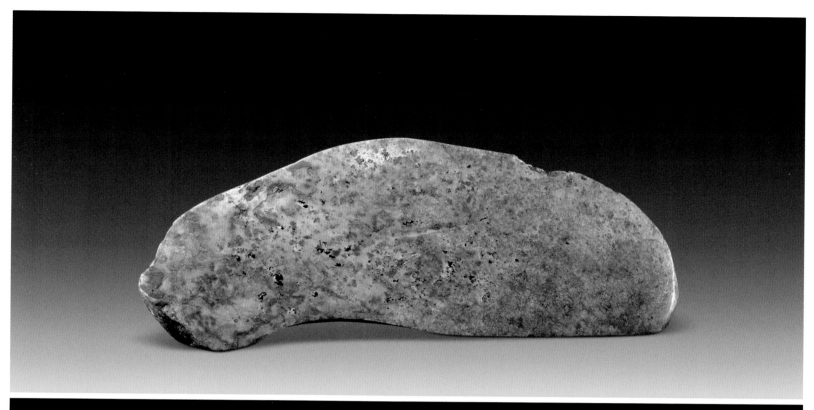

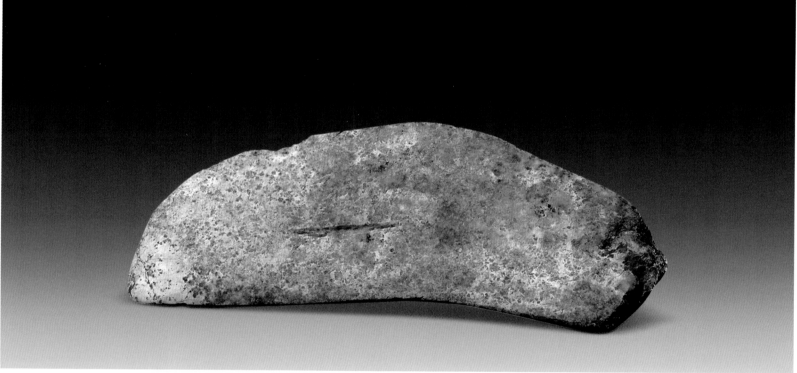

新201585
玉石料
新石器时代
高6厘米 宽17厘米 厚2.5厘米
备注：1987年安徽省含山县凌家滩出土

128

Xin 201585
Jade stone
Neolithic Age
Height: 6 cm Width: 17 cm Thickness: 2.5 cm
Unearthed at Lingjiatan, Hanshan County,
Anhui Province in 1987

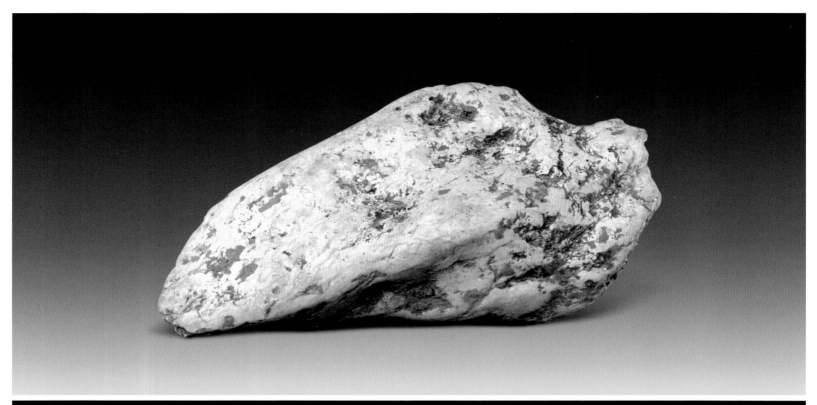

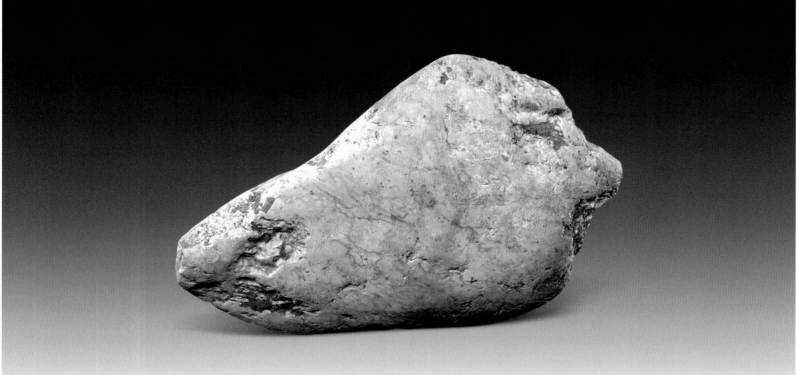

新201586

玉石料

新石器时代

高9厘米 宽15厘米 厚3厘米

备注：1987年安徽省含山县凌家滩出土

129

Xin 201586

Jade stone
Neolithic Age

Height: 9 cm Width: 15 cm Thickness: 3 cm
Unearthed at Lingjiatan, Hanshan County,
Anhui Province in 1987

新201587

玉石料
新石器时代

高6厘米 宽12.5厘米 厚3厘米

备注：1987年安徽省含山县凌家滩出土

130

Xin 201587

Jade stone
Neolithic Age

Height: 6 cm Width: 12.5 cm Thickness: 3 cm
Unearthed at Lingjiatan, Hanshan County,
Anhui Province in 1987

新201588

玉石料
新石器时代

高8厘米 宽9厘米 厚5厘米

备注：1987年安徽省含山县凌家滩出土

131

Xin 201588

Jade stone
Neolithic Age

Height: 8 cm Width: 9 cm Thickness: 5 cm
Unearthed at Lingjiatan, Hanshan County,
Anhui Province in 1987

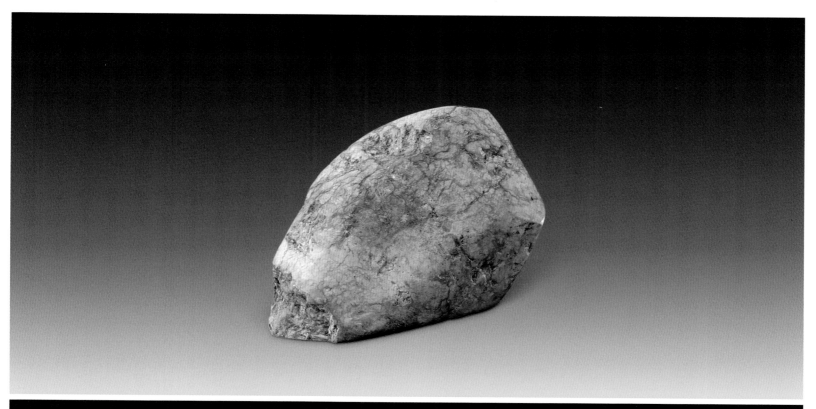

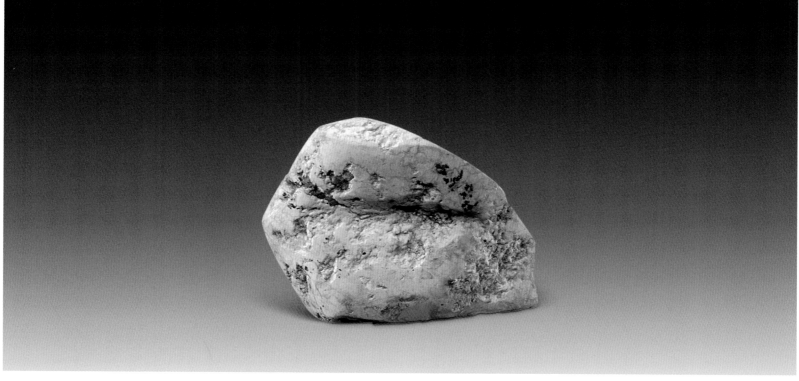

新201589

玉石料

新石器时代

高7厘米 宽10厘米 厚3厘米

备注：1987年安徽省含山县凌家滩出土

132

Xin 201589

Jade stone

Neolithic Age

Height: 7 cm Width: 10 cm Thickness: 3 cm

Unearthed at Lingjiatan, Hanshan County,
Anhui Province in 1987

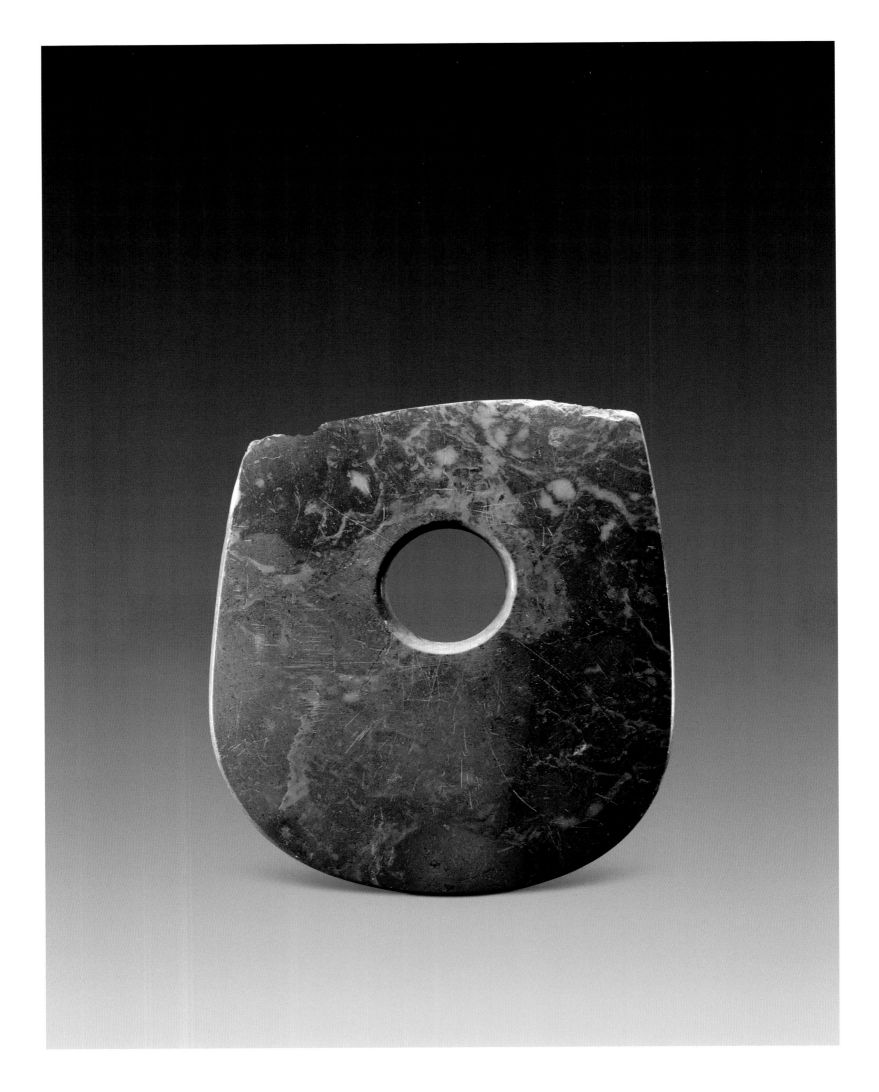

新201590

石斧
新石器时代
长16.4厘米 宽15.6厘米 厚1厘米

备注：1987年安徽省含山县凌家滩出土

133

Xin 201590

Stone axe
Neolithic Age
Length: 16.4 cm Width: 15.6 cm Thickness: 1 cm
Unearthed at Lingjiatan, Hanshan County,
Anhui Province in 1987

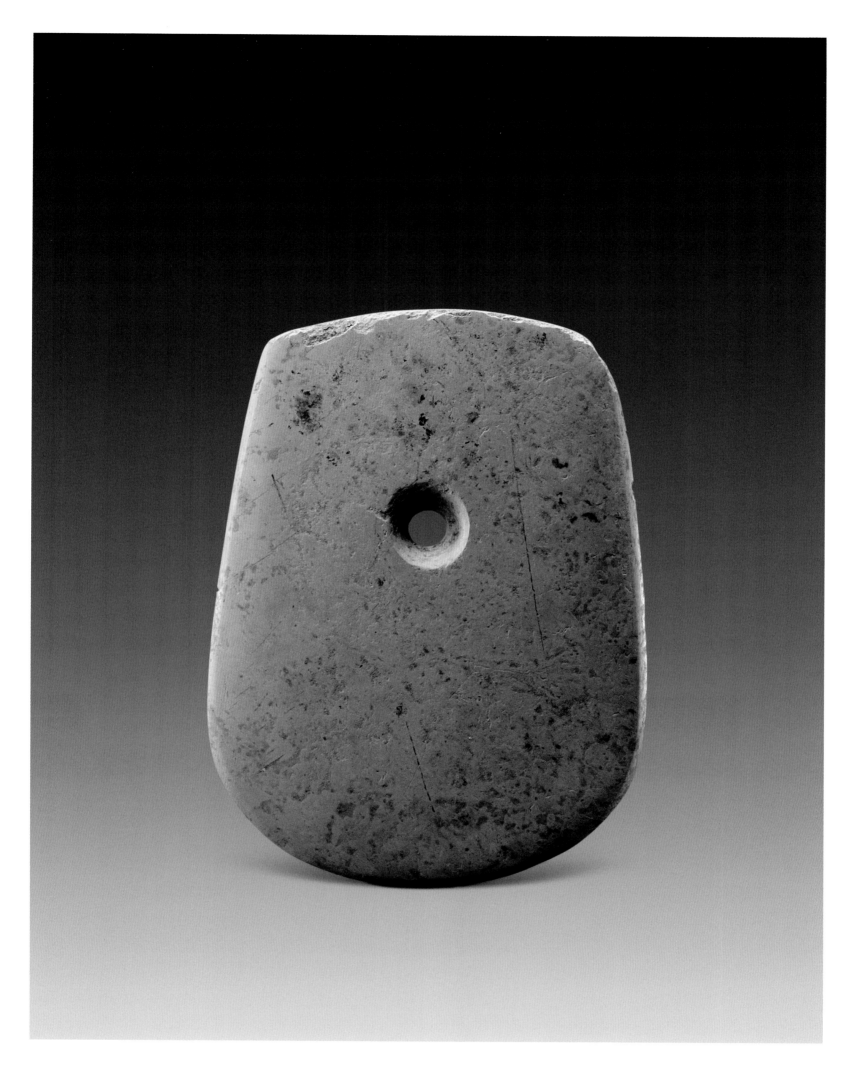

新201591
石斧
新石器时代
长20厘米 宽14.5厘米 厚1厘米
备注：1987年安徽省含山县凌家滩出土

134

Xin 201591
Stone axe
Neolithic Age
Length: 20 cm Width: 14.5 cm Thickness: 1 cm
Unearthed at Lingjiatan, Hanshan County,
Anhui Province in 1987

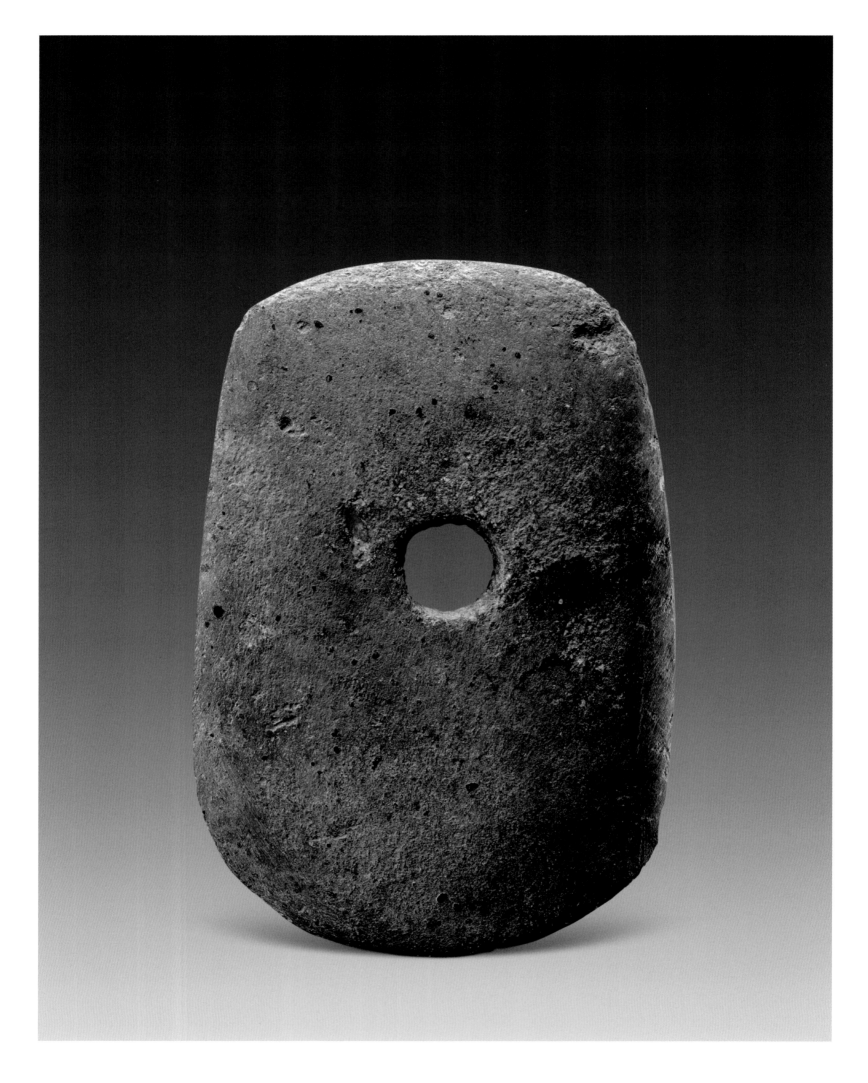

新201592
石斧
新石器时代

长34.5厘米 宽23厘米 厚2.7厘米

135 | 备注：1987年安徽省含山县凌家滩出土

Xin 201592
Stone axe
Neolithic Age

Length: 34.5 cm Width: 23 cm Thickness: 2.7 cm
*Unearthed at Lingjiatan, Hanshan County, Anhui Province
in 1987*

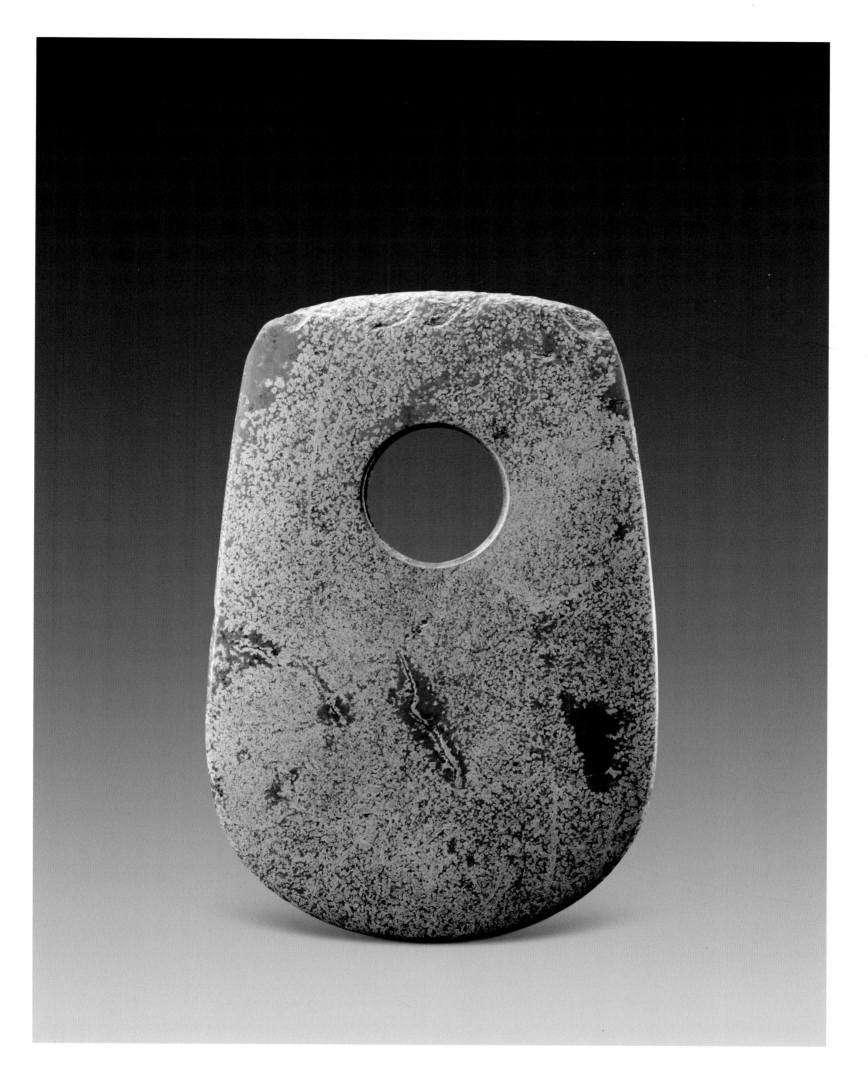

新201593

石斧
新石器时代

长20.8厘米 宽13.8厘米 厚1.3厘米

备注：1987年安徽省含山县凌家滩出土

136

Xin 201593
Stone axe
Neolithic Age

Length: 20.8 cm Width: 13.8 cm Thickness: 1.3 cm
Unearthed at Lingjiatan, Hanshan County, Anhui Province in 1987

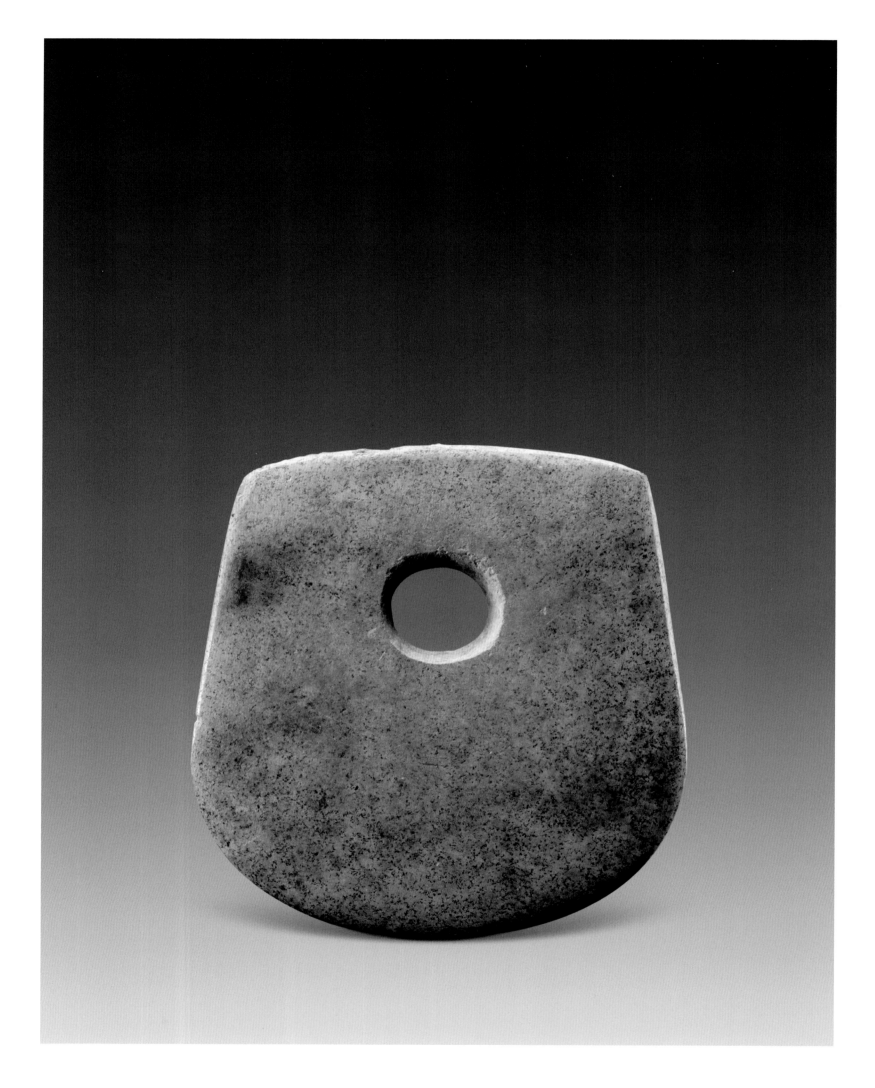

新201594
石斧
新石器时代
长18厘米　宽17.3厘米　厚1.3厘米
备注：1987年安徽省含山县凌家滩出土

137

Xin 201594
Stone axe
Neolithic Age
Length: 18 cm　Width: 17.3 cm　Thickness: 1.3 cm
Unearthed at Lingjiatan, Hanshan County,
Anhui Province in 1987

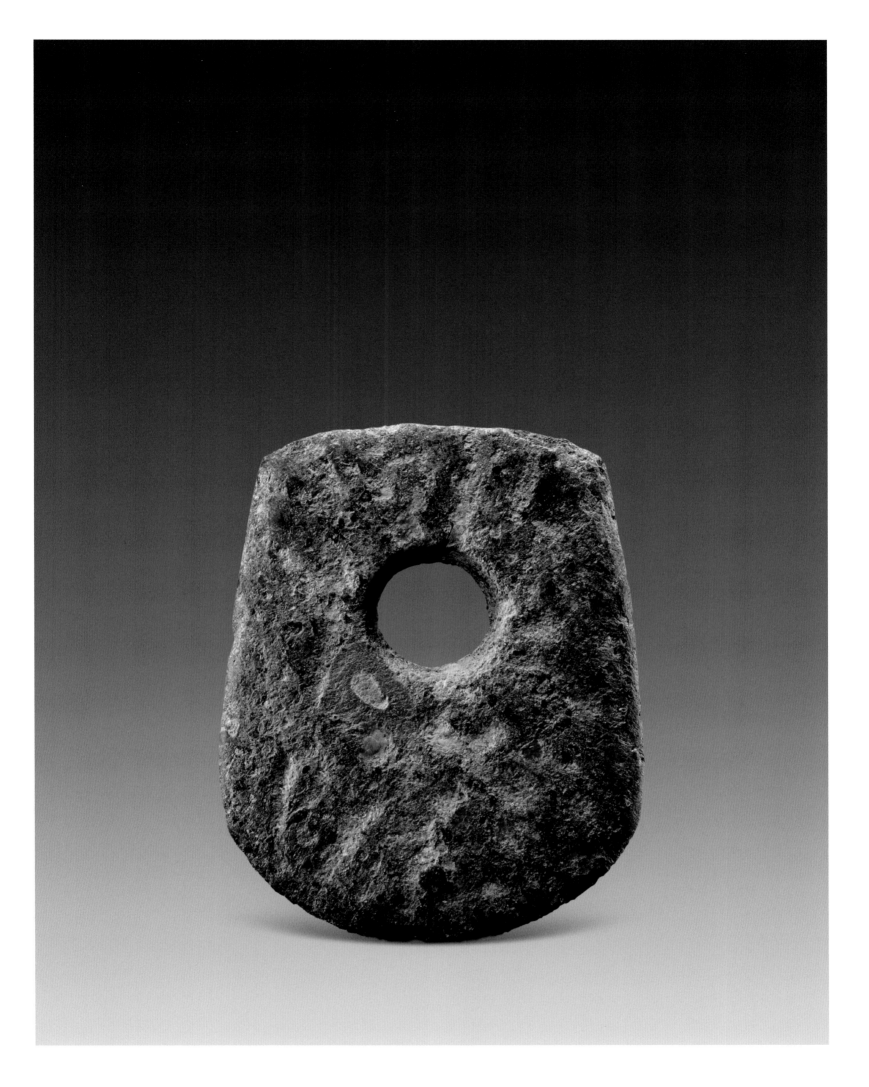

新201597
石斧
新石器时代
长18.5厘米 宽15.5厘米 厚1.7厘米
备注：1987年安徽省含山县凌家滩出土

138

Xin 201597
Stone axe
Neolithic Age
Length: 18.5 cm Width: 15.5 cm Thickness: 1.7 cm
Unearthed at Lingjiatan, Hanshan County,
Anhui Province in 1987

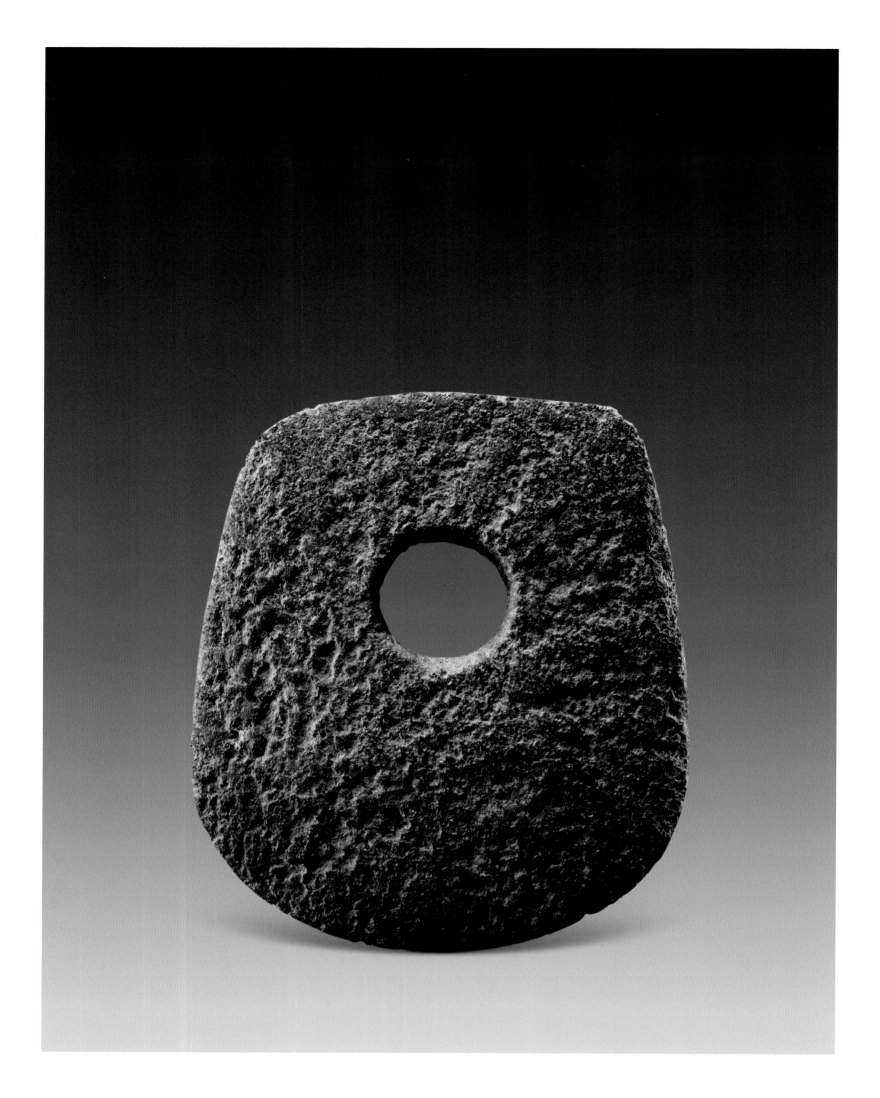

新201598
石斧
新石器时代
长18.3厘米 宽15.7厘米 厚1.6厘米
备注：1987年安徽省含山县凌家滩出土

139

Xin 201598
Stone axe
Neolithic Age
Length: 18.3 cm Width: 15.7 cm
Thickness: 1.6 cm
Unearthed at Lingjiatan, Hanshan County,
Anhui Province in 1987

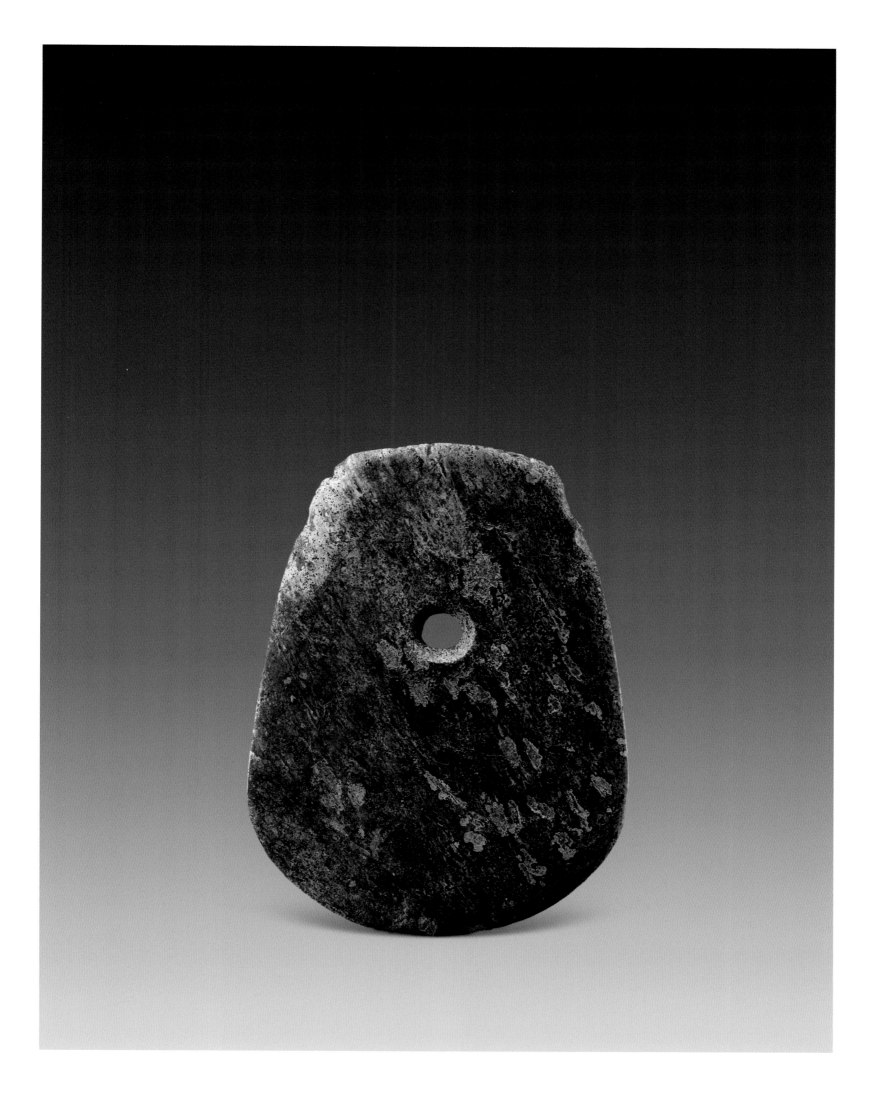

新201599

石斧
新石器时代

长15厘米 宽 11.3厘米 厚1.3厘米

备注：1987年安徽省含山县凌家滩出土

140

Xin 201599

Stone axe
Neolithic Age

Length: 15 cm Width: 11.3 cm
Thickness: 1.3 cm
Unearthed at Lingjiatan, Hanshan County,
Anhui Province in 1987

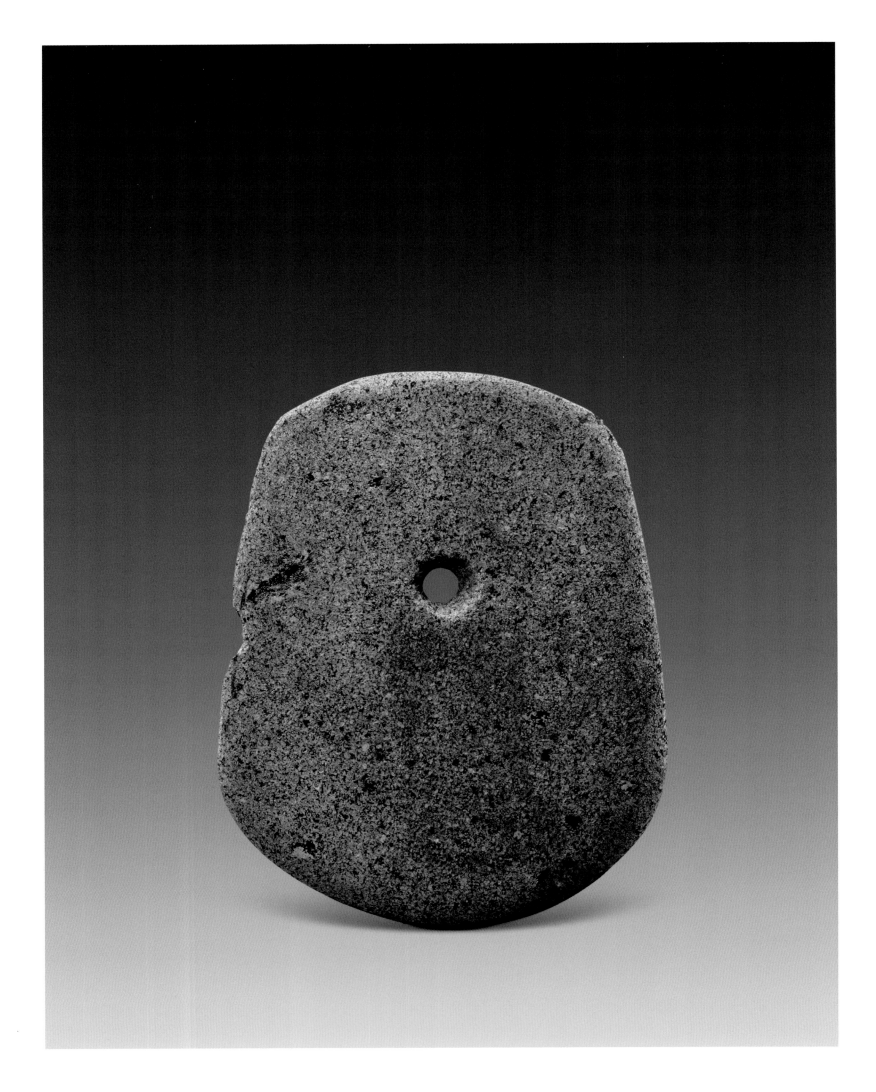

新201600
石斧
新石器时代
长19.8厘米 宽15.4厘米 厚1.2厘米
备注：1987年安徽省含山县凌家滩出土

141

Xin 201600
Stone axe
Neolithic Age
Length: 19.8 cm Width: 15.4 cm Thickness: 1.2 cm
Unearthed at Lingjiatan, Hanshan County,
Anhui Province in 1987

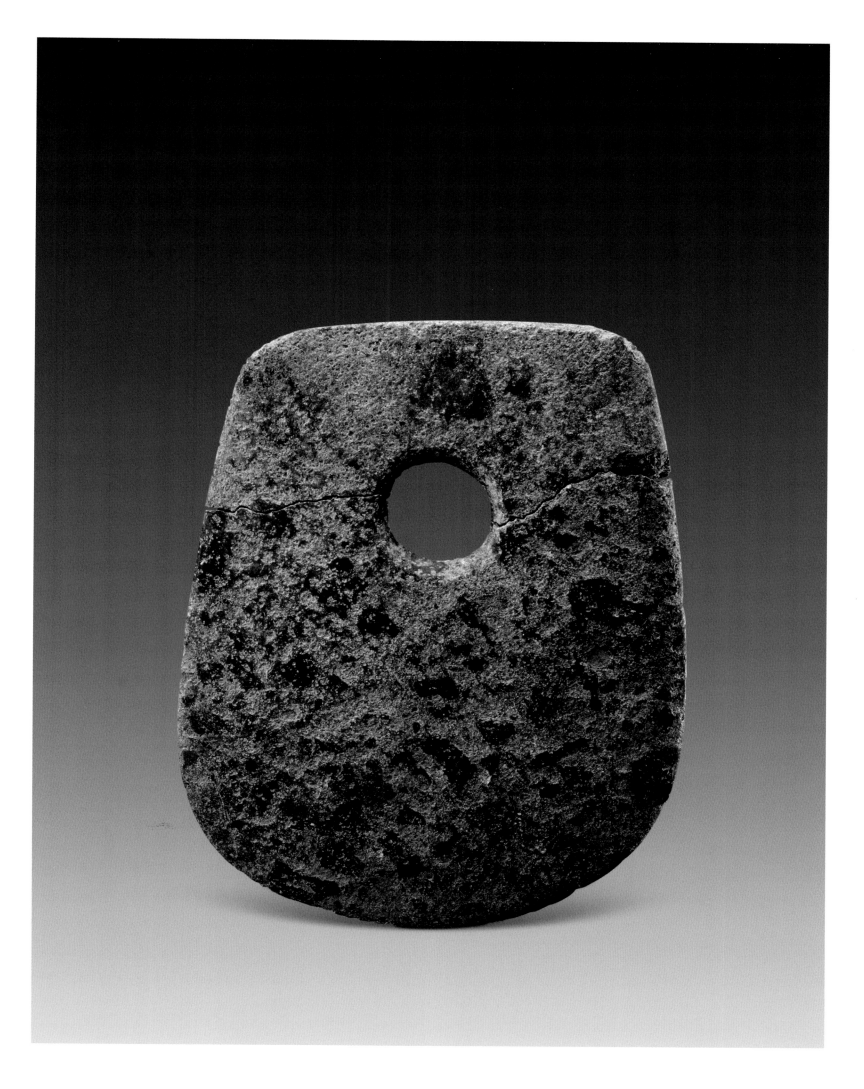

新201601

石斧
新石器时代

长24.1厘米 宽19.3厘米 厚1.5厘米

备注：1987年安徽省含山县凌家滩出土

142

Xin 201601
Stone axe
Neolithic Age

Length: 24.1 cm Width: 19.3 cm Thickness: 1.5 cm
Unearthed at Lingjiatan, Hanshan County,
Anhui Province in 1987

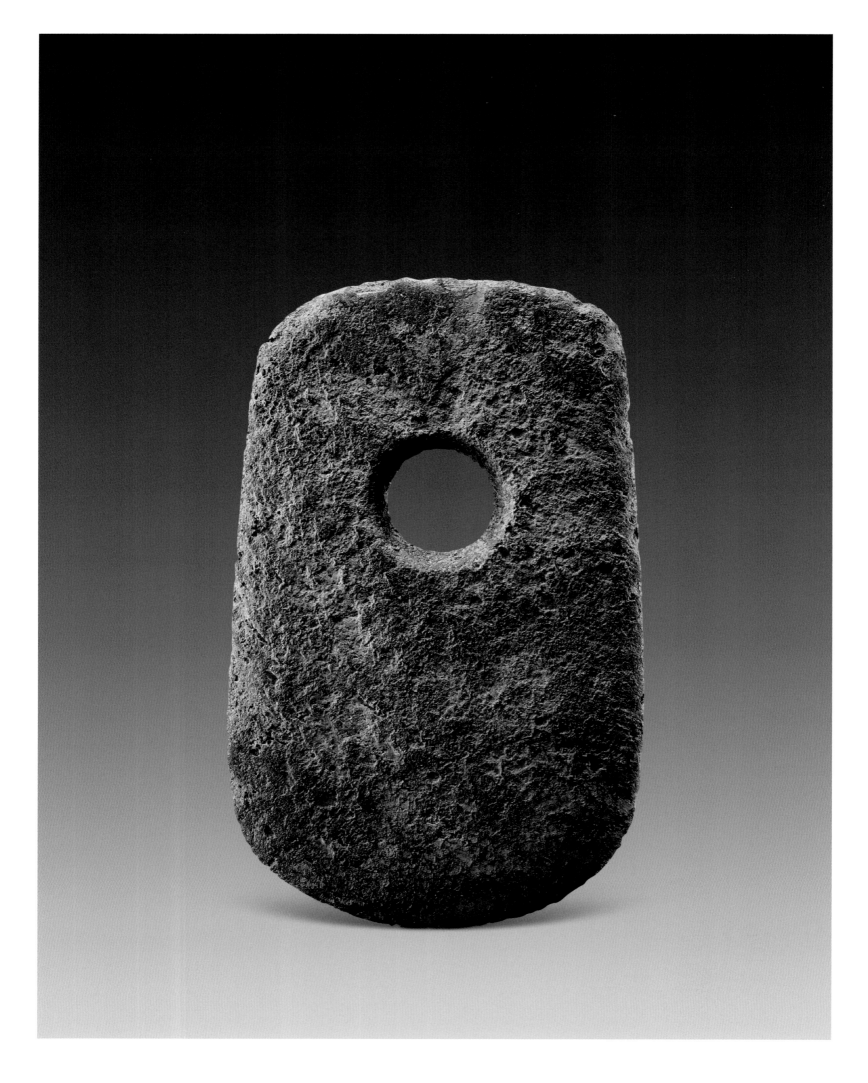

新201602

石斧
新石器时代

长21.4厘米 宽13.2厘米 厚1.4厘米

备注：1987年安徽省含山县凌家滩出土

143

Xin 201602

Stone axe
Neolithic Age

Length: 21.4 cm Width: 13.2 cm
Thickness: 1.4 cm
Unearthed at Lingjiatan, Hanshan County,
Anhui Province in 1987

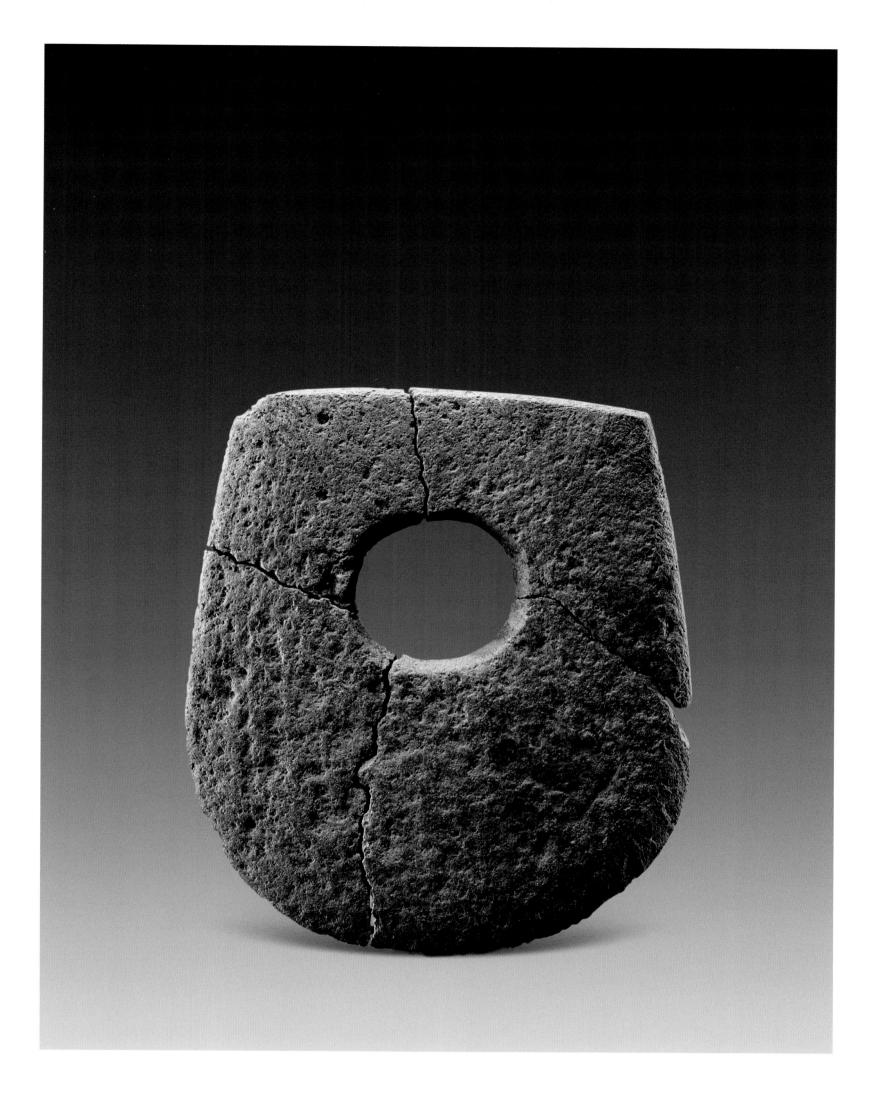

新201606

石斧
新石器时代

长19.3厘米 宽16.5厘米 厚1.5厘米

备注：1987年安徽省含山县凌家滩出土

144

Xin 201606

Stone axe
Neolithic Age

Length: 19.3 cm Width: 16.5 cm
Thickness: 1.5 cm
Unearthed at Lingjiatan, Hanshan County,
Anhui Province in 1987

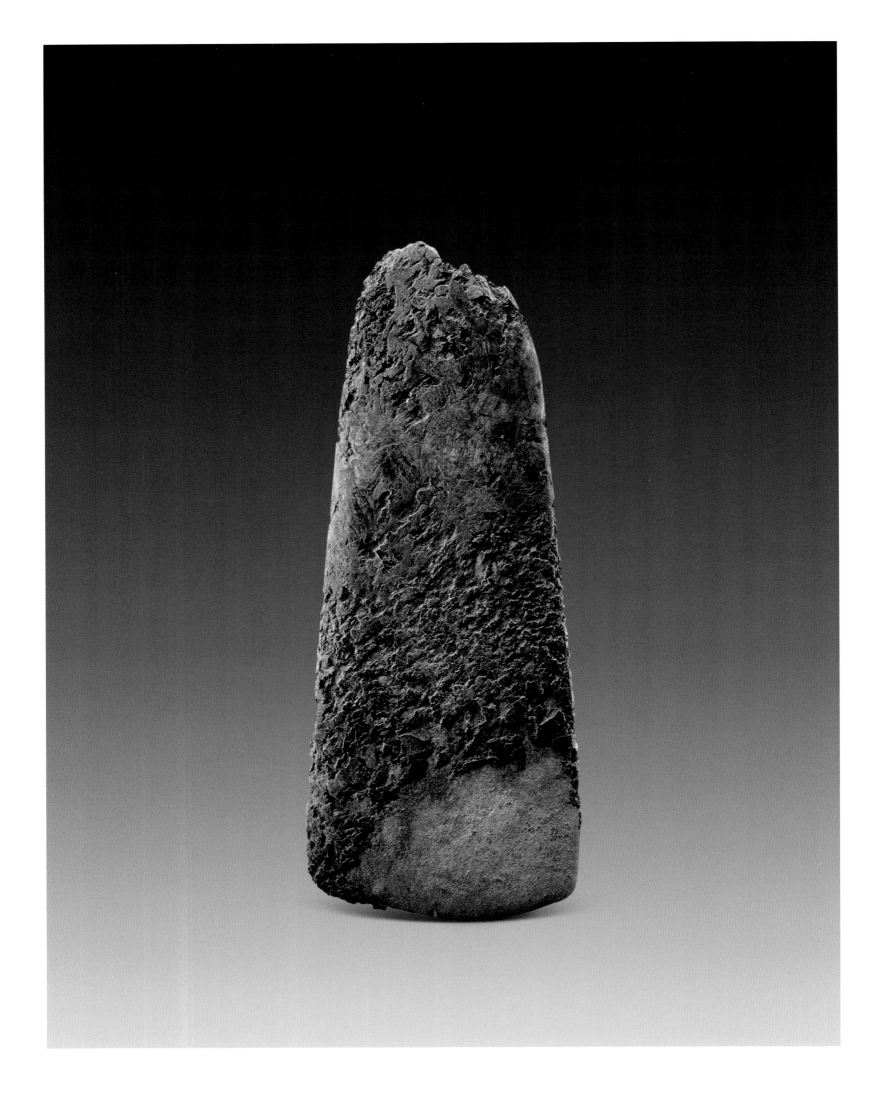

新201605

石斧
新石器时代
长22.8厘米 宽9厘米 厚0.8厘米
备注：1987年安徽省含山县凌家滩出土

145

Xin 201605
Stone axe
Neolithic Age
Length: 22.8 cm Width: 9 cm Thickness: 0.8 cm
Unearthed at Lingjiatan, Hanshan County,
Anhui Province in 1987

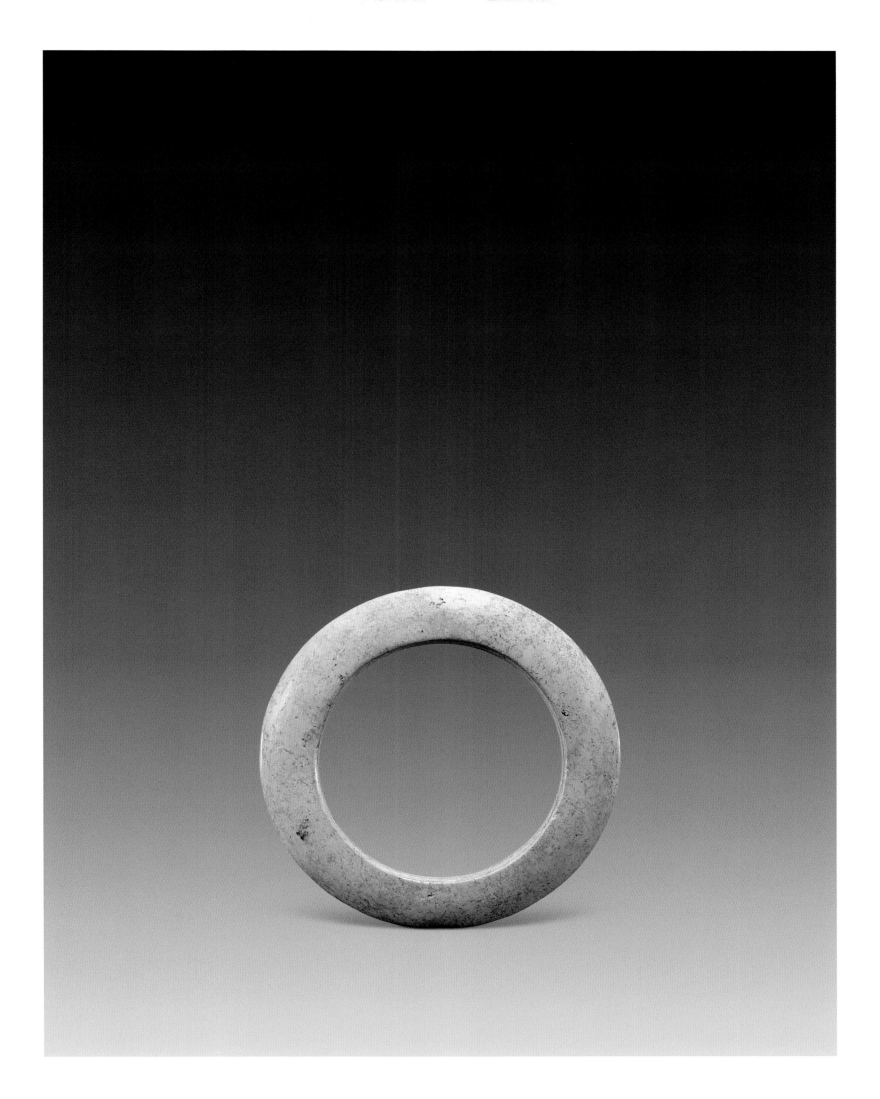

新201596
石环
新石器时代
径9.5厘米 孔径6.5厘米 厚2.3厘米
备注：1987年安徽省含山县凌家滩出土

146

Xin 201596
Stone ring
Neolithic Age
Diameter: 9.5 cm Internal diameter: 6.5 cm
Thickness: 2.3 cm
Unearthed at Lingjiatan, Hanshan County,
Anhui Province in 1987

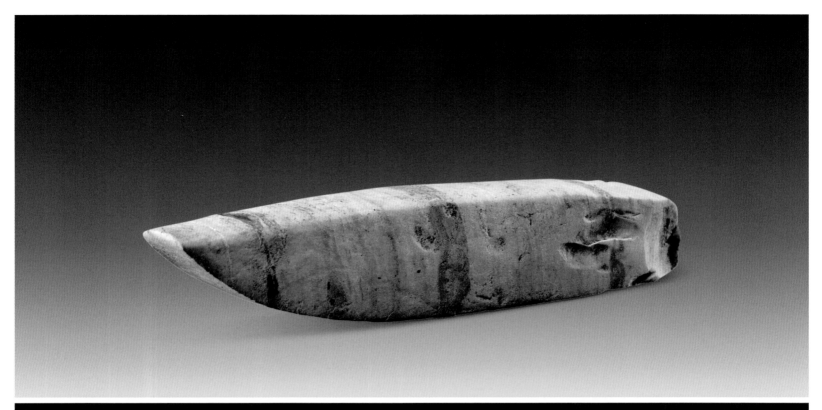

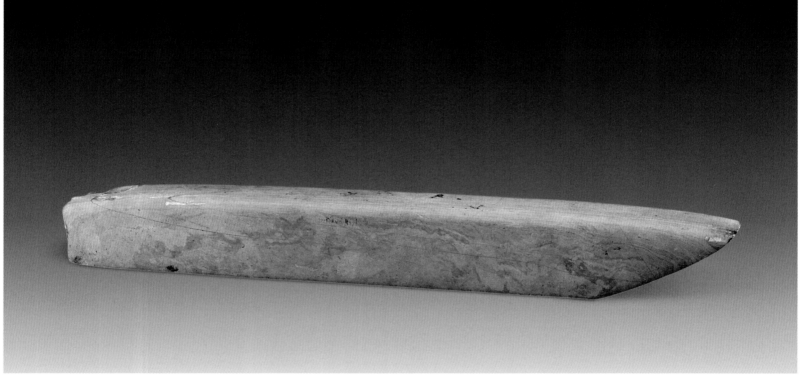

新201607

石凿
新石器时代
长14.3厘米 宽2.1厘米 厚3厘米
备注：1987年安徽省含山县凌家滩出土

147

Xin 201607
Stone chisel
Neolithic Age
Length: 14.3 cm Width: 2.1 cm
Thickness: 3 cm
Unearthed at Lingjiatan, Hanshan County,
Anhui Province in 1987

新201595

石凿
新石器时代
长30.5厘米 宽3.6厘米 厚3.8厘米
备注：1987年安徽省含山县凌家滩出土

148

Xin 201595
Stone chisel
Neolithic Age
Length: 30.5 cm Width: 3.6 cm
Thickness: 3.8 cm
Unearthed at Lingjiatan, Hanshan County,
Anhui Province in 1987

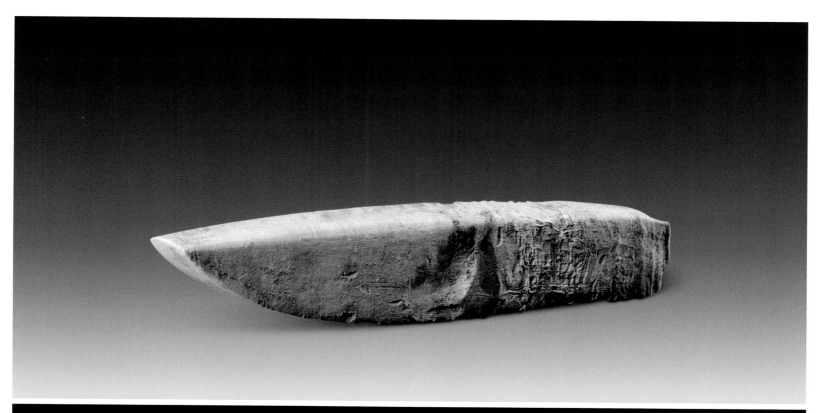

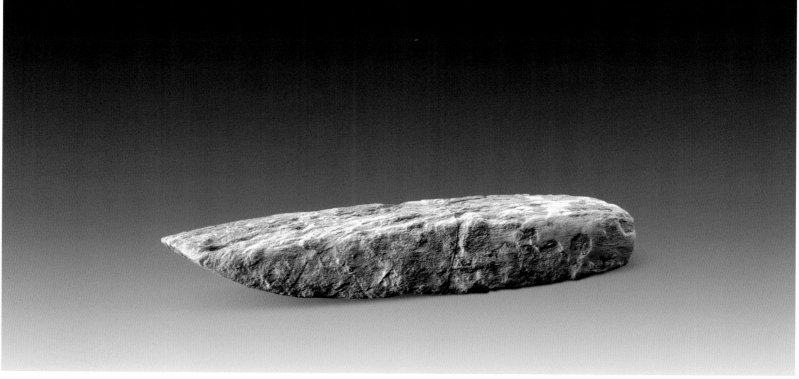

新201608
石凿
新石器时代
长13.8厘米　宽2厘米　厚2.6厘米
备注：1987年安徽省含山县凌家滩出土

149

Xin 201608
Stone chisel
Neolithic Age
Length: 13.8 cm Width: 2 cm
Thickness: 2.6 cm
Unearthed at Lingjiatan, Hanshan County,
Anhui Province in 1987

新201609
石凿
新石器时代
长 12.6厘米　宽2.5厘米　厚2厘米
备注：1987年安徽省含山县凌家滩出土

150

Xin 201609
Stone chisel
Neolithic Age
Length: 12.6 cm Width: 2.5 cm
Thickness: 2 cm
Unearthed at Lingjiatan, Hanshan County,
Anhui Province in 1987

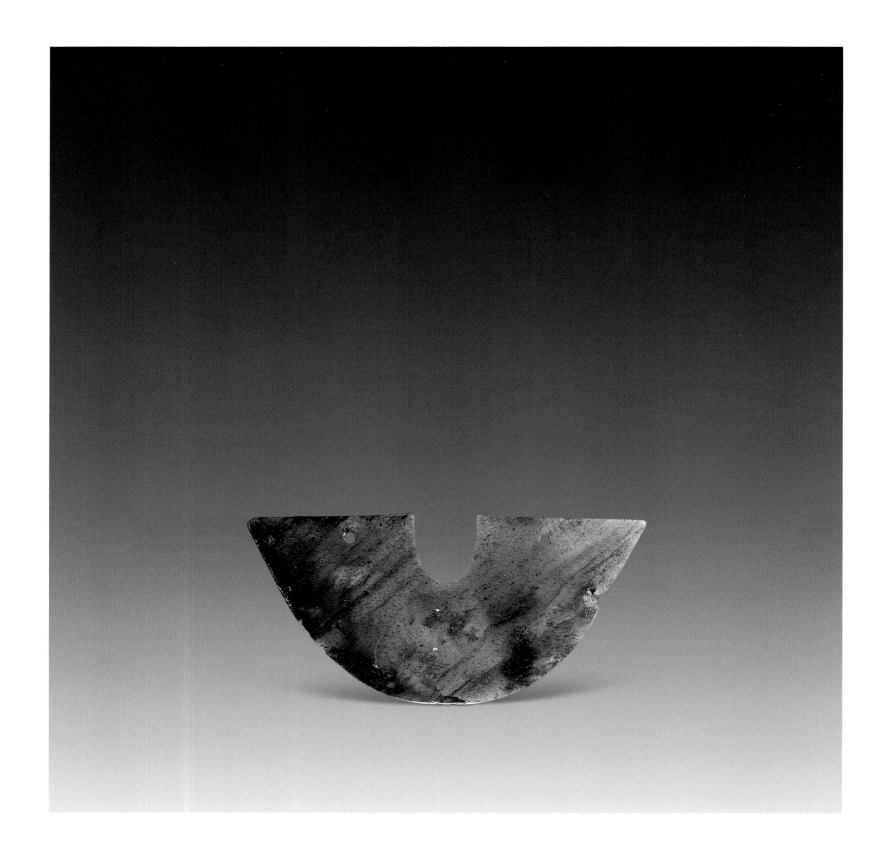

新130757

玉璜
崧泽文化

151 长10.6厘米 端宽4.4厘米 厚0.3厘米

Xin 130757
Jade Huang
Songze Culture
Length: 10.6 cm End width: 4.4 cm
Thickness: 0.3 cm

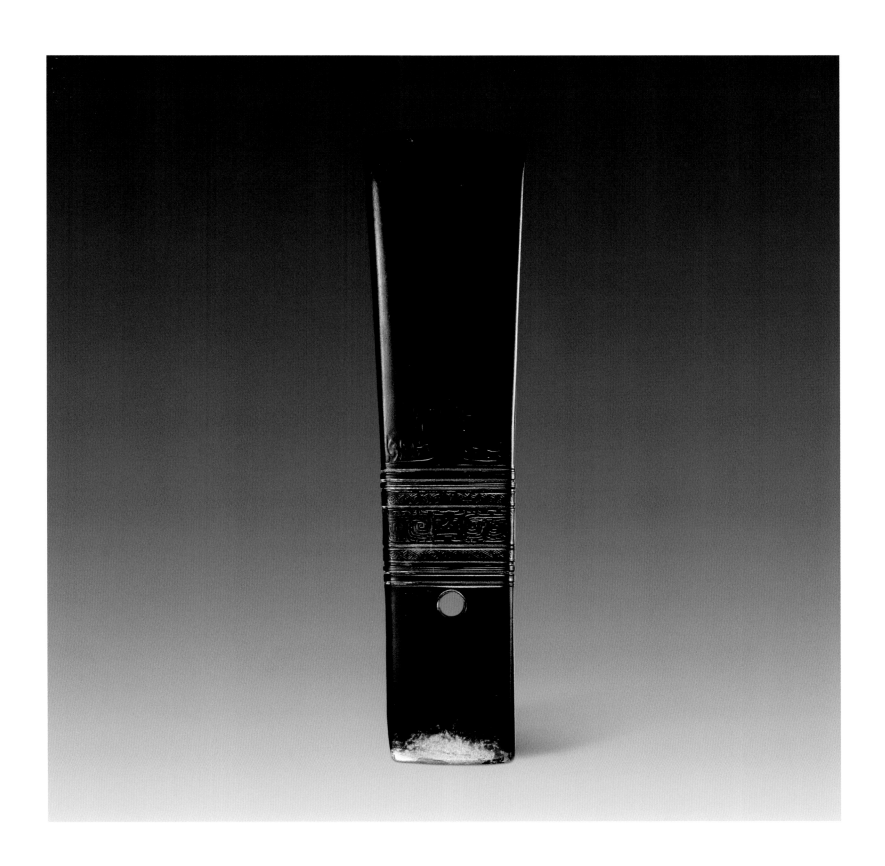

新67199
玉兽面纹圭
石家河文化

152

长21.8厘米 宽5.5厘米 厚1厘米

Xin 67199
Jade Gui with animal-face design
Shijiahe Culture
Length: 21.8 cm Width: 5.5 cm Thickness: 1 cm

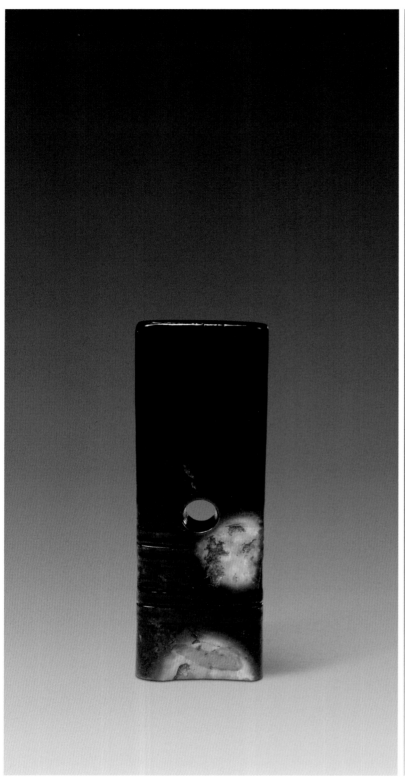

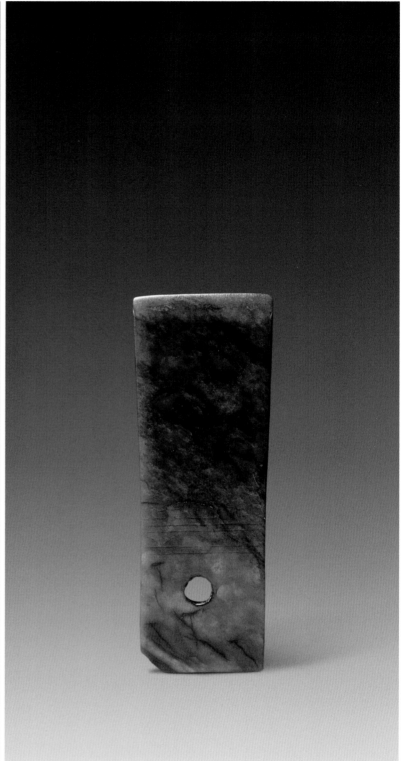

新116020

玉兽面纹圭
石家河文化

长9.9厘米 宽3.5厘米 厚0.9厘米

备注：残，青玉，表面染黑褐色

153

Xin 116020

Jade Gui with animal-face design
Shijiahe Culture

Length: 9.9 cm Width: 3.5 cm Thickness: 0.9 cm
This is a green jade incomplete object and the surface was dyed dark brown

新116021

玉鸟纹圭
石家河文化

长10.4厘米 宽3.5厘米 厚0.8厘米

154

Xin 116021

Jade Gui with bird design
Shijiahe Culture

Length: 10.4 cm Width: 3.5 cm Thickness: 0.8 cm

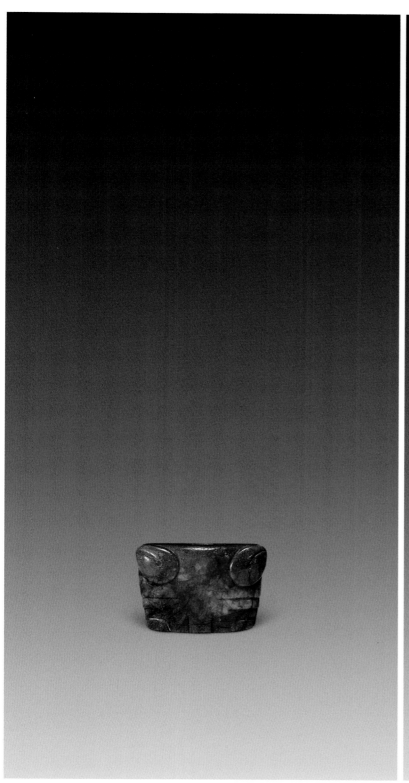

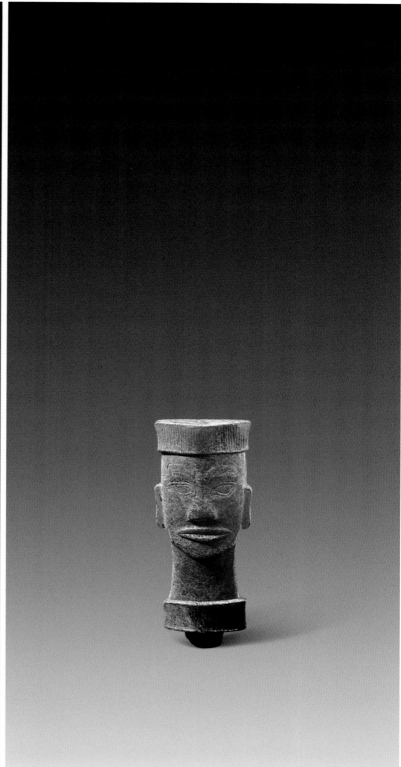

故83924

玉兽首

石家河文化

155 | 高2.5厘米　宽3.4厘米　厚1.4厘米

Gu 83924

Jade animal head

Shijiahe Culture

Height: 2.5 cm　Width: 3.4 cm
Thickness: 1.4 cm

新141652

玉人首

石家河文化

156 | 高6.3厘米　宽2.6厘米　厚0.7厘米

Xin 141652

Jade human head

Shijiahe Culture

Height: 6.3 cm　Width: 2.6 cm
Thickness: 0.7 cm

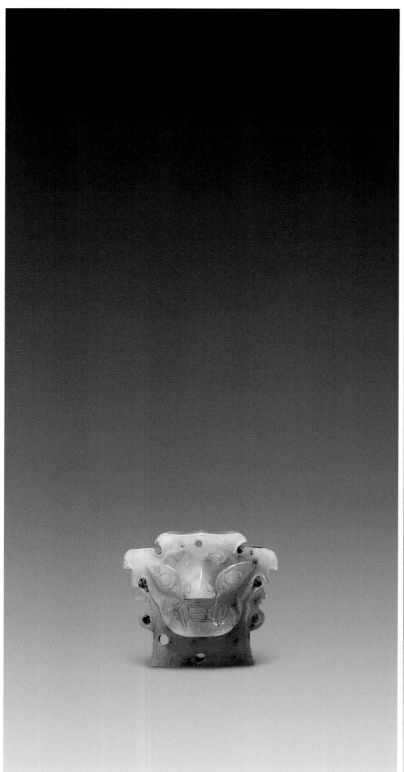

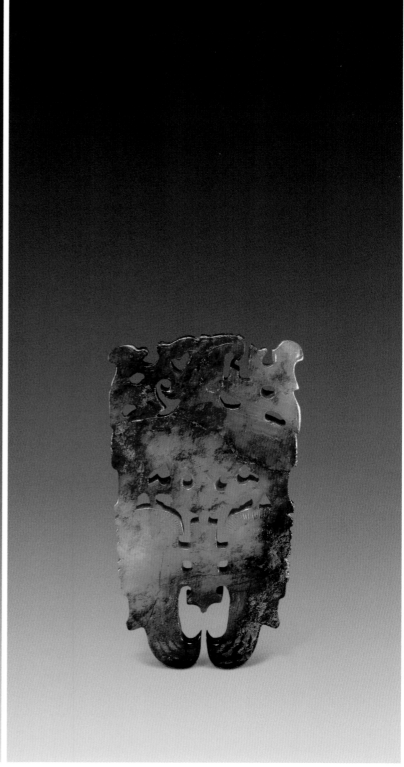

新200405

玉人首
石家河文化

157 高3.7厘米 宽4.2厘米 厚1.7厘米

Xin 200405

Jade human head
Shijiahe Culture

Height: 3.7 cm Width: 4.2 cm
Thickness: 1.7 cm

故103950

玉鹰攫人首佩
石家河文化

158 长9.1厘米 宽5.2厘米 厚0.9厘米

Gu 103950

Jade pendant with an eagle
grabbing human head
Shijiahe Culture

Length: 9.1 cm Width: 5.2 cm
Thickness: 0.9 cm

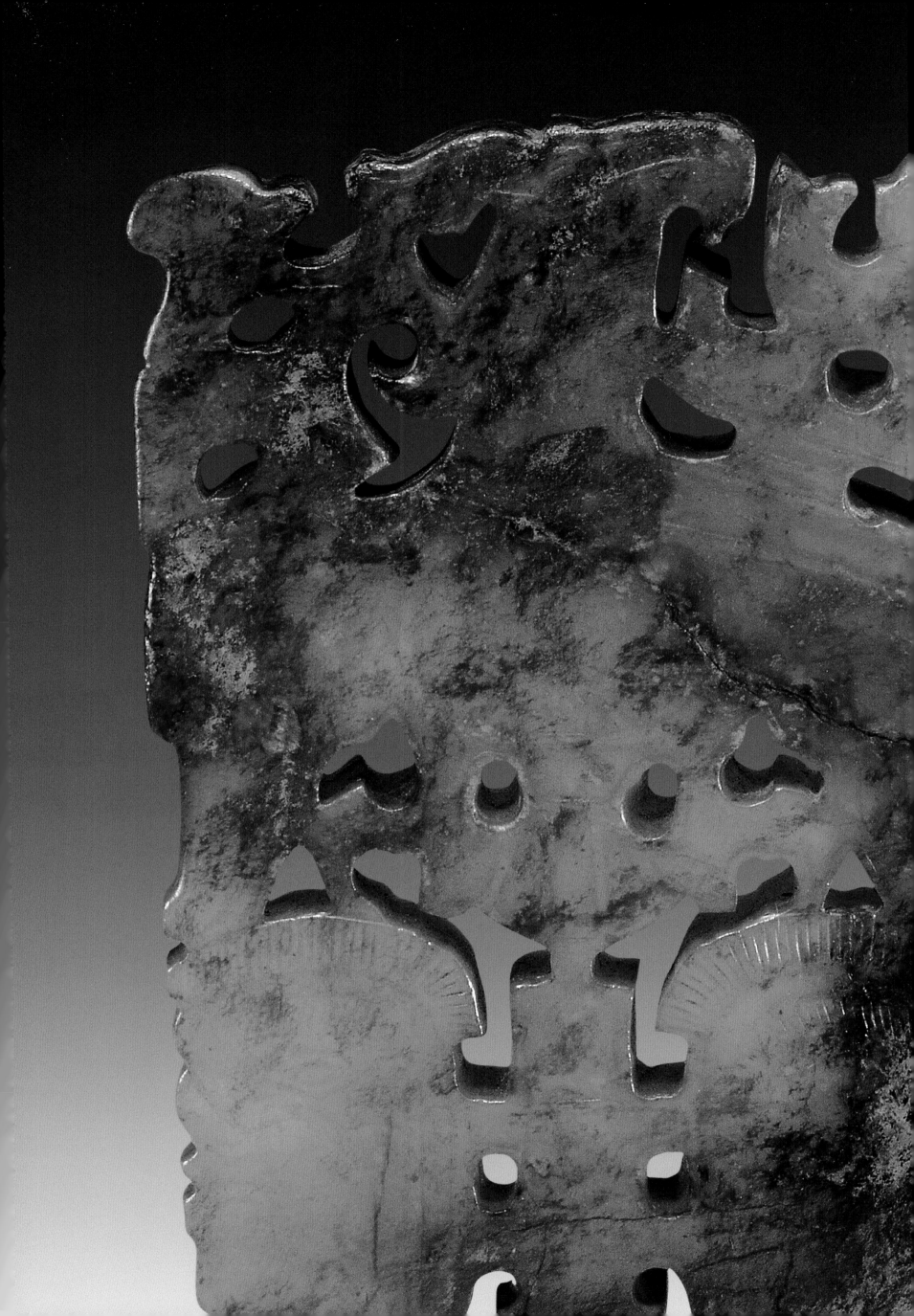

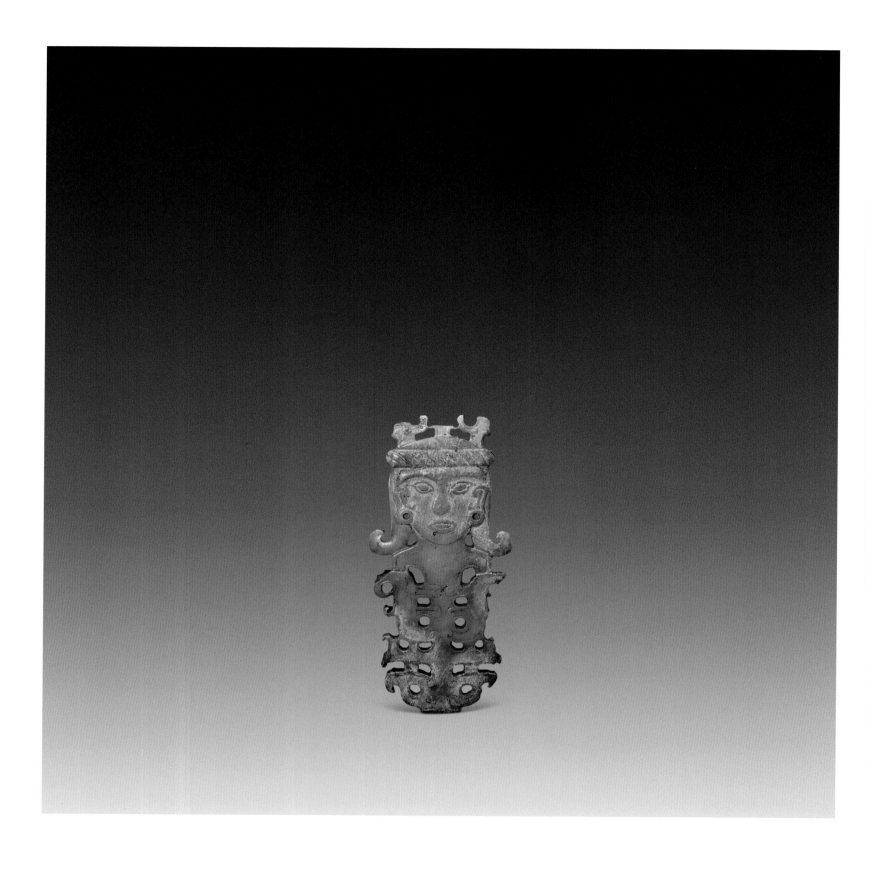

新141917
玉女人佩
石家河文化

159 长8.2厘米　宽4厘米　厚0.6厘米

Xin 141917
Jade pendant with female
figure
Shijiahe Culture
Length: 8.2 cm　Width: 4 cm
Thickness: 0.6 cm

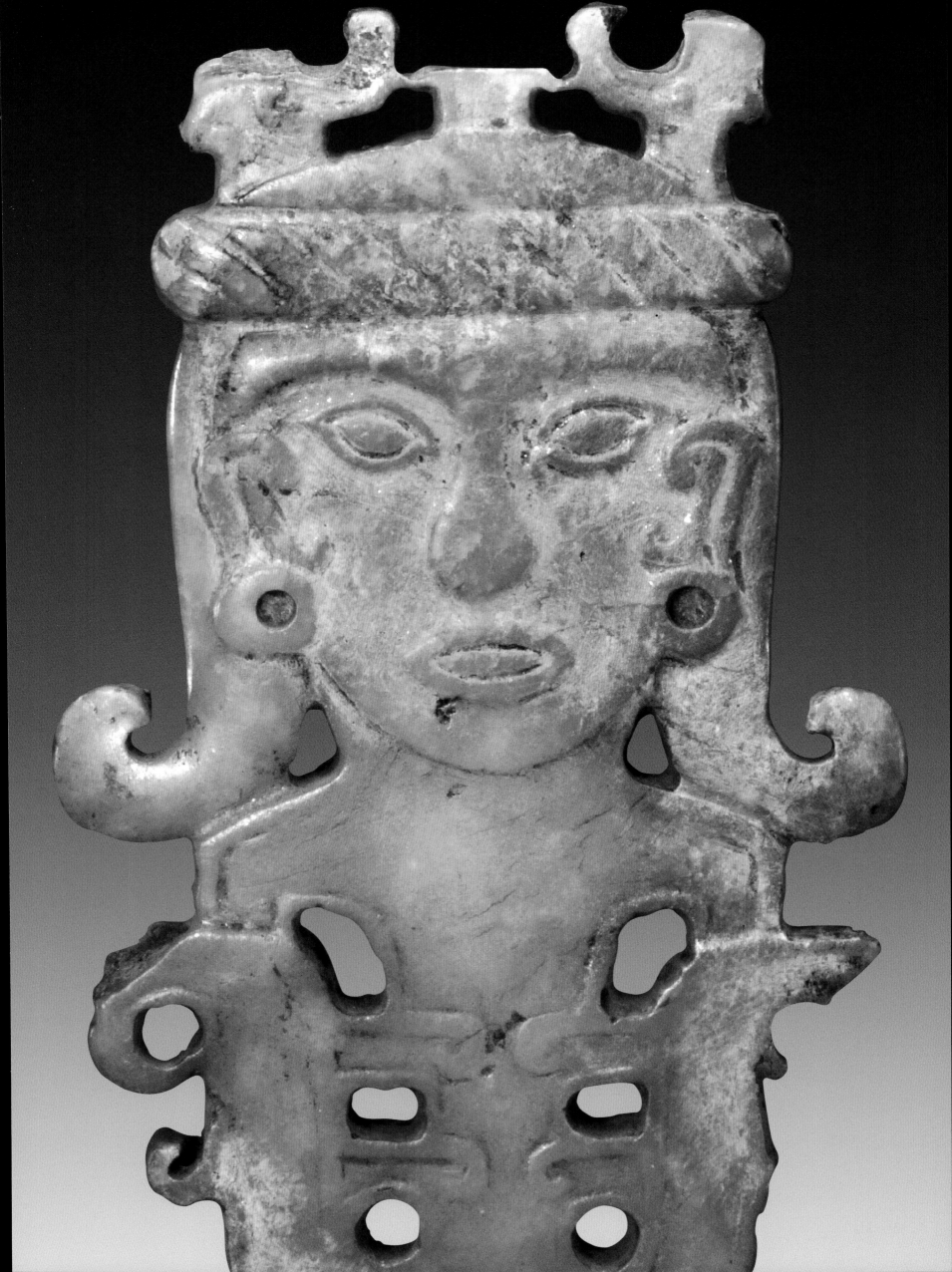

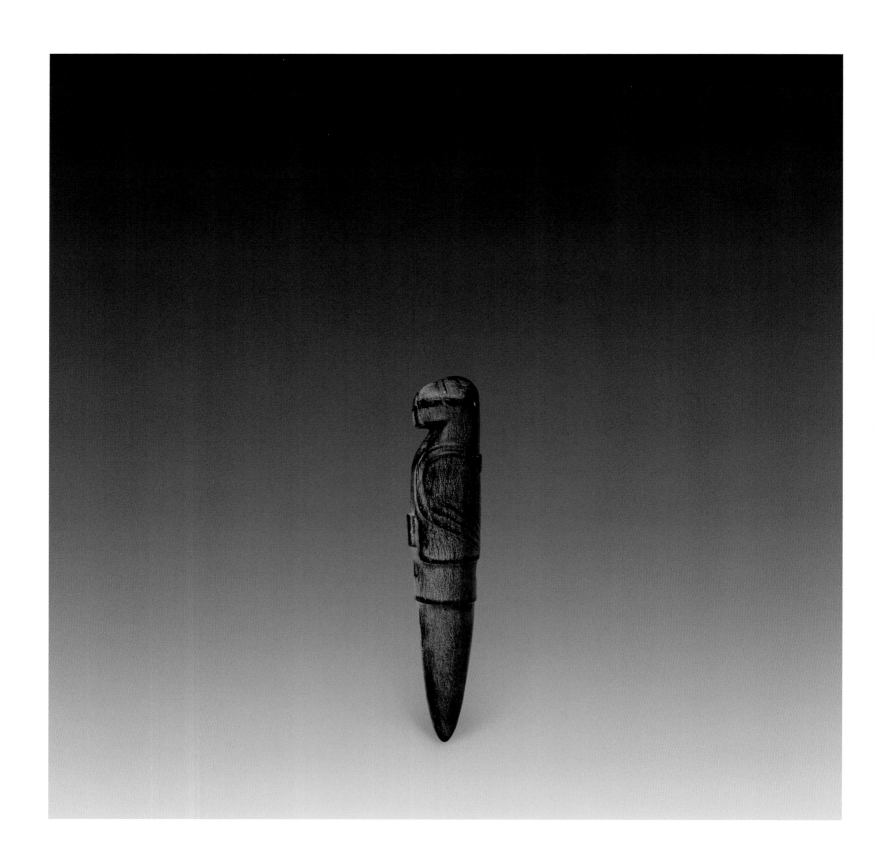

新150439
玉鸟纹觿
石家河文化
长9.9厘米　径1.9×1.8厘米

160

Xin 150439
Jade Xi with bird design
Shijiahe Culture
Length: 9.9 cm　Diameter: 1.9×1.8 cm

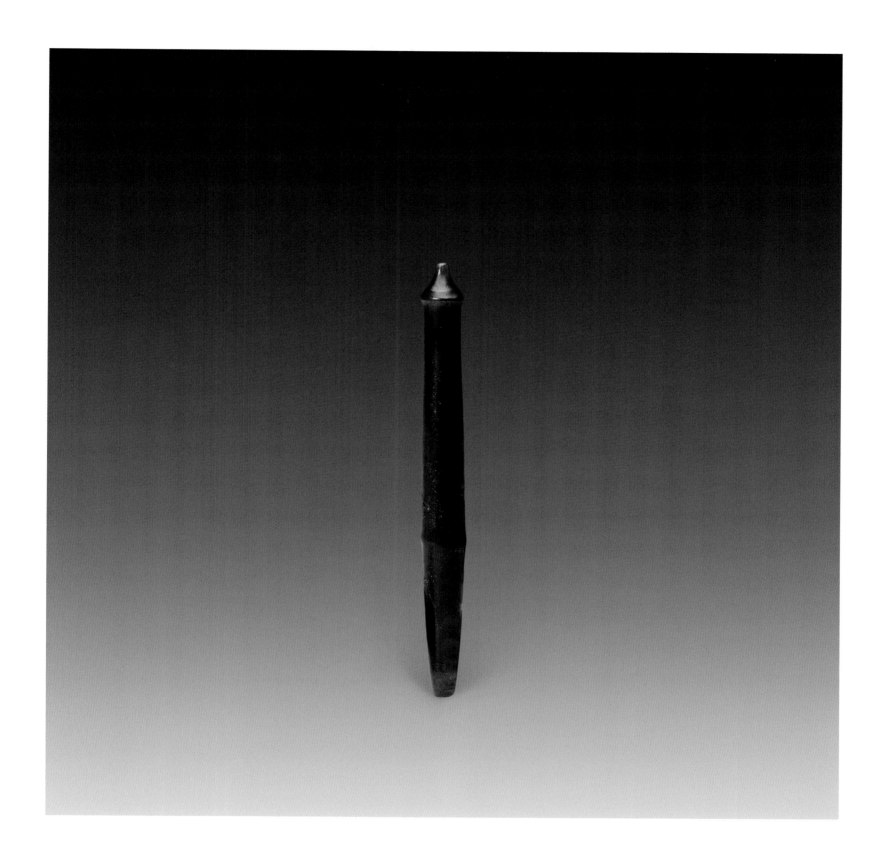

新131771
玉锥形器
石家河文化
长11.9厘米

161

Xin 131771
Awl-shaped jade object
Shijiahe Culture
Length: 11.9 cm

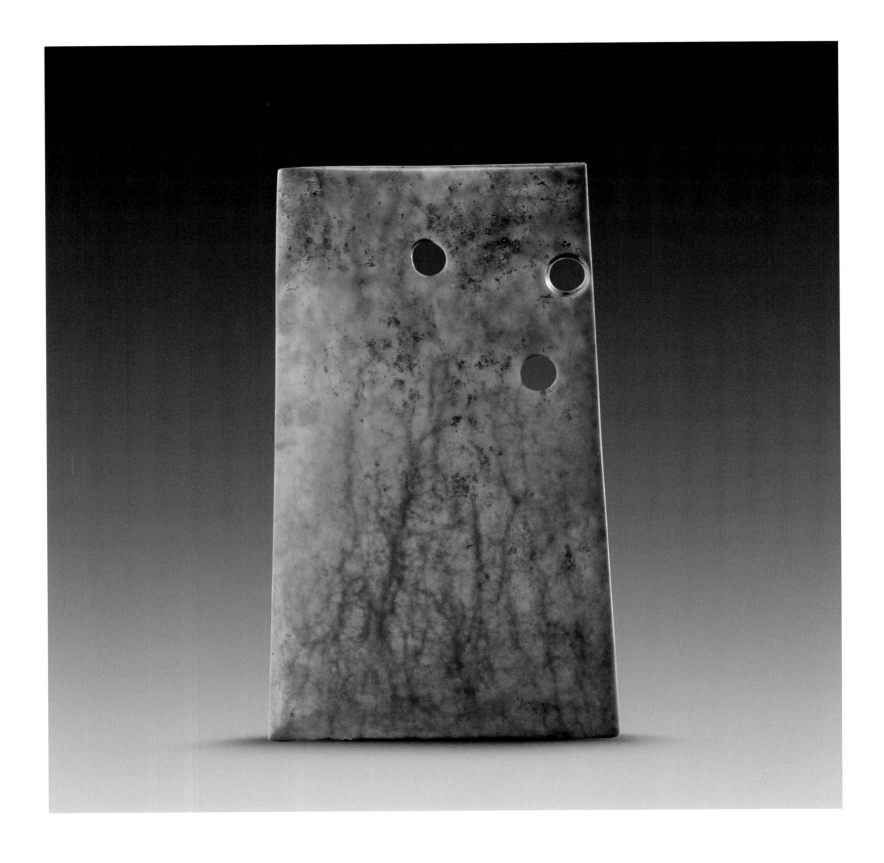

新74881
玉铲
大汶口文化
长26.7厘米 宽16.1厘米 厚0.9厘米

162

Xin 74881
Jade spade
Dawenkou Culture
Length: 26.7 cm Width: 16.1 cm
Thickness: 0.9 cm

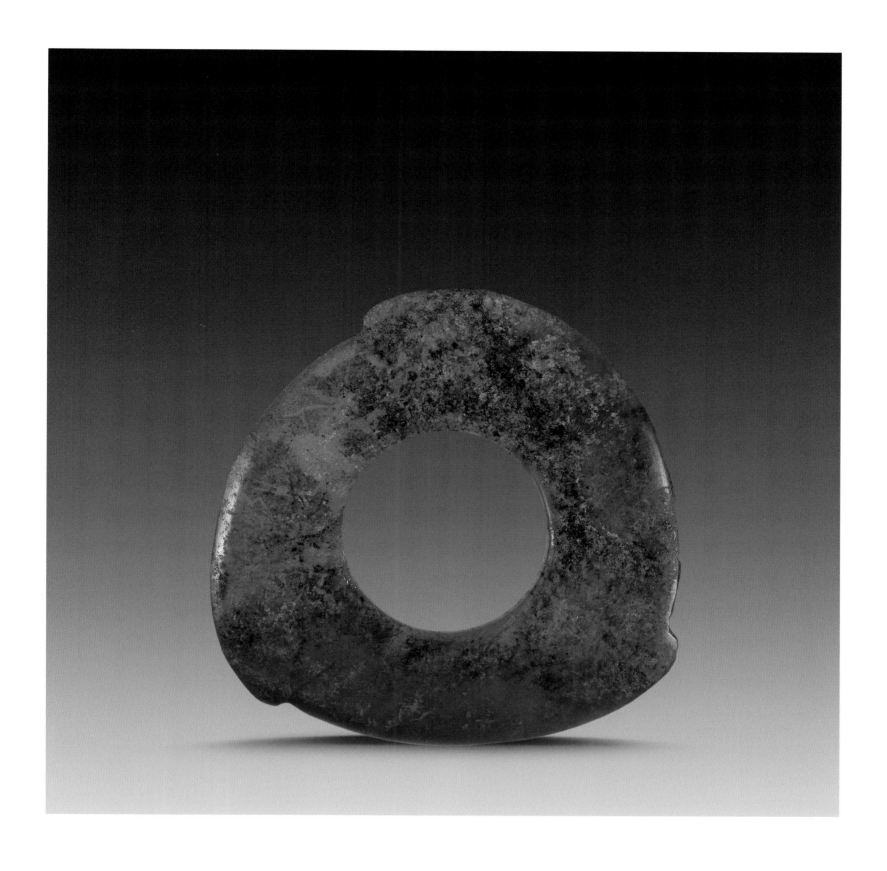

新143646
玉璇玑
大汶口文化

163 径15.8厘米 孔径6.6厘米 厚0.6厘米

Xin 143646
Jade Xuanji
Dawenkou Culture
Diameter: 15.8 cm Internal diameter: 6.6 cm
Thickness: 0.6 cm

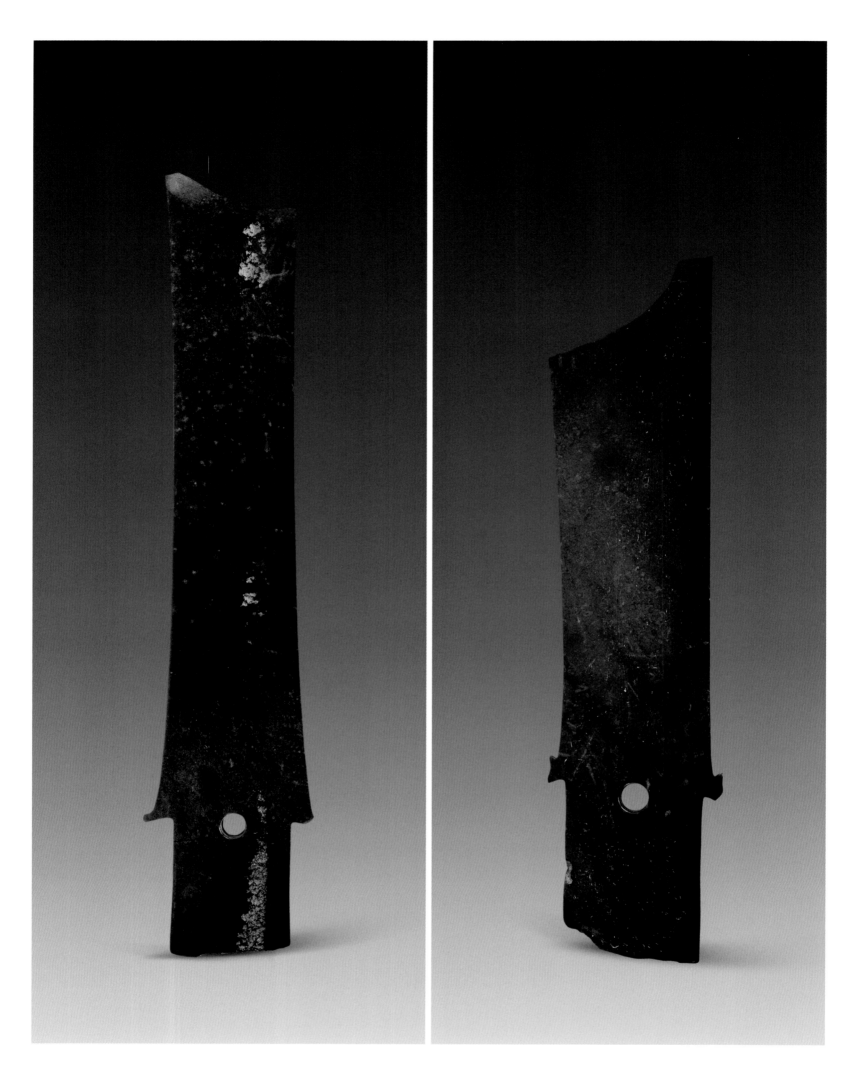

新125945
玉牙璋
陕西龙山文化
长27.3厘米 宽5.6厘米 厚0.6厘米
Xin 125945

164

Jade Yazhang
Longshan Culture of Shaanxi
Length: 27.3 cm Width: 5.6 cm
Thickness: 0.6 cm

新63141
玉牙璋
陕西龙山文化
长24.8厘米 宽5.5厘米 厚0.2厘米
备注：断、残
Xin 63141

165

Jade Yazhang
Longshan Culture of Shaanxi
Length: 24.8 cm Width: 5.5 cm
Thickness: 0.2 cm
Incomplete

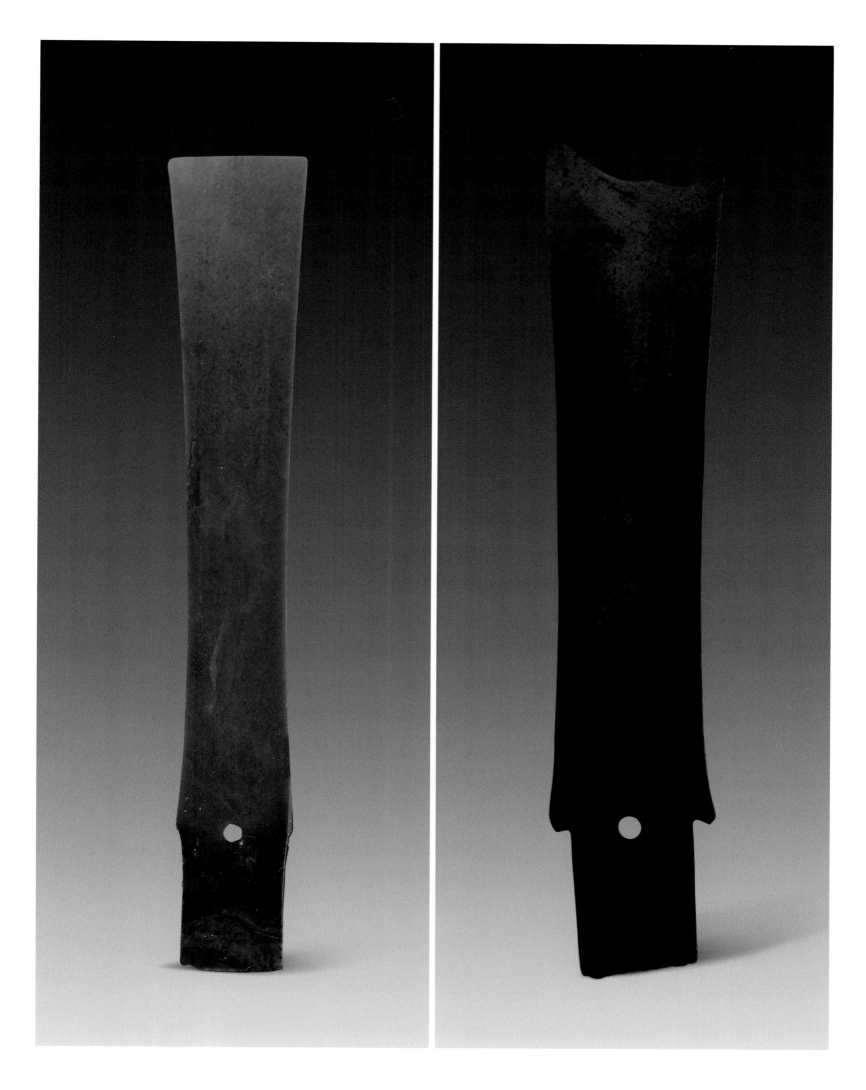

新74869
玉牙璋
陕西龙山文化

166 | 长31.8厘米 宽5.3厘米 厚0.8厘米

Xin 74869
Jade Yazhang
Longshan Culture of Shaanxi
Length: 31.8 cm Width: 5.3 cm
Thickness: 0.8 cm

新178341
玉牙璋
龙山文化

167 | 长33.5厘米 宽7厘米 厚0.2厘米
备注：局部后改动

Xin 178341
Jade Yazhang
Longshan Culture
Length: 33.5 cm Width: 7 cm
Thickness: 0.2 cm
Partly re-shaped

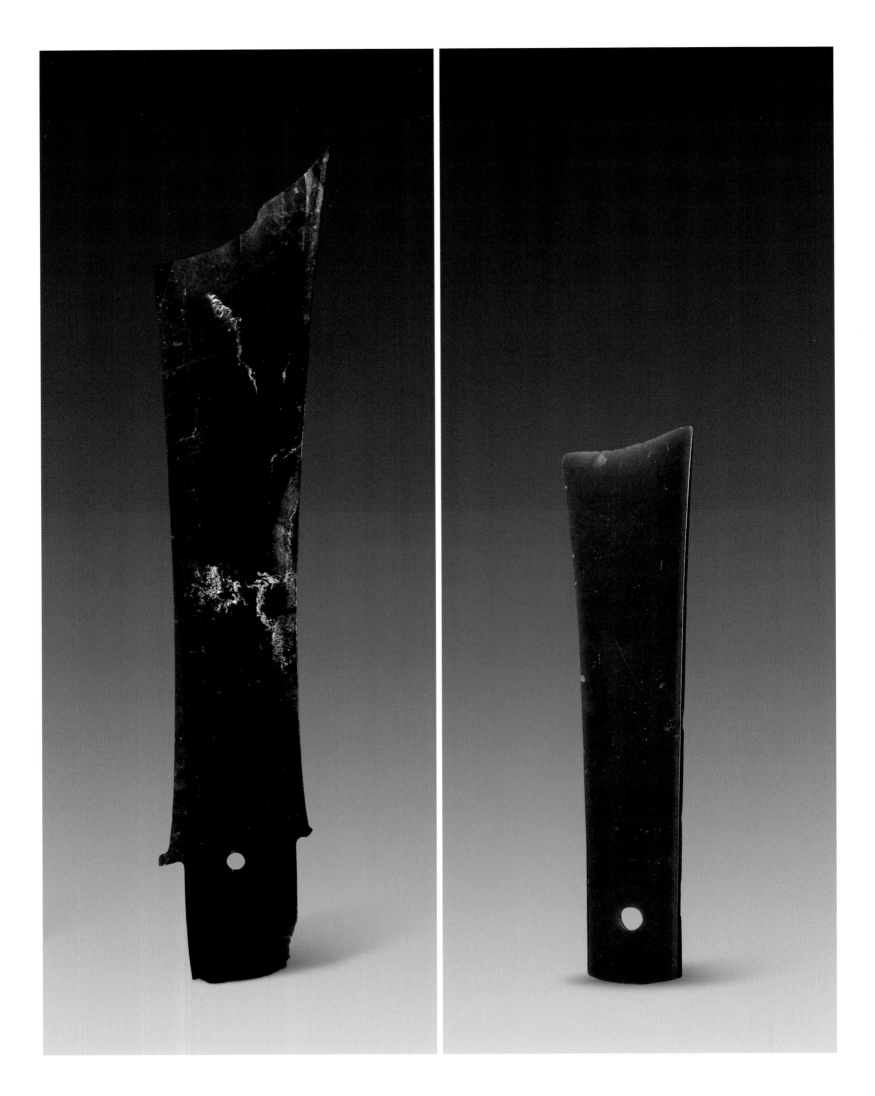

新178342

玉牙璋
龙山文化

长40.7厘米 宽9厘米 厚0.2厘米

备注：局部后改动

168

Xin 178342

Jade Yazhang
Longshan Culture

Length: 40.7 cm Width: 9 cm
Thickness: 0.2 cm
Partly re-shaped

新150246

玉璋
龙山文化

长18.2厘米 宽4.5厘米 厚0.6厘米

169

Xin 150246

Jade Zhang
Longshan Culture

Length: 18.2 cm Width: 4.5 cm
Thickness: 0.6 cm

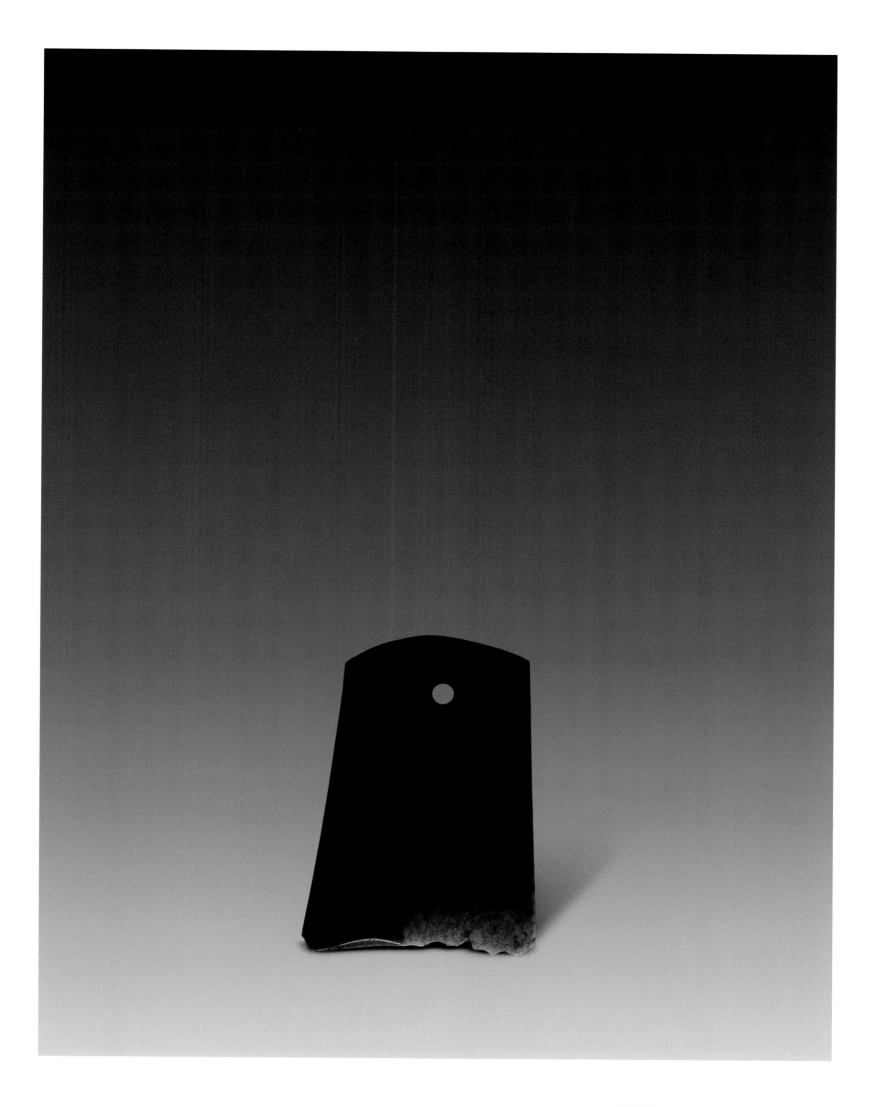

新141540

玉斧
陕西龙山文化

长9厘米　宽6.3厘米　厚0.2厘米

备注：后改动

170

Xin 141540

Jade axe
Longshan Culture of Shaanxi

Length: 9 cm　Width: 6.3 cm
Thickness: 0.2 cm
Re-shaped

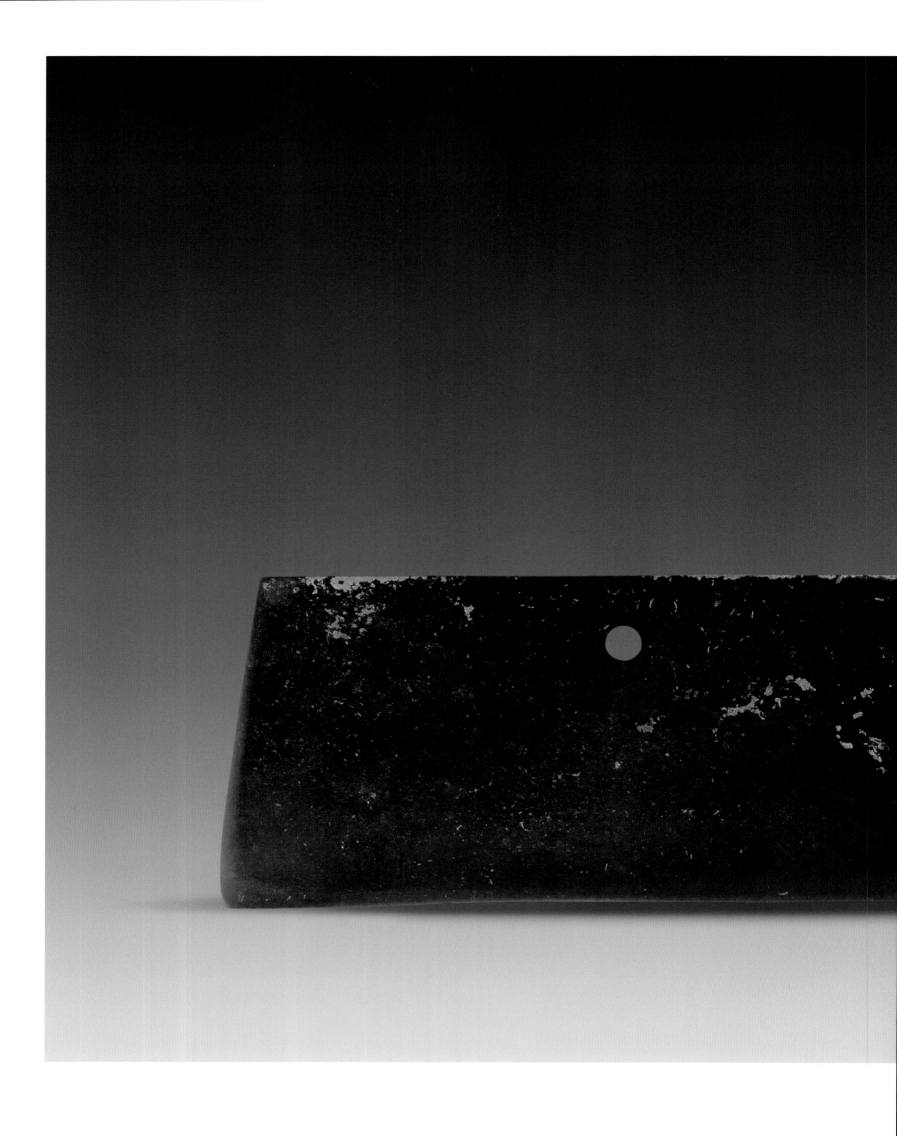

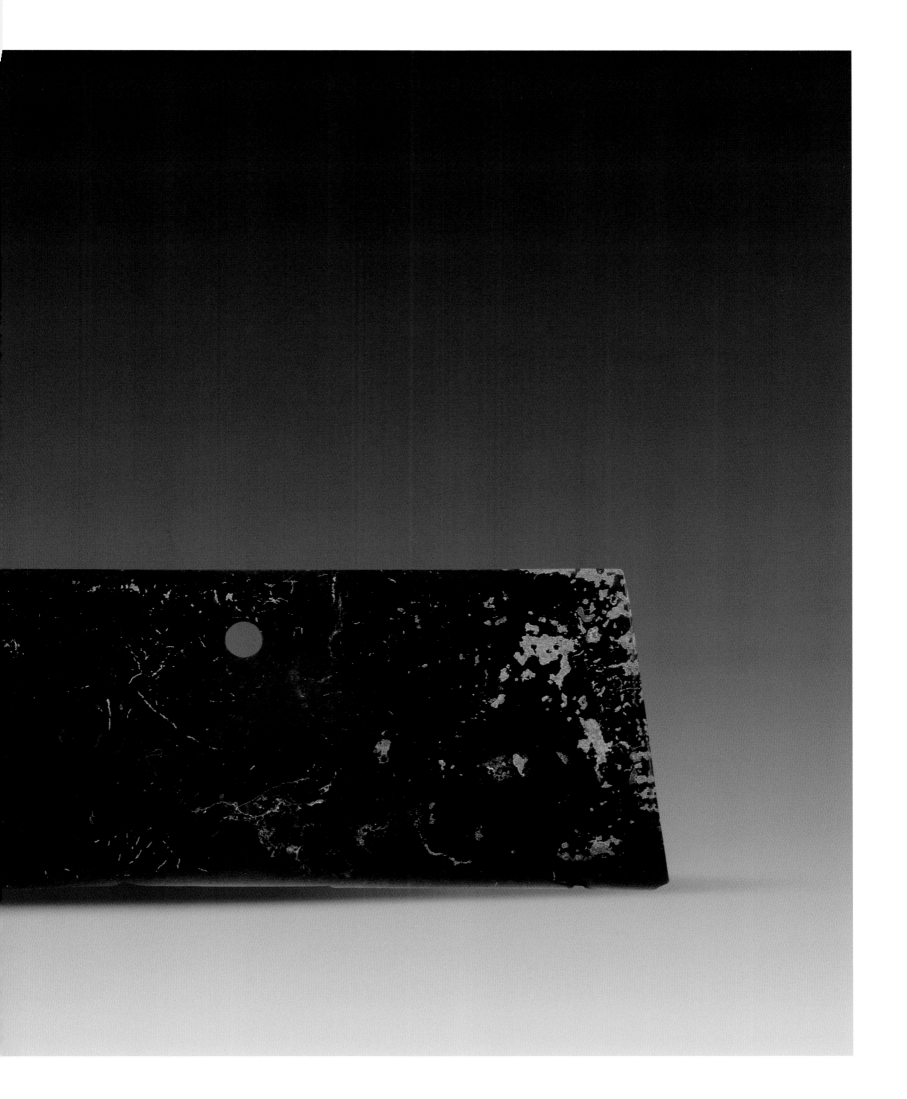

新51689

玉二孔刀
陕西龙山文化

171

长37.5厘米 宽9.2厘米 厚0.2厘米

Xin 51689

Jade knife with two holes
Longshan Culture of Shaanxi

Length: 37.5 cm Width: 9.2 cm
Thickness: 0.2 cm

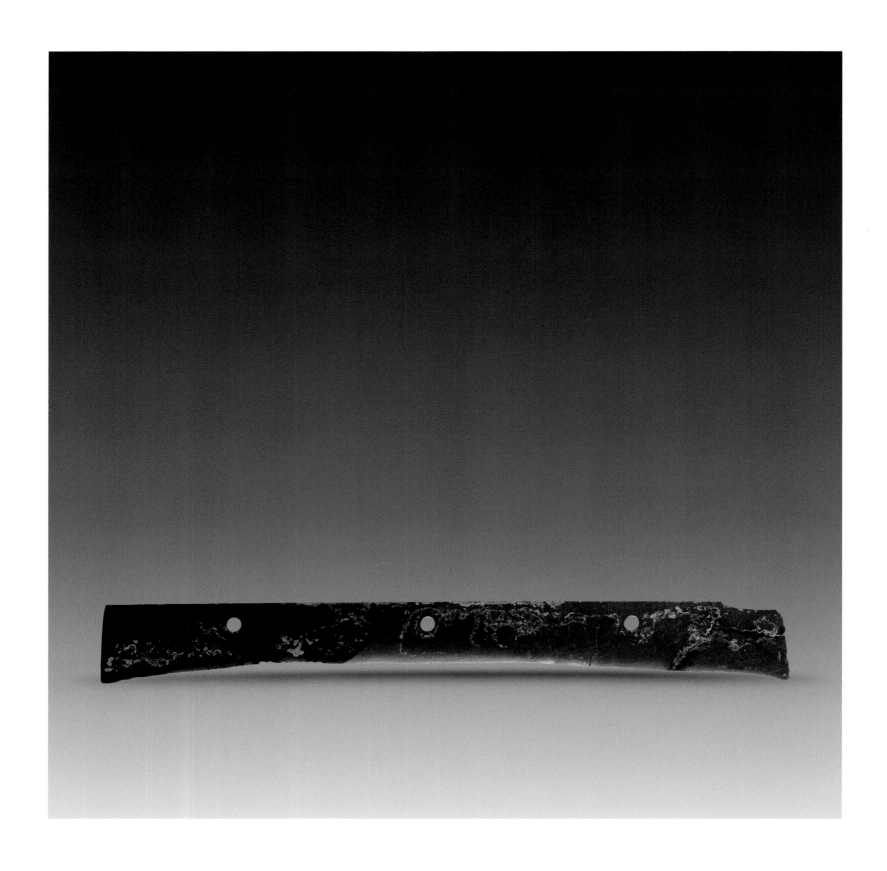

新51684

玉三孔刀
陕西龙山文化

172 长48.8厘米　端宽5.9厘米　厚0.1厘米

Xin 51684

Jade knife with three holes
Longshan Culture of Shaanxi

Length: 48.8 cm　End width: 5.9 cm
Thickness: 0.1 cm

新51690

玉三孔刀
陕西龙山文化

173 长34.6厘米　端宽9.1厘米　厚0.1厘米

Xin 51690

Jade knife with three holes
Longshan Culture of Shaanxi

Length: 34.6 cm　End width: 9.1 cm
Thickness: 0.1 cm

新51685
玉四孔刀
陕西龙山文化

174 长32.3厘米 宽6.6厘米 厚0.1厘米

Xin 51685
Jade knife with four holes
Longshan Culture of Shaanxi
Length: 32.3 cm Width: 6.6 cm
Thickness: 0.1 cm

新51688

玉四孔刀
陕西龙山文化

长47.6厘米　宽7.2厘米

175

Xin 51688
Jade knife with four holes
Longshan Culture of Shaanxi
Length: 47.6 cm Width: 7.2 cm

新123415

玉五孔刀
陕西龙山文化

176 长50.1厘米 宽8.5厘米 厚0.4厘米

Xin 123415

Jade knife with five holes
Longshan Culture of Shaanxi

Length: 50.1 cm Width: 8.5 cm
Thickness: 0.4 cm

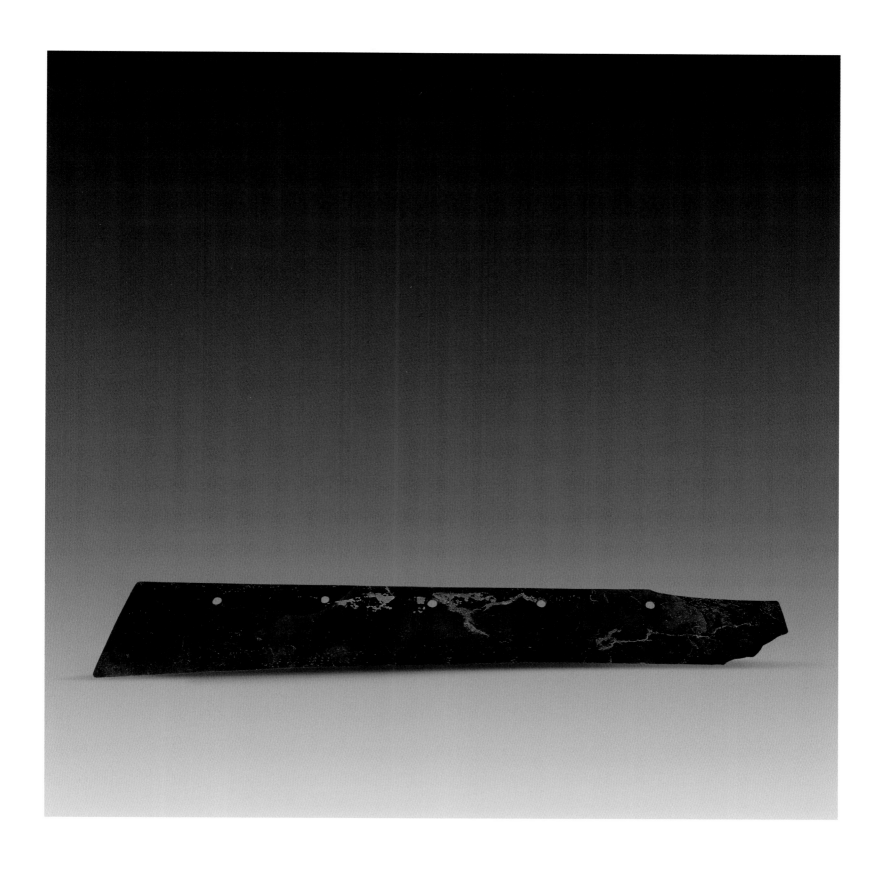

新51682
玉五孔刀
陕西龙山文化

177 长78.7厘米　宽12.8厘米　厚0.3厘米

Xin 51682
Jade knife with five holes
Longshan Culture of Shaanxi
Length: 78.7 cm Width: 12.8 cm
Thickness: 0.3 cm

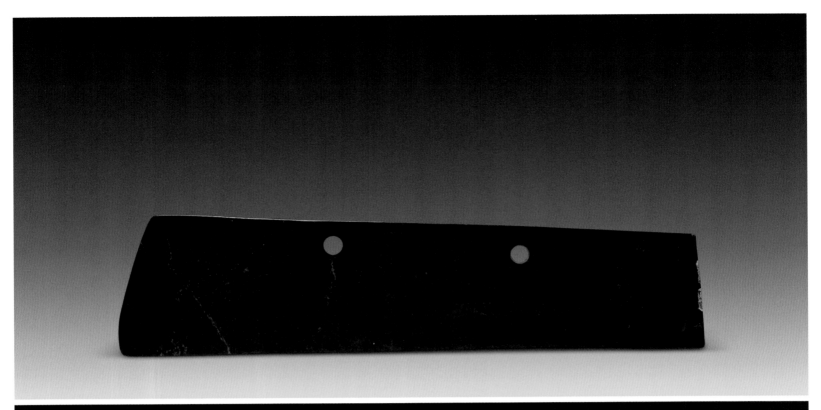

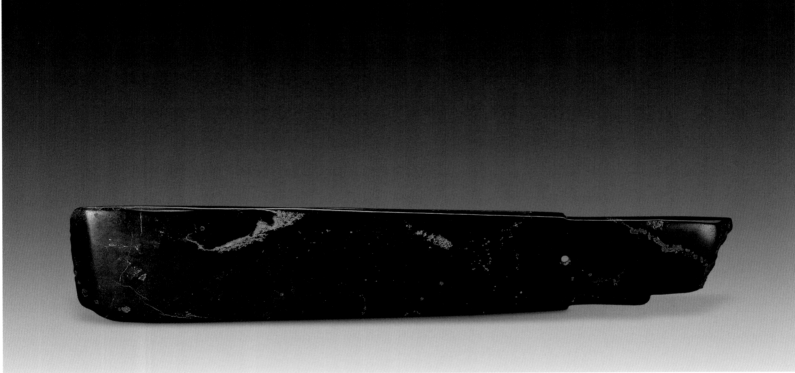

新141192
玉刀
陕西龙山文化

长30.5厘米 宽7.4厘米 厚0.3厘米

备注：残，有改动

178

Xin 141192

Jade knife
Longshan Culture of Shaanxi

Length: 30.5 cm Width: 7.4 cm
Thickness: 0.3 cm
Incomplete and re-shaped

新9610
玉刀
龙山文化

长41厘米 宽7.7厘米 厚1.1厘米

179

Xin 9610

Jade knife
Longshan Culture

Length: 41 cm Width: 7.7 cm
Thickness: 1.1 cm

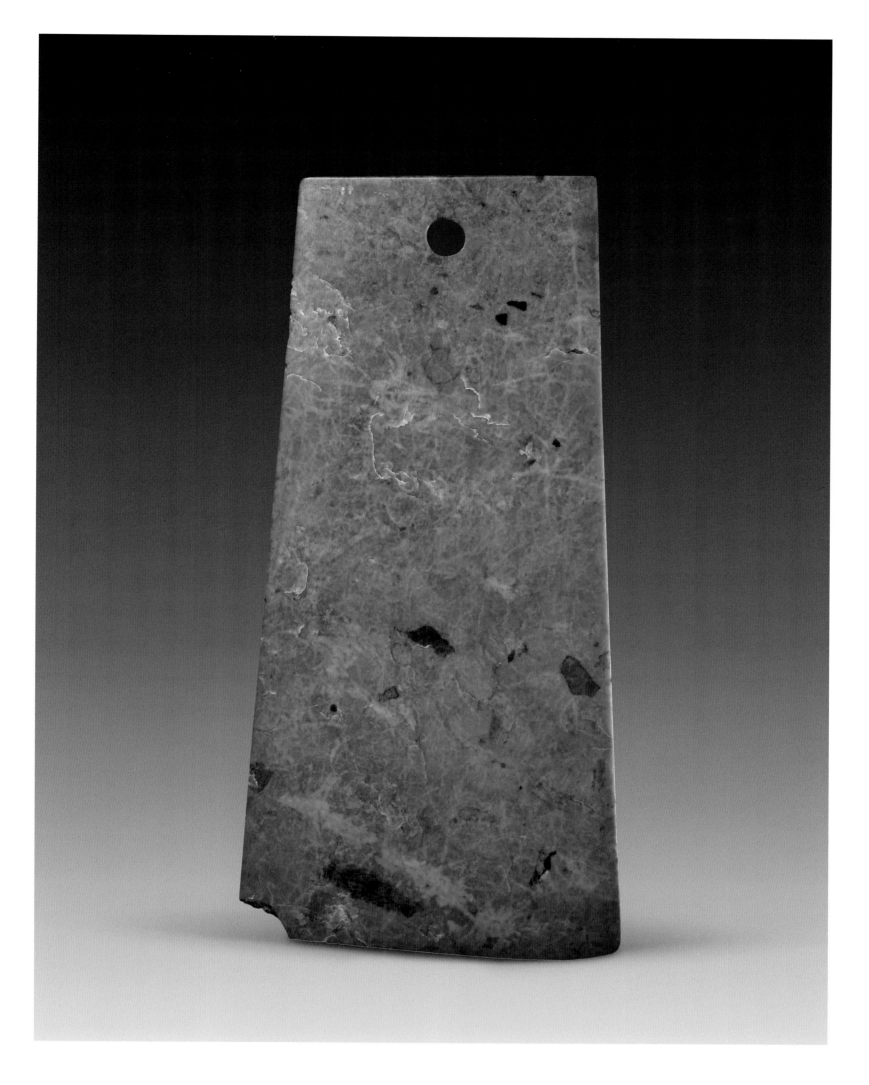

新99949
玉铲
龙山文化
长37.9厘米 宽18厘米 厚0.6厘米
180
Xin 99949
Jade spade
Longshan Culture
Length: 37.9 cm Width: 18 cm
Thickness: 0.6 cm

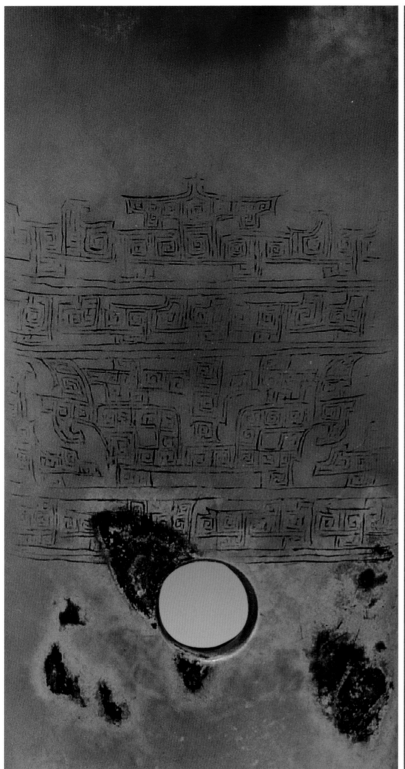
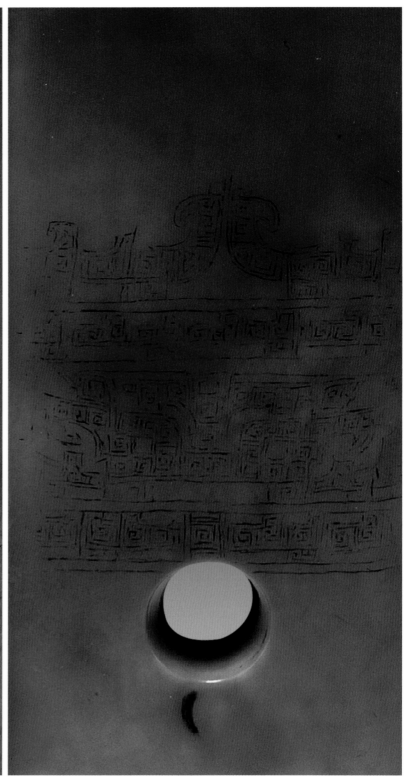

新78644

玉兽面纹圭
龙山文化

长20.8厘米　宽6.5厘米　厚0.8厘米

181 | 备注：后刻纹饰

Xin 78644

Jade Gui with animal-face design
Longshan Culture

Length: 20.8 cm　Width: 6.5 cm
Thickness: 0.8 cm
With design engraved later

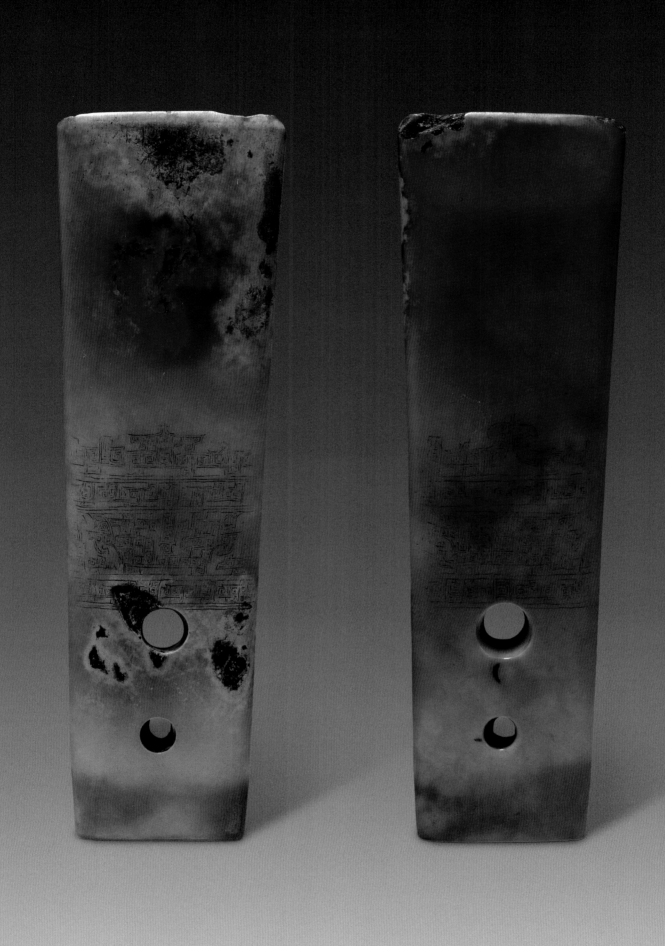

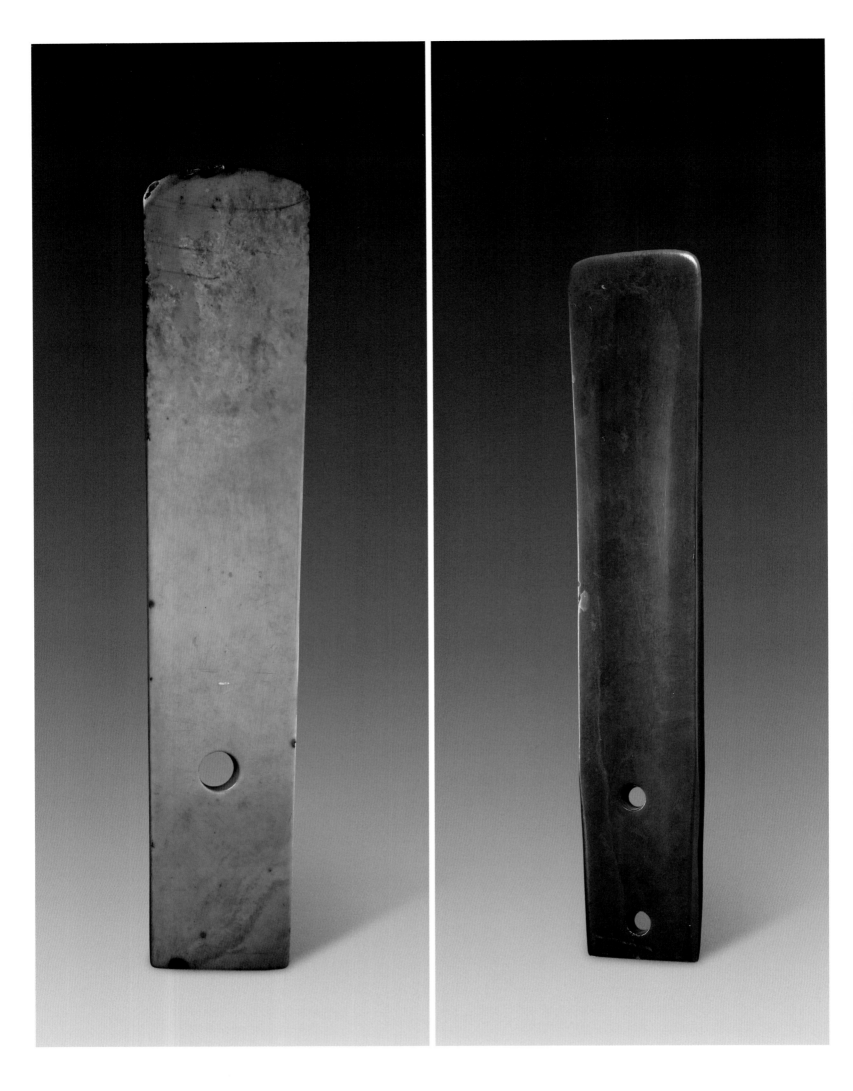

新93150
玉圭
龙山文化
长31.8厘米 宽6.4厘米 厚0.7厘米
182
Xin 93150
Jade Gui
Longshan Culture
Length: 31.8 cm Width: 6.4 cm
Thickness: 0.7 cm

故95866
玉圭
龙山文化
长25.8厘米 宽5厘米 厚0.8厘米
183
备注：后改动
Gu 95866
Jade Gui
Longshan Culture
Length: 25.8 cm Width: 5 cm
Thickness: 0.8 cm
Re-shaped

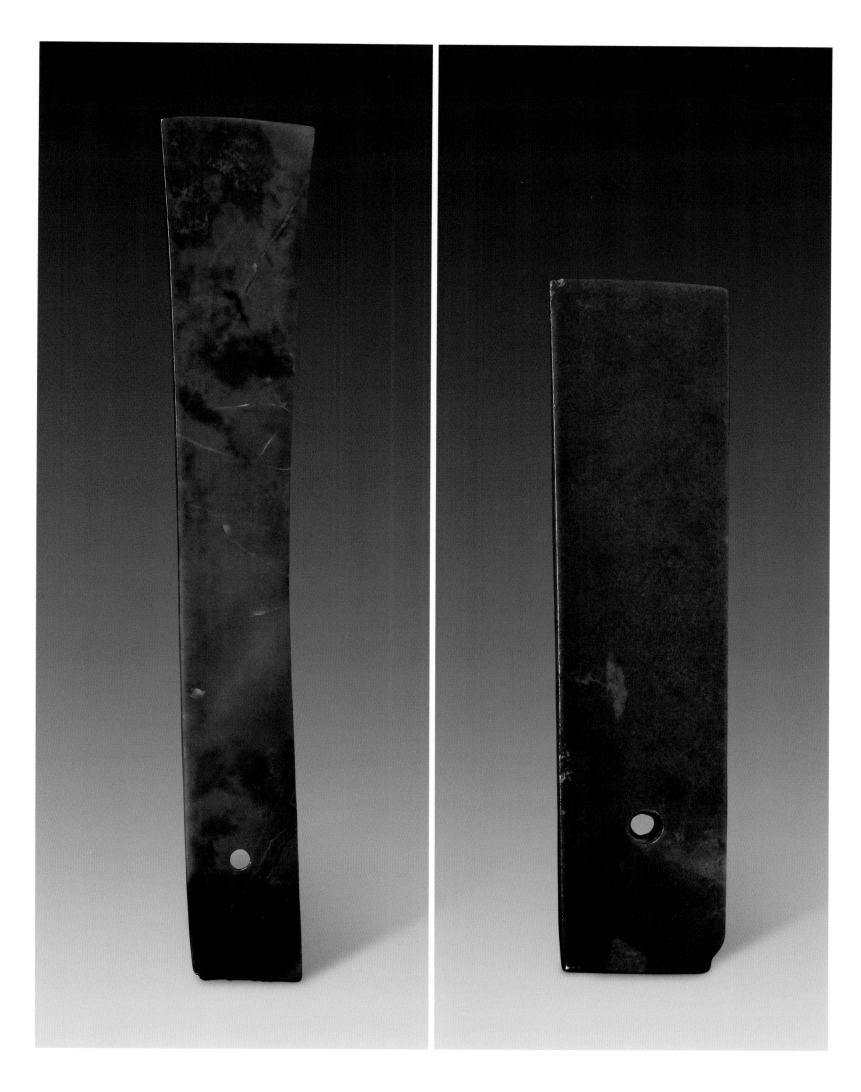

新136939

玉圭
龙山文化

184 | 长36.3厘米　宽6.3厘米　厚0.6厘米

Xin 136939

Jade Gui
Longshan Culture

Length: 36.3 cm　Width: 6.3 cm
Thickness: 0.6 cm

新78648

玉圭
龙山文化

185 | 长24.8厘米　宽6.3厘米　厚0.9厘米

Xin 78648

Jade Gui
Longshan Culture

Length: 24.8 cm　Width: 6.3 cm
Thickness: 0.9 cm

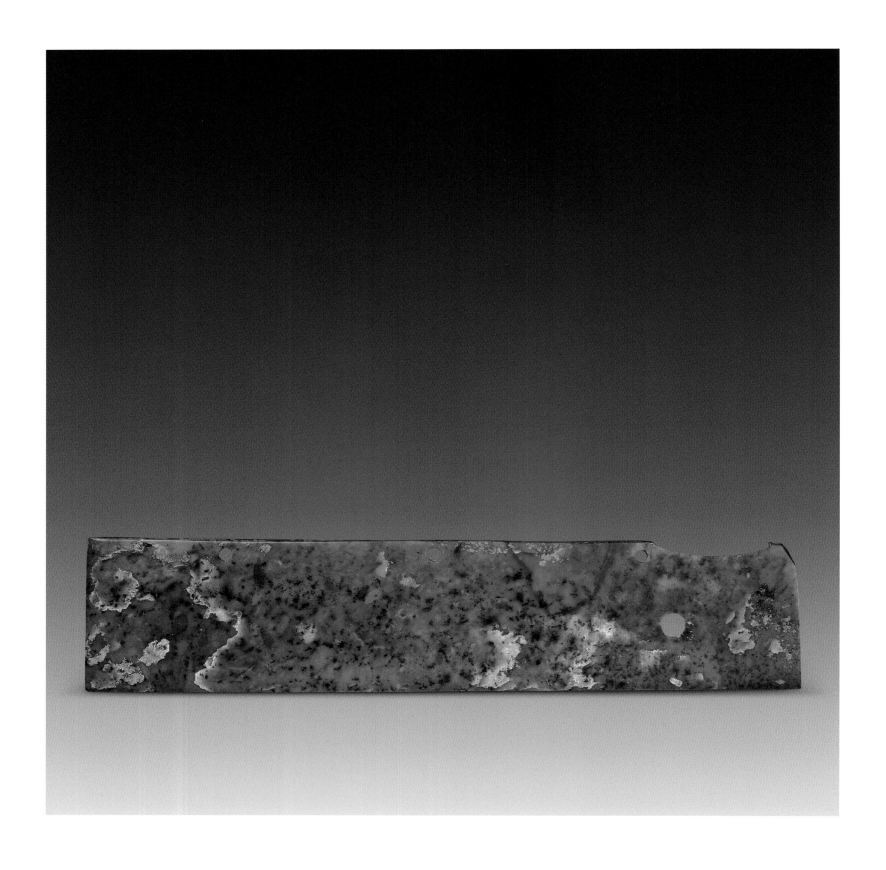

新51691
玉刀
齐家文化
长40.6厘米 宽9.1厘米 厚0.3厘米

186

Xin 51691
Jade knife
Qijia Culture
Length: 40.6 cm Width: 9.1 cm
Thickness: 0.3 cm

新78649
玉刀
齐家文化
长17.9厘米　宽5.1厘米　厚0.7厘米

187

Xin 78649
Jade knife
Qijia Culture
Length: 17.9 cm　Width: 5.1 cm
Thickness: 0.7 cm

故83966

玉二孔刀
齐家文化
长28厘米 宽6.4厘米 厚1.1厘米
备注：刻乾隆题诗

188

Gu 83966
Jade knife with two holes
Qijia Culture
Length: 28 cm Width: 6.4 cm Thickness: 1.1 cm
Inscribed with a poem by Emperor Qianlong

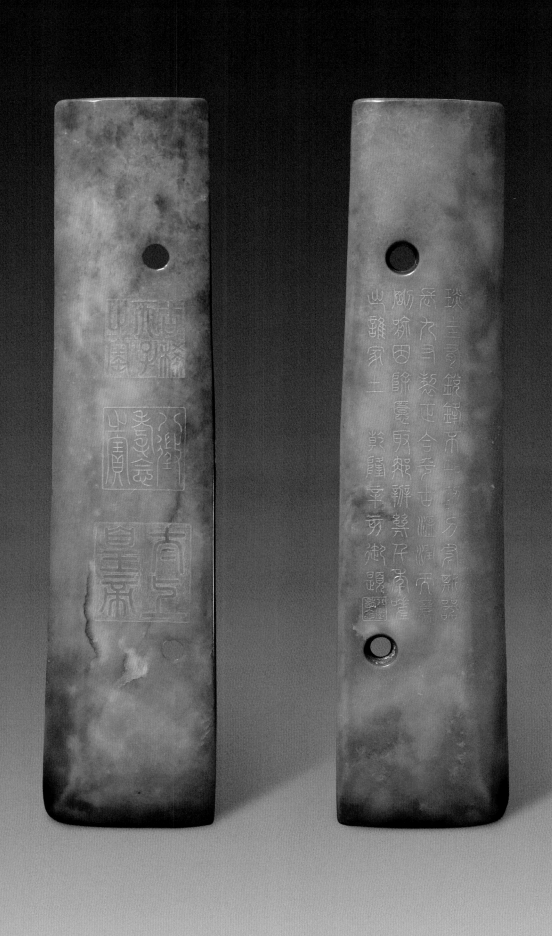

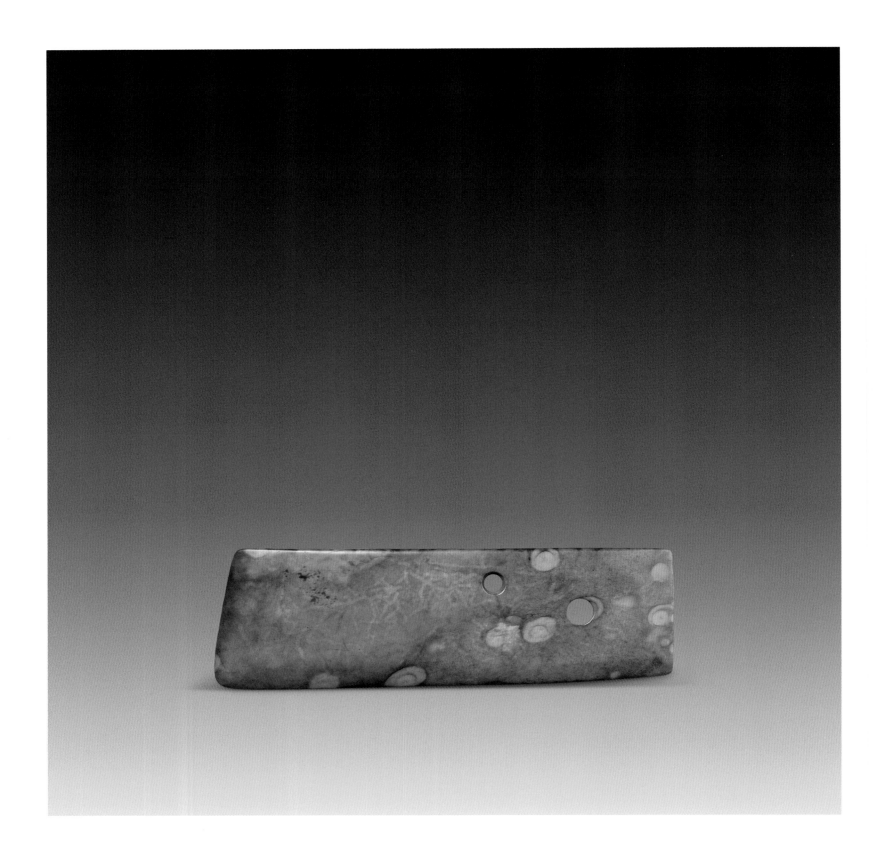

新51699
玉二孔刀
齐家文化

189 长16.2厘米 宽5.1厘米 厚1厘米

Xin 51699
Jade knife with two holes
Qijia Culture
Length: 16.2 cm Width: 5.1 cm
Thickness: 1 cm

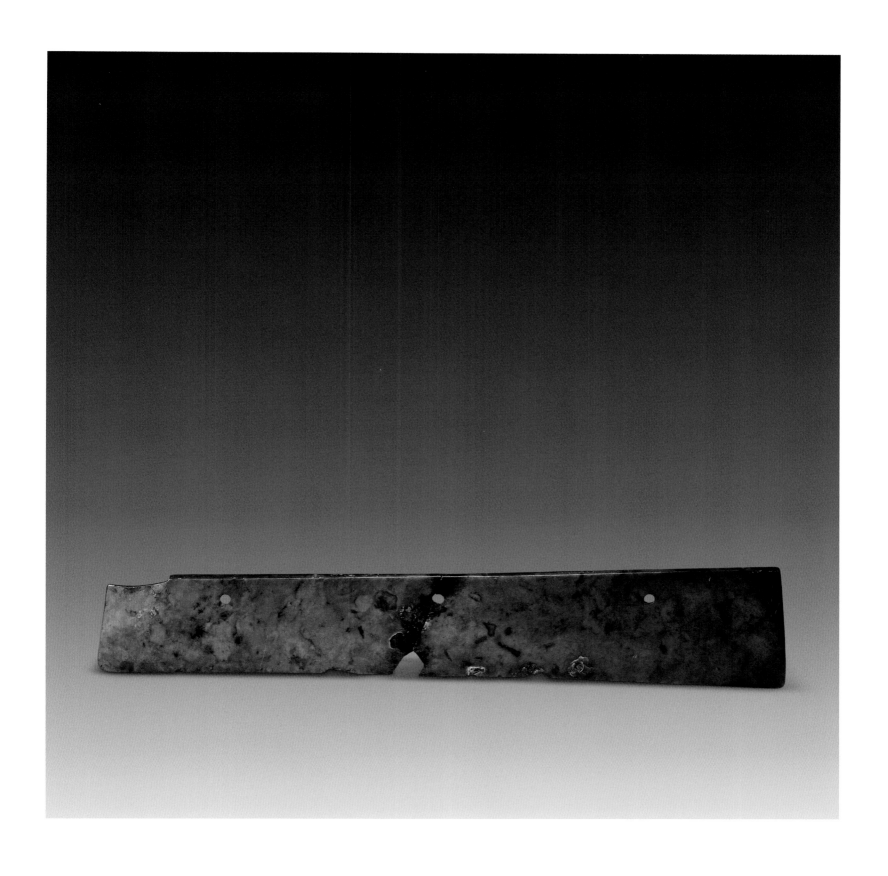

新107421

玉三孔刀
齐家文化

190 | 长48.8厘米 宽9.1厘米 厚0.6厘米

Xin 107421
Jade knife with three holes
Qijia Culture
Length: 48.8 cm Width: 9.1 cm
Thickness: 0.6 cm

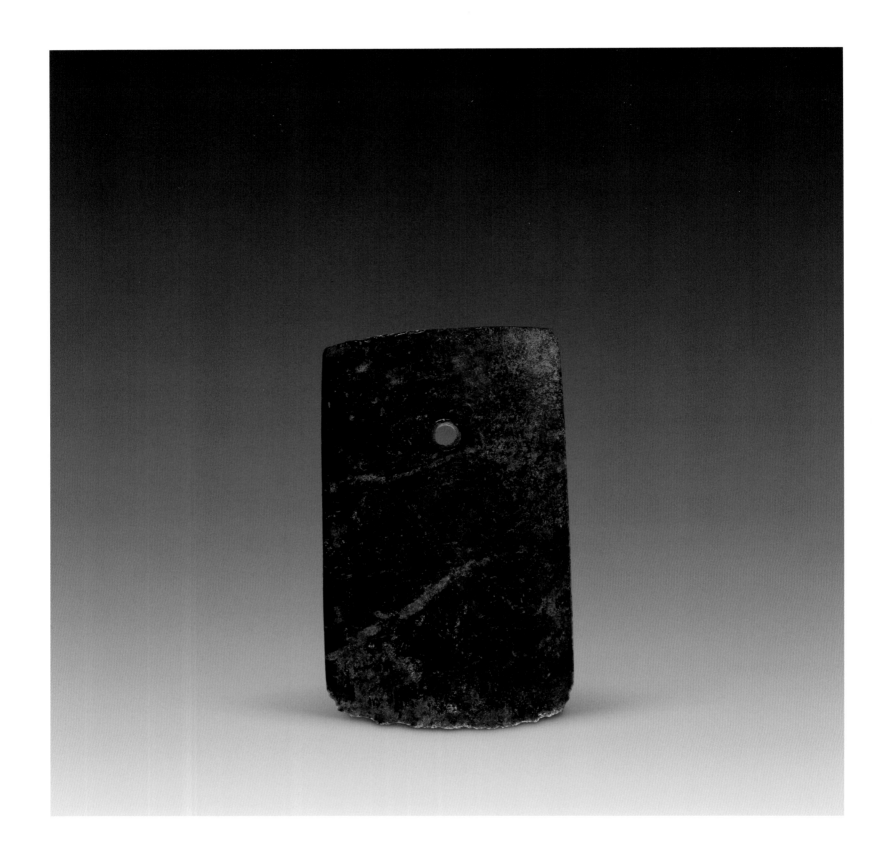

新60780
玉斧
齐家文化
191 | 长11.2厘米 宽6.7厘米 厚0.3厘米
Xin 60780
Jade axe
Qijia Culture
Length: 11.2 cm Width: 6.7 cm
Thickness: 0.3 cm

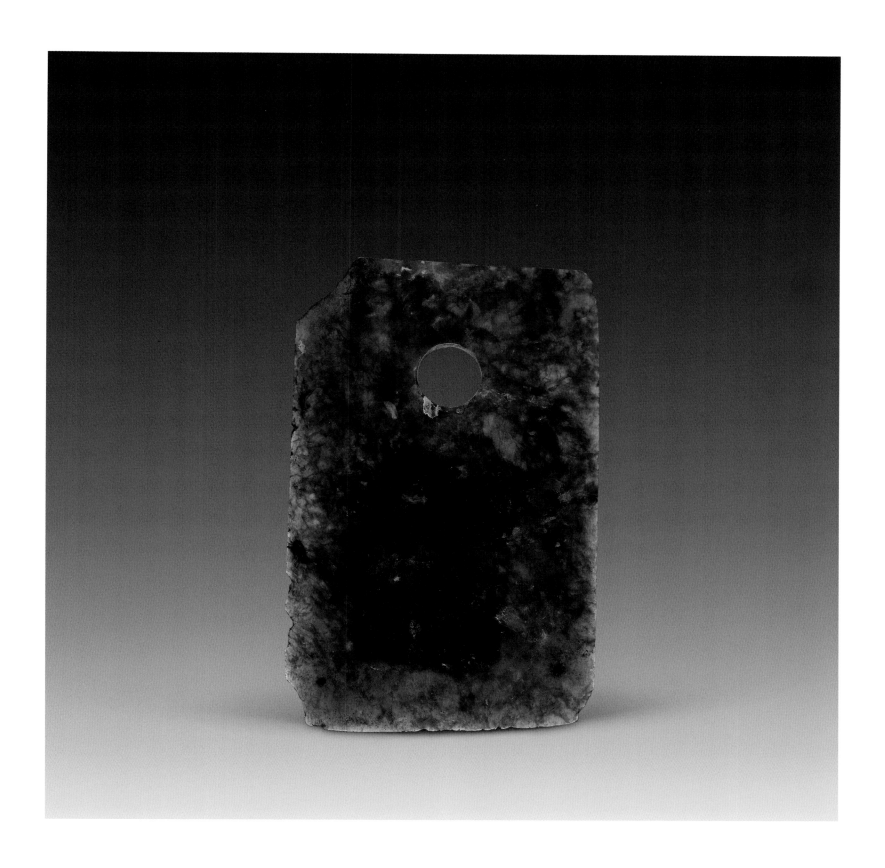

新60779
玉斧
齐家文化
192 长13.6厘米 宽8.6厘米 厚0.3厘米
Xin 60779
Jade axe
Qijia Culture
Length: 13.6 cm Width: 8.6 cm
Thickness: 0.3 cm

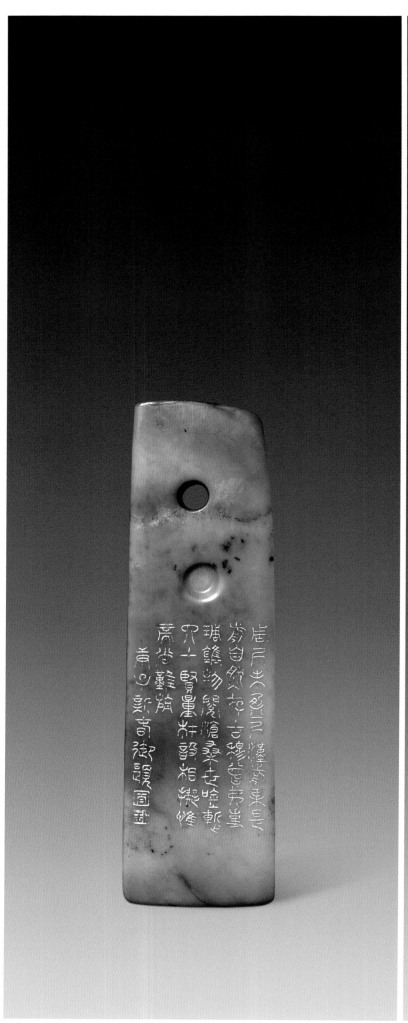

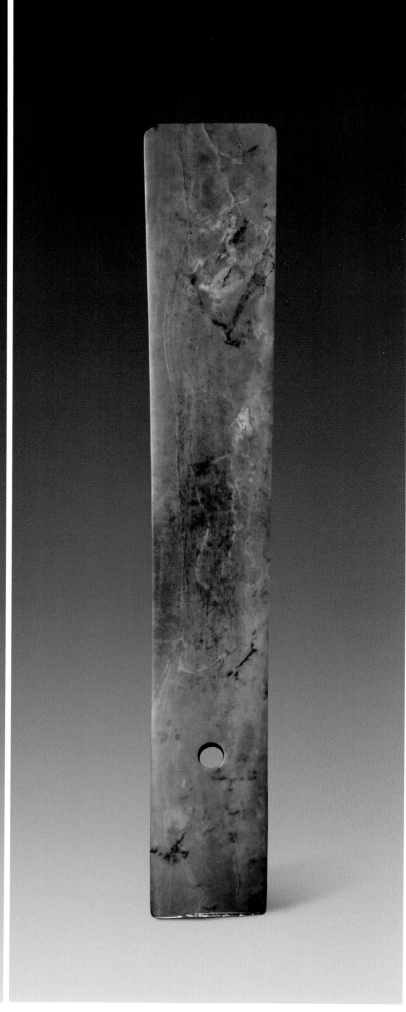

故83919

玉圭

齐家文化

长13.9厘米 宽4.1厘米 厚1.1厘米

193 | 备注：后刻乾隆题诗
————————

Gu 83919

Jade Gui

Qijia Culture

Length: 13.9 cm Width: 4.1 cm
Thickness: 1.1 cm

Inscribed with a poem by Emperor Qianlong

新63136

玉圭

齐家文化

长34.9厘米 宽5.7厘米 厚0.8厘米

194 | Xin 63136

Jade Gui

Qijia Culture

Length: 34.9 cm Width: 5.7 cm
Thickness: 0.8 cm

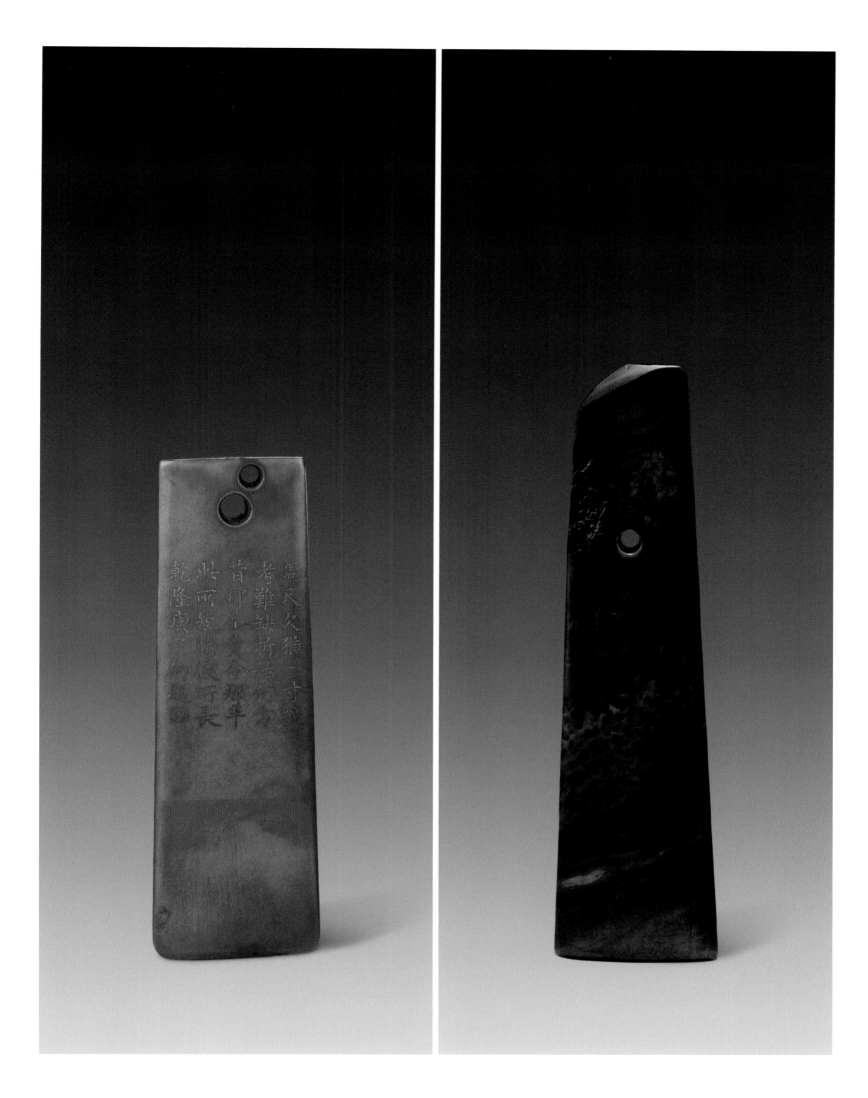

故83918

玉圭

齐家文化

长13.8厘米 宽4.6厘米 厚0.5厘米

195 | 备注：后刻乾隆御题诗

Gu 83918

Jade Gui

Qijia Culture

Length: 13.8 cm Width: 4.6 cm Thickness: 0.5 cm

Inscribed with a poem by Emperor Qianlong

故83869

玉圭

齐家文化

长26.4厘米 宽7.1厘米 厚0.6厘米

196 | Gu 83869

Jade Gui

Qijia Culture

Length: 26.4 cm Width: 7.1 cm
Thickness: 0.6 cm

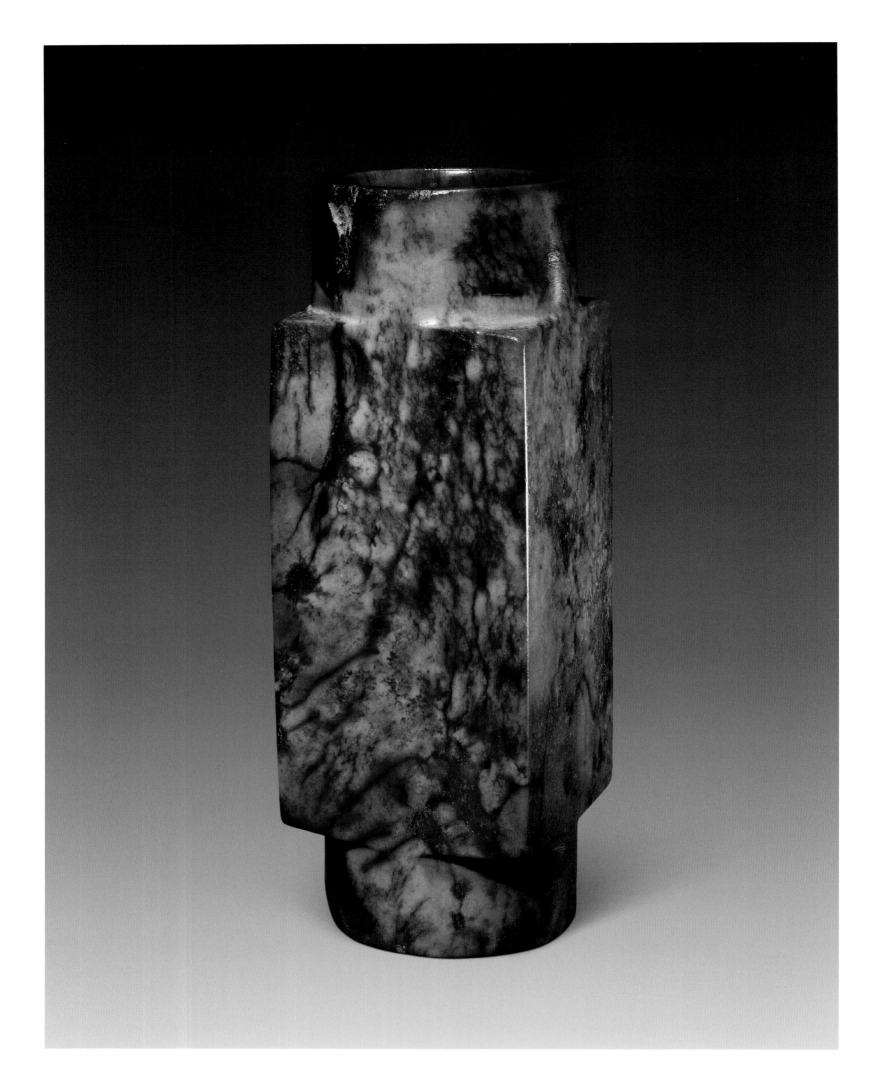

故95997

玉琮
齐家文化

197 高28.2厘米 口径9.4厘米 底径9厘米

Gu 95997

Jade Cong
Qijia Culture

Height: 28.2 cm Mouth diameter: 9.4 cm
Bottom diameter: 9 cm

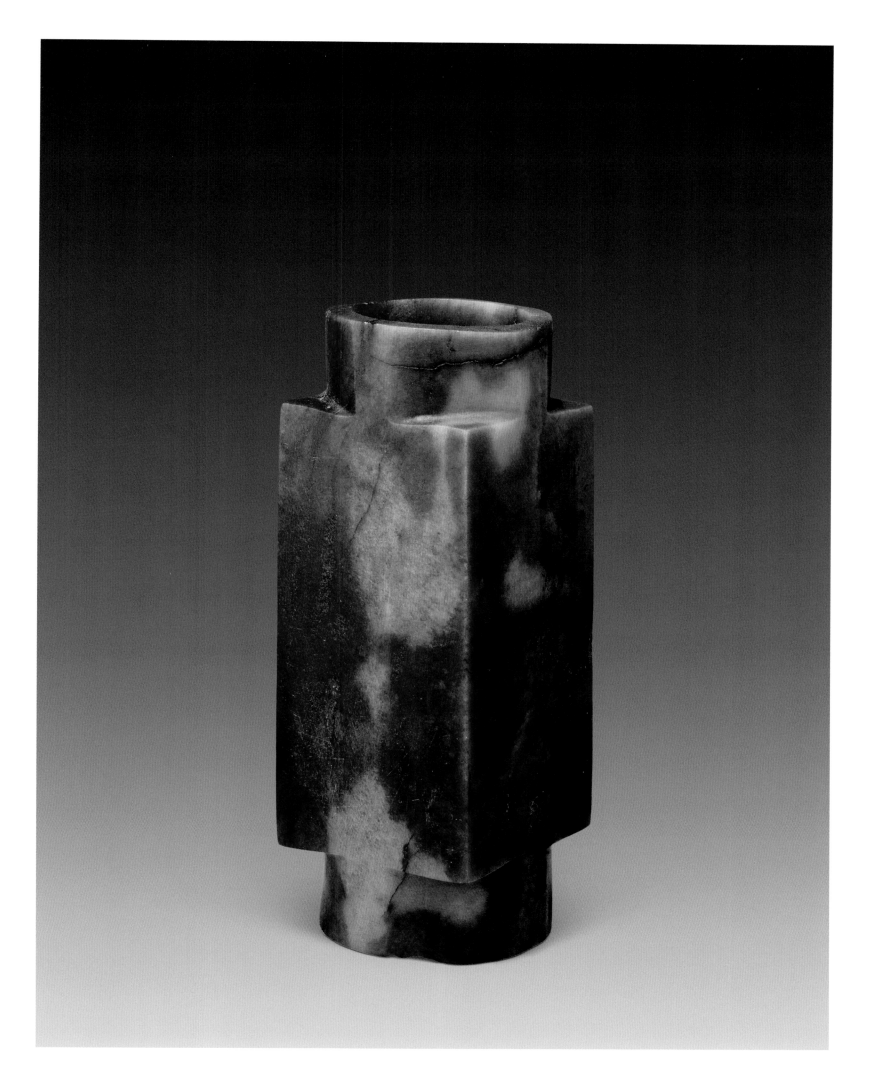

故95999

玉琮
齐家文化

198 高22.2厘米 口径8.1厘米 底径8.2厘米

Gu 95999

Jade Cong
Qijia Culture

Height: 22.2 cm Mouth diameter: 8.1 cm
Bottom diameter: 8.2 cm

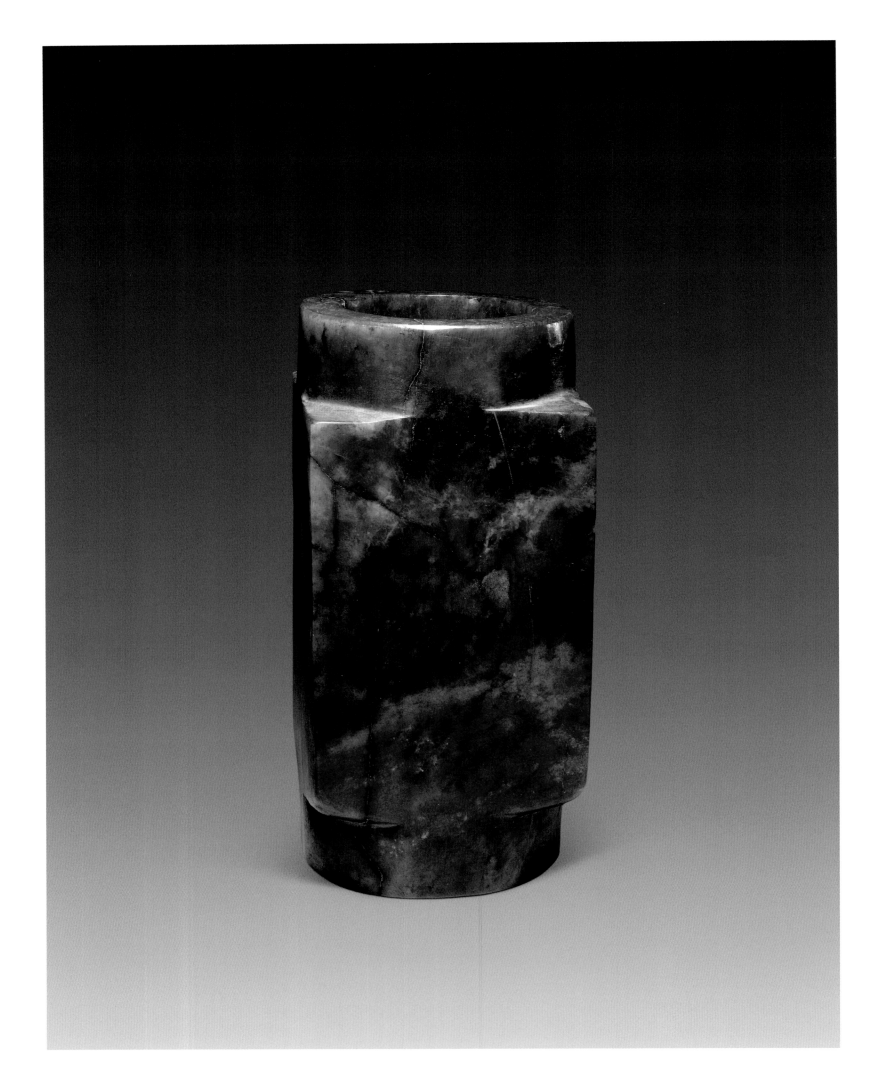

故95998

玉琮
齐家文化

199 | 高19厘米 口径8.9厘米 底径8.9厘米

Gu 95998

Jade Cong
Qijia Culture

Height: 19 cm Mouth diameter: 8.9 cm
Bottom diameter: 8.9 cm

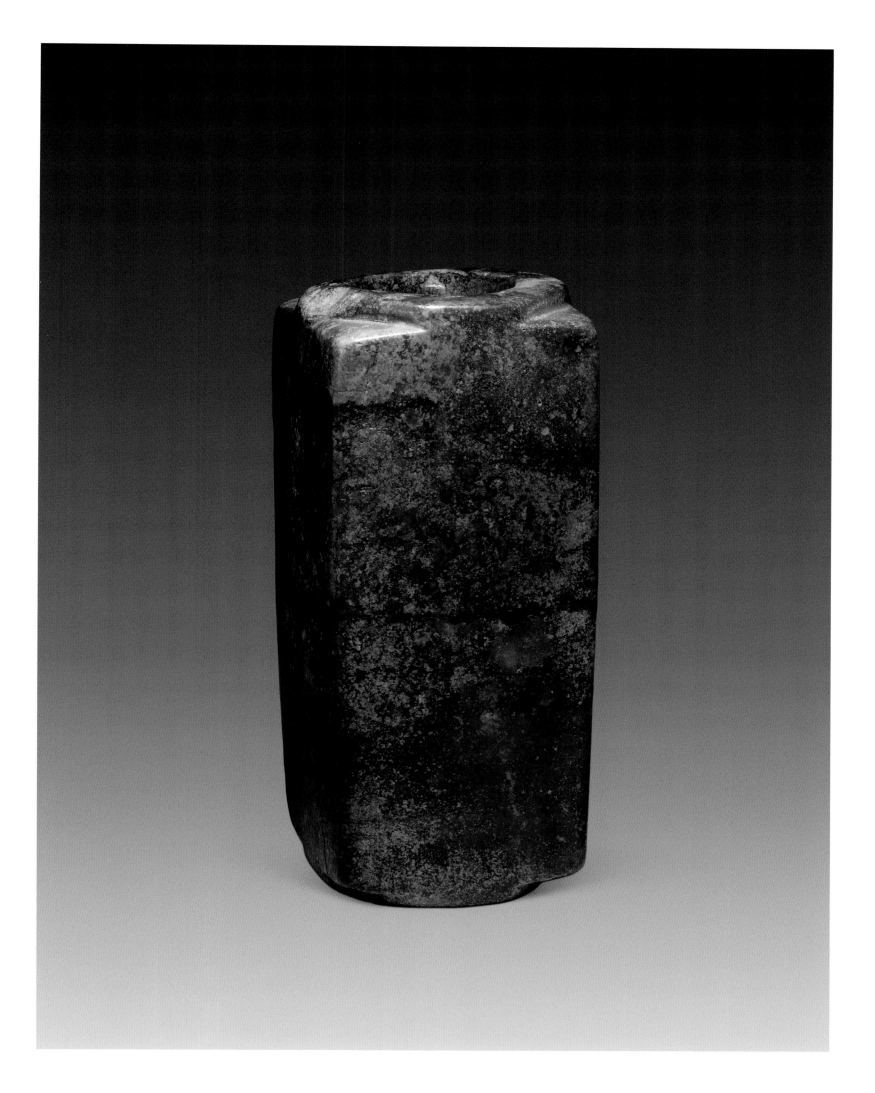

新132562

玉琮
齐家文化

200 | 高20厘米 口径8.2厘米 底径7.7厘米

Xin 132562
Jade Cong
Qijia Culture
Height: 20 cm Mouth diameter: 8.2 cm
Bottom diameter: 7.7 cm

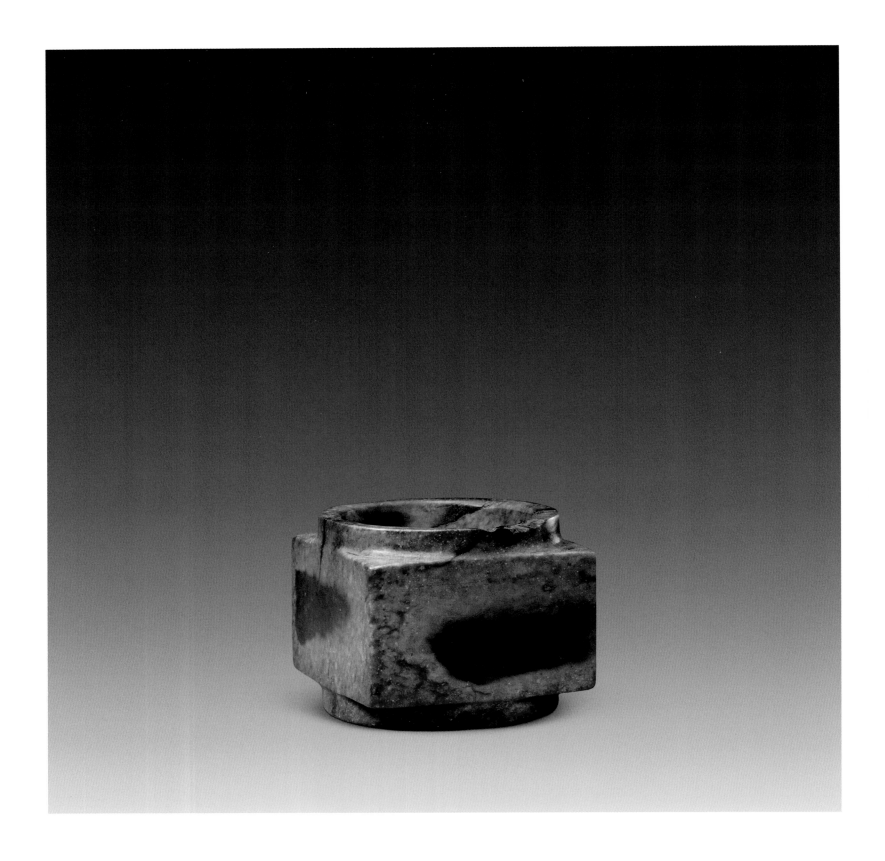

新125062
玉琮
齐家文化

201 高5.6厘米 口径6.4厘米 底径5.6厘米

Xin 125062
Jade Cong
Qijia Culture
Height: 5.6 cm　Mouth diameter: 6.4 cm
Bottom diameter: 5.6 cm

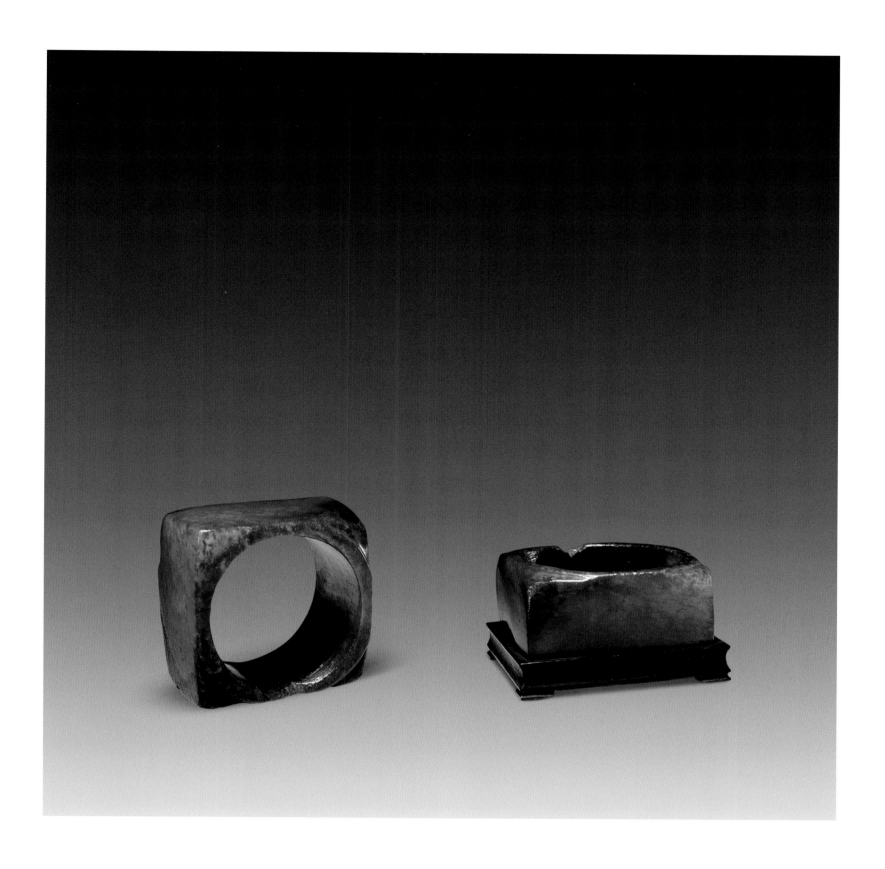

故84414

玉琮
齐家文化

高2.3厘米　径4.5厘米

备注：四面后磨，有染色，附红木座

202

Gu 84414

Jade Cong
Qijia Culture

Height: 2.3 cm　Diameter: 4.5 cm
Polished, dyed and with a mahogany base

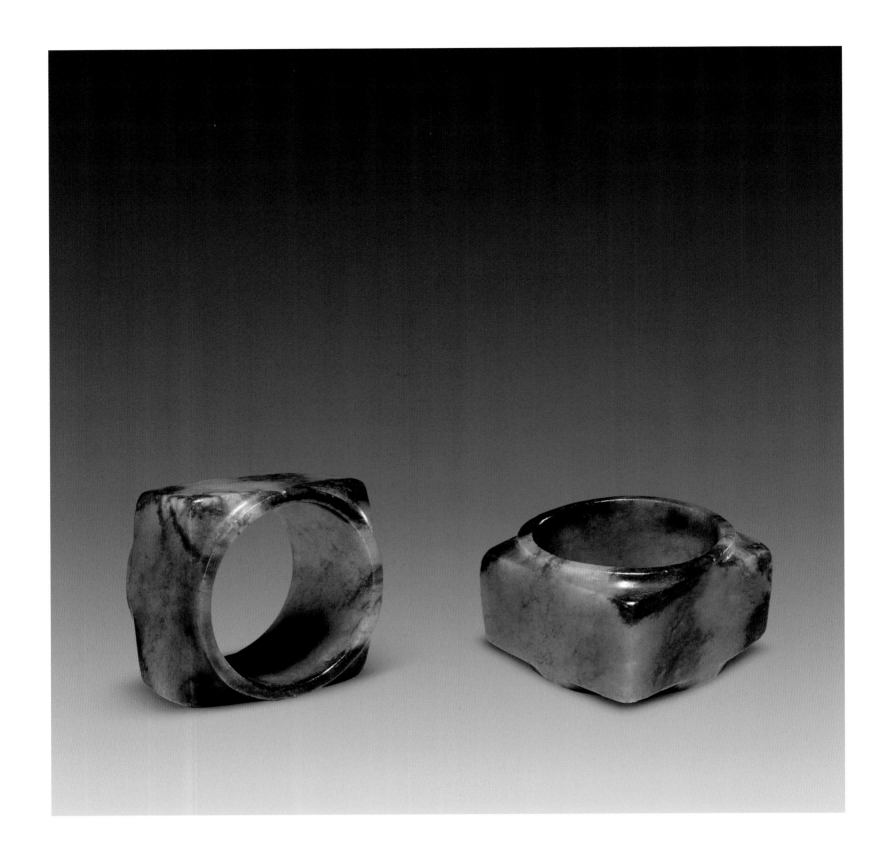

新178456

玉琮
齐家文化

203 高4厘米 径6.2厘米

Xin 178456

Jade Cong
Qijia Culture

Height: 4 cm Diameter: 6.2 cm

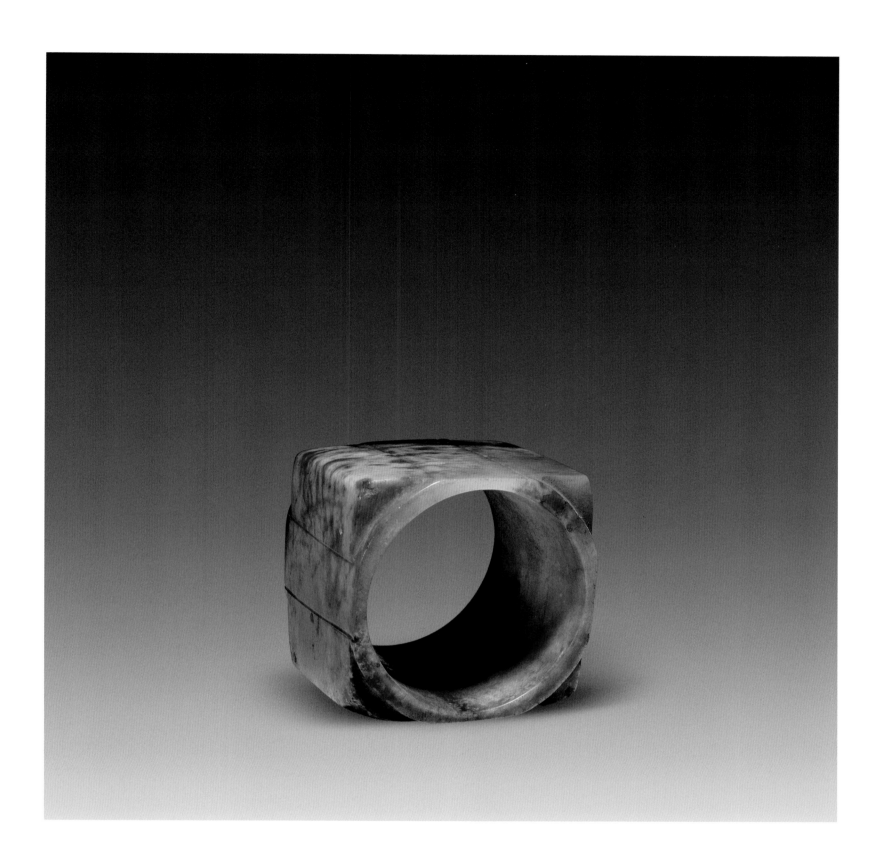

故84724
玉琮
齐家文化
高5.1厘米 口径6.5厘米
底径6.7厘米
备注：清配铜胆，加木座

204

Gu 84724
Jade Cong
Qijia Culture
Height: 5.1 cm Mouth diameter: 6.5 cm
Bottom diameter: 6.7 cm
With a copper liner and a wooden base

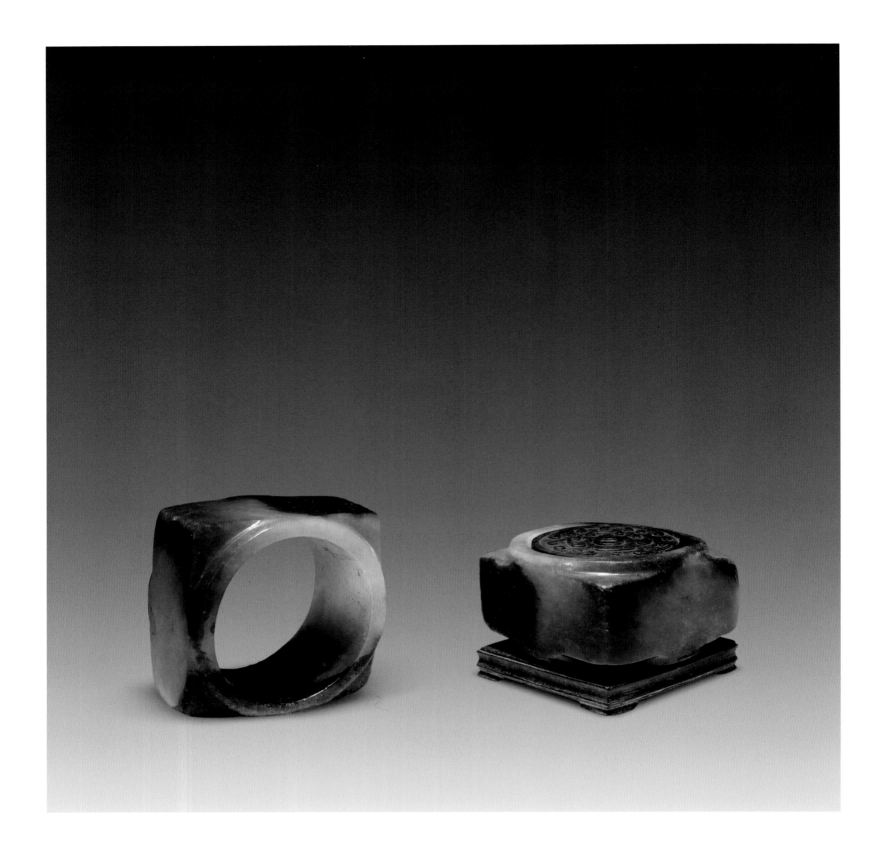

故84726

玉琮
新石器时代
高3.6厘米　径6厘米
备注：清代配木托轴心

205

Gu 84726
Jade Cong
Neolithic Age
Height: 3.6 cm　Diameter: 6 cm
With an axis-like wood support
equipped in the Qing Dynasty

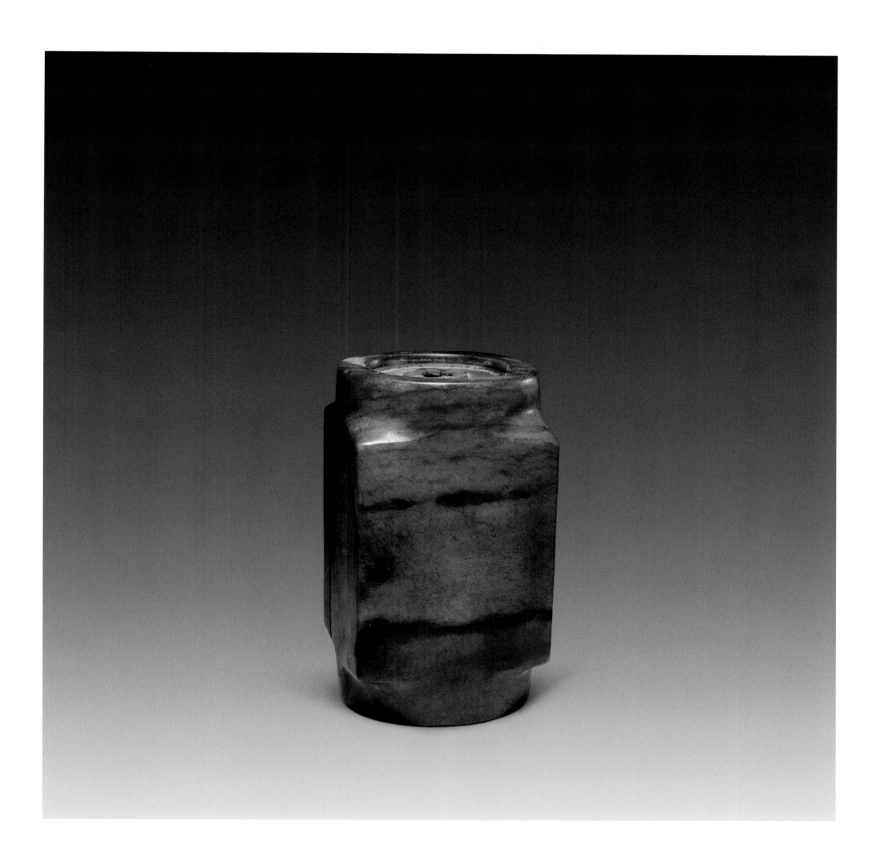

故96003
玉琮
新石器时代
高10.3厘米 口径5.6厘米 底径5.7厘米

206

Gu 96003
Jade Cong
Neolithic Age
Height: 10.3 cm Mouth diameter: 5.6 cm
Bottom diameter: 5.7 cm

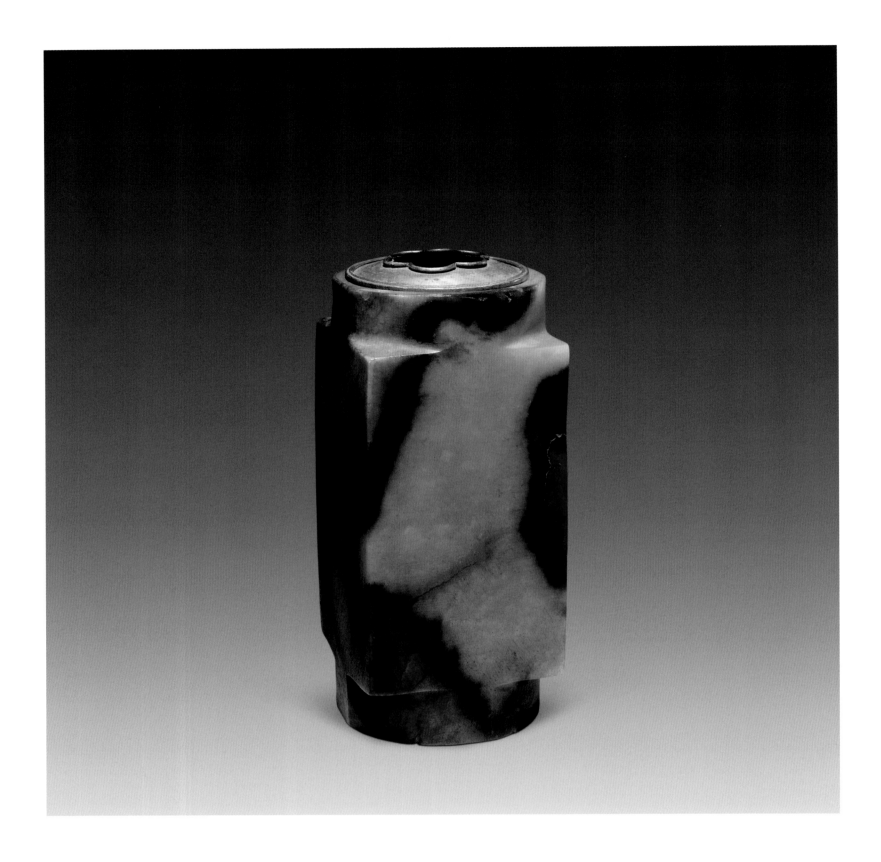

故83950

玉琮
新石器时代
高13.5厘米　口径5.9厘米　底径5.9厘米
备注：清代配铜胆

207

Gu 83950

Jade Cong
Neolithic Age
Height: 13.5 cm　Mouth diameter: 5.9 cm
Bottom diameter: 5.9 cm
With a copper liner equipped in the Qing Dynasty

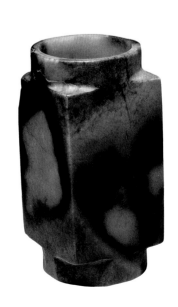
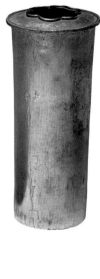

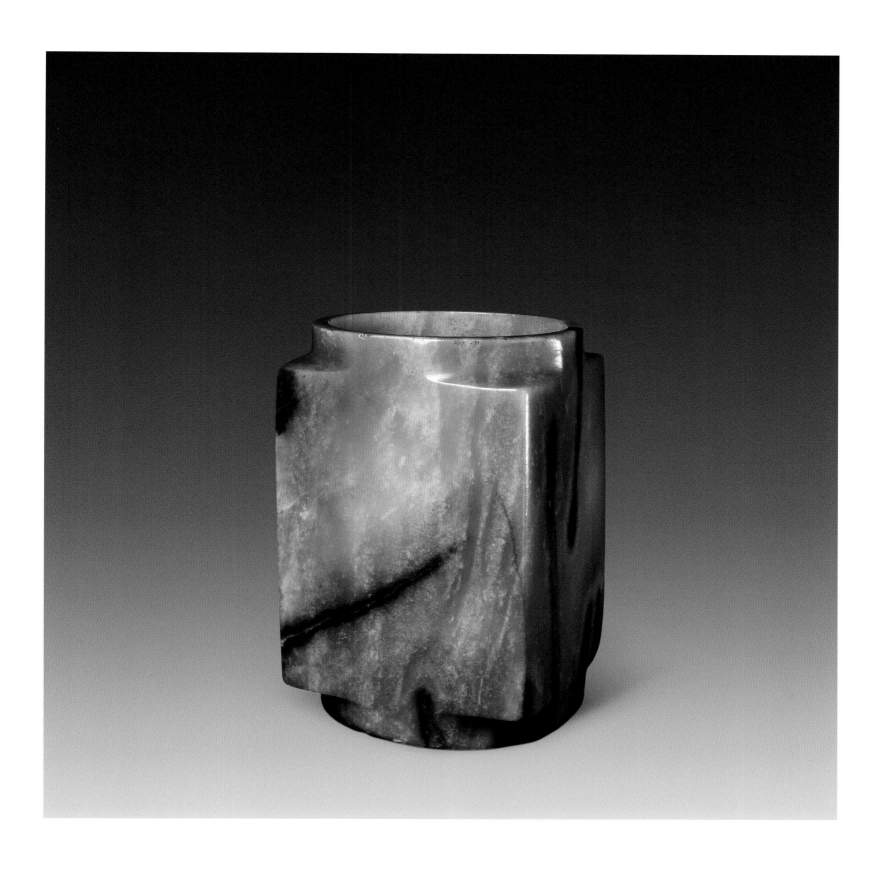

新105774

玉琮

新石器时代

高13.3厘米 口径8.5厘米 底径8.6厘米

208

Xin 105774

Jade Cong

Neolithic Age

Height: 13.3 cm Mouth diameter: 8.5 cm
Bottom diameter: 8.6 cm

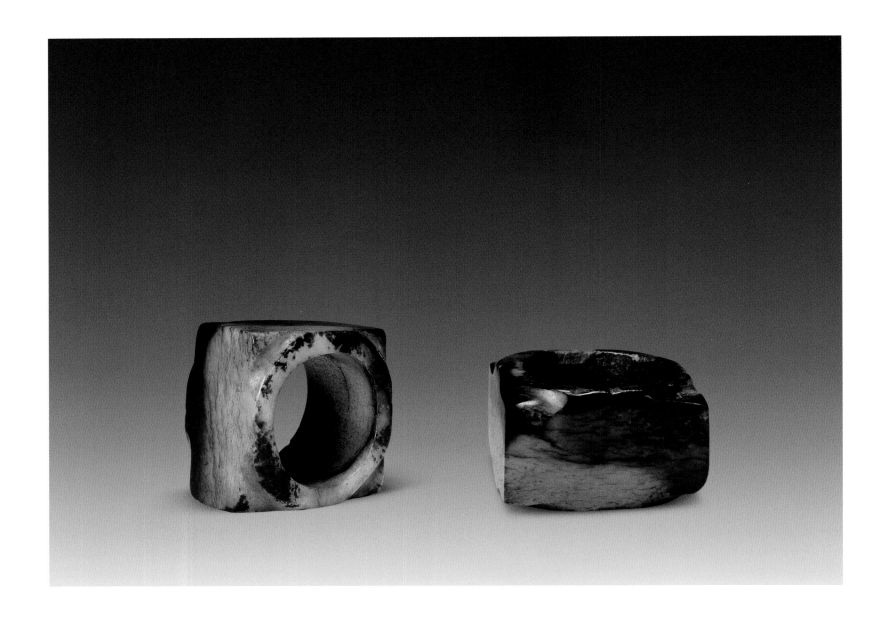

故84729

玉琮
新石器时代或商代

209 高3.5厘米　径5.6厘米

Gu 84729

Jade Cong
Neolithic Age or Shang Dynasty
Height: 3.5 cm Diameter: 5.6 cm

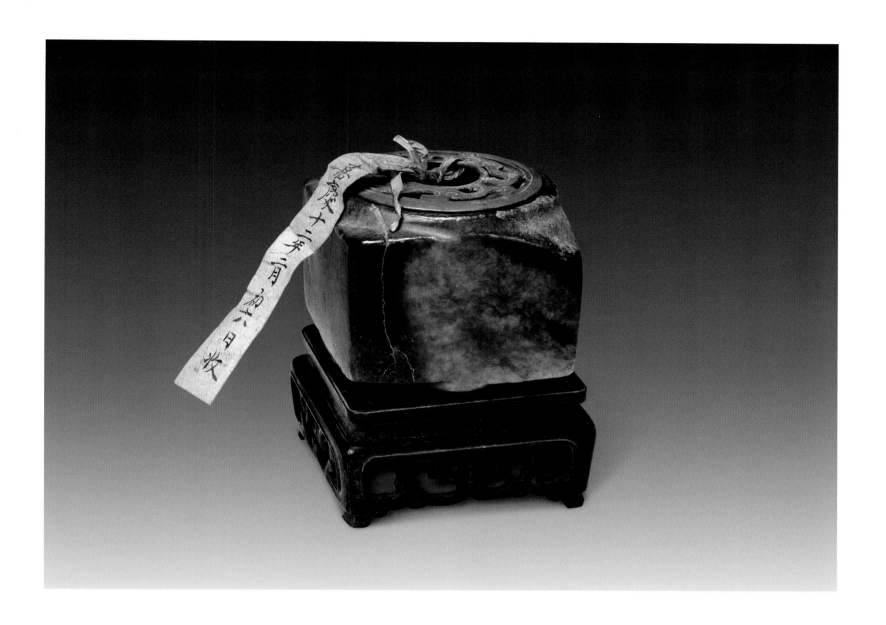

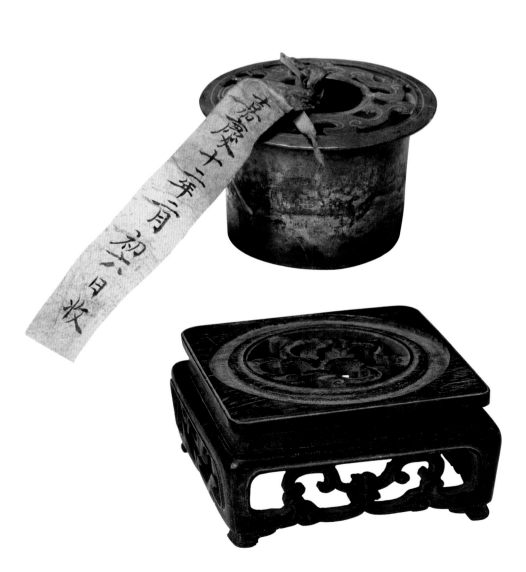

故96007

玉琮

新石器时代或商代

高5厘米 径6厘米

备注：附清代造木座、铜胆、黄笺

210

Gu 96007

Jade Cong

Neolithic Age or Shang Dynasty

Height: 5 cm Diameter: 6 cm

With a copper liner, a wooden base and a yellow piece of paper label in the Qing Dynasty

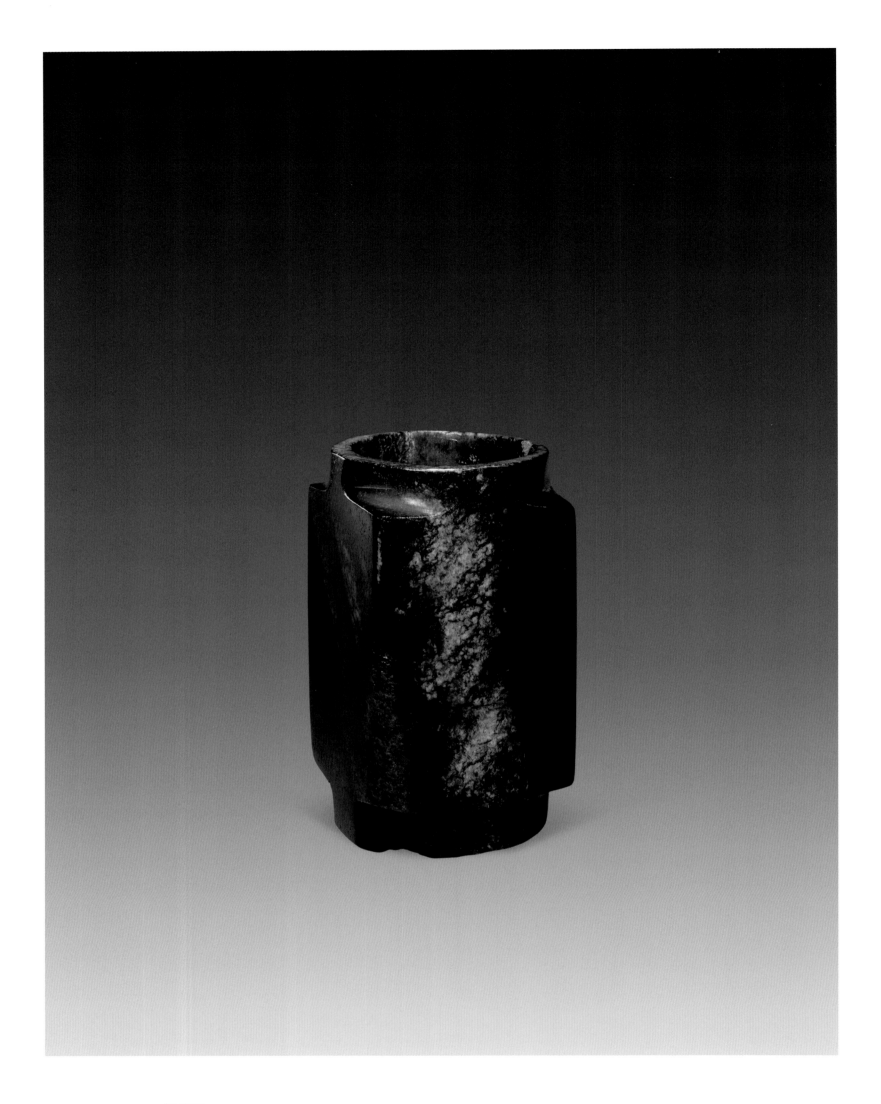

新120835

玉琮
新石器时代或商代
高11.8厘米 径6.1厘米
备注：表面烧黑色

211

Xin 120835

Jade Cong
Neolithic Age or Shang Dynasty
Height: 11.8 cm Diameter: 6.1 cm
The surface was burned black

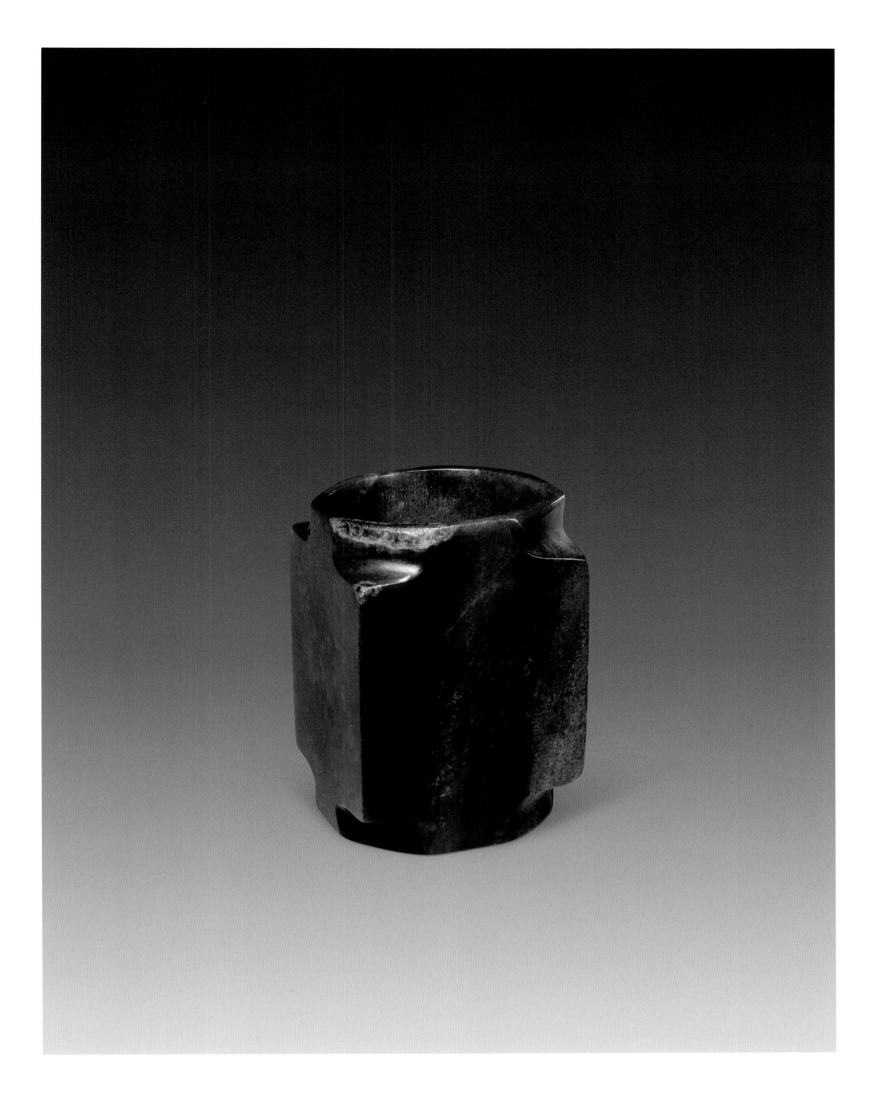

新120864

玉琮
新石器时代或商代

212　高10.6厘米　径7.3厘米

Xin 120864

Jade Cong
Neolithic Age or Shang Dynasty

Height: 10.6 cm　Diameter: 7.3 cm

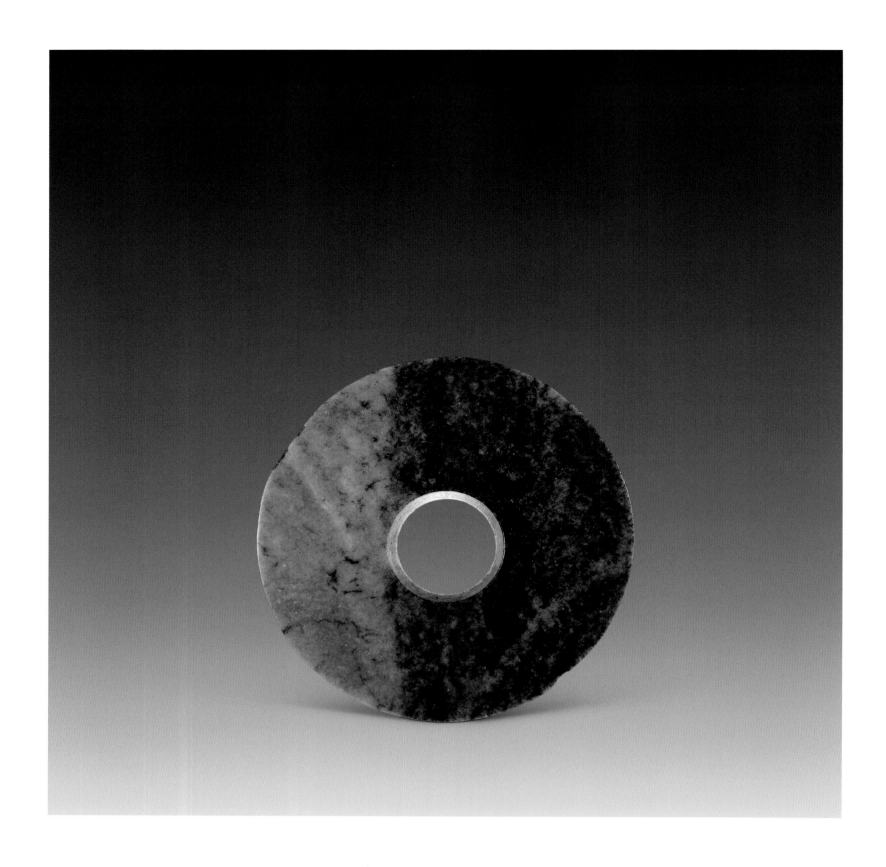

故85346

玉璧
齐家文化

213 | 径15.5厘米 孔径4厘米 厚1厘米

Gu 85346
Jade Bi
Qijia Culture
Diameter: 15.5 cm Internal diameter: 4 cm
Thickness: 1 cm

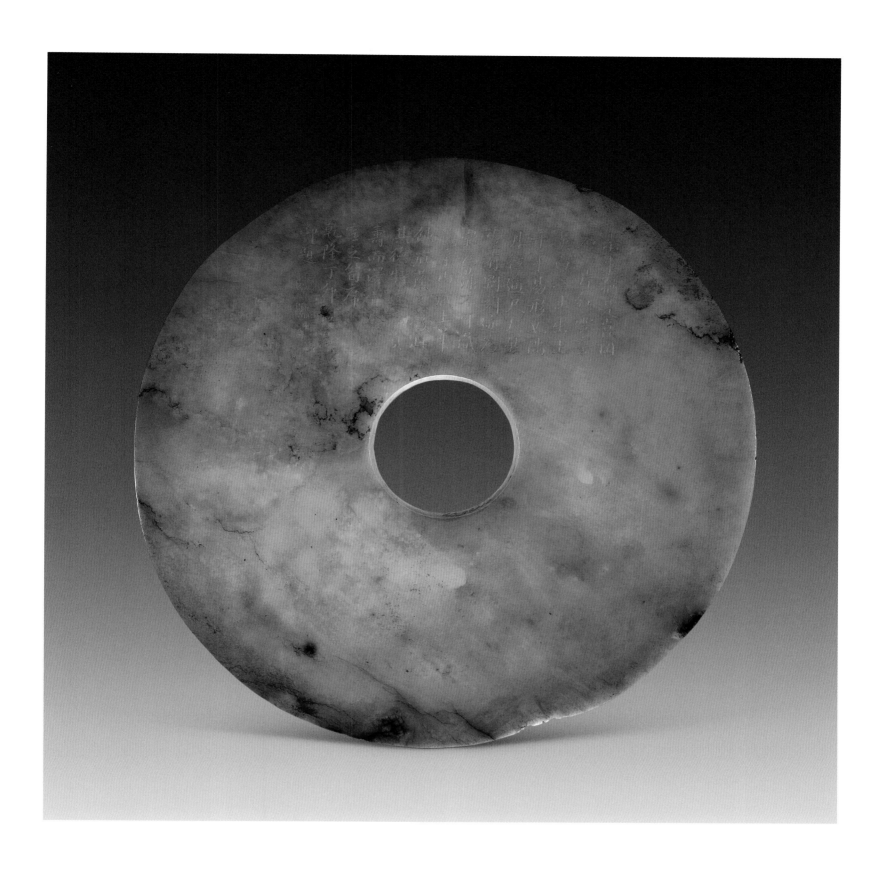

故99212

玉璧
齐家文化
径30.5厘米 孔径7.4厘米 厚1.3厘米
备注：后刻乾隆题诗

214

Gu 99212
Jade Bi
Qijia Culture
Diameter: 30.5 cm Internal diameter: 7.4 cm
Thickness: 1.3 cm
Inscribed with a poem by Emperor Qianlong

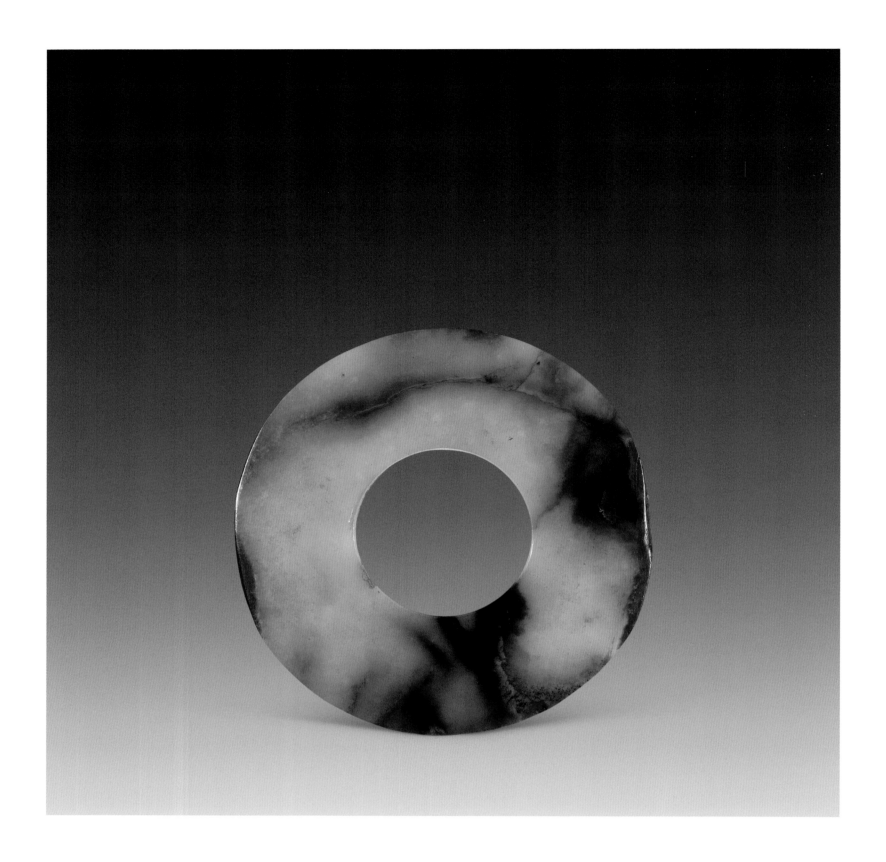

故84078

玉璧

齐家文化

215 径12.6厘米 孔径5.1厘米 厚0.5厘米

Gu 84078

Jade Bi
Qijia Culture

Diameter: 12.6 cm Internal diameter: 5.1 cm
Thickness: 0.5 cm

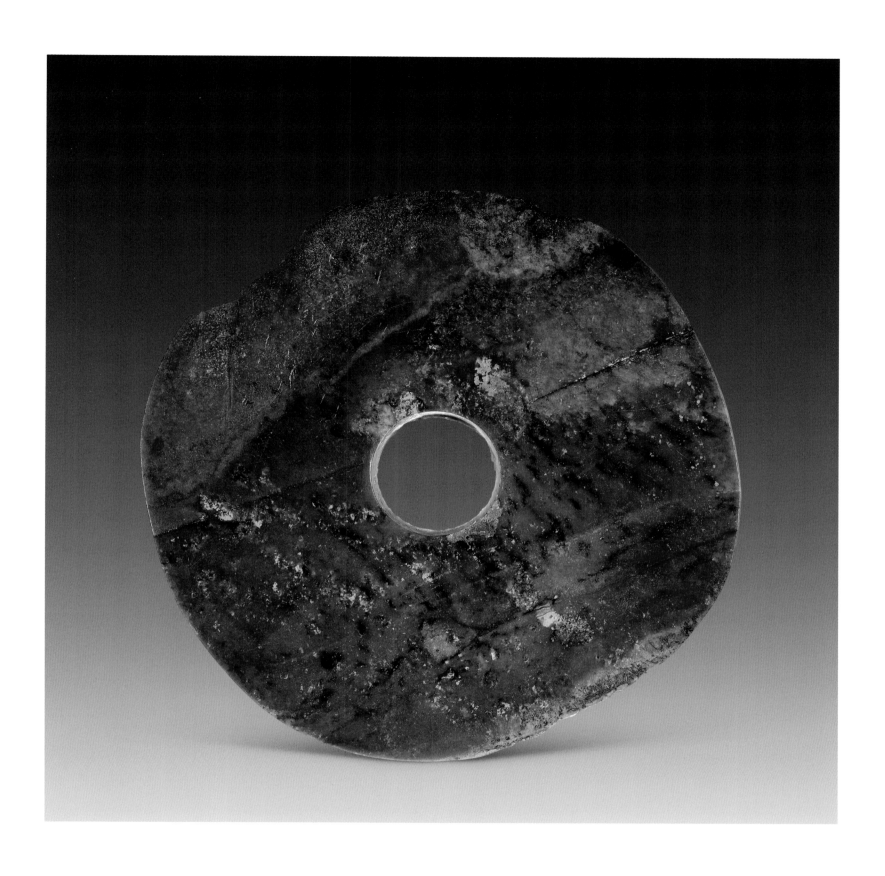

新51578
玉璧
齐家文化
径27.4×27.2厘米 孔径5.5×5.4厘米 厚1.3厘米

216

Xin 51578
Jade Bi
Qijia Culture
Diameter: 27.4×27.2 cm
Internal diameter: 5.5×5.4 cm Thickness: 1.3 cm

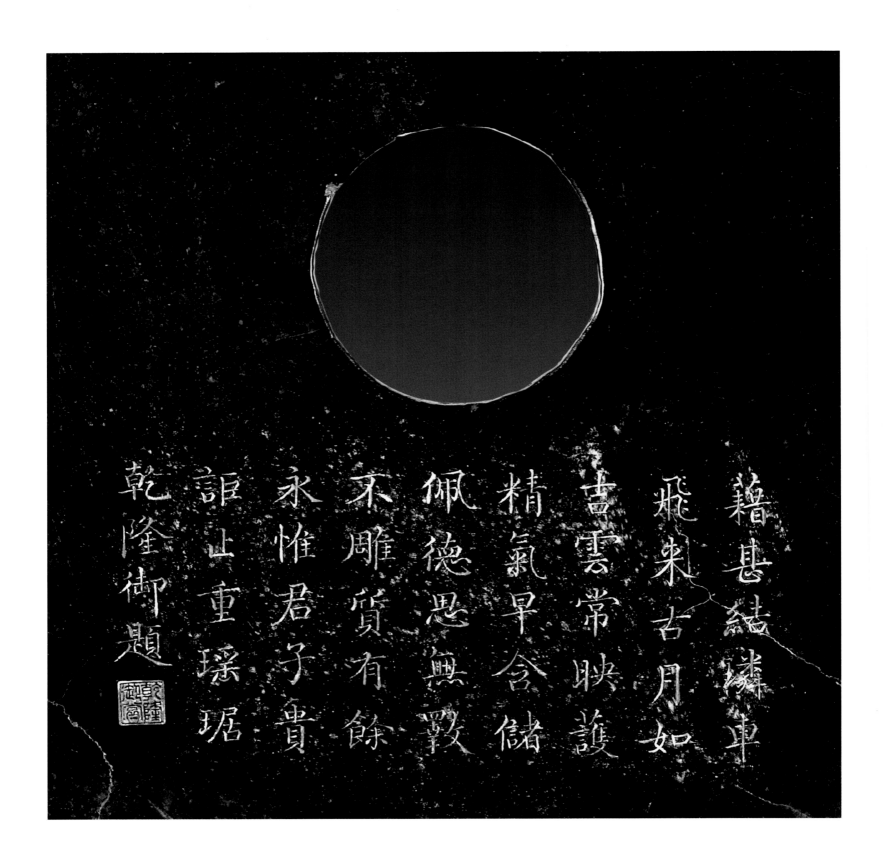

籍甚結鄰車
飛來古月如
壹雲常映護
精氣早含儲
佩德思無斁
不雕質有餘
永惟君子實
詎止重瑤琚
乾隆御題

故83872

玉璧
齐家文化
径28.1×27.2厘米　孔径6.3×5.7厘米　厚1.1厘米

备注：后刻乾隆题诗

217

Gu 83872
Jade Bi
Qijia Culture
Diameter: 28.1×27.2 cm　Internal diameter: 6.3×5.7 cm
Thickness: 1.1 cm
Inscribed with a poem by Emperor Qianlong

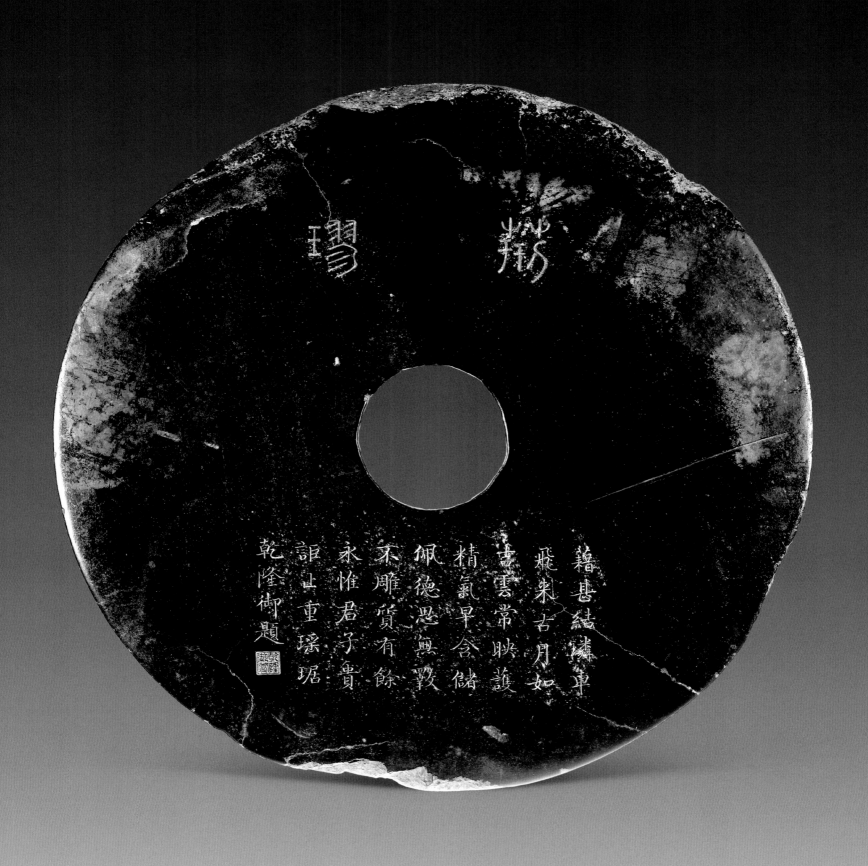

璿 蒼

藉甚結綺車
飛朱古月如
壽雲常映護
精氣早含儲
佩德思無斁
不雕質有餘
永惟君子貴
詎止重瑤琚
乾隆御題

新127824
玉环
齐家文化

218 径11厘米　孔径5.1厘米　厚0.5厘米

Xin 127824
Jade ring
Qijia Culture
Diameter: 11 cm　Internal diameter: 5.1 cm
Thickness: 0.5 cm

新196662

玉璜
齐家文化

219 长20.2厘米 端宽6.9厘米 厚0.7厘米

Xin 196662

Jade Huang
Qijia Culture

Length: 20.2 cm End width: 6.9 cm
Thickness: 0.7 cm

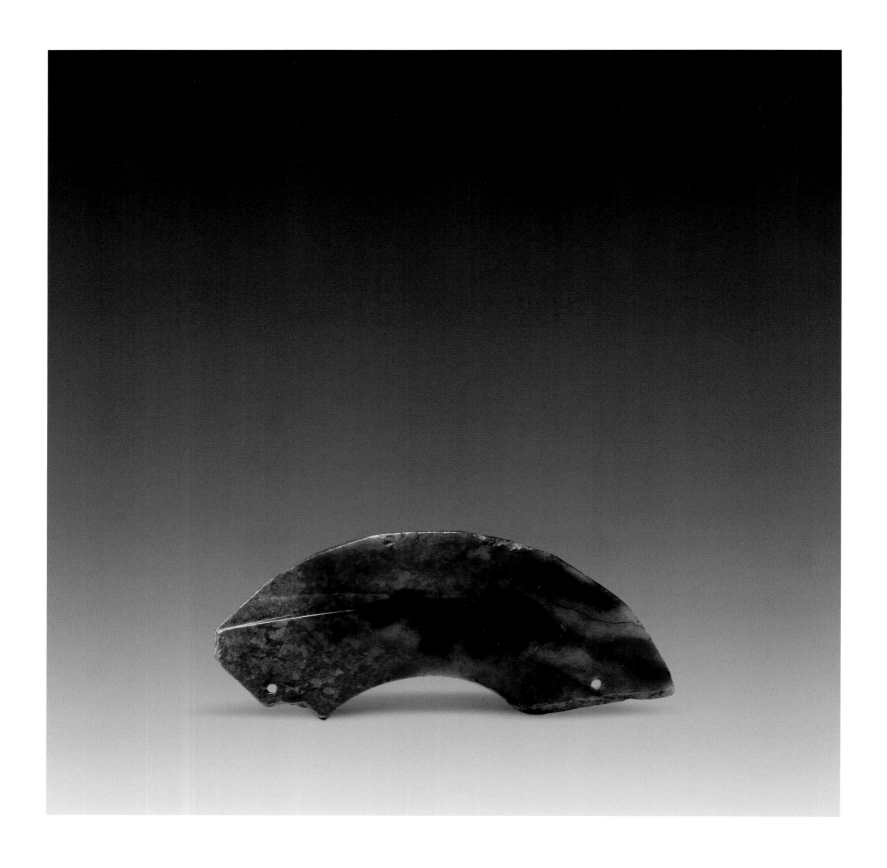

故94530

玉璜
齐家文化
长12厘米 端宽4厘米 厚0.5厘米

220

Gu 94530

Jade Huang
Qijia Culture

Length: 12 cm End width: 4 cm
Thickness: 0.5 cm

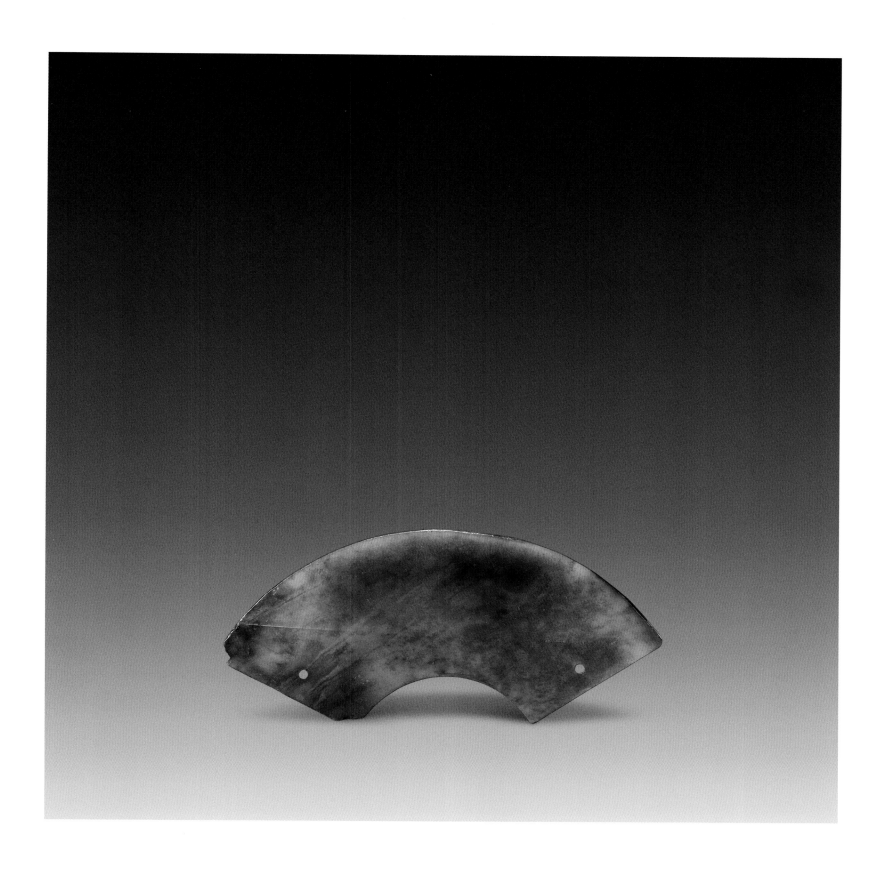

故84438

玉璜
齐家文化

221 长11.5厘米　端宽4.2厘米　厚0.4厘米

Gu 84438

Jade Huang
Qijia Culture

Length: 11.5 cm End width: 4.2 cm
Thickness: 0.4 cm

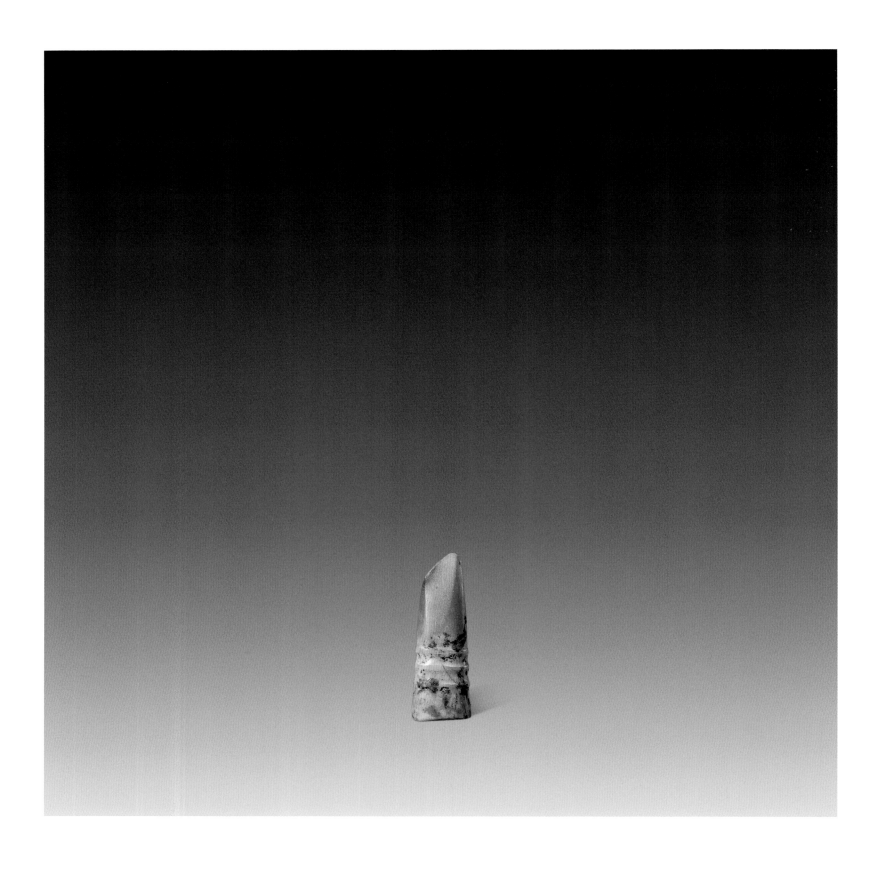

新116053
玉弦纹刀
新石器时代

222 长4.6厘米　宽1.6厘米　厚1.4厘米

Xin 116053
Jade knife with bowstring design
Neolithic Age

Length: 4.6 cm　Width: 1.6 cm
Thickness: 1.4 cm

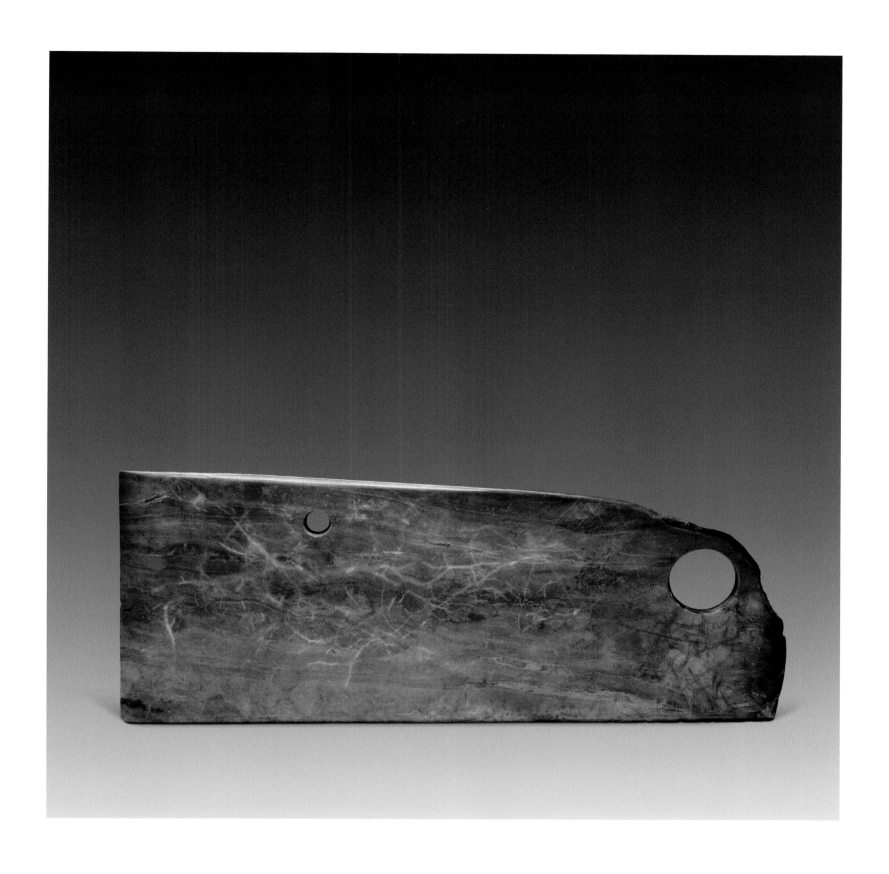

新142842

玉双孔刀
新石器时代

223 | 长21.3厘米 宽8.3厘米 厚0.3厘米

Xin 142842

Jade knife with two holes
Neolithic Age

Length: 21.3 cm Width: 8.3 cm
Thickness: 0.3 cm

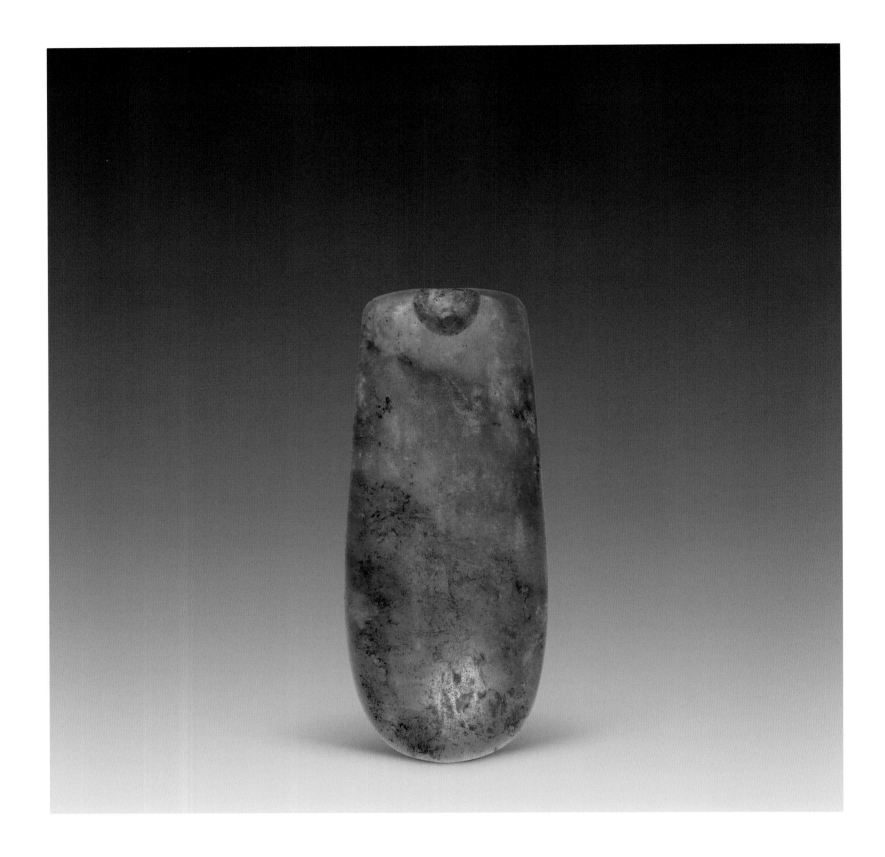

新143645
玉斧
新石器时代
224 | 长13厘米　宽5.5厘米　厚2厘米

Xin 143645
Jade axe
Neolithic Age
Length: 13 cm　Width: 5.5 cm
Thickness: 2 cm

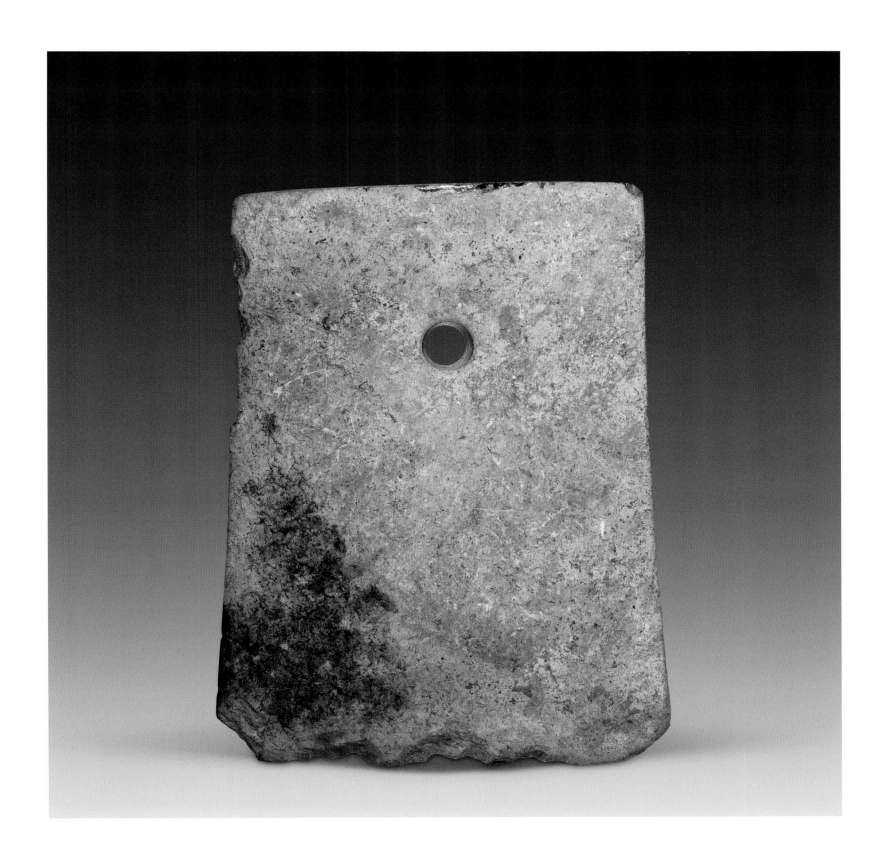

新143644

玉斧
新石器时代

225 | 长17.7厘米 宽13.3厘米 厚0.5厘米

Xin 143644

Jade axe
Neolithic Age

Length: 17.7 cm Width: 13.3 cm
Thickness: 0.5 cm

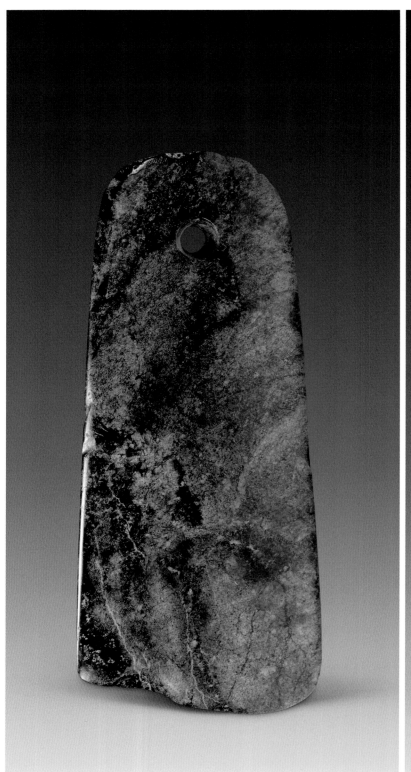

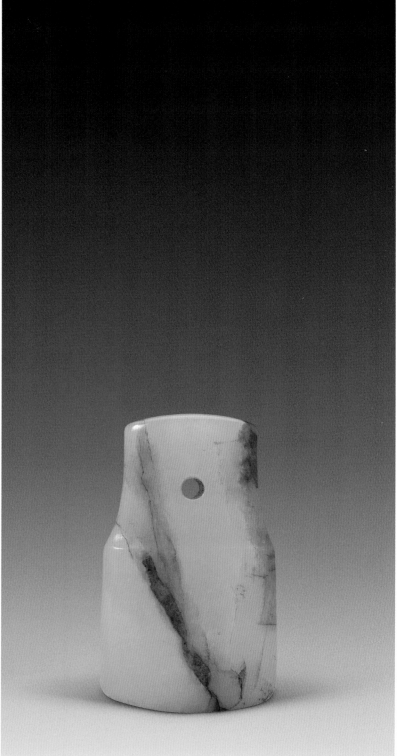

新123458

玉斧
新石器时代

长18.2厘米 宽7.5厘米 厚1.4厘米

226

Xin 123458

Jade axe
Neolithic Age

Length: 18.2 cm Width: 7.5 cm
Thickness: 1.4 cm

故94528

玉斧
新石器时代

长8.2厘米 宽4.7厘米 厚0.7厘米

227 备注：清宫改制

Gu 94528

Jade axe
Neolithic Age

Length: 8.2 cm Width: 4.7 cm
Thickness: 0.7 cm
Re-shaped in the Qing court

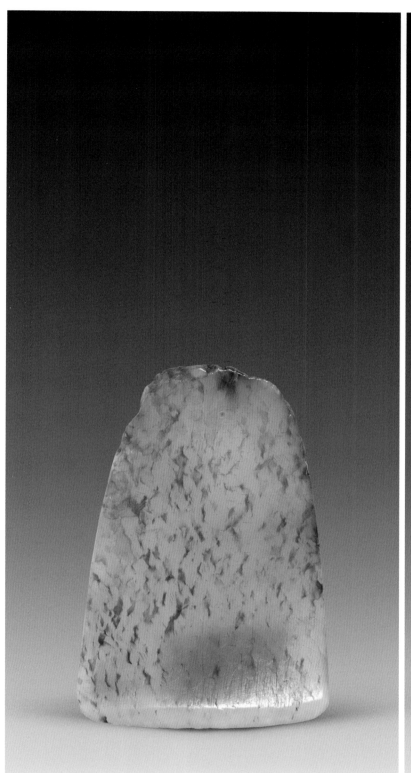

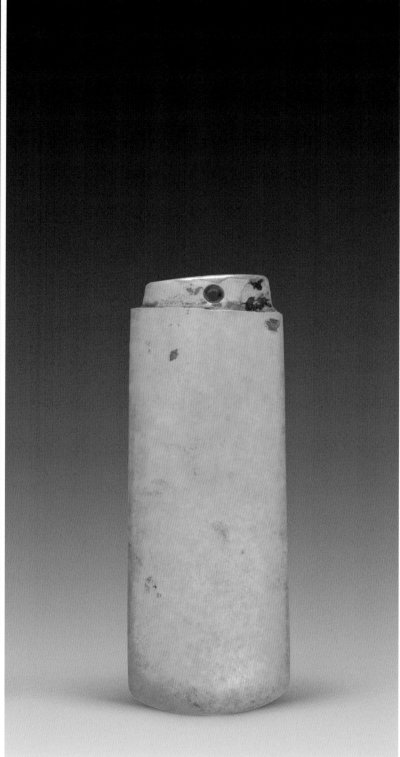

故95137

玉斧

新石器时代

228 | 长10厘米 宽6.7厘米 厚0.7厘米

Gu 95137

Jade axe
Neolithic Age

Length: 10 cm Width: 6.7 cm
Thickness: 0.7 cm

新116009

玉斧

新石器时代

229 | 长12.1厘米 宽4.3厘米 厚1厘米

Xin 116009

Jade axe
Neolithic Age

Length: 12.1 cm Width: 4.3 cm
Thickness: 1 cm

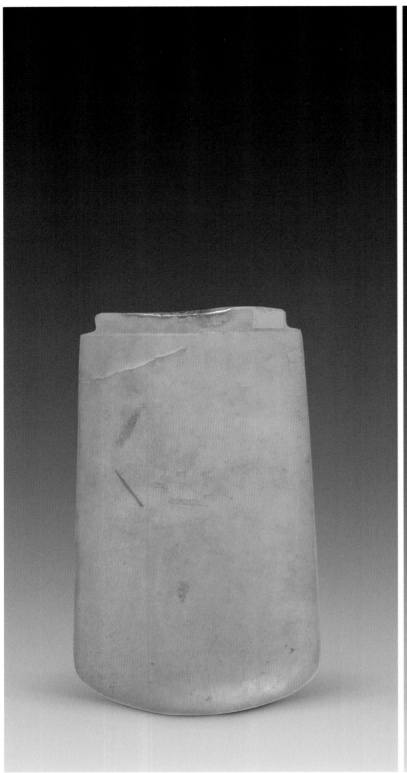

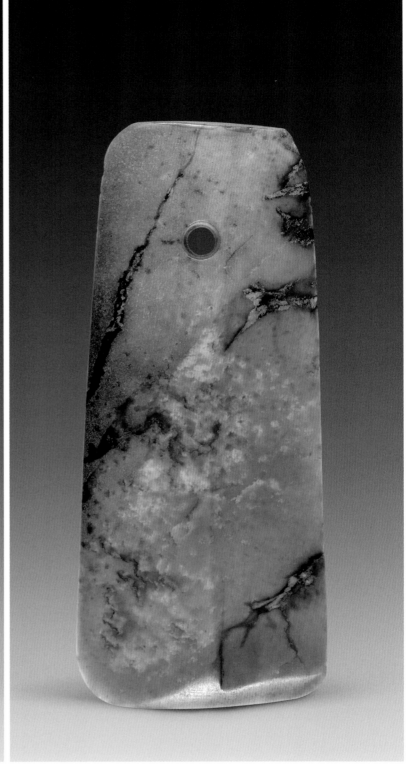

新112681

玉斧
新石器时代

230 | 长11.6厘米 宽6.8厘米 厚0.5厘米

Xin 112681

Jade axe
Neolithic Age

Length: 11.6 cm Width: 6.8 cm
Thickness: 0.5 cm

新123832

玉斧
新石器时代

231 | 长16.1厘米 宽6.7厘米 厚0.8厘米

Xin 123832

Jade axe
Neolithic Age

Length: 16.1 cm Width: 6.7 cm
Thickness: 0.8 cm

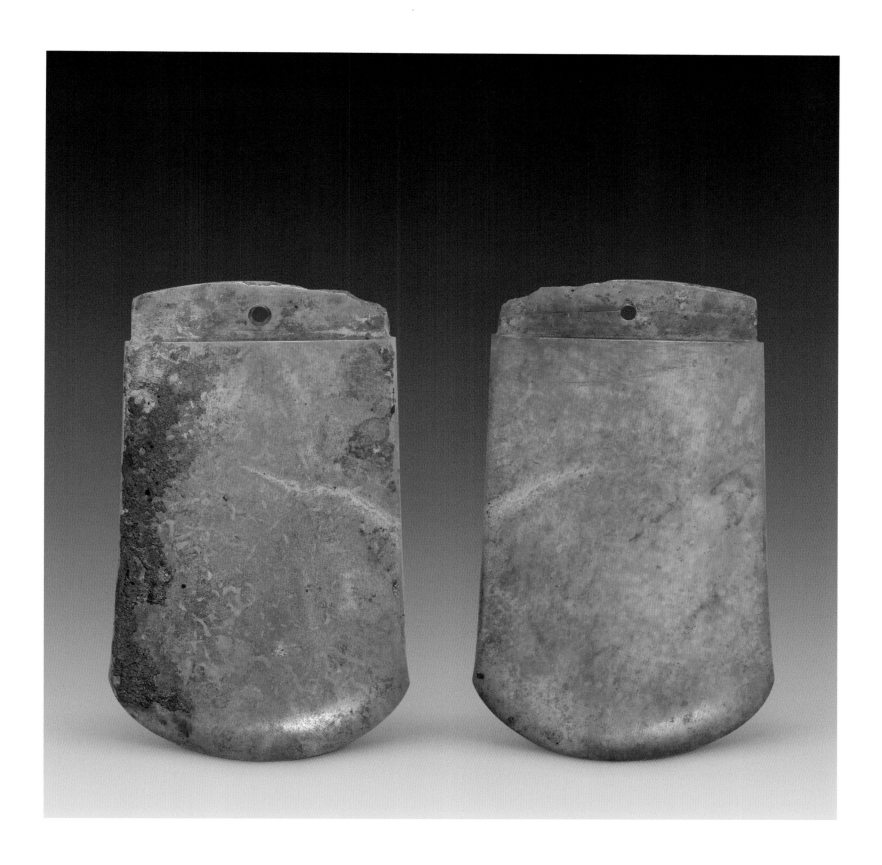

新18911

玉斧
新石器时代

232

长13.7厘米　宽8.3厘米　厚0.5厘米

Xin 18911
Jade axe
Neolithic Age
Length: 13.7 cm Width: 8.3 cm
Thickness: 0.5 cm

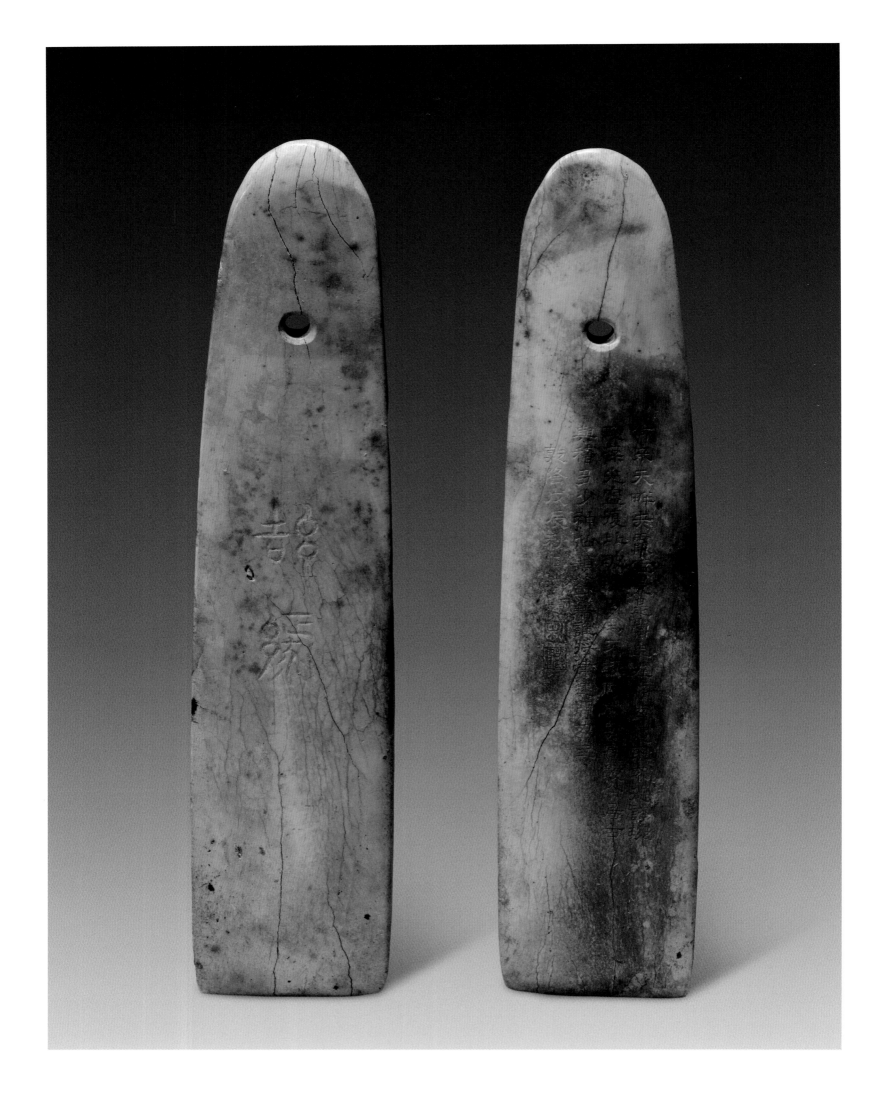

故89412

玉斧

新石器时代

长23.5厘米 宽5.2厘米 厚1.1厘米

备注：后刻字

233

Gu 89412

Jade axe
Neolithic Age

Length: 23.5 cm　Width: 5.2 cm
Thickness: 1.1 cm
With characters inscribed later

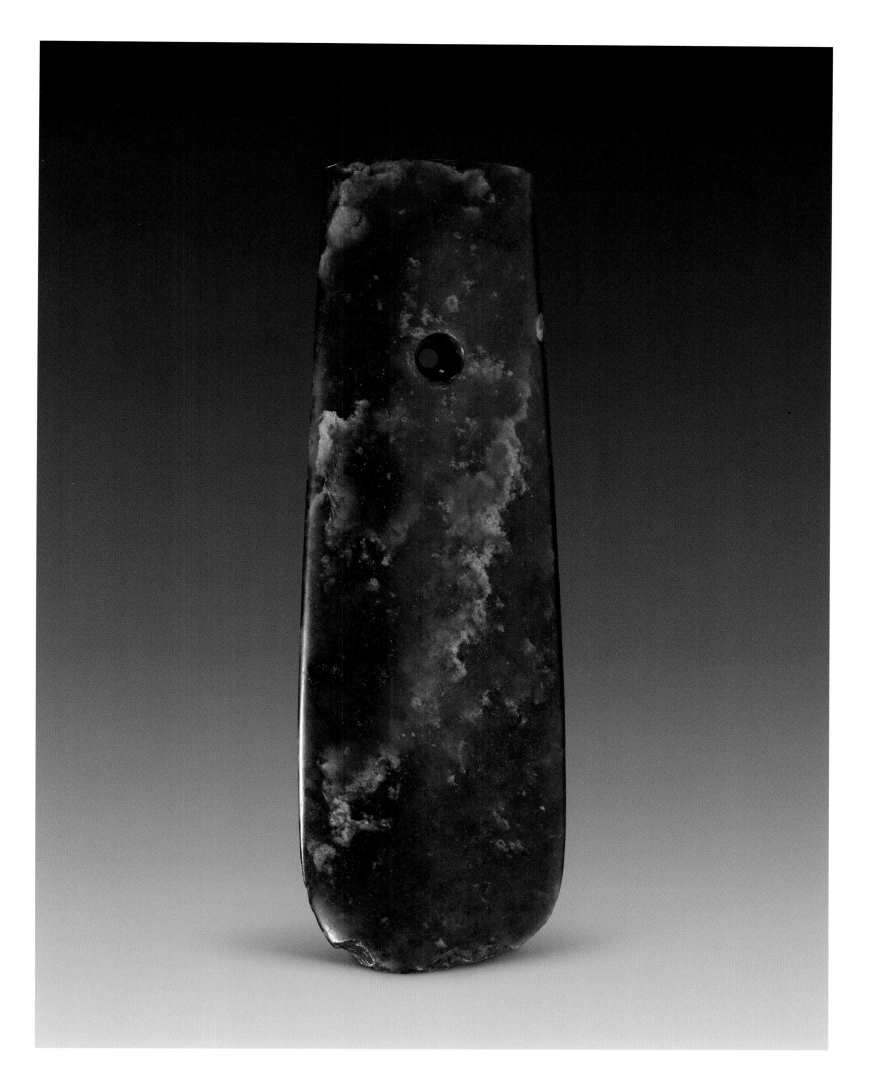

新14160

玉斧
新石器时代
长22.5厘米 宽7.2厘米 厚1.2厘米

234

Xin 14160

Jade axe
Neolithic Age
Length: 22.5 cm Width: 7.2 cm
Thickness: 1.2 cm

故83953

玉斧

新石器时代

长13.3厘米 宽5.9厘米 厚0.5厘米

备注：后刻乾隆题诗，附"含章比德"木函

Gu 83953

Jade axe
Neolithic Age

Length: 13.3 cm Width: 5.9 cm
Thickness: 0.5 cm
*With a poem by Emperor Qianlong and a wood box
inscribed with "Han Zhang Bi De"*

故84632

玉斧

新石器时代或商代

长9.6厘米 宽5.5厘米 厚0.5厘米

备注：清代刻纹，附乾隆年制款"表德含辉"木函

Gu 84632

Jade axe

Neolithic Age or Shang Dynasty

Length: 9.6 cm Width: 5.5 cm Thickness: 0.5 cm

With designs engraved in the Qing Dynasty and a wood box "Biao De Han Hui" made in Emperor Qianlong's regin

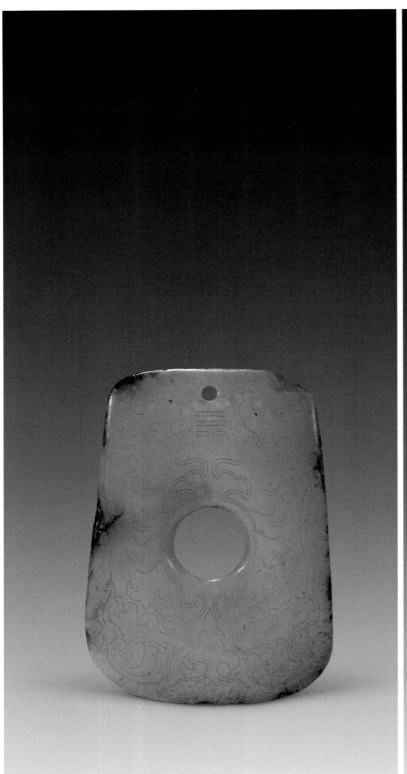

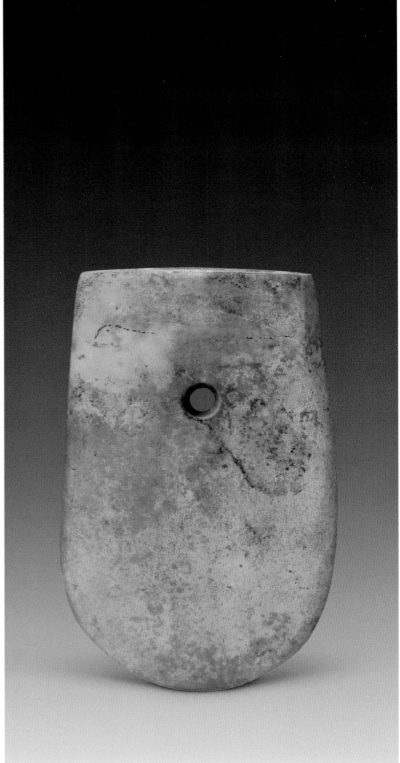

故94565

玉斧
新石器时代或商代

长9.2厘米　宽6.5厘米　厚0.6厘米

备注：清代刻纹

237

Gu 94565

Jade axe
Neolithic Age or Shang Dynasty

Length: 9.2 cm　Width: 6.5 cm
Thickness: 0.6 cm
With designs engraved in the Qing Dynasty

新141434

玉斧
新石器时代或商代

长11.6厘米　宽7.1厘米　厚0.8厘米

238

Xin 141434

Jade axe
Neolithic Age or Shang Dynasty

Length: 11.6 cm　Width: 7.1 cm
Thickness: 0.8 cm

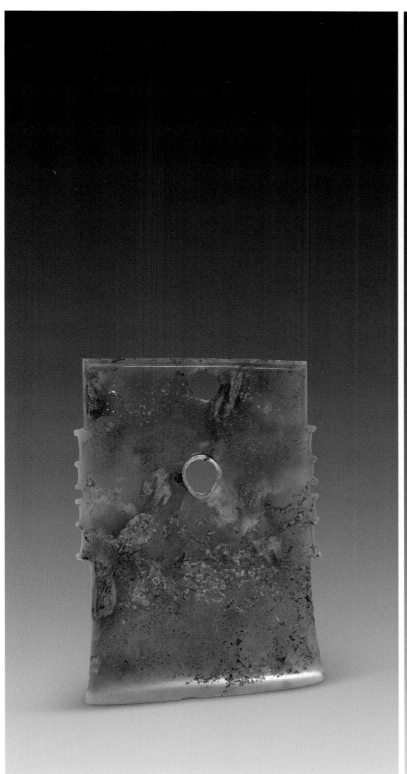

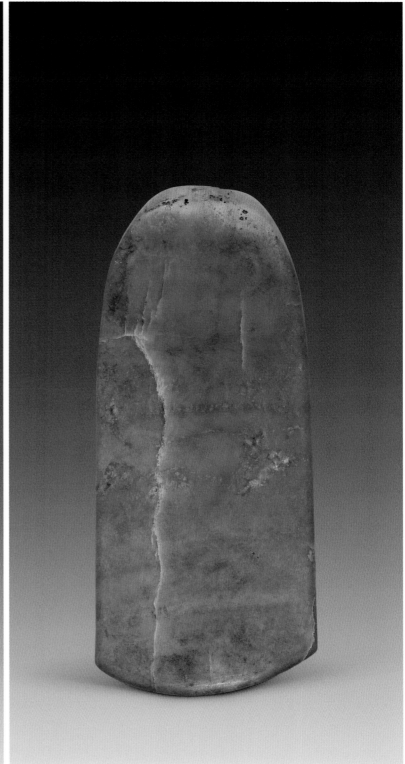

新74517
玉戚
新石器时代
长9.5厘米　宽6.5厘米　厚0.8厘米

239

Xin 74517
Jade Qi
Neolithic Age
Length: 9.5 cm　Width: 6.5 cm
Thickness: 0.8 cm

新72893
玉钺
新石器时代
长14厘米　宽5.7厘米　厚0.4厘米

240

Xin 72893
Jade Yue
Neolithic Age
Length: 14 cm　Width: 5.7 cm
Thickness: 0.4 cm

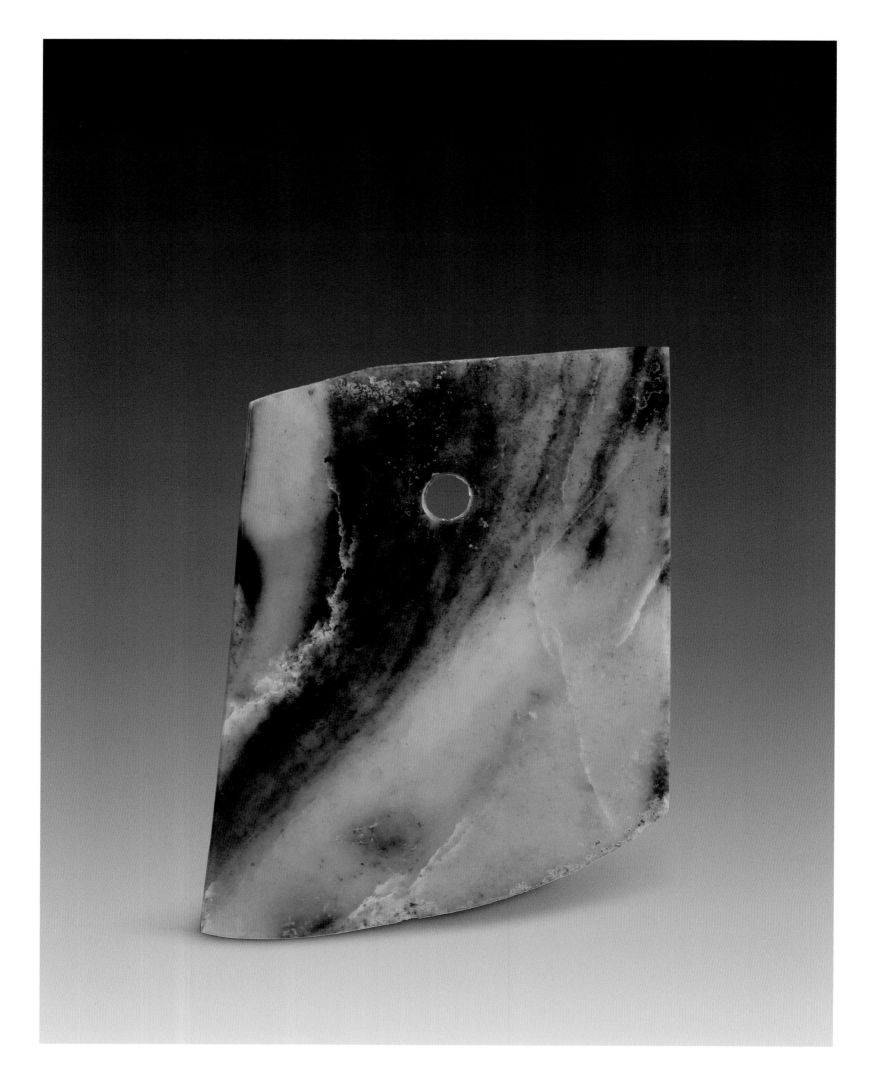

新51683
玉铲
新石器时代
241 | 长17厘米　宽14.8厘米　厚0.4厘米
Xin 51683
Jade spade
Neolithic Age
Length: 17 cm　Width: 14.8 cm
Thickness: 0.4 cm

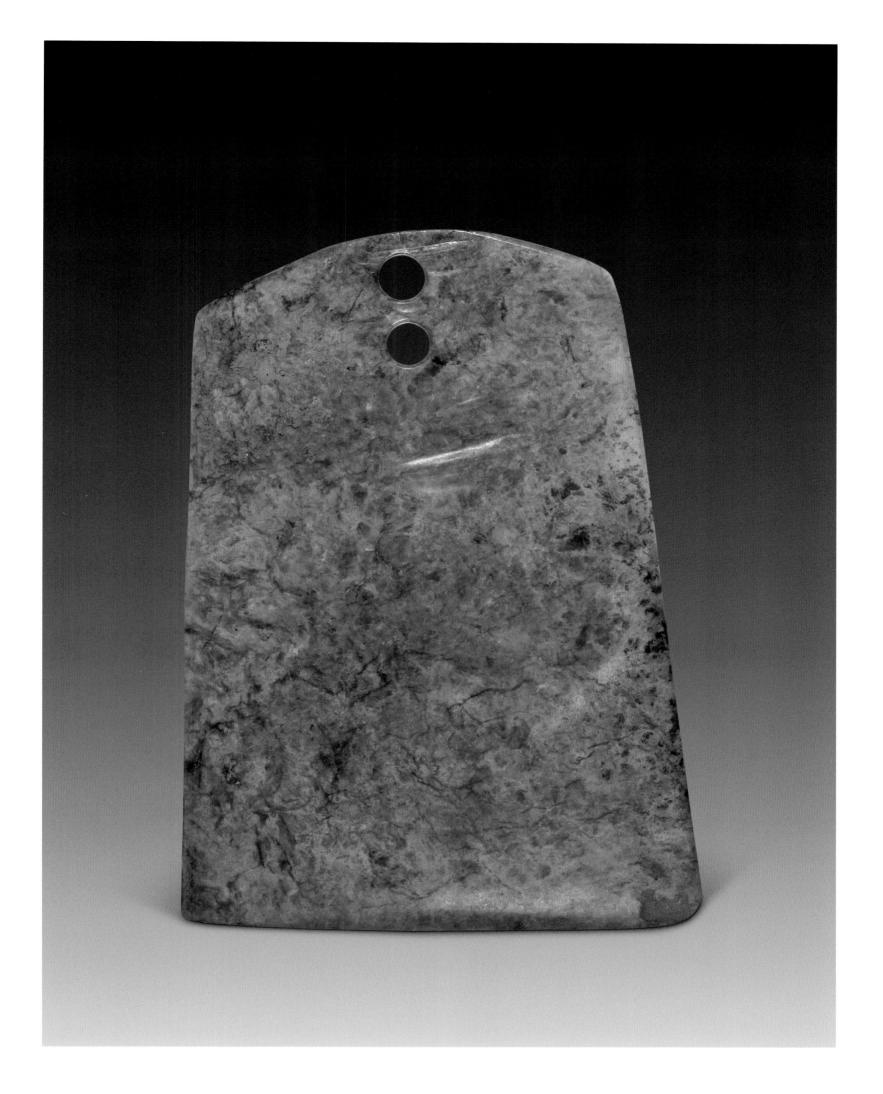

新106313

玉铲

新石器时代

242 长22.5厘米 宽16.3厘米 厚0.7厘米

Xin 106313

Jade spade
Neolithic Age

Length: 22.5 cm Width: 16.3 cm
Thickness: 0.7 cm

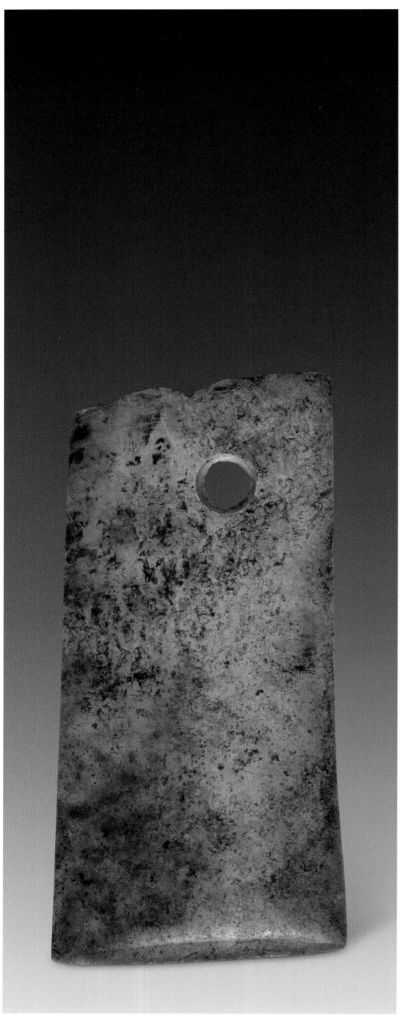

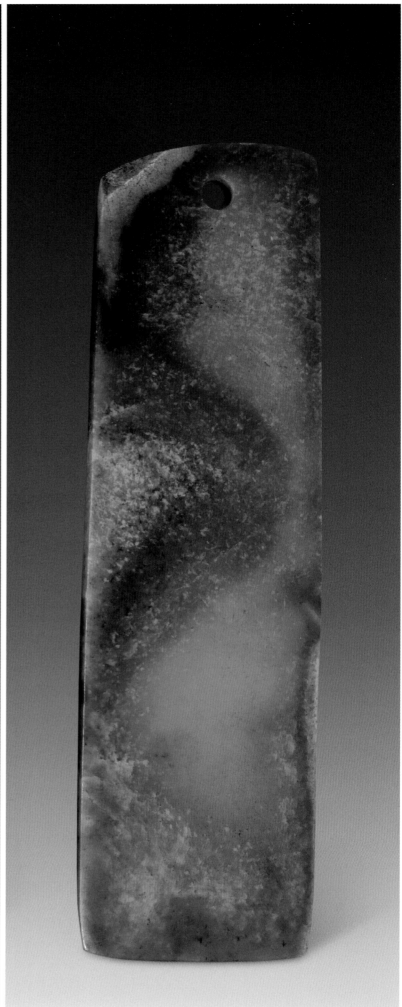

新116152
玉铲
新石器时代
243 | 长18厘米 宽8.9厘米 厚0.7厘米

Xin 116152
Jade spade
Neolithic Age
Length: 18 cm Width: 8.9 cm
Thickness: 0.7 cm

新98982
玉铲
新石器时代
长24.8厘米 宽7厘米 厚1.1厘米
备注：边及表面有改动
244 | Xin 98982
Jade spade
Neolithic Age
Length: 24.8 cm Width: 7 cm
Thickness: 1.1 cm
With the edge and surface re-shaped

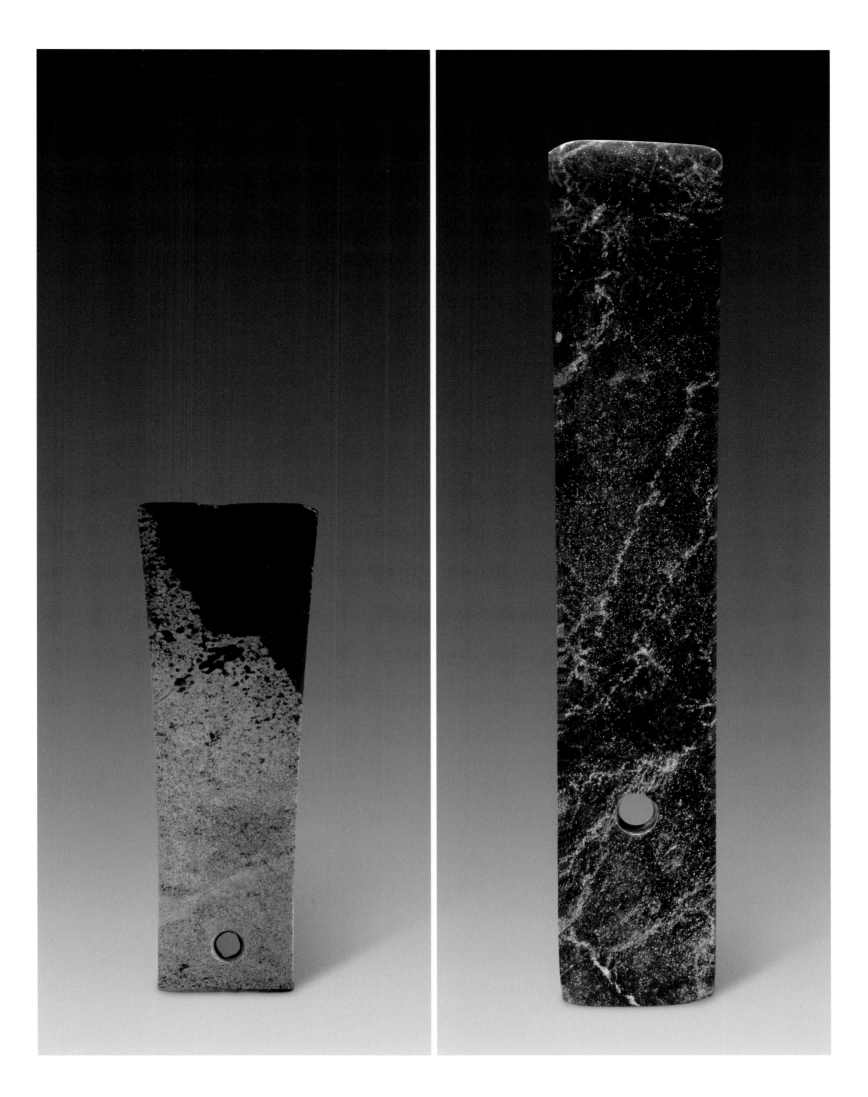

新105778
玉圭
新石器时代
245 | 长14.7厘米 宽5.2厘米 厚0.5厘米

Xin 105778
Jade Gui
Neolithic Age
Length: 14.7 cm Width: 5.2 cm
Thickness: 0.5 cm

新151152
玉圭
新石器时代
246 | 长26.3厘米 宽5.2厘米 厚1厘米

Xin 151152
Jade Gui
Neolithic Age
Length: 26.3 cm Width: 5.2 cm
Thickness: 1 cm

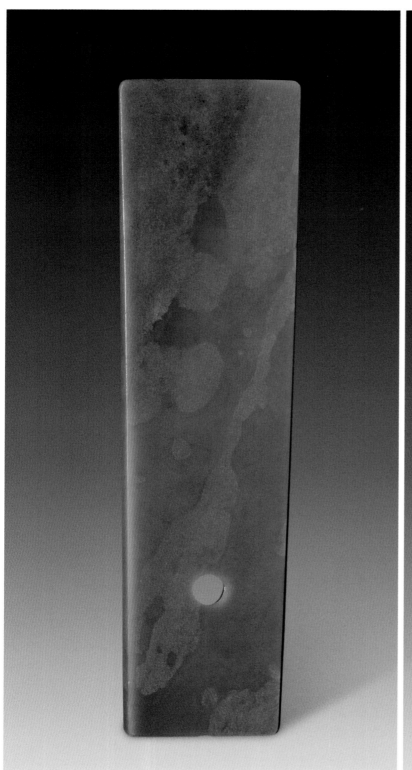

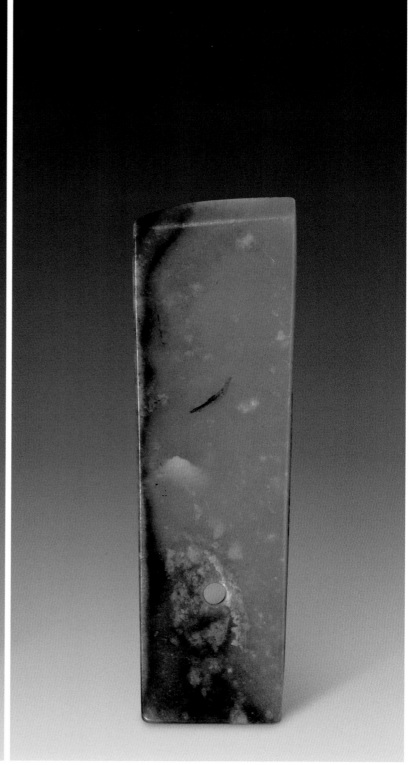

新115426
玉圭
新石器时代
长18厘米　宽4.9厘米　厚0.8厘米
247
Xin 115426
Jade Gui
Neolithic Age
Length: 18 cm　Width: 4.9 cm
Thickness: 0.8 cm

故95071
玉圭
新石器时代
长14.5厘米　宽4.4厘米　厚0.7厘米
248
Gu 95071
Jade Gui
Neolithic Age
Length: 14.5 cm　Width: 4.4 cm
Thickness: 0.7 cm

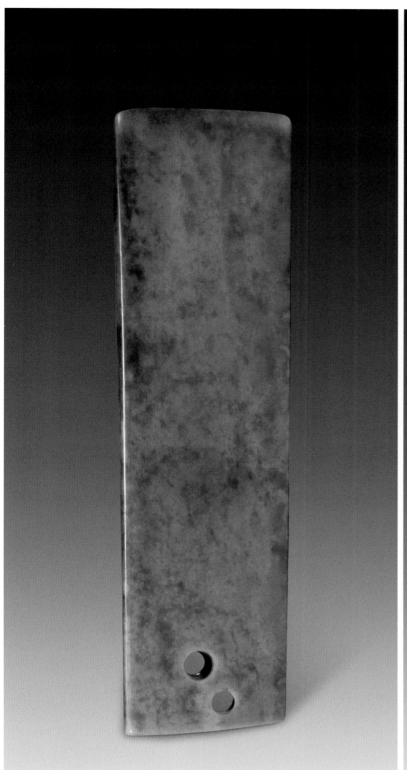

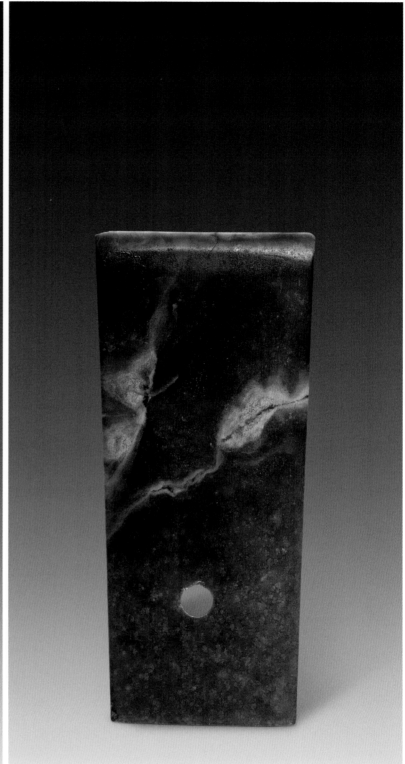

新127861

玉圭

新石器时代

249 | 长17.2厘米　宽4.6厘米　厚0.9厘米

Xin 127861

Jade Gui
Neolithic Age

Length: 17.2 cm　Width: 4.6 cm
Thickness: 0.9 cm

新105779

玉圭

新石器时代

250 | 长13.6厘米　宽5.8厘米　厚0.4厘米

Xin 105779

Jade Gui
Neolithic Age

Length: 13.6 cm　Width: 5.8 cm
Thickness: 0.4 cm

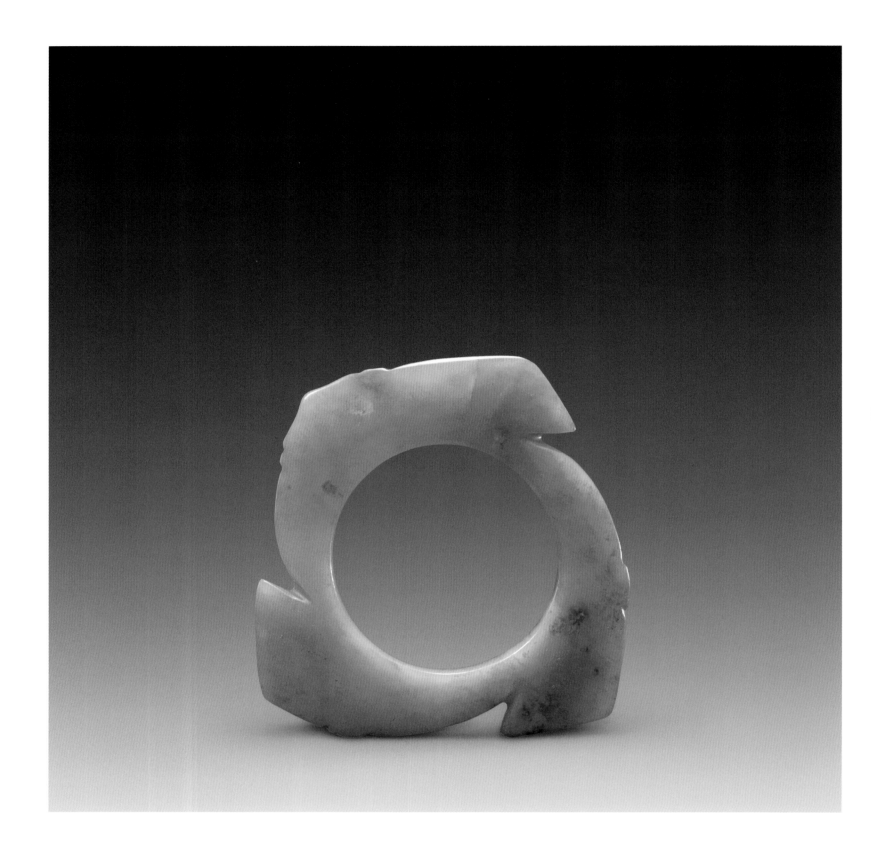

新156500

玉璇玑

新石器时代

251 径10.4厘米 孔径6.4厘米 厚0.8厘米

Xin 156500

Jade Xuanji
Neolithic Age

Diameter: 10.4 cm Internal diameter: 6.4 cm
Thickness: 0.8 cm

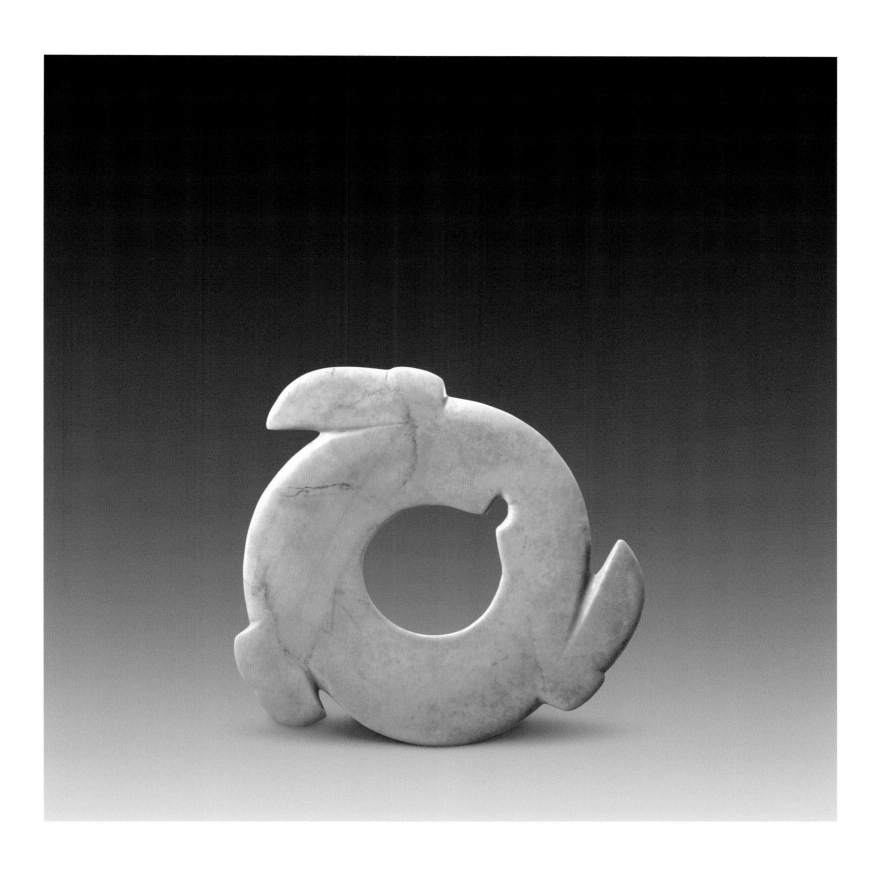

新110038

玉璇玑
新石器时代或商代

252 径10.5厘米 孔径3.3厘米 厚0.4厘米

Xin 110038
Jade Xuanji
Neolithic Age or Shang Dynasty
Diameter: 10.5 cm Internal diameter: 3.3 cm
Thickness: 0.4 cm

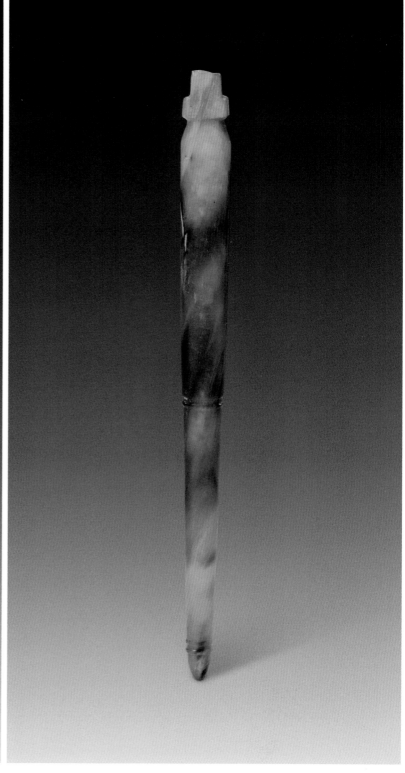

新116223

玉人首

新石器时代或商

253 | 高4.5厘米　宽3.5厘米　厚1.1厘米

Xin 116223

Jade human head

Neolithic Age or Shang Dynasty

Height: 4.5 cm　Width: 3.5 cm

Thickness: 1.1 cm

新93128

玉笄

新石器时代

254 | 长17.4厘米　宽1.3厘米

Xin 93128

Jade hairpin

Neolithic Age

Length: 17.4 cm　Width: 1.3 cm

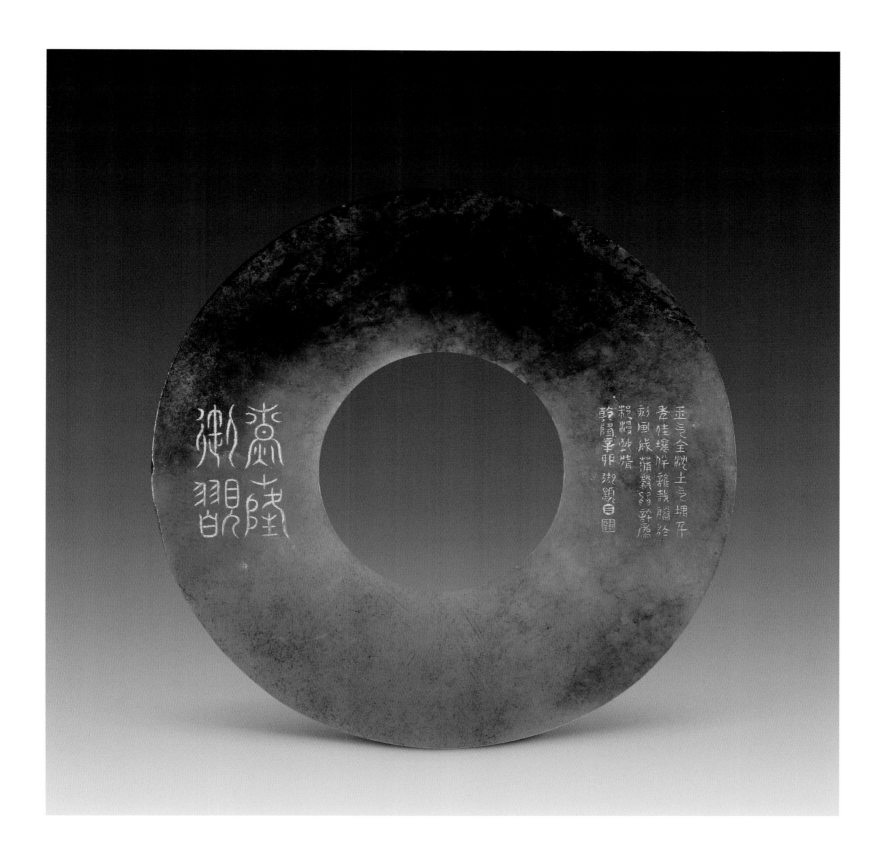

故83909

玉璧

新石器时代

径15.2厘米　孔径6.3厘米　厚0.6厘米

备注：后刻乾隆题诗

255

Gu 83909

Jade Bi

Neolithic Age

Diameter: 15.2 cm Internal diameter: 6.3 cm
Thickness: 0.6 cm
Inscribed with a poem by Emperor Qianlong

故84930

玉璧

新石器时代

径6.8厘米 孔径3厘米

备注：附清代紫檀容镜盒

256

Gu 84930

Jade Bi

Neolithic Age

Diameter: 6.8 cm Internal diameter: 3 cm

With a red sandalwood box for mirror of the Qing Dynasty

故84925

玉璧

新石器时代

径7.8厘米 孔径3.5厘米

备注：附清代紫檀容镜盒

257

Gu 84925

Jade Bi

Neolithic Age

Diameter: 7.8 cm Internal diameter: 3.5 cm

With a red sandalwood box for mirror of the Qing Dynasty

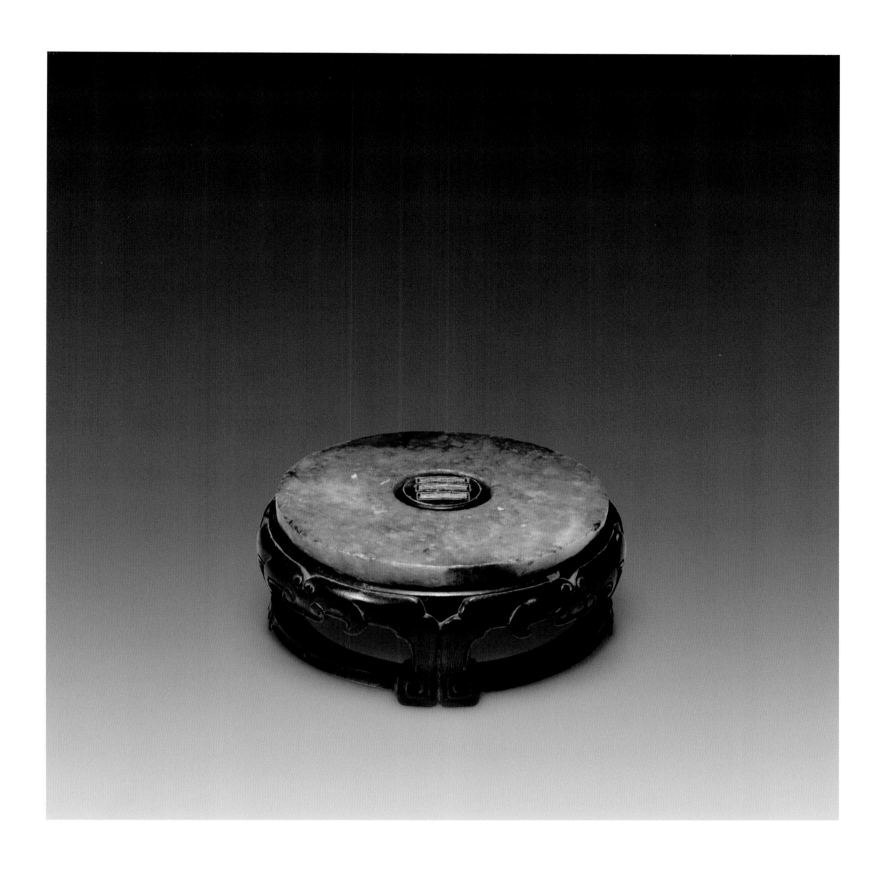

故84929
玉璧
新石器时代
径8.9厘米 孔径2.4厘米

258

备注：附清代木座

Gu 84929
Jade Bi
Neolithic Age
Diameter: 8.9 cm Internal diameter: 2.4 cm
With a wood base equipped in the Qing Dynasty

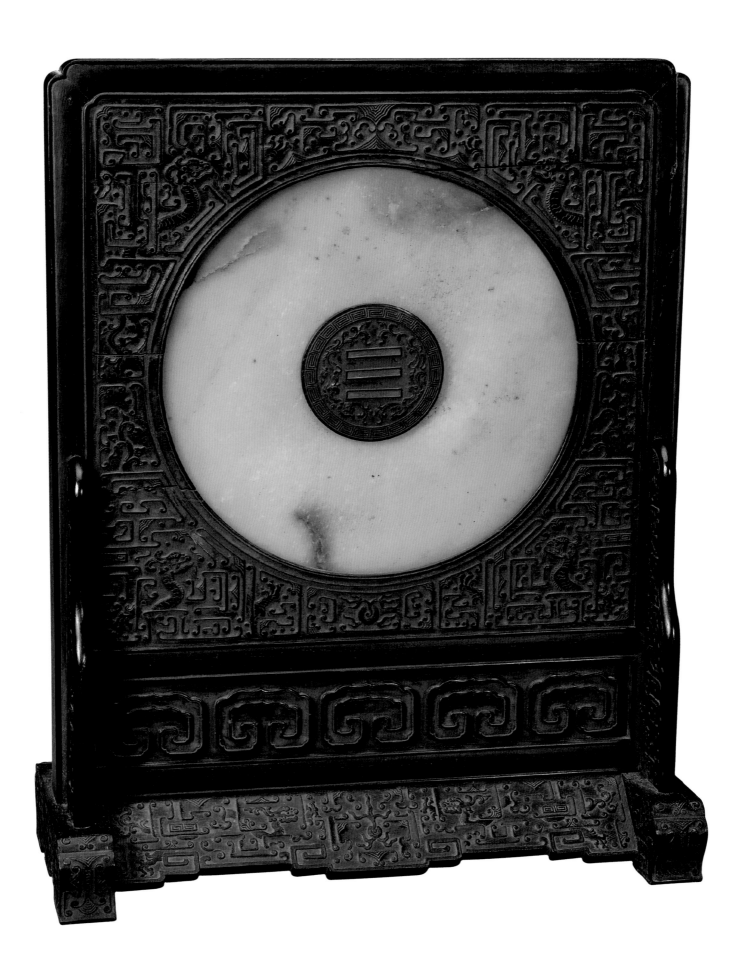

故100541

玉璧

新石器时代

径23.1厘米 孔径7.5厘米 厚0.9厘米

备注：后配乾隆题诗紫檀框座

259

Gu 100541

Jade Bi

Neolithic Age

Diameter: 23.1 cm Internal diameter: 7.5 cm

Thickness: 0.9 cm

With a red sandalwood stand and inscribed with a poem
by Emperor Qianlong

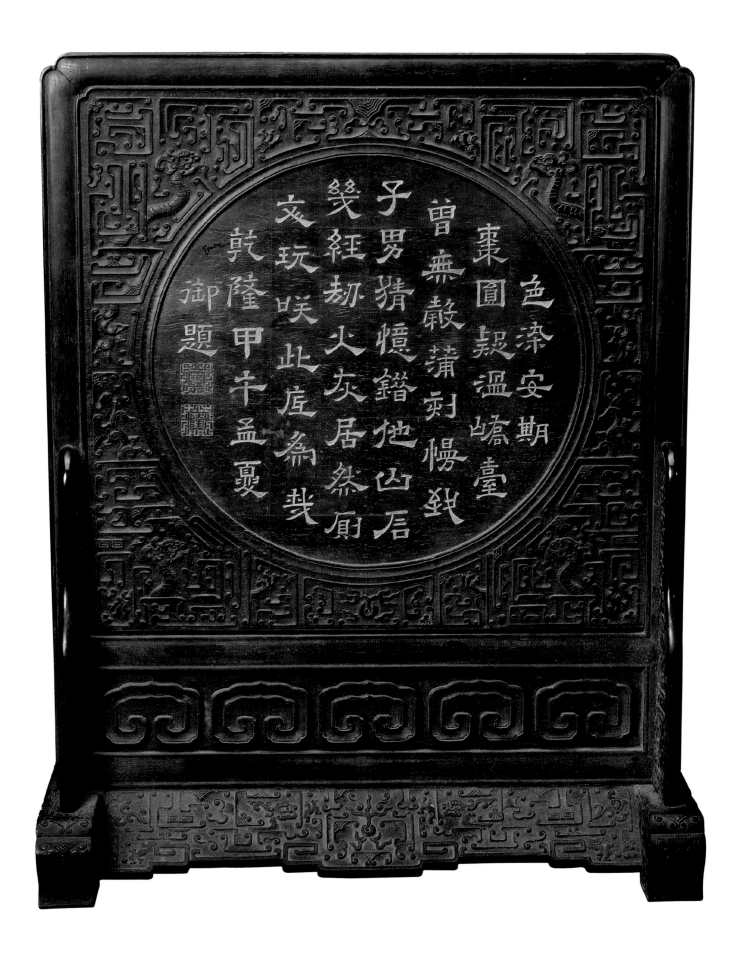

色渌安期
棗圓觳溫㠔臺
曾無穀蒲剹惕致
子男猜憶鎔他山后
燹經劫火灰居然厨
文玩暎此庭為㦸
乾隆甲午孟夏
御題

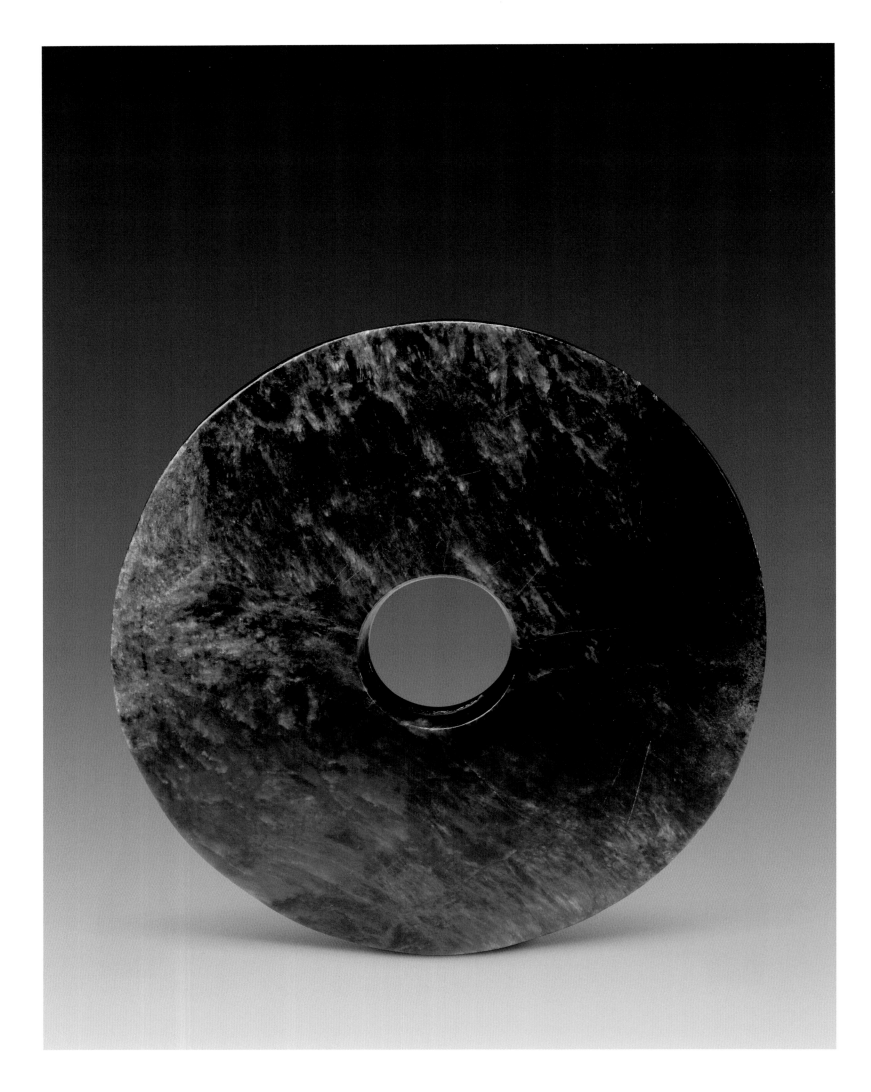

故95744

玉璧
新石器时代

径18.3厘米 孔径4.4厘米 厚1.3厘米

260

Gu 95744

Jade Bi
Neolithic Age

Diameter: 18.3 cm Internal diameter: 4.4 cm
Thickness: 1.3 cm

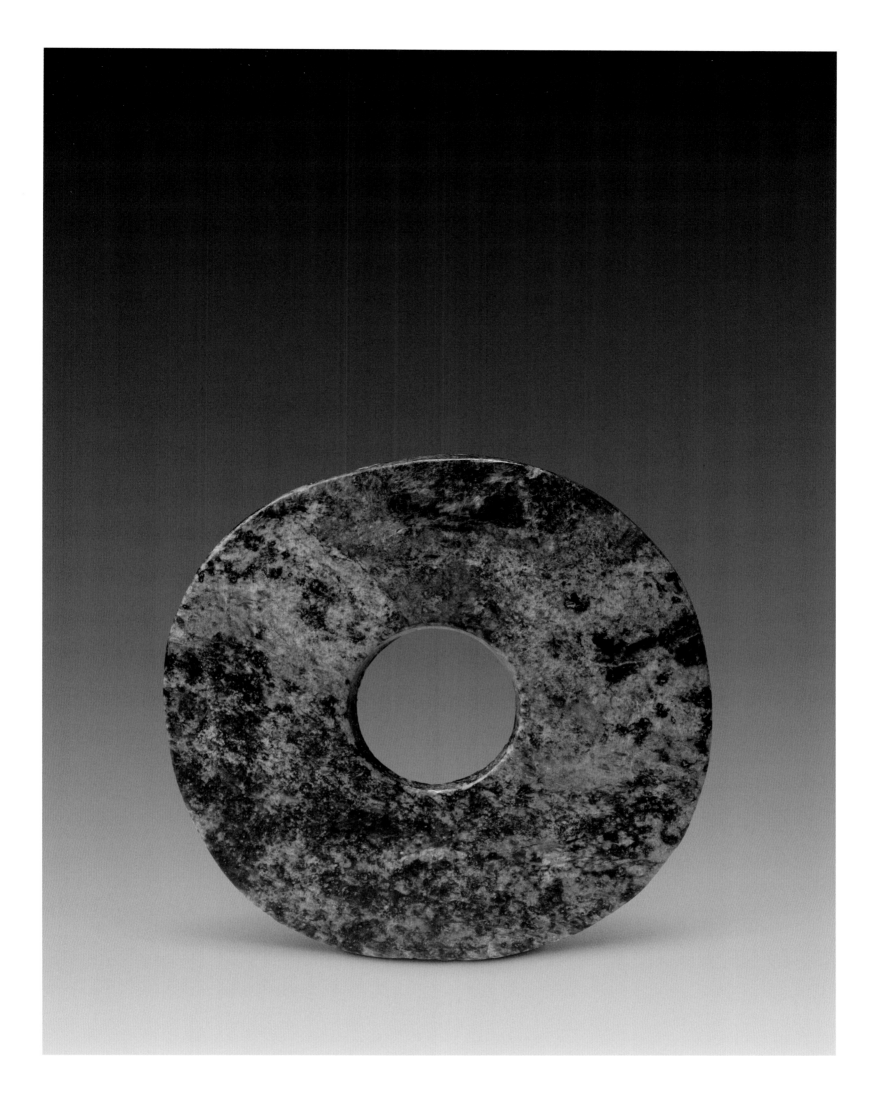

新117155

玉璧
新石器时代

径15厘米　孔径4.6厘米　厚1.1厘米

261

Xin 117155

Jade Bi
Neolithic Age

Diameter: 15 cm Internal diameter: 4.6 cm
Thickness: 1.1 cm

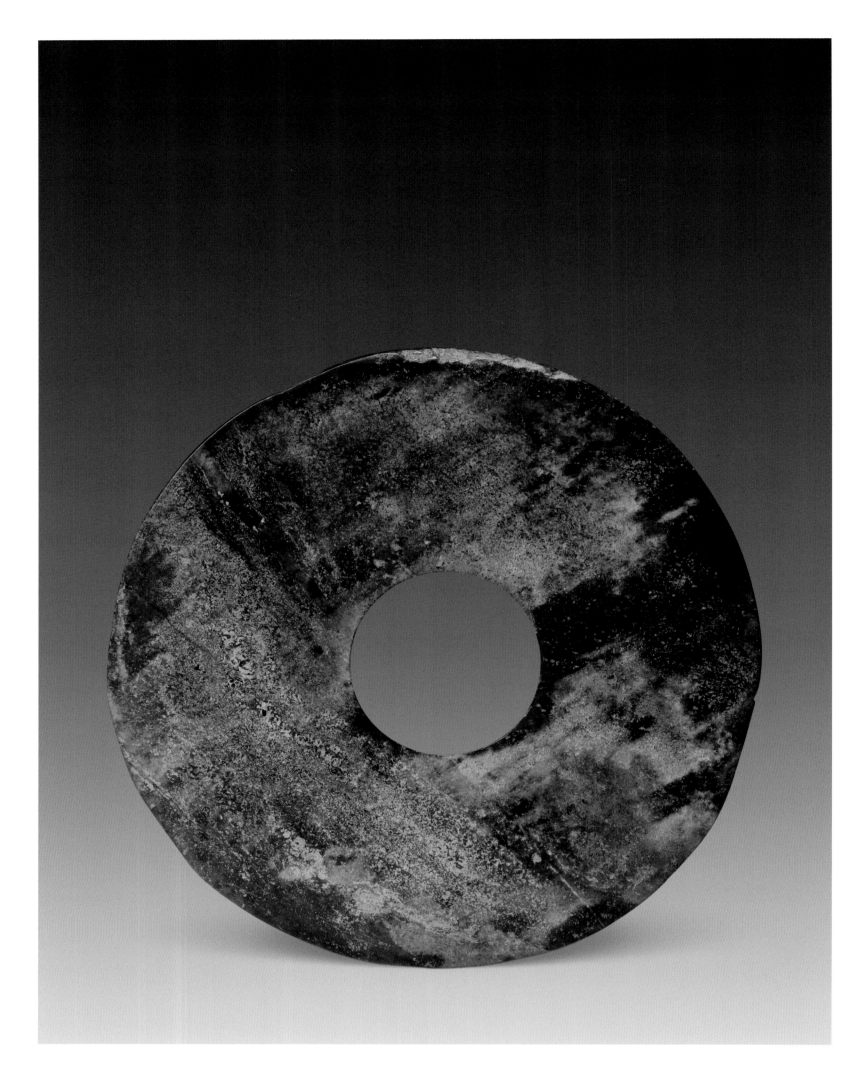

新99032

玉璧

新石器时代

262 | 径18.8厘米 孔径5.5厘米 厚0.6厘米

Xin 99032

Jade Bi

Neolithic Age

Diameter: 18.8 cm Internal diameter: 5.5 cm
Thickness: 0.6 cm

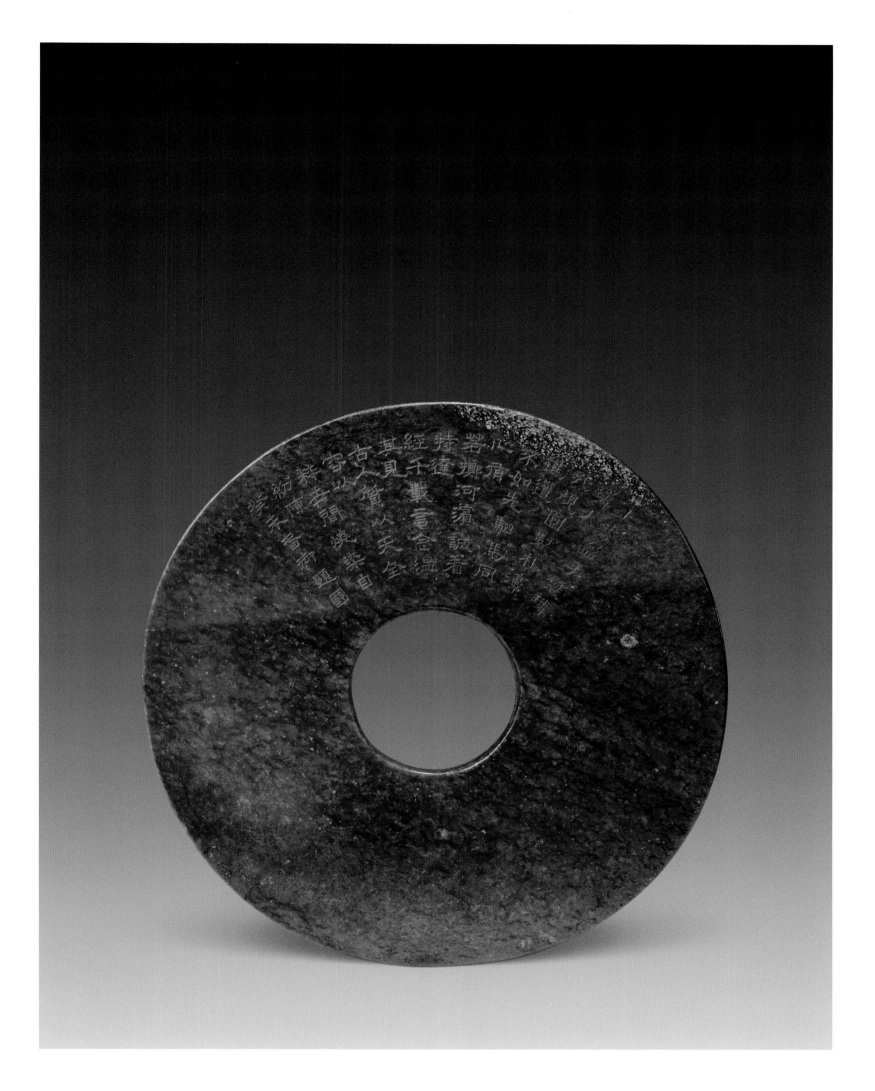

故83908

玉璧

新石器时代

径15.9厘米　孔径4.5厘米　厚1.1厘米

备注：后刻乾隆《题汉玉璧》诗

Gu 83908

Jade Bi
Neolithic Age

Diameter: 15.9 cm Internal diameter: 4.5 cm
Thickness: 1.1 cm
*With a poem "Ti Han Yu Bi"(Inscribed to Han
jade Bi) by Emperor Qianlong*

263

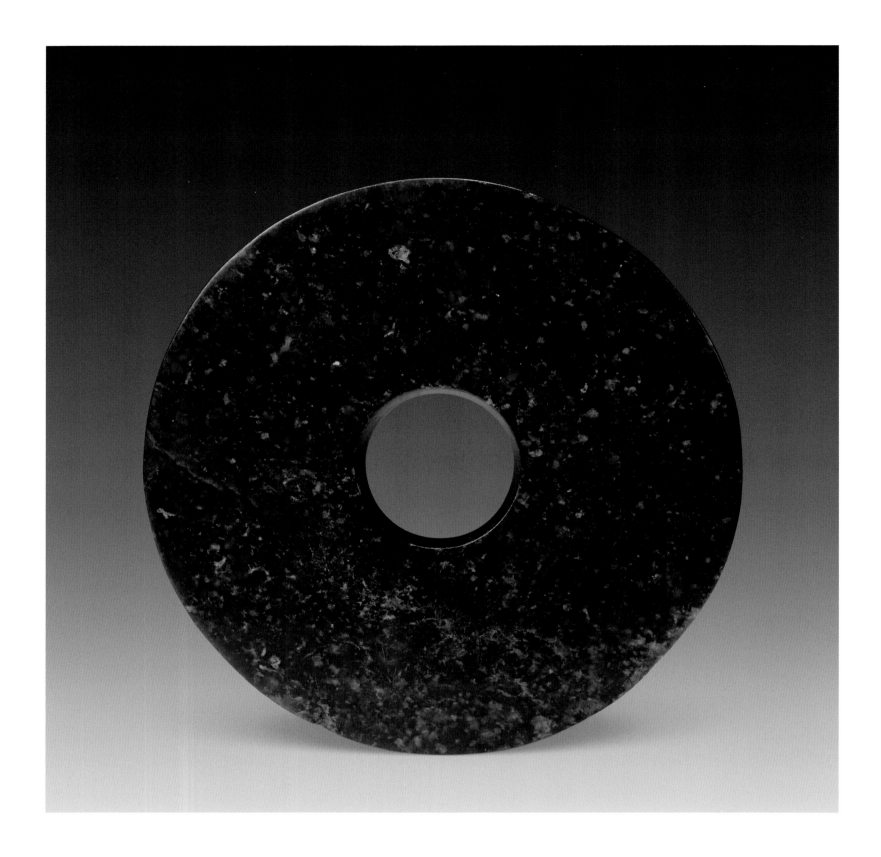

新123894

玉璧

新石器时代

264 径17.6厘米　孔径4.5厘米　厚0.8厘米

Xin 123894

Jade Bi
Neolithic Age

Diameter: 17.6 cm　Internal diameter: 4.5 cm
Thickness: 0.8 cm

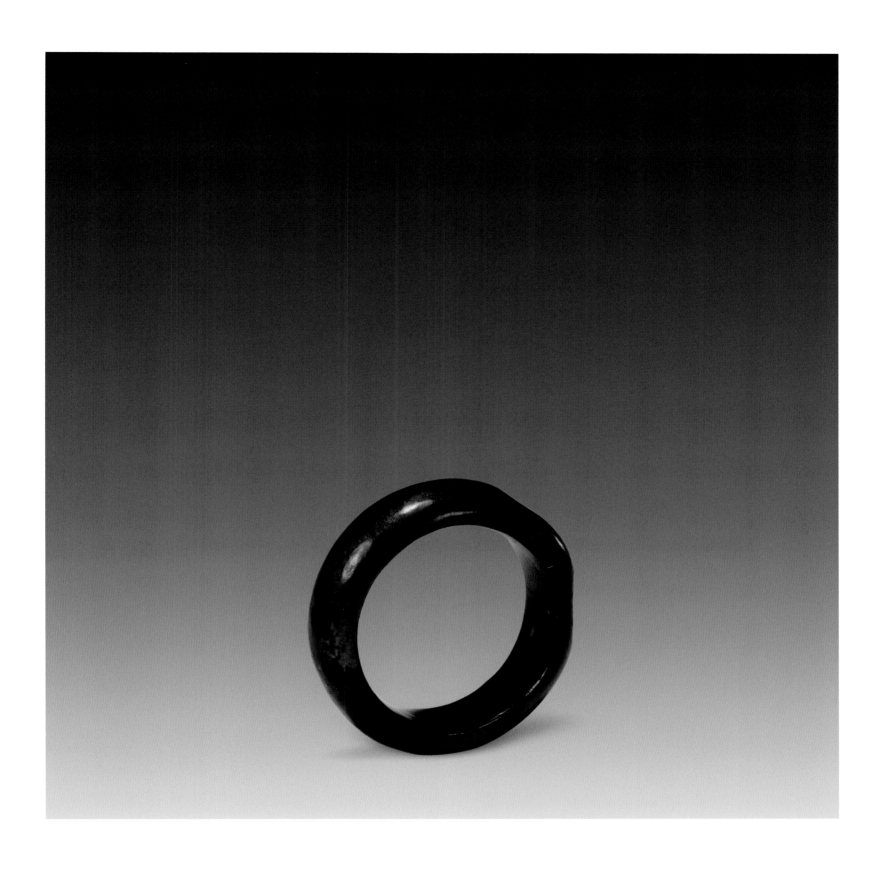

新123357
玉镯
新石器时代
径7.6厘米 孔径5.7厘米

265

Xin 123357
Jade bracelet
Neolithic Age
Diameter: 7.6 cm
Internal diameter: 5.7 cm

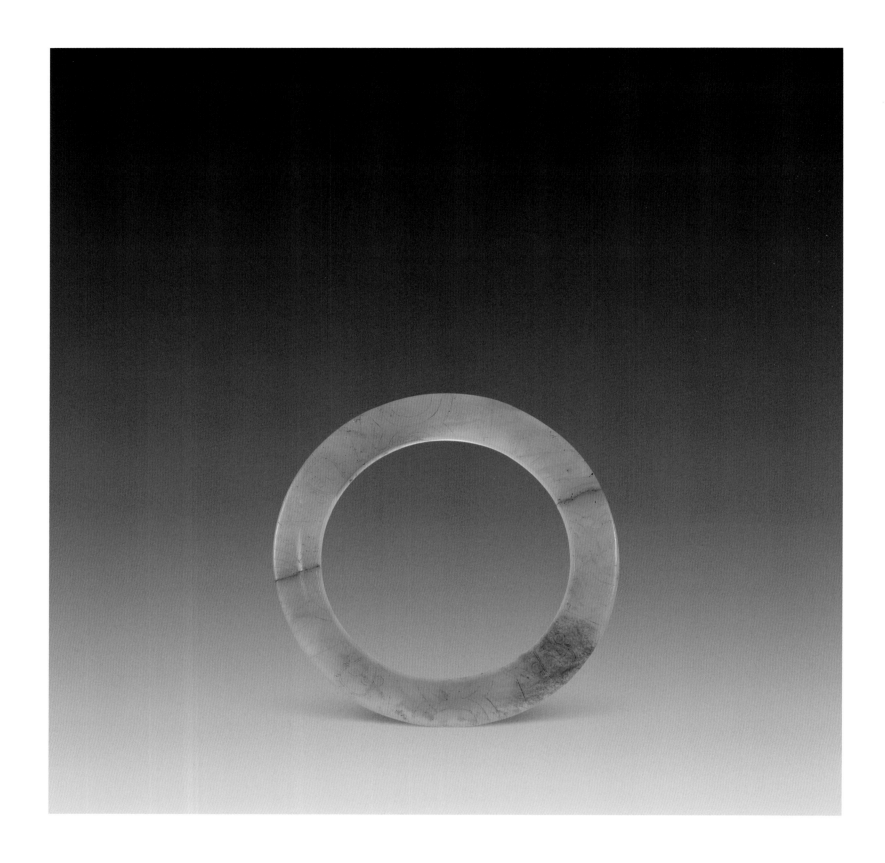

新143912
玉人面纹环
新石器时代
266 径9.1厘米 孔径6.5厘米

Xin 143912
Jade ring with human-face design
Neolithic Age
Diameter: 9.1 cm
Internal diameter: 6.5 cm

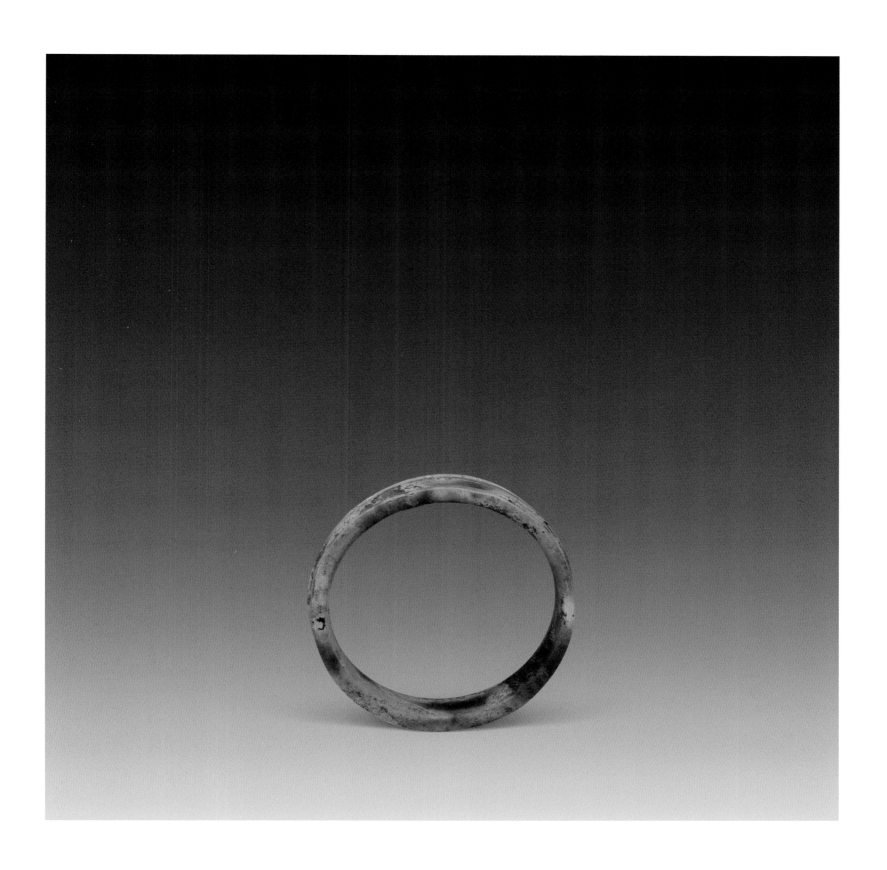

新78657
玉弦纹环
新石器时代
径7.1厘米　孔径6.2厘米

267

Xin 78657
Jade ring with bowstring design
Neolithic Age
Diameter: 7.1 cm　Internal diameter: 6.2 cm

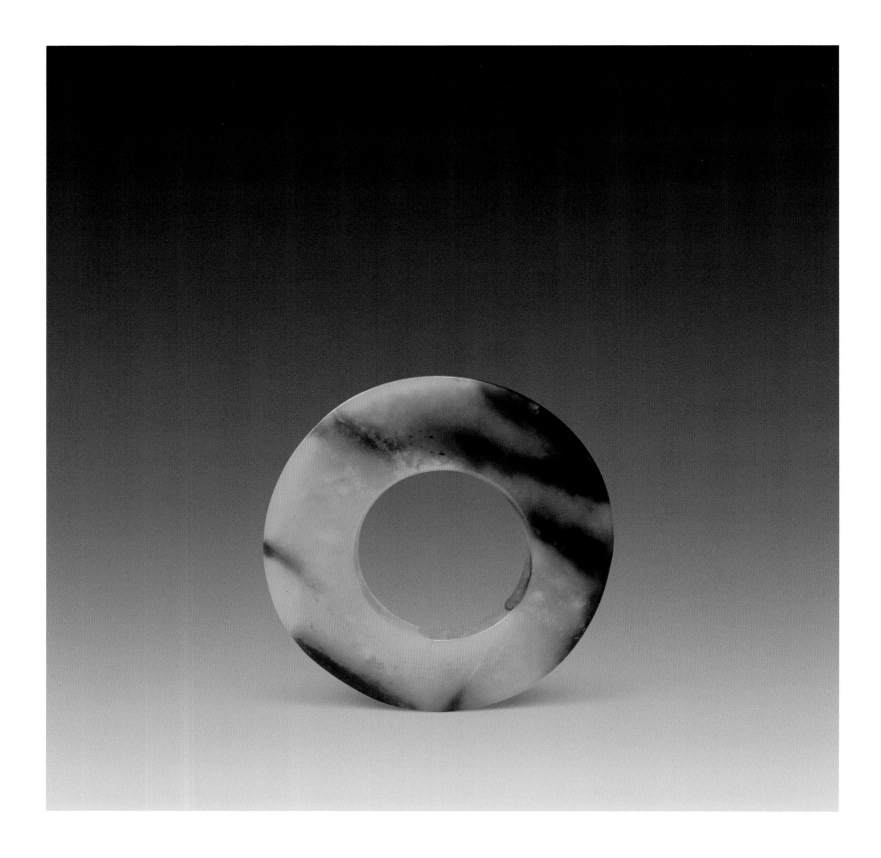

故84927

玉环

新石器时代

径9.3厘米 孔径4.4厘米 厚0.6厘米

备注：附清代木盒

268

Gu 84927

Jade ring

Neolithic Age

Diameter: 9.3 cm Internal diameter: 4.4 cm
Thickness: 0.6 cm

With a wood box of the Qing Dynasty

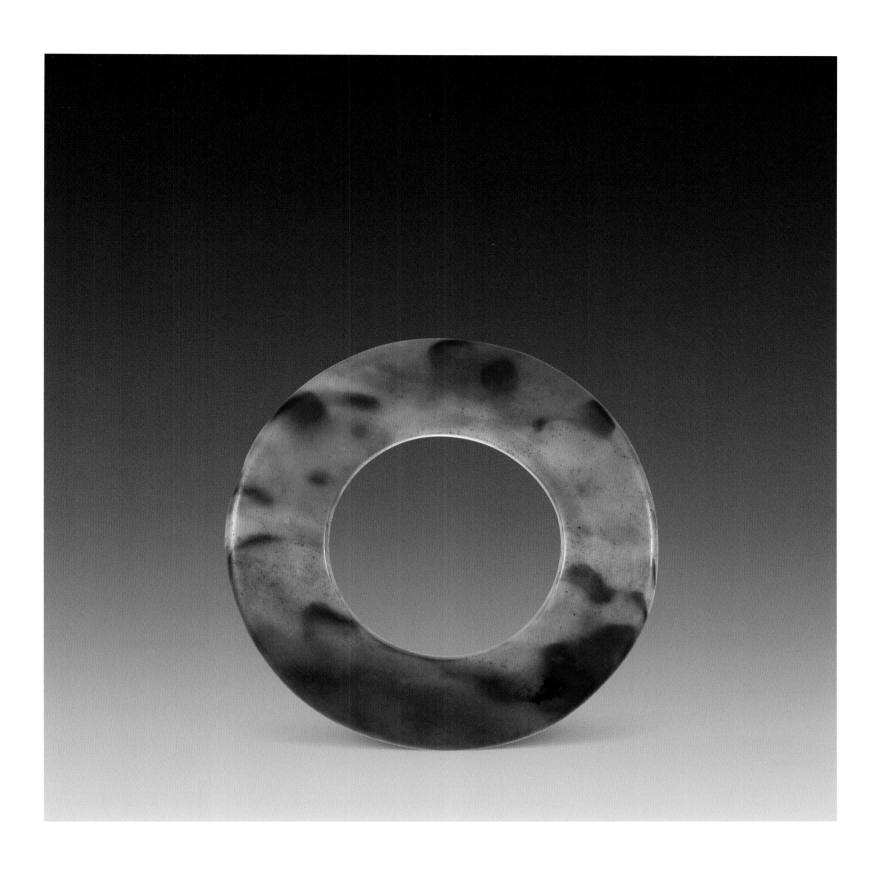

故83871
玉环
新石器时代
269 | 径11.5厘米 孔径6.2厘米 厚0.8厘米
Gu 83871
Jade ring
Neolithic Age
Diameter: 11.5 cm Internal diameter: 6.2 cm
Thickness: 0.8 cm

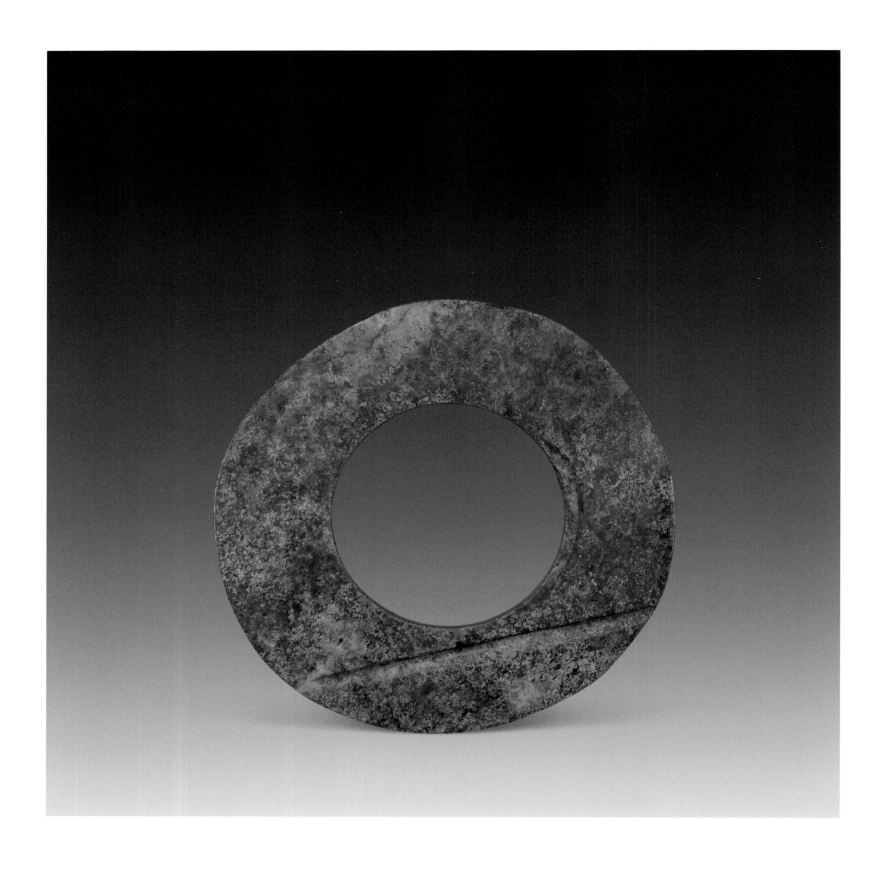

新112682

玉环

新石器时代

270 径11.9厘米 孔径6.1厘米 厚0.7厘米

Xin 112682

Jade ring
Neolithic Age

Diameter: 11.9 cm Internal diameter: 6.1 cm
Thickness: 0.7 cm

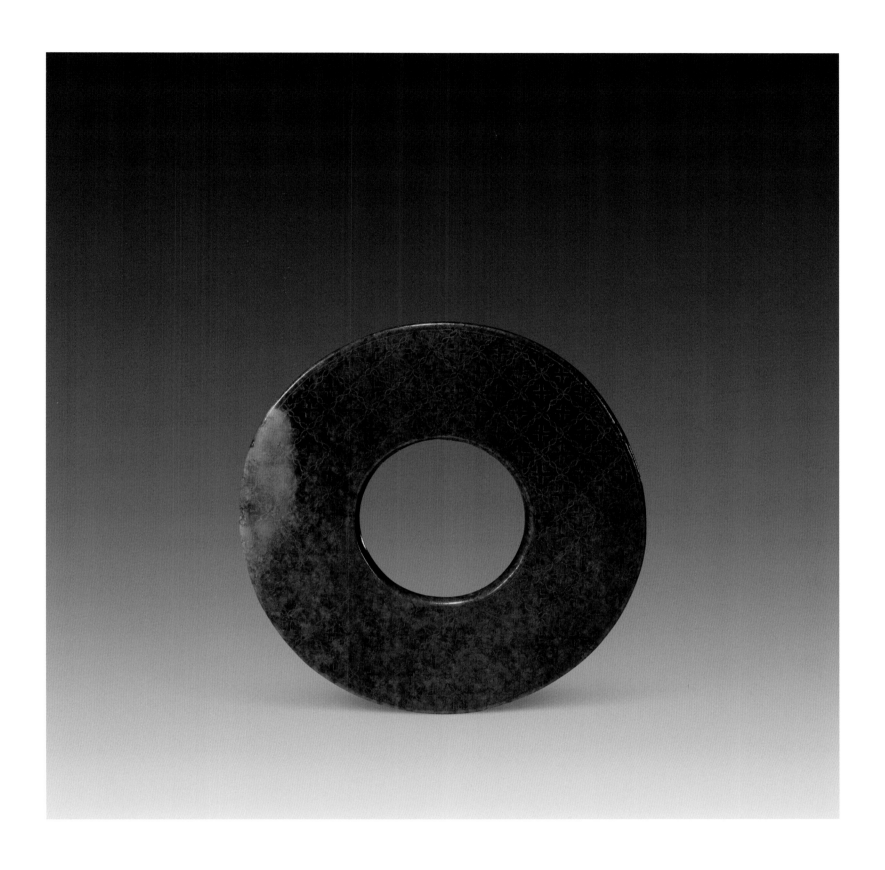

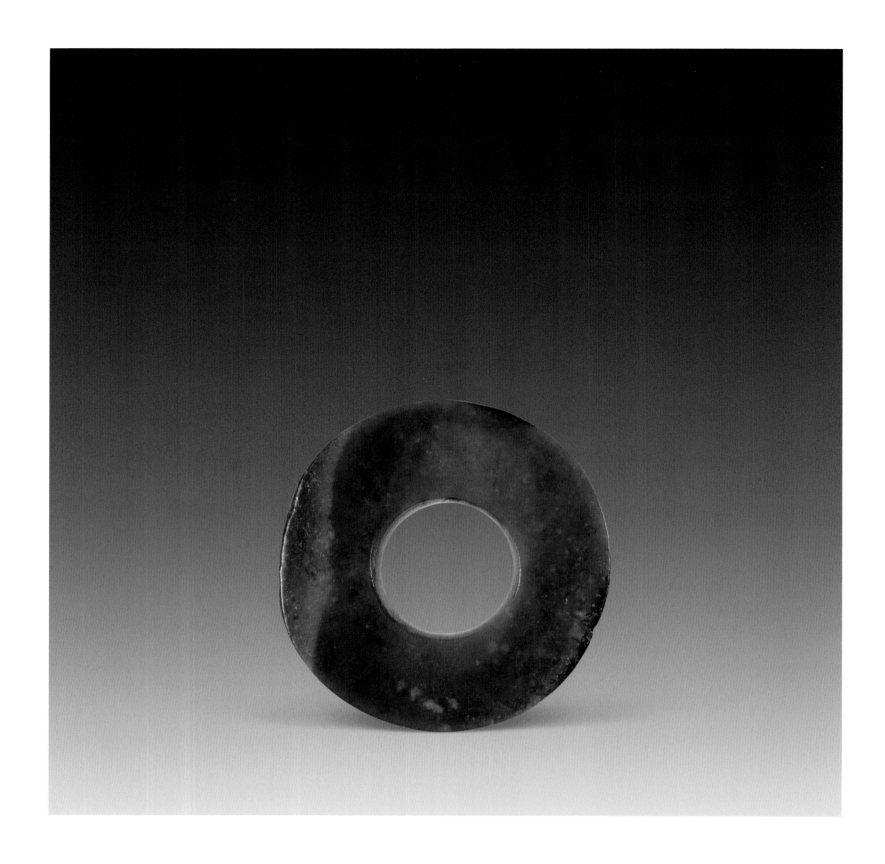

新123876

玉环
新石器时代

272 | 径8.8厘米 孔径3.7厘米 厚0.4厘米

Xin 123876

Jade ring
Neolithic Age

Diameter: 8.8 cm Internal diameter: 3.7 cm
Thickness: 0.4 cm

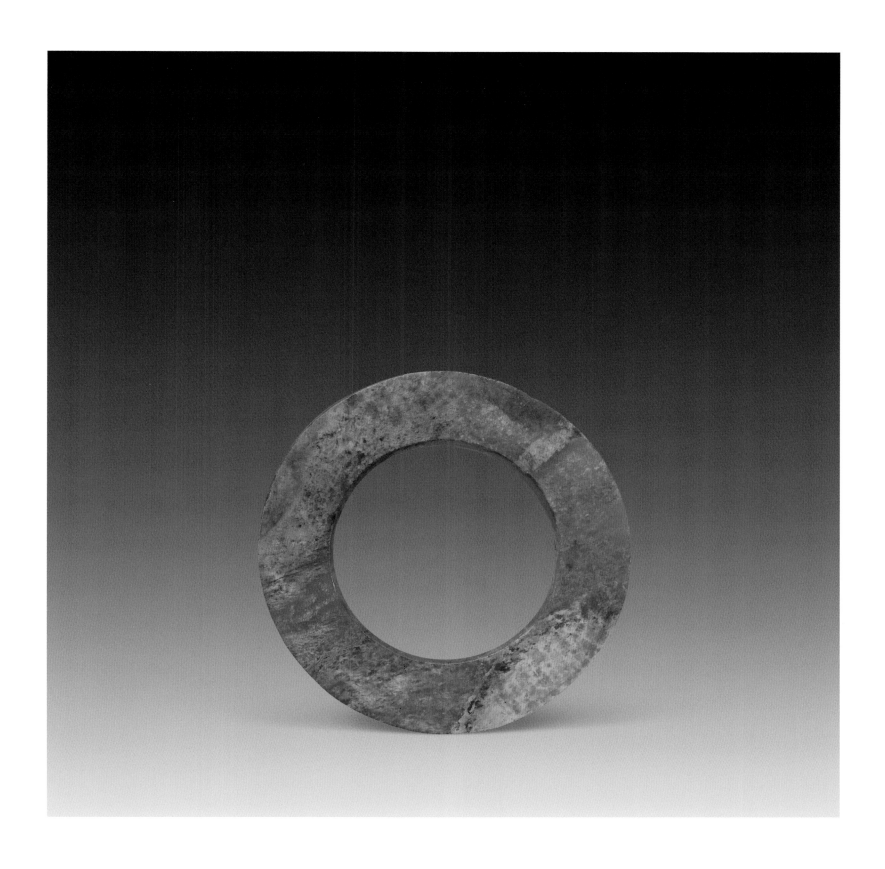

新112683

玉环
新石器时代

273　径9.9厘米　孔径6厘米　厚0.7厘米

Xin 112683
Jade ring
Neolithic Age
Diameter: 9.9 cm　Internal diameter: 6 cm
Thickness: 0.7 cm

故94302

玉环

新石器时代

径4厘米　孔径1.6厘米

备注：附清宫配匣诗册

274

Gu 94302

Jade ring

Neolithic Age

Diameter: 4 cm　Internal diameter: 1.6 cm

*With a box for poem album equipped in
the Qing court*

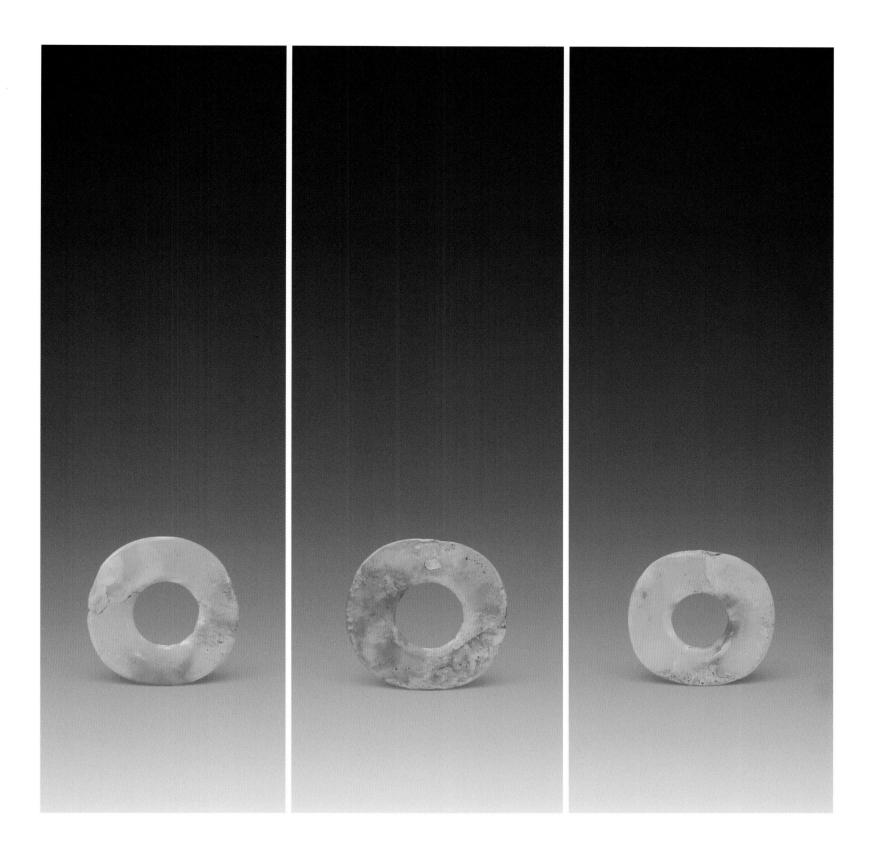

新196150
玉环
新石器时代
275 | 径4.4厘米 孔径1.9厘米 厚0.3厘米
Xin 196150
Jade ring
Neolithic Age
Diameter: 4.4 cm Internal diameter: 1.9 cm
Thickness: 0.3 cm

新196151
玉环
新石器时代
276 | 径4.3厘米 孔径1.8厘米 厚0.2厘米
Xin 196151
Jade ring
Neolithic Age
Diameter: 4.3 cm Internal diameter: 1.8 cm
Thickness: 0.2 cm

新196152
玉环
新石器时代
277 | 径3.9厘米 孔径1.5厘米 厚0.2厘米
Xin 196152
Jade ring
Neolithic Age
Diameter: 3.9 cm Internal diameter: 1.5 cm
Thickness: 0.2 cm

新196153
玉环
新石器时代

278 | 径3.6厘米 孔径1.5厘米 厚0.2厘米

Xin 196153
Jade ring
Neolithic Age
Diameter: 3.6 cm Internal diameter: 1.5 cm
Thickness: 0.2 cm

新196154
玉环
新石器时代

279 | 径3.5厘米 孔径1.3厘米 厚0.2厘米

Xin 196154
Jade ring
Neolithic Age
Diameter: 3.5 cm Internal diameter: 1.3 cm
Thickness: 0.2 cm

新196155
玉环
新石器时代

280 | 径3.6厘米 孔径1.6厘米 厚0.2厘米

Xin 196155
Jade ring
Neolithic Age
Diameter: 3.6 cm Internal diameter: 1.6 cm
Thickness: 0.2 cm

新196156
玉环
新石器时代

281 | 径3.4厘米 孔径1.2厘米 厚0.2厘米

Xin 196156
Jade ring
Neolithic Age
Diameter: 3.4 cm Internal diameter: 1.2 cm
Thickness: 0.2 cm

新196157
玉环
新石器时代
径3厘米　孔径1.4厘米　厚0.2厘米

282

Xin 196157
Jade ring
Neolithic Age
Diameter: 3 cm　Internal diameter: 1.4 cm
Thickness: 0.2 cm

新196158
玉环
新石器时代
径3厘米　孔径1厘米　厚0.2厘米

283

Xin 196158
Jade ring
Neolithic Age
Diameter: 3 cm　Internal diameter: 1 cm
Thickness: 0.2 cm

新196159
玉环
新石器时代
径2.7厘米　孔径1.2厘米　厚0.2厘米

284

Xin 196159
Jade ring
Neolithic Age
Diameter: 2.7 cm　Internal diameter: 1.2 cm
Thickness: 0.2 cm

新196160
玉环
新石器时代
径2.5厘米　孔径0.9厘米　厚0.2厘米

285

Xin 196160
Jade ring
Neolithic Age
Diameter: 2.5 cm　Internal diameter: 0.9 cm
Thickness: 0.2 cm

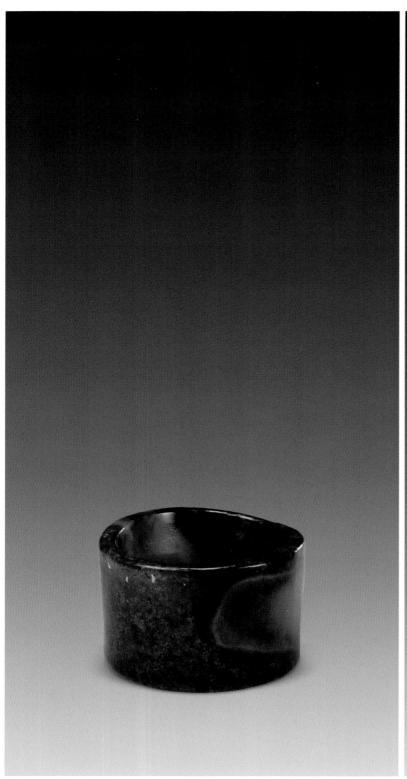

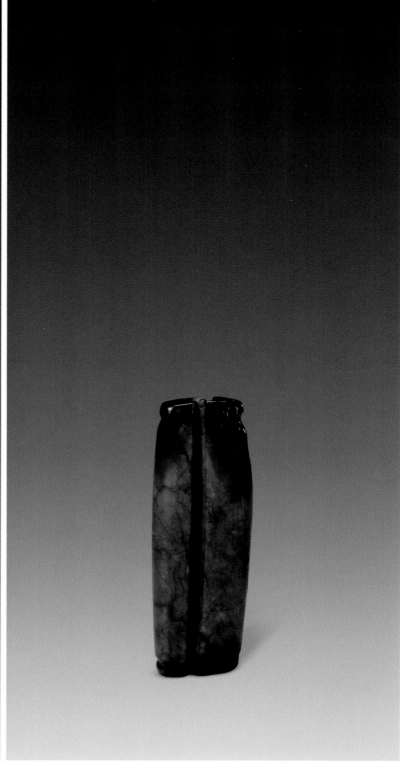

新176284

玉箍

新石器时代或商代

286 高3.6厘米 口径5.5厘米

Xin 176284

Jade hoop

Neolithic Age or Shang Dynasty

Height: 3.6 cm Mouth diameter: 5.5 cm

故84749

玉带槽条形器

新石器时代

287 长7.7厘米 宽2.3厘米 厚1.2厘米

Gu 84749

Fluted jade object

Neolithic Age

Length: 7.7 cm Width: 2.3 cm
Thickness: 1.2 cm

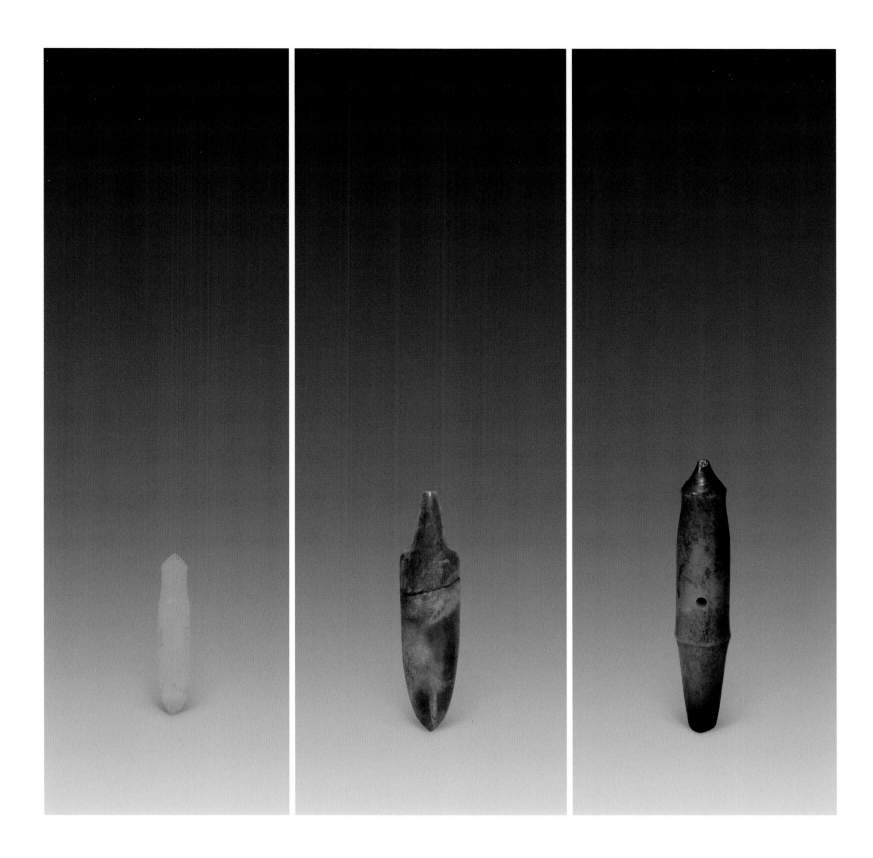

新93136
玉锥形器
新石器时代
288 | 长4.4厘米　宽0.8厘米　厚0.8厘米
Xin 93136
Awl-shaped jade object
Neolithic Age
Length: 4.4 cm　Width: 0.8 cm
Thickness: 0.8 cm

新116115
玉锥形器
新石器时代
289 | 长6.6厘米　宽1.6厘米　厚0.7厘米
Xin 116115
Awl-shaped jade object
Neolithic Age
Length: 6.6 cm　Width: 1.6 cm
Thickness: 0.7 cm

故95637
玉锥形器
新石器时代
290 | 长7.5厘米　宽1.2厘米　厚1.2厘米
Gu 95637
Awl-shaped jade object
Neolittic Age
Length: 7.5 cm　Width: 1.2 cm
Thickness: 1.2 cm

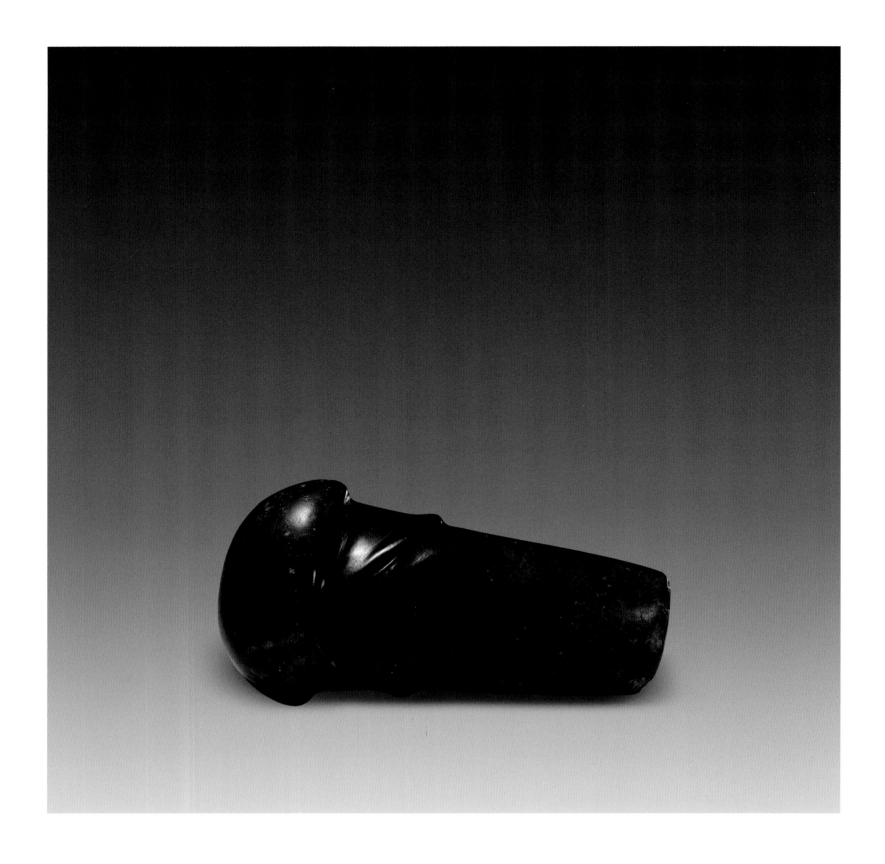

新166040
玉杵
新石器时代
长12.1厘米　首宽6.4厘米　厚4厘米

Xin 166040
Jade pestle
Neolithic Age
Length: 12.1 cm　Head width: 6.4 cm
Thickness: 4 cm

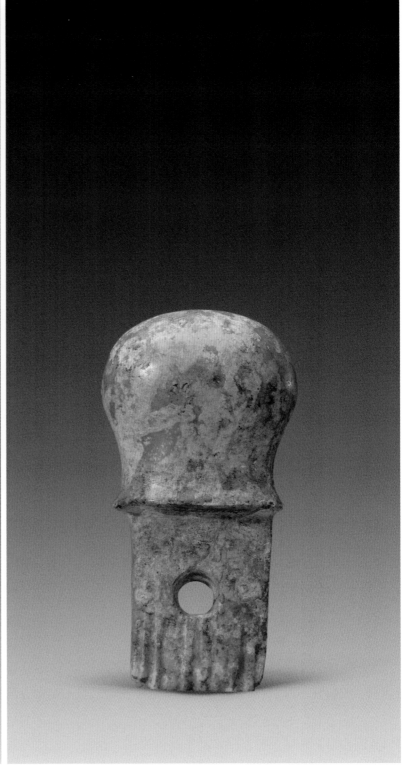

新115940

玉柄

新石器时代

292 | 长7.2厘米　宽3.2厘米　厚2.4厘米

Xin 115940

Jade handle
Neolithic Age

Length: 7.2 cm　Width: 3.2 cm
Thickness: 2.4 cm

新141588

玉柄

新石器时代

293 | 长10.6厘米　宽5厘米　厚4厘米

Xin 141588

Jade handle
Neolithic Age

Length: 10.6 cm　Width: 5 cm
Thickness: 4 cm

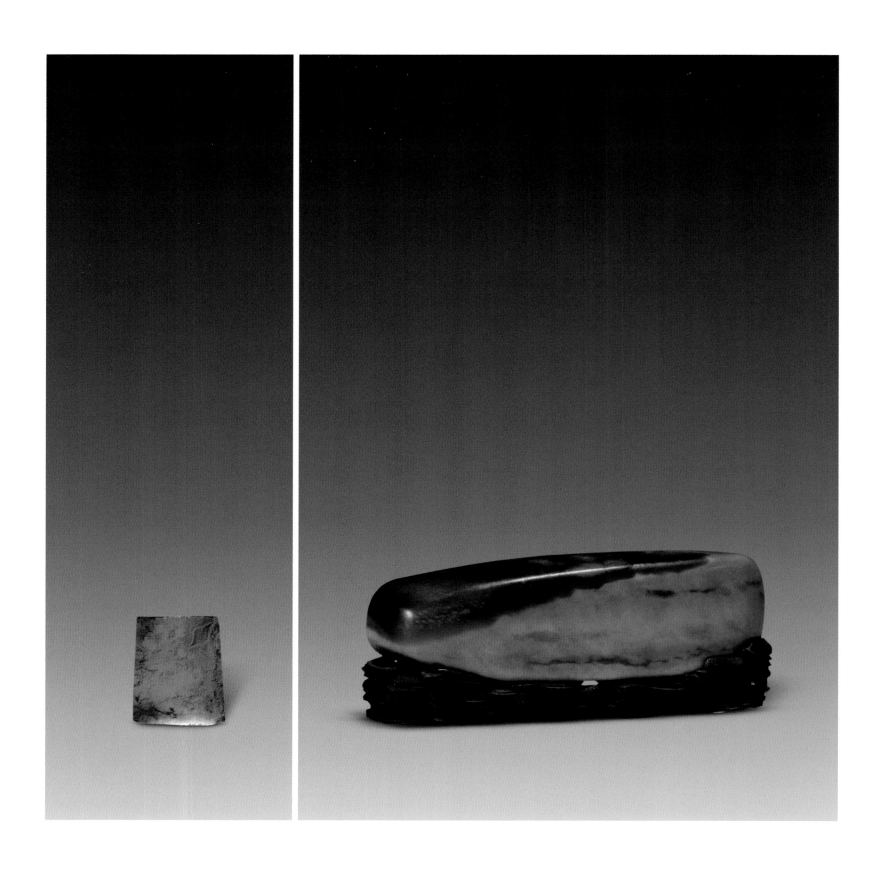

故95163
玉凿
新石器时代
长3厘米 宽2.5厘米 厚0.5厘米

294

Gu 95163
Jade chisel
Neolithic Age
Length: 3 cm Width: 2.5 cm
Thickness: 0.5 cm

故83963
玉凿
新石器时代
长11.3厘米 宽3.4厘米 厚2.3厘米
备注：后配红木座

295

Gu 83963
Jade chisel
Neolithic Age
Length: 11.3 cm Width: 3.4 cm
Thickness: 2.3 cm
With an amahogany base equipped later

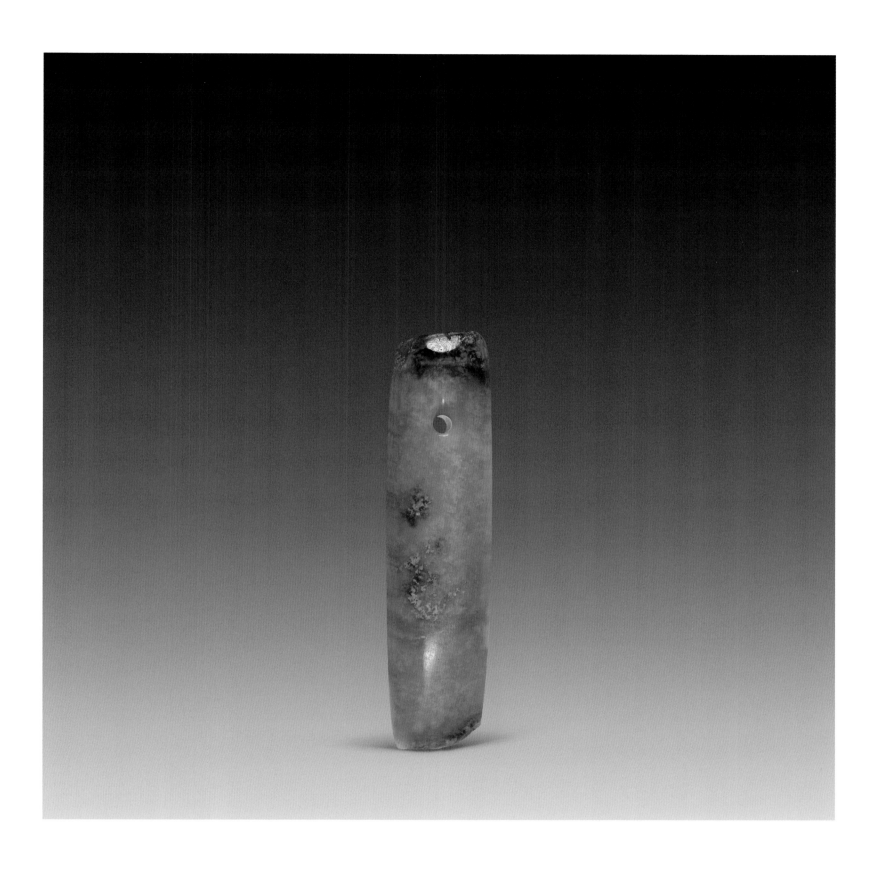

新141592

玉凿

新石器时代

296

长13.1厘米 宽3.1厘米 厚2.5厘米

Xin 141592

Jade chisel
Neolithic Age

Length: 13.1 cm Width: 3.1 cm
Thickness: 2.5 cm

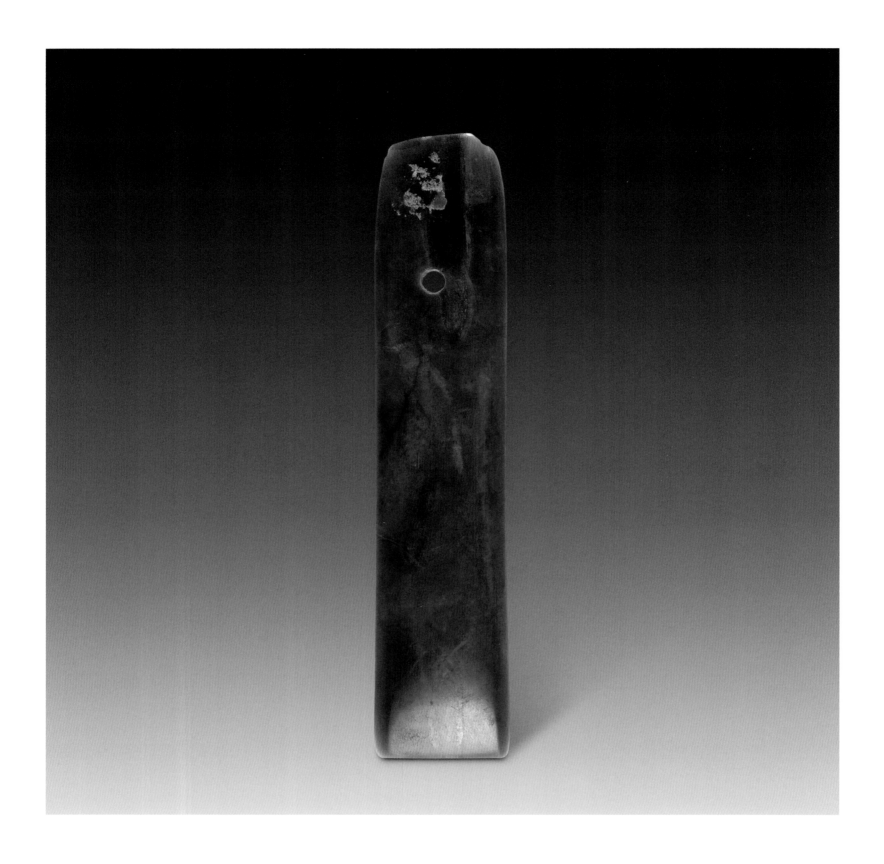

新143640
玉凿
新石器时代
长21.4厘米　宽4.5厘米　厚0.8厘米

297

Xin 143640
Jade chisel
Neolithic Age
Length: 21.4 cm　Width: 4.5 cm
Thickness: 0.8 cm

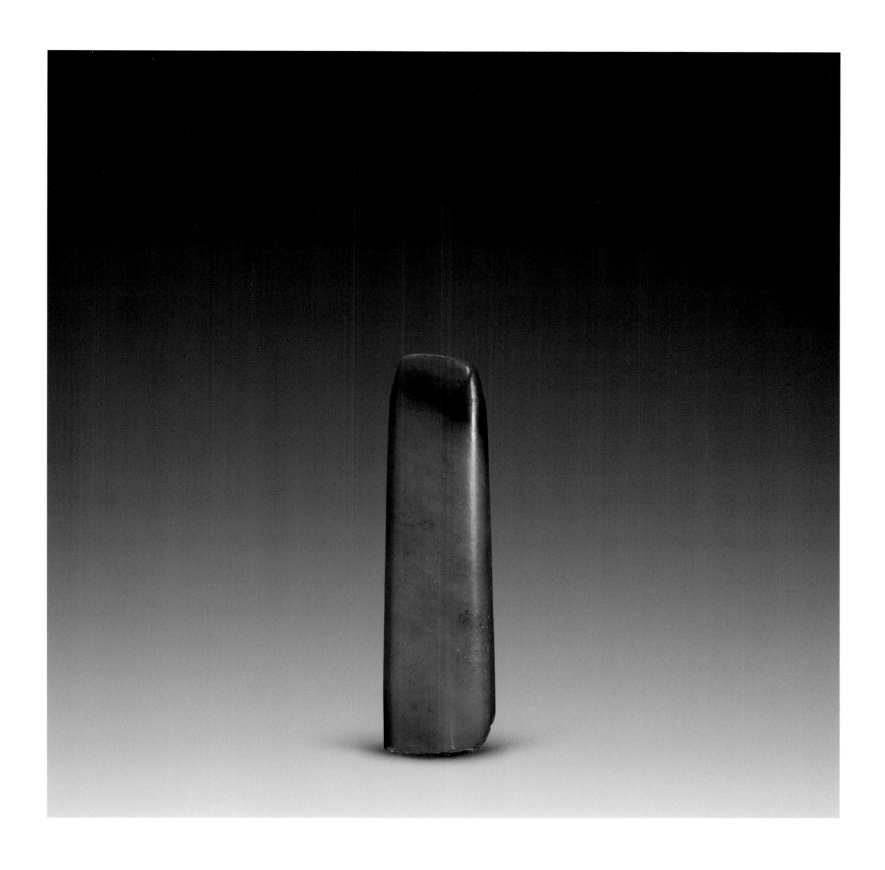

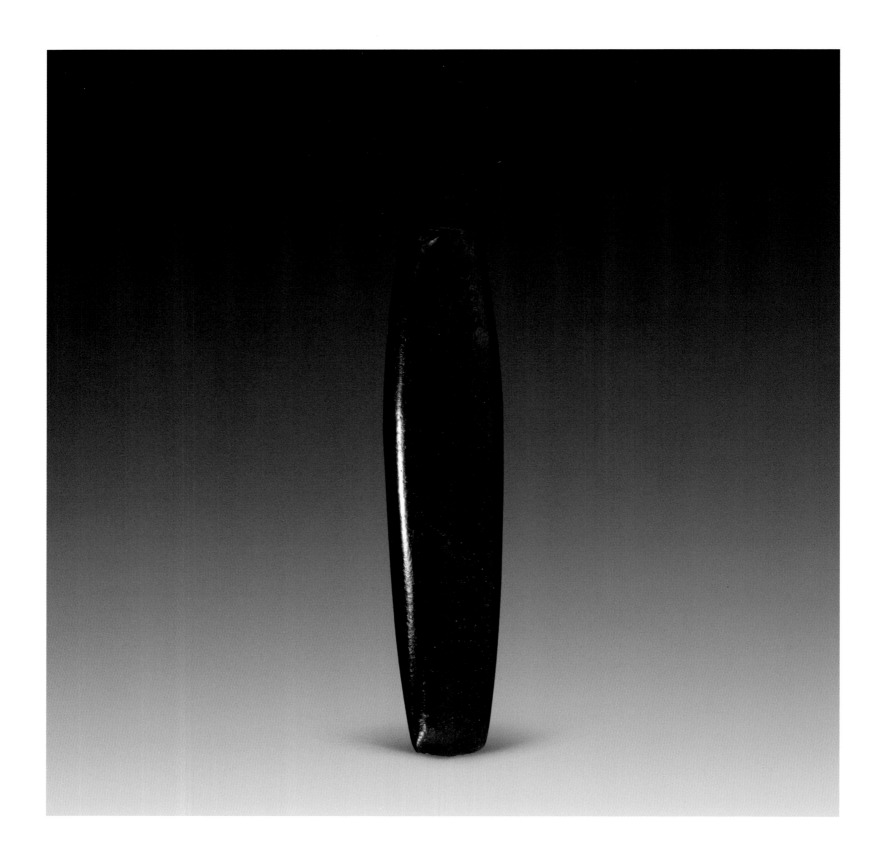

新110053

玉凿

新石器时代

299 长14.5厘米 宽3.1厘米 厚2.4厘米

Xin 110053

Jade chisel
Neolithic Age

Length: 14.5 cm Width: 3.1 cm
Thickness: 2.4 cm

图版索引

Index

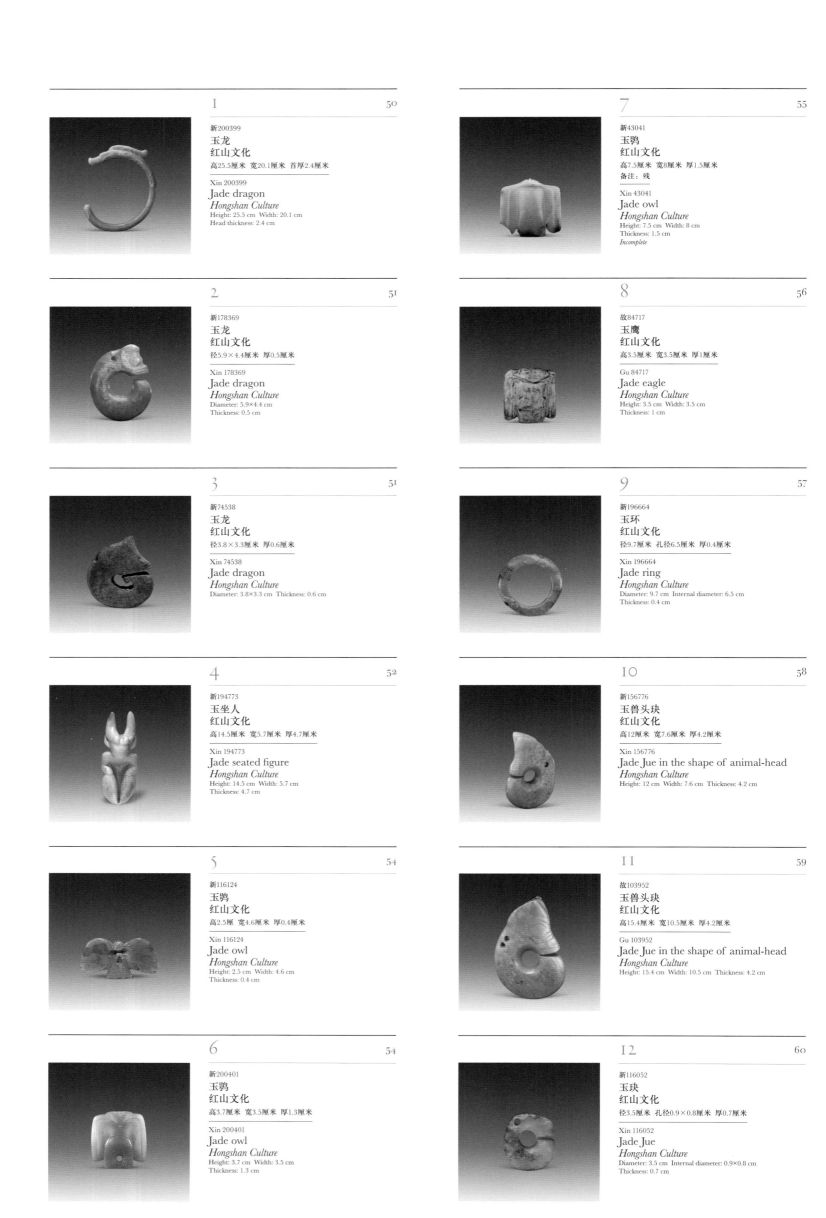

1　　50	7　　55
新200399 **玉龙** **红山文化** 高25.5厘米　宽20.1厘米　首厚2.4厘米 Xin 200399 **Jade dragon** *Hongshan Culture* Height: 25.5 cm　Width: 20.1 cm Head thickness: 2.4 cm	新43041 **玉鹗** **红山文化** 高7.5厘米　宽8厘米　厚1.5厘米 备注：残 Xin 43041 **Jade owl** *Hongshan Culture* Height: 7.5 cm　Width: 8 cm Thickness: 1.5 cm *Incomplete*
2　　51	8　　56
新178369 **玉龙** **红山文化** 径5.9×4.4厘米　厚0.5厘米 Xin 178369 **Jade dragon** *Hongshan Culture* Diameter: 5.9×4.4 cm Thickness: 0.5 cm	故84717 **玉鹰** **红山文化** 高3.5厘米　宽3.5厘米　厚1厘米 Gu 84717 **Jade eagle** *Hongshan Culture* Height: 3.5 cm　Width: 3.5 cm Thickness: 1 cm
3　　51	9　　57
新74538 **玉龙** **红山文化** 径3.8×3.3厘米　厚0.6厘米 Xin 74538 **Jade dragon** *Hongshan Culture* Diameter: 3.8×3.3 cm　Thickness: 0.6 cm	新196664 **玉环** **红山文化** 径9.7厘米　孔径6.5厘米　厚0.4厘米 Xin 196664 **Jade ring** *Hongshan Culture* Diameter: 9.7 cm　Internal diameter: 6.5 cm Thickness: 0.4 cm
4　　52	10　　58
新194773 **玉坐人** **红山文化** 高14.5厘米　宽5.7厘米　厚4.7厘米 Xin 194773 **Jade Jue seated figure** *Hongshan Culture* Height: 14.5 cm　Width: 5.7 cm Thickness: 4.7 cm	新156776 **玉兽头玦** **红山文化** 高12厘米　宽7.6厘米　厚4.2厘米 Xin 156776 **Jade Jue in the shape of animal-head** *Hongshan Culture* Height: 12 cm　Width: 7.6 cm　Thickness: 4.2 cm
5　　54	11　　59
新116124 **玉鹗** **红山文化** 高2.5厘　宽4.6厘米　厚0.4厘米 Xin 116124 **Jade owl** *Hongshan Culture* Height: 2.5 cm　Width: 4.6 cm Thickness: 0.4 cm	故103952 **玉兽头玦** **红山文化** 高15.4厘米　宽10.5厘米　厚4.2厘米 Gu 103952 **Jade Jue in the shape of animal-head** *Hongshan Culture* Height: 15.4 cm　Width: 10.5 cm　Thickness: 4.2 cm
6　　54	12　　60
新200401 **玉鹗** **红山文化** 高3.7厘米　宽3.5厘米　厚1.3厘米 Xin 200401 **Jade owl** *Hongshan Culture* Height: 3.7 cm　Width: 3.5 cm Thickness: 1.3 cm	新116052 **玉玦** **红山文化** 径3.5厘米　孔径0.9×0.8厘米　厚0.7厘米 Xin 116052 **Jade Jue** *Hongshan Culture* Diameter: 3.5 cm　Internal diameter: 0.9×0.8 cm Thickness: 0.7 cm

13 60

故94359

玉玦
红山文化

径5厘米 孔径2×2.2厘米

Gu 94359

Jade Jue
Hongshan Culture
Diameter: 5 cm
Internal diameter: 2×2.2 cm

14 61

新200400

玉勾云形佩
红山文化

长13.7厘米 宽6.4厘米 厚0.75厘米

Xin 200400

Cloud-shaped jade pendant
Hongshan Culture
Length: 13.7 cm Width: 6.4 cm Thickness: 0.75 cm

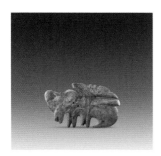

15 62

新141648

玉兽面纹饰件
红山文化

长8.3厘米 宽4.9厘米 厚0.3厘米
备注：残

Xin 141648

Jade pendant with animal-face design
Hongshan Culture
Length: 8.3 cm Width: 4.9 cm Thickness: 0.3 cm
The pendant is incomplete

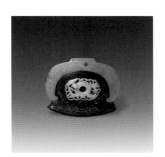

16 62

故95791

玉角形饰件
红山文化

长20.2厘米 宽12.5厘米 厚0.7厘米
备注：后修改, 清代配座

Gu 95791

Horned-shaped jade ornament
Hongshan Culture
Length: 20.2 cm Width: 12.5 cm
Thickness: 0.7 cm
Re-shaped and with a support equipped in the Qing Dynasty

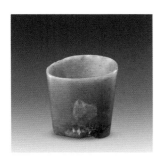

17 64

新96961

玉马蹄形器
红山文化

高9.5厘米 口径9×7.1厘米 底径6.9×5.5厘米

Xin 96961

Jade object in the shape of horse-hoof
Hongshan Culture
Height: 9.5 cm Mouth diameter: 9×7.1 cm
Bottom diameter: 6.9×5.5 cm

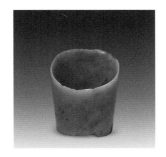

18 64

新111962

玉马蹄形器
红山文化

高9.9厘米 口径7.8厘米 底径6.6厘米

Xin 111962

Jade object in the shape of horse-hoof
Hongshan Culture
Height: 9.9 cm Mouth diameter: 7.8 cm
Bottom diameter: 6.6 cm

19 65

新178421

玉马蹄形器
红山文化

高11.7厘米 口径7厘米 底径6厘米

Xin 178421

Jade object in the shape of horse-hoof
Hongshan Culture
Height: 11.7 cm Mouth diameter: 7 cm
Bottom diameter: 6 cm

20 66

新51589

玉马蹄形器
红山文化

高17.2厘米 口径10×6.1厘米 底径7.2×5.9厘米

Xin 51589

Jade object in the shape of horse-hoof
Hongshan Culture
Height: 17.2 cm Mouth diameter: 10×6.1 cm
Bottom diameter: 7.2×5.9 cm

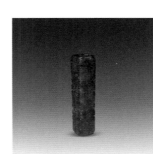

21 68

故84935

玉三节琮
良渚文化

高8.2厘米 宽1.8厘米 口径2.2厘米

Gu 84935

Jade Cong
Liangzhu Culture
Height: 8.2 cm Width: 1.8 cm
Mouth diameter: 2.2 cm

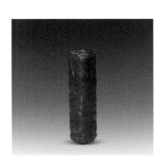

22 68

故83956

玉四节琮
良渚文化

高7.4厘米 宽1.7厘米 口径1.6厘米

Gu 83956

Jade Cong
Liangzhu Culture
Height: 7.4 cm Width: 1.7 cm
Mouth diameter: 1.6 cm

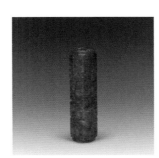

23 69

故84686

玉四节琮
良渚文化

高7厘米 口径1.6厘米

Gu 84686

Jade Cong
Liangzhu Culture
Height: 7 cm Mouth diameter: 1.6 cm

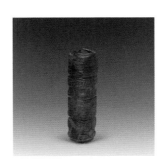

24 69

故83957

玉四节琮
良渚文化

高7.4厘米 口径1.8厘米

Gu 83957

Jade Cong
Liangzhu Culture
Height: 7.4 cm Mouth diameter: 1.8 cm

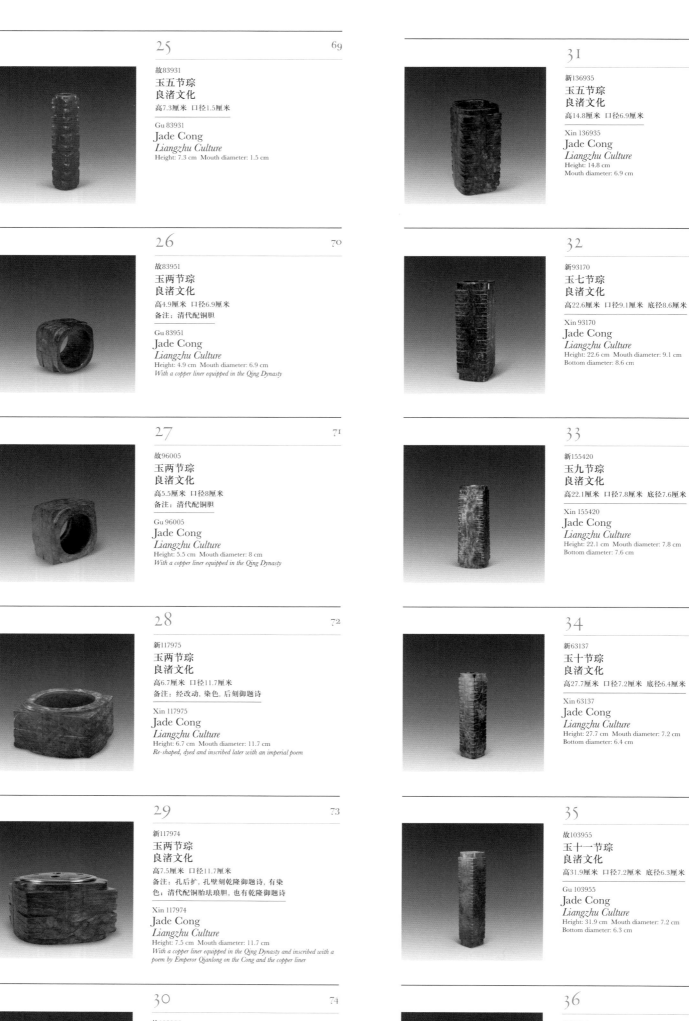

25 69

故83931
玉五节琮
良渚文化
高7.3厘米 口径1.5厘米

Gu 83931
Jade Cong
Liangzhu Culture
Height: 7.3 Mouth diameter: 1.5 cm

26 70

故83951
玉两节琮
良渚文化
高4.9厘米 口径6.9厘米
备注：清代配铜胆

Gu 83951
Jade Cong
Liangzhu Culture
Height: 4.9 cm Mouth diameter: 6.9 cm
With a copper liner equipped in the Qing Dynasty

27 71

故96005
玉两节琮
良渚文化
高5.5厘米 口径8厘米
备注：清代配铜胆

Gu 96005
Jade Cong
Liangzhu Culture
Height: 5.5 cm Mouth diameter: 8 cm
With a copper liner equipped in the Qing Dynasty

28 72

新117975
玉两节琮
良渚文化
高6.7厘米 口径11.7厘米
备注：经改动，染色，后刻御题诗

Xin 117975
Jade Cong
Liangzhu Culture
Height: 6.7 cm Mouth diameter: 11.7 cm
Re-shaped, dyed and inscribed later with an imperial poem

29 73

新117974
玉两节琮
良渚文化
高7.5厘米 口径11.7厘米
备注：孔后扩，孔壁刻乾隆御题诗，有染
色；清代配铜胎珐琅胆，也有乾隆御题诗

Xin 117974
Jade Cong
Liangzhu Culture
Height: 7.5 cm Mouth diameter: 11.7 cm
*With a copper liner equipped in the Qing Dynasty and inscribed with a
poem by Emperor Qianlong on the Cong and the copper liner*

30 74

故103956
玉三节琮
良渚文化
高6.7厘米 口径8.2厘米
备注：内壁后刻乾隆御题诗；清代配铜胎珐琅
胆，也有乾隆御题诗

Gu 103956
Jade Cong
Liangzhu Culture
Height: 6.7 cm Mouth diameter: 8.2 cm
*A poem by Emperor Qianlong was inscribed inside the jade Cong, and
a copper liner equipped in the Qing Dynasty and a poem by Emperor
Qianlong was inscribed on it*

31 76

新136935
玉五节琮
良渚文化
高14.8厘米 口径6.9厘米

Xin 136935
Jade Cong
Liangzhu Culture
Height: 14.8 cm
Mouth diameter: 6.9 cm

32 76

新93170
玉七节琮
良渚文化
高22.6厘米 口径9.1厘米 底径8.6厘米

Xin 93170
Jade Cong
Liangzhu Culture
Height: 22.6 cm Mouth diameter: 9.1 cm
Bottom diameter: 8.6 cm

33 77

新155420
玉九节琮
良渚文化
高22.1厘米 口径7.8厘米 底径7.6厘米

Xin 155420
Jade Cong
Liangzhu Culture
Height: 22.1 cm Mouth diameter: 7.8 cm
Bottom diameter: 7.6 cm

34 78

新63137
玉十节琮
良渚文化
高27.7厘米 口径7.2厘米 底径6.4厘米

Xin 63137
Jade Cong
Liangzhu Culture
Height: 27.7 cm Mouth diameter: 7.2 cm
Bottom diameter: 6.4 cm

35 78

故103955
玉十一节琮
良渚文化
高31.9厘米 口径7.2厘米 底径6.3厘米

Gu 103955
Jade Cong
Liangzhu Culture
Height: 31.9 cm Mouth diameter: 7.2 cm
Bottom diameter: 6.3 cm

36 79

故96000
玉十二节琮
良渚文化
高30.9厘米 口径7.5厘米 底径6.5厘米

Gu 96000
Jade Cong
Liangzhu Culture
Height: 30.9 cm Mouth diameter: 7.5 cm
Bottom diameter: 6.5 cm

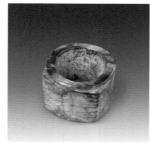

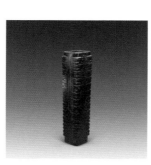

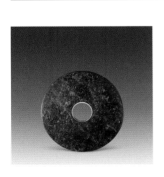

37 79

故83949

玉十五节琮
良渚文化

高34.8厘米 口径6.5厘米 底径5.6厘米

Gu 83949

Jade Cong
Liangzhu Culture
Height: 34.8 cm Mouth diameter: 6.5 cm
Bottom diameter: 5.6 cm

38 80

故103954

玉璧
良渚文化

径31.6厘米 孔径6.5厘米 厚1.1厘米

备注：后刻乾隆御题诗

Gu 103954

Jade Bi
Liangzhu Culture
Diameter: 31.6 cm Internal diameter: 6.5 cm
Thickness: 1.1 cm
Inscribed with a poem by Emperor Qianlong

39 81

故83946

玉璧
良渚文化

径27.9厘米 孔径4.4厘米 厚1.2厘米

备注：外壁有一周凹槽

Gu 83946

Jade Bi
Liangzhu Culture
Diameter: 27.9 cm Internal diameter: 4.4 cm
Thickness: 1.2 cm
With a flute circled around the external edge

40 82

故83998

玉璧
良渚文化

径22.2厘米 孔径4.7厘米 厚1厘米

Gu 83998

Jade Bi
Liangzhu Culture
Diameter: 22.2 cm Internal diameter: 4.7 cm
Thickness: 1 cm

41 83

新127481

玉璧
良渚文化

径20.1厘米 孔径4.7厘米 厚1.1厘米

Xin 127481

Jade Bi
Liangzhu Culture
Diameter: 20.1 cm Internal diameter: 4.7 cm
Thickness: 1.1 cm

42 84

新9611

玉璧
良渚文化

径14.8厘米 孔径3.9厘米 厚1.4厘米

备注：后刻乾隆《咏汉玉素璧》诗

Xin 9611

Jade Bi
Liangzhu Culture
Diameter: 14.8 cm Internal diameter: 3.9 cm
Thickness: 1.4 cm
*Inscribed with a poem "Yong Han Yu Su Bi" (Ode to the Han jade Bi)
by Emperor Qianlong*

43 86

故83948

玉璧
良渚文化

径19.5厘米 孔径4厘米 厚2.1厘米

Gu 83948

Jade Bi
Liangzhu Culture
Diameter: 19.5 cm Internal diameter: 4 cm
Thickness: 2.1 cm

44 87

新127860

玉璧
良渚文化

径27.1厘米 孔径4.7厘米 厚1.1厘米

Xin 127860

Jade Bi
Liangzhu Culture
Diameter: 27.1 cm Internal diameter: 4.7 cm
Thickness: 1.1 cm

45 88

故95074

玉璜
良渚文化

长9.5厘米 宽3厘米 厚0.4厘米

备注：后改动，有染色

Gu 95074

Jade Huang
Liangzhu Culture
Length: 9.5 cm Width: 3 cm Thickness: 0.4 cm
Re-shaped and dyed

46 89

故84491

玉兽面纹璜
良渚文化

长19.5厘米 宽2.7厘米 厚0.8厘米

备注：后改制

Gu 84491

Jade Huang with animal-face design
Liangzhu Culture
Length: 19.5 cm Width: 2.7 cm Thickness: 0.8 cm
Re-shaped

47 90

故84042

玉兽面纹璜
良渚文化

长20.8厘米 宽8.3厘米 厚0.6厘米

Gu 84042

Jade Huang with animal-face design
Liangzhu Culture
Length: 20.8 cm Width: 8.3 cm Thickness: 0.6 cm

48 92

新200403

玉兽面纹饰
良渚文化

长3.2厘米 宽4.8厘米 厚0.7厘米

Xin 200403

Jade pendant with animal-face design
Liangzhu Culture
Length: 3.2 cm Width: 4.8 cm Thickness: 0.7 cm

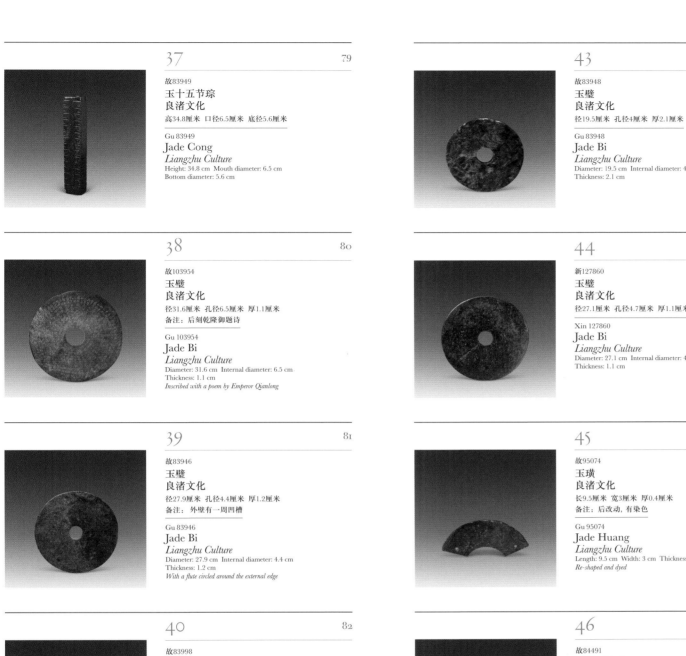
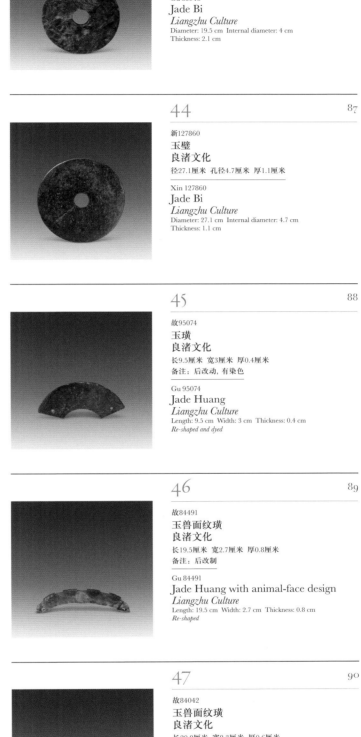
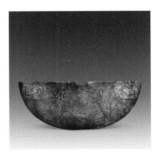
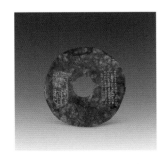
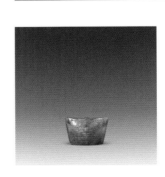

49 93

新196059
玉锥形器
良渚文化
长9.6厘米 宽0.8厘米 厚0.7厘米

Xin 196059
Awl-shaped jade object
Liangzhu Culture
Length: 9.6 cm Width: 0.8 cm
Thickness: 0.7 cm

50 93

新97512
玉锥形器
良渚文化
长18.6厘米 宽1厘米 厚1厘米

Xin 97512
Awl-shaped jade object
Liangzhu Culture
Length: 18.6 cm Width: 1 cm
Thickness: 1 cm

51 93

故84823
玉管
良渚文化
长2.5厘米 径1.5×1.2厘米

Gu 84823
Jade tube
Liangzhu Culture
Length: 2.5 cm Diameter: 1.5×1.2 cm

52 93

新201492
玉两节琮
新石器时代
高2厘米 宽1.6厘米 口径0.9×0.8厘米
备注：1979年安徽省潜山县永岗村出土

Xin 201492
Jade Cong
Neolithic Age
Height: 2 cm Width: 1.6 cm
Mouth diameter: 0.9×0.8 cm
Unearthed at Yonggang village, Qianshan County, Anhui Province in 1979

53 94

新201603
石三孔刀
新石器时代
长20.8厘米 宽9.4厘米 厚0.6厘米
备注：1979年安徽省潜山县永岗村出土

Xin 201603
Stone knife with three holes
Neolithic Age
Length: 20.8 cm Width: 9.4 cm Thickness: 0.6 cm
Unearthed at Yonggang village, Qianshan County, Anhui Province in 1979

54 95

新201604
石五孔刀
新石器时代
长27.1厘米 宽7.9厘米 厚0.5厘米
备注：1979年安徽省潜山县永岗村出土

Xin 201604
Stone knife with five holes
Neolithic Age
Length: 27.1 cm Width: 7.9 cm Thickness: 0.5 cm
Unearthed at Yonggang village, Qianshan County, Anhui Province in 1979

55 96

新201476
玉刻图长方板
新石器时代
长11.4厘米 宽8.3厘米 厚0.7厘米
备注：1987年安徽省含山县凌家滩出土

Xin 201476
Rectangular jade plate with engraved design
Neolithic Age
Length: 11.4 cm Width: 8.3 cm Thickness: 0.7 cm
Unearthed at Lingjiatan, Hanshan County, Anhui Province in 1987

56 98

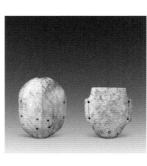

新201477
玉龟壳
新石器时代
背甲 长9.4厘米 宽7.6厘米 厚0.8厘米
腹甲 长7.9厘米 宽7.5厘米 厚1.3厘米
备注：1987年安徽省含山县凌家滩出土

Xin 201477
Jade tortoise-shell
Neolithic Age
Back length: 9.4 cm Width: 7.6 cm Thickness: 0.8 cm
Belly length: 7.9 cm Width: 7.5 cm Thickness: 1.3 cm
Unearthed at Lingjiatan, Hanshan County, Anhui Province in 1987

57 99

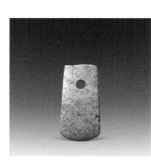

新201493
玉斧
新石器时代
长17厘米 宽8.5厘米 厚1厘米
备注：1987年安徽省含山县凌家滩出土

Xin 201493
Jade axe
Neolithic Age
Length: 17 cm Width: 8.5 cm Thickness: 1 cm
Unearthed at Lingjiatan, Hanshan County, Anhui Province in 1987

58 99

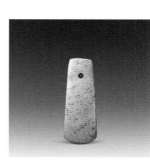

新201486
玉斧
新石器时代
长23.7厘米 宽8.7厘米 厚1厘米
备注：1987年安徽省含山县凌家滩出土

Xin 201486
Jade axe
Neolithic Age
Length: 23.7 cm Width: 8.7 cm
Thickness: 1 cm
Unearthed at Lingjiatan, Hanshan County, Anhui Province in 1987

59 100

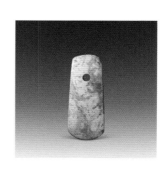

新201498
玉斧
新石器时代
长19.3厘米 宽8厘米 厚0.8厘米
备注：1987年安徽省含山县凌家滩出土

Xin 201498
Jade axe
Neolithic Age
Length: 19.3 cm Width: 8 cm
Thickness: 0.8 cm
Unearthed at Lingjiatan, Hanshan County, Anhui Province in 1987

60 100

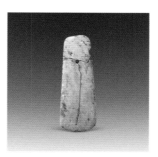

新201582
玉斧
新石器时代
长20.2厘米 宽7.7厘米 厚1.6厘米
备注：1987年安徽省含山县凌家滩出土

Xin 201582
Jade axe
Neolithic Age
Length: 20.2 cm Width: 7.7 cm
Thickness: 1.6 cm
Unearthed at Lingjiatan, Hanshan County, Anhui Province in 1987

61

61 101

新201495
玉斧
新石器时代
长18.2厘米 宽6.6厘米 厚1.4厘米
备注：1987年安徽省含山县凌家滩出土

Xin 201495
Jade axe
Neolithic Age
Length: 18.2 cm Width: 6.6 cm
Thickness: 1.4 cm
Unearthed at Lingjiatan, Hanshan County,
Anhui Province in 1987

62 101

新201494
玉斧
新石器时代
长24厘米 宽6.5厘米 厚1.7厘米
备注：1987年安徽省含山县凌家滩出土

Xin 201494
Jade axe
Neolithic Age
Length: 24 cm Width: 6.5 cm
Thickness: 1.7 cm
Unearthed at Lingjiatan, Hanshan County,
Anhui Province in 1987

63 102

新201583
玉斧
新石器时代
长19.5厘米 宽8.7厘米 厚1.2厘米
备注：1987年安徽省含山县凌家滩出土

Xin 201583
Jade axe
Neolithic Age
Length: 19.5 cm Width: 8.7 cm
Thickness: 1.2 cm
Unearthed at Lingjiatan, Hanshan County,
Anhui Province in 1987

64 102

新201520
玉斧
新石器时代
长19.5厘米 宽6.3厘米 厚1厘米
备注：1987年安徽省含山县凌家滩出土

Xin 201520
Jade axe
Neolithic Age
Length: 19.5 cm Width: 6.3 cm
Thickness: 1 cm
Unearthed at Lingjiatan, Hanshan County,
Anhui Province in 1987

65 103

新201475
玉人
新石器时代
高9.6厘米 宽2.3厘米 厚0.8厘米
备注：1987年安徽省含山县凌家滩出土

Xin 201475
Jade figure
Neolithic Age
Height: 9.6 cm Width: 2.3 cm
Thickness: 0.8 cm
Unearthed at Lingjiatan, Hanshan County, Anhui Province in 1987

66 104

新201610
玉重环璧
新石器时代
径11.2厘米 孔径2.9厘米 厚0.5厘米
备注：1987年安徽省含山县凌家滩出土

Xin 201610
Jade double-ring Bi
Neolithic Age
Diameter: 11.2 cm Internal diameter: 2.9 cm
Thickness: 0.5 cm
Unearthed at Lingjiatan, Hanshan County,
Anhui Province in 1987

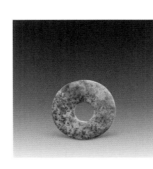

67 105

新201496
玉璧
新石器时代
径6.9厘米 孔径2.2厘米 厚0.2厘米
备注：1987年安徽省含山县凌家滩出土

Xin 201496
Jade Bi
Neolithic Age
Diameter: 6.9 cm Internal diameter: 2.2 cm
Thickness: 0.2 cm
Unearthed at Lingjiatan, Hanshan County, Anhui Province in 1987

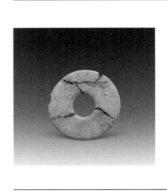

68 106

新201559
玉璧
新石器时代
径8.9×8.7厘米 孔径2.6厘米 厚0.2厘米
备注：1987年安徽省含山县凌家滩出土

Xin 201559
Jade Bi
Neolithic Age
Diameter: 8.9×8.7 cm Internal diameter: 2.6 cm
Thickness: 0.2 cm
Unearthed at Lingjiatan, Hanshan County, Anhui Province in 1987

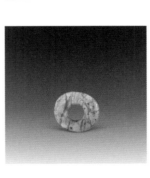

69 106

新201530
玉环
新石器时代
径3.8×3.3厘米 孔径1.3厘米 厚0.5厘米
备注：1987年安徽省含山县凌家滩出土

Xin 201530
Jade ring
Neolithic Age
Diameter: 3.8×3.3 cm Internal diameter: 1.3 cm
Thickness: 0.5 cm
Unearthed at Lingjiatan, Hanshan County, Anhui Province in 1987

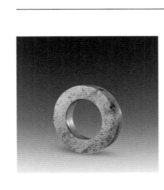

70 107

新201487
玉环
新石器时代
径11厘米 孔径6.5厘米 厚2.6厘米
备注：1987年安徽省含山县凌家滩出土

Xin 201487
Jade ring
Neolithic Age
Diameter: 11 cm Internal diameter: 6.5 cm
Thickness: 2.6 cm
Unearthed at Lingjiatan, Hanshan County, Anhui Province in 1987

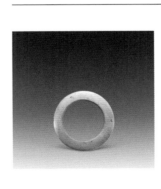

71 108

新201485
玉环
新石器时代
径9厘米 孔径6.2厘米 厚1.3厘米
备注：1987年安徽省含山县凌家滩出土

Xin 201485
Jade ring
Neolithic Age
Diameter: 9 cm Internal diameter: 6.2 cm
Thickness: 1.3 cm
Unearthed at Lingjiatan, Hanshan County, Anhui Province in 1987

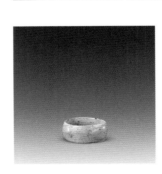

72 109

新201497
玉镯
新石器时代
径4.5厘米 孔径3.7厘米 厚0.3厘米
备注：1987年安徽省含山县凌家滩出土

Xin 201497
Jade bracelet
Neolithic Age
Diameter: 4.5 cm Internal diameter: 3.7 cm
Thickness: 0.3 cm
Unearthed at Lingjiatan, Hanshan County,
Anhui Province in 1987

新201578
玉璜
新石器时代
长10.8厘米　宽4.5厘米　厚0.6厘米
备注：1987年安徽省含山县凌家滩出土

Xin 201578
Jade Huang
Neolithic Age
Length: 10.8 cm　Width: 4.5 cm
Thickness: 0.6 cm
Unearthed at Lingjiatan, Hanshan County,
Anhui Province in 1987

新201527
玉璜
新石器时代
长9.6厘米　端宽2.2厘米　厚0.2厘米
备注：1987年安徽省含山县凌家滩出土

Xin 201527
Jade Huang
Neolithic Age
Length: 9.6 cm　End width: 2.2 cm
Thickness: 0.2 cm
Unearthed at Lingjiatan, Hanshan County,
Anhui Province in 1987

新201525
玉璜
新石器时代
长15.7厘米　端宽2.6厘米　厚0.5厘米
备注：1987年安徽省含山县凌家滩出土

Xin 201525
Jade Huang
Neolithic Age
Length: 15.7 cm　End width: 2.6 cm
Thickness: 0.5 cm
Unearthed at Lingjiatan, Hanshan County,
Anhui Province in 1987

新201524
玉璜
新石器时代
长12厘米　端宽2.9厘米　厚0.6厘米
备注：1987年安徽省含山县凌家滩出土

Xin 201524
Jade Huang
Neolithic Age
Length: 12 cm　End width: 2.9 cm
Thickness: 0.6 cm
Unearthed at Lingjiatan, Hanshan County,
Anhui Province in 1987

新201553
玉璜
新石器时代
长10.3厘米　端宽2.8厘米　厚0.2厘米
备注：1987年安徽省含山县凌家滩出土

Xin 201553
Jade Huang
Neolithic Age
Length: 10.3 cm　End width: 2.8 cm
Thickness: 0.2 cm
Unearthed at Lingjiatan, Hanshan County,
Anhui Province in 1987

新201554
玉璜
新石器时代
长9.2厘米　端宽2.2厘米　厚0.3厘米
备注：1987年安徽省含山县凌家滩出土

Xin 201554
Jade Huang
Neolithic Age
Length: 9.2 cm　End width: 2.2 cm
Thickness: 0.3 cm
Unearthed at Lingjiatan, Hanshan County,
Anhui Province in 1987

新201555
玉璜
新石器时代
长11.2厘米　端宽2.1厘米　厚0.3厘米
备注：1987年安徽省含山县凌家滩出土

Xin 201555
Jade Huang
Neolithic Age
Length: 11.2 cm　End width: 2.1 cm
Thickness: 0.3 cm
Unearthed at Lingjiatan, Hanshan County,
Anhui Province in 1987

新201556
玉璜
新石器时代
长8.7厘米　端宽2厘米　厚0.2厘米
备注：1987年安徽省含山县凌家滩出土

Xin 201556
Jade Huang
Neolithic Age
Length: 8.7 cm　End width: 2 cm
Thickness: 0.2 cm
Unearthed at Lingjiatan, Hanshan County,
Anhui Province in 1987

新201557
玉璜
新石器时代
长15.3厘米　端宽2.6厘米　厚0.3厘米
备注：1987年安徽省含山县凌家滩出土

Xin 201557
Jade Huang
Neolithic Age
Length: 15.3 cm　End width: 2.6 cm
Thickness: 0.3 cm
Unearthed at Lingjiatan, Hanshan County,
Anhui Province in 1987

新201528
玉璜
新石器时代
长11厘米　端宽2.6厘米　厚0.2厘米
备注：1987年安徽省含山县凌家滩出土

Xin 201528
Jade Huang
Neolithic Age
Length: 11 cm　End width: 2.6 cm
Thickness: 0.2 cm
Unearthed at Lingjiatan, Hanshan County,
Anhui Province in 1987

新201523
玉璜
新石器时代
长11.1厘米　端宽2.1厘米　厚0.3厘米
备注：1987年安徽省含山县凌家滩出土

Xin 201523
Jade Huang
Neolithic Age
Length: 11.1 cm　End width: 2.1 cm
Thickness: 0.3 cm
Unearthed at Lingjiatan, Hanshan County,
Anhui Province in 1987

新201482
玉璜
新石器时代
长23厘米　端宽2.2厘米　厚0.6厘米
备注：1987年安徽省含山县凌家滩出土

Xin 201482
Jade Huang
Neolithic Age
Length: 23 cm　End width: 2.2 cm
Thickness: 0.6 cm
Unearthed at Lingjiatan, Hanshan County,
Anhui Province in 1987

85

新201526
玉璜
新石器时代
长21.3厘米 端宽4.1厘米 厚0.2厘米
备注：1987年安徽省含山县凌家滩出土

Xin 201526
Jade Huang
Neolithic Age
Length: 21.3 cm End width: 4.1 cm
Thickness: 0.2 cm
Unearthed at Lingjiatan, Hanshan County,
Anhui Province in 1987

86

新201558
玉璜
新石器时代
长13.8厘米 端宽4厘米 厚0.2厘米
备注：残，1987年安徽省含山县凌家滩出土

Xin 201558
Jade Huang
Neolithic Age
Length: 13.8 cm End width: 4 cm
Thickness: 0.2 cm
Incomplete and unearthed at Lingjiatan, Hanshan County,
Anhui Province in 1987

87

新201480
玉双虎首璜
新石器时代
长11.9厘米 端宽2.5厘米 厚0.4厘米
备注：1987年安徽省含山县凌家滩出土

Xin 201480
Jade Huang with double-tigerhead
design
Neolithic Age
Length: 11.9 cm End width: 2.5 cm Thickness: 0.4 cm
Unearthed at Lingjiatan, Hanshan County,
Anhui Province in 1987

88

新201479
玉对接璜
新石器时代
长16.9厘米 端宽1.9厘米 厚0.6厘米
备注：1987年安徽省含山县凌家滩出土

Xin 201479
Jade Huang
Neolithic Age
Length: 16.9 cm End width: 1.9 cm
Thickness: 0.6 cm
Unearthed at Lingjiatan, Hanshan County,
Anhui Province in 1987

89

新201483
玛瑙璜
新石器时代
长19.2厘米 端宽1.5厘米 厚1厘米
备注：1987年安徽省含山县凌家滩出土

Xin 201483
Agate Huang
Neolithic Age
Length: 19.2 cm End width: 1.5 cm
Thickness: 1 cm
Unearthed at Lingjiatan, Hanshan County,
Anhui Province in 1987

90

新201484
玛瑙璜
新石器时代
长18.8厘米 端宽1.4厘米 厚0.9厘米
备注：1987年安徽省含山县凌家滩出土

Xin 201484
Agate Huang
Neolithic Age
Length: 18.8 cm End width: 1.4 cm
Thickness: 0.9 cm
Unearthed at Lingjiatan, Hanshan County,
Anhui Province in 1987

91

新201529
玉玦
新石器时代
径6厘米 孔径2.1厘米 厚0.4厘米
备注：1987年安徽省含山县凌家滩出土

Xin 201529
Jade Jue
Neolithic Age
Diameter: 6 cm Internal diameter: 2.1 cm
Thickness: 0.4 cm
Unearthed at Lingjiatan, Hanshan County,
Anhui Province in 1987

92

新201532
玉玦
新石器时代
径2.7×2.5厘米 孔径0.7厘米 厚0.3厘米
备注：1987年安徽省含山县凌家滩出土

Xin 201532
Jade Jue
Neolithic Age
Diameter: 2.7×2.5 cm Internal diameter: 0.7 cm
Thickness: 0.3 cm
Unearthed at Lingjiatan, Hanshan County,
Anhui Province in 1987

93

新201536
玉玦
新石器时代
径2.7厘米 孔径1.1厘米 厚0.4厘米
备注：1987年安徽省含山县凌家滩出土

Xin 201536
Jade Jue
Neolithic Age
Diameter: 2.7 cm Internal diameter: 1.1 cm
Thickness: 0.4 cm
Unearthed at Lingjiatan, Hanshan County,
Anhui Province in 1987

94

新201537
玉玦
新石器时代
径2.5×2.2厘米 孔径0.6厘米 厚0.5厘米
备注：1987年安徽省含山县凌家滩出土

Xin 201537
Jade Jue
Neolithic Age
Diameter: 2.5×2.2 cm Internal diameter: 0.6 cm
Thickness: 0.5 cm
Unearthed at Lingjiatan, Hanshan County,
Anhui Province in 1987

95

新201538
玉玦
新石器时代
径2.7厘米 孔径0.9厘米 厚0.3厘米
备注：1987年安徽省含山县凌家滩出土

Xin 201538
Jade Jue
Neolithic Age
Diameter: 2.7 cm Internal diameter: 0.9 cm
Thickness: 0.3 cm
Unearthed at Lingjiatan, Hanshan County,
Anhui Province in 1987

96

新201539
玉玦
新石器时代
径2.5厘米 孔径0.8厘米 厚0.4厘米
备注：1987年安徽省含山县凌家滩出土

Xin 201539
Jade Jue
Neolithic Age
Diameter: 2.5 cm Internal diameter: 0.8 cm
Thickness: 0.4 cm
Unearthed at Lingjiatan, Hanshan County,
Anhui Province in 1987

122

123

124

125

126

127

128

128

128

128

129

129

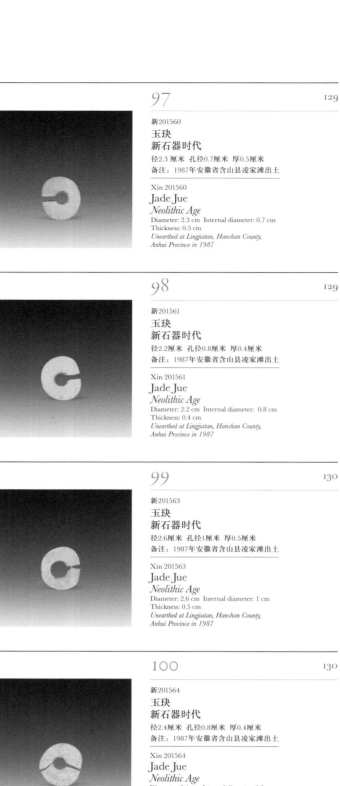

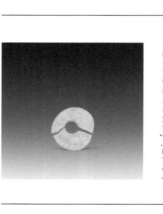

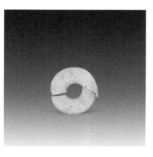

97

新201560
玉玦
新石器时代
径2.3厘米 孔径0.7厘米 厚0.5厘米
备注：1987年安徽省含山县凌家滩出土

Xin 201560
Jade Jue
Neolithic Age
Diameter: 2.3 cm Internal diameter: 0.7 cm
Thickness: 0.5 cm
Unearthed at Lingjiatan, Hanshan County,
Anhui Province in 1987

98

129

新201561
玉玦
新石器时代
径2.2厘米 孔径0.8厘米 厚0.4厘米
备注：1987年安徽省含山县凌家滩出土

Xin 201561
Jade Jue
Neolithic Age
Diameter: 2.2 cm Internal diameter: 0.8 cm
Thickness: 0.4 cm
Unearthed at Lingjiatan, Hanshan County,
Anhui Province in 1987

99

130

新201563
玉玦
新石器时代
径2.6厘米 孔径1厘米 厚0.5厘米
备注：1987年安徽省含山县凌家滩出土

Xin 201563
Jade Jue
Neolithic Age
Diameter: 2.6 cm Internal diameter: 1 cm
Thickness: 0.5 cm
Unearthed at Lingjiatan, Hanshan County,
Anhui Province in 1987

100

130

新201564
玉玦
新石器时代
径2.4厘米 孔径0.8厘米 厚0.4厘米
备注：1987年安徽省含山县凌家滩出土

Xin 201564
Jade Jue
Neolithic Age
Diameter: 2.4 cm Internal diameter: 0.8 cm
Thickness: 0.4 cm
Unearthed at Lingjiatan, Hanshan County,
Anhui Province in 1987

101

130

新201565
玉玦
新石器时代
径2.4厘米 孔径0.9厘米 厚0.4厘米
备注：1987年安徽省含山县凌家滩出土

Xin 201565
Jade Jue
Neolithic Age
Diameter: 2.4 cm Internal diameter: 0.9 cm
Thickness: 0.4 cm
Unearthed at Lingjiatan, Hanshan County,
Anhui Province in 1987

102

130

新201566
玉玦
新石器时代
径2.6厘米 孔径0.8厘米 厚0.4厘米
备注：1987年安徽省含山县凌家滩出土

Xin 201566
Jade Jue
Neolithic Age
Diameter: 2.6 cm Internal diameter: 0.8 cm
Thickness: 0.4 cm
Unearthed at Lingjiatan, Hanshan County,
Anhui Province in 1987

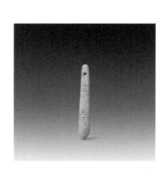

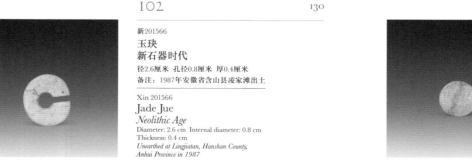

103

131

新201522
玉坠
新石器时代
长8.5厘米 宽1.2厘米 厚0.7厘米
备注：1987年安徽省含山县凌家滩出土

Xin 201522
Jade pendant
Neolithic Age
Length: 8.5 cm Width: 1.2 cm Thickness: 0.7 cm
Unearthed at Lingjiatan, Hanshan County,
Anhui Province in 1987

104

131

新201478
玉条纹三角形饰
新石器时代
长10.3厘米 宽6厘米 厚0.5厘米
备注：1987年安徽省含山县凌家滩出土

Xin 201478
Jade triangle ornament with stripe design
Neolithic Age
Length: 10.3 cm Width: 6 cm Thickness: 0.5 cm
Unearthed at Lingjiatan, Hanshan County,
Anhui Province in 1987

105

131

新201531
玉丁形饰
新石器时代
高3.2厘米 宽4.6厘米 厚1.5厘米
备注：1987年安徽省含山县凌家滩出土

Xin 201531
T-shaped jade ornament
Neolithic Age
Height: 3.2 cm Width: 4.6 cm
Thickness: 1.5 cm
Unearthed at Lingjiatan, Hanshan County,
Anhui Province in 1987

106

132

新201548
玉饰
新石器时代
径2.1厘米 厚0.4厘米
备注：1987年安徽省含山县凌家滩出土

Xin 201548
Jade ornament
Neolithic Age
Diameter: 2.1 cm Thickness: 0.4 cm
Unearthed at Lingjiatan, Hanshan County,
Anhui Province in 1987

107

132

新201550
玉饰
新石器时代
径2厘米 厚0.5厘米
备注：1987年安徽省含山县凌家滩出土

Xin 201550
Jade ornament
Neolithic Age
Diameter: 2 cm Thickness: 0.5 cm
Unearthed at Lingjiatan, Hanshan County,
Anhui Province in 1987

108

132

新201551
玉饰
新石器时代
径1.8厘米 厚0.6厘米
备注：1987年安徽省含山县凌家滩出土

Xin 201551
Jade ornament
Neolithic Age
Diameter: 1.8 cm Thickness: 0.6 cm
Unearthed at Lingjiatan, Hanshan County,
Anhui Province in 1987

109 132

新201552
玉饰
新石器时代
径2.1厘米 厚0.9厘米
备注：1987年安徽省含山县凌家滩出土

Xin 201552
Jade ornament
Neolithic Age
Diameter: 2.1 cm Thickness: 0.9 cm
Unearthed at Lingjiatan, Hanshan County,
Anhui Province in 1987

110 133

新201569
玉饰
新石器时代
径2.1厘米 厚0.4厘米
备注：1987年安徽省含山县凌家滩出土

Xin 201569
Jade ornament
Neolithic Age
Diameter: 2.1 cm Thickness: 0.4 cm
Unearthed at Lingjiatan, Hanshan County,
Anhui Province in 1987

111 133

新201570
玉饰
新石器时代
径1.7厘米 厚0.8厘米
备注：1987年安徽省含山县凌家滩出土

Xin 201570
Jade ornament
Neolithic Age
Diameter: 1.7 cm Thickness: 0.8 cm
Unearthed at Lingjiatan, Hanshan County,
Anhui Province in 1987

112 133

新201571
玉饰
新石器时代
径2.3厘米 厚0.4厘米
备注：1987年安徽省含山县凌家滩出土

Xin 201571
Jade ornament
Neolithic Age
Diameter: 2.3 cm Thickness: 0.4 cm
Unearthed at Lingjiatan, Hanshan County,
Anhui Province in 1987

113 133

新201572
玉饰
新石器时代
径0.9厘米 厚0.6厘米
备注：1987年安徽省含山县凌家滩出土

Xin 201572
Jade ornament
Neolithic Age
Diameter: 0.9 cm Thickness: 0.6 cm
Unearthed at Lingjiatan, Hanshan County,
Anhui Province in 1987

114 134

新201573
玉饰
新石器时代
径0.9厘米 厚0.6厘米
备注：1987年安徽省含山县凌家滩出土

Xin 201573
Jade ornament
Neolithic Age
Diameter: 0.9 cm Thickness: 0.6 cm
Unearthed at Lingjiatan, Hanshan County,
Anhui Province in 1987

115 134

新201575
玉饰
新石器时代
径1厘米 厚0.6厘米
备注：1987年安徽省含山县凌家滩出土

Xin 201575
Jade ornament
Neolithic Age
Diameter: 1 cm Thickness: 0.6 cm
Unearthed at Lingjiatan, Hanshan County,
Anhui Province in 1987

116 134

新201576
玉饰
新石器时代
径0.9厘米 厚0.5厘米
备注：1987年安徽省含山县凌家滩出土

Xin 201576
Jade ornament
Neolithic Age
Diameter: 0.9 cm Thickness: 0.5 cm
Unearthed at Lingjiatan, Hanshan County,
Anhui Province in 1987

117 134

新201577
玉饰
新石器时代
径1厘米 厚0.4厘米
备注：1987年安徽省含山县凌家滩出土

Xin 201577
Jade ornament
Neolithic Age
Diameter: 1 cm Thickness: 0.4 cm
Unearthed at Lingjiatan, Hanshan County,
Anhui Province in 1987

118 135

新201544 新201545 新201546 新201547
玉饰
新石器时代
长2.3～2.6厘米 宽2～2.7厘米 厚0.6～0.9厘米
备注：1987年安徽省含山县凌家滩出土

Xin 201544, Xin 201545, Xin 201546, Xin 201547
Jade ornaments
Neolithic Age
Length: 2.3-2.6 cm Width: 2-2.7 cm
Thickness: 0.6-0.9 cm
Unearthed at Lingjiatan, Hanshan County,
Anhui Province in 1987

119 136

新201574
玉饰
新石器时代
高1.7厘米 底径1.9厘米
备注：1987年安徽省含山县凌家滩出土

Xin 201574
Jade ornament
Neolithic Age
Height: 1.7 cm Bottom diameter: 1.9 cm
Unearthed at Lingjiatan, Hanshan County,
Anhui Province in 1987

120 136

新201567
玉饰
新石器时代
长4.2厘米 宽1.8厘米 厚0.4厘米
备注：1987年安徽省含山县凌家滩出土

Xin 201567
Jade ornament
Neolithic Age
Length: 4.2 cm Width: 1.8 cm
Thickness: 0.4 cm
Unearthed at Lingjiatan, Hanshan County,
Anhui Province in 1987

121 136	**127** 140
新201568 **玉饰** **新石器时代** 长3.6厘米 宽1.6厘米 厚0.3厘米 备注：1987年安徽省含山县凌家滩出土 Xin 201568 Jade ornament *Neolithic Age* Length: 3.6 cm Width: 1.6 cm Thickness: 0.3 cm *Unearthed at Lingjiatan, Hanshan County,* *Anhui Province in 1987*	新201584 **玉石料** **新石器时代** 高7.5厘米 宽9.5厘米 厚4.5厘米 备注：1987年安徽省含山县凌家滩出土 Xin 201584 Jade stone *Neolithic Age* Height: 7.5 cm Width: 9.5 cm Thickness: 4.5 cm *Unearthed at Lingjiatan, Hanshan County, Anhui Province in 1987*
122 136	**128** 141
新201579 **玉饰** **新石器时代** 长4厘米 宽2.5厘米 厚0.4厘米 备注：残，1987年安徽省含山县凌家滩出土 Xin 201579 Jade ornament *Neolithic Age* Length: 4 cm Width: 2.5 cm Thickness: 0.4 cm *Incomplete, unearthed at Lingjiatan, Hanshan County,* *Anhui Province in 1987*	新201585 **玉石料** **新石器时代** 高6厘米 宽17厘米 厚2.5厘米 备注：1987年安徽省含山县凌家滩出土 Xin 201585 Jade stone *Neolithic Age* Height: 6 cm Width: 17 cm Thickness: 2.5 cm *Unearthed at Lingjiatan, Hanshan County,* *Anhui Province in 1987*
123 137	**129** 142
新201481 **玉多边形片** **新石器时代** 长8.9厘米 宽4.1厘米 厚0.2厘米 备注：1987年安徽省含山县凌家滩出土 Xin 201481 Jade polygonal flake *Neolithic Age* Length: 8.9 cm Width: 4.1 cm Thickness: 0.2 cm *Unearthed at Lingjiatan, Hanshan County,* *Anhui Province in 1987*	新201586 **玉石料** **新石器时代** 高9厘米 宽15厘米 厚3厘米 备注：1987年安徽省含山县凌家滩出土 Xin 201586 Jade stone *Neolithic Age* Height: 9 cm Width: 15 cm Thickness: 3 cm *Unearthed at Lingjiatan, Hanshan County,* *Anhui Province in 1987*
124 138	**130** 143
新201533 新201534 新201535 新201540 新201541 新201542 **玉管形器（6 件）** **新石器时代** 高1.5厘米 径1.3～1.4厘米 备注：1987年安徽省含山县凌家滩出土 Xin 201533, Xin 201534, Xin 201535 Xin 201540, Xin 201541, Xin 201542 Jade tubes (six pieces) *Neolithic Age* Height: 1.5 cm Diameter: 1.3-1.4 cm *Unearthed at Lingjiatan, Hanshan County,* *Anhui Province in 1987*	新201587 **玉石料** **新石器时代** 高6厘米 宽12.5厘米 厚3厘米 备注：1987年安徽省含山县凌家滩出土 Xin 201587 Jade stone *Neolithic Age* Height: 6 cm Width: 12.5 cm Thickness: 3 cm *Unearthed at Lingjiatan, Hanshan County,* *Anhui Province in 1987*
125 138	**131** 144
新201521 **玛瑙管** **新石器时代** 长5.8厘米 径1.5厘米 备注：1987年安徽省含山县凌家滩出土 Xin 201521 Agate tube *Neolithic Age* Length: 5.8 cm Diameter: 1.5 cm *Unearthed at Lingjiatan, Hanshan County,* *Anhui Province in 1987*	新201588 **玉石料** **新石器时代** 高8厘米 宽9厘米 厚5厘米 备注：1987年安徽省含山县凌家滩出土 Xin 201588 Jade stone *Neolithic Age* Height: 8 cm Width: 9 cm Thickness: 5 cm *Unearthed at Lingjiatan, Hanshan County,* *Anhui Province in 1987*
126 139	**132** 145
新201474 **玉勺** **新石器时代** 长16.5厘米 宽2.8厘米 备注：1987年安徽省含山县凌家滩出土 Xin 201474 Jade spoon *Neolithic Age* Length: 16.5 cm Width: 2.8 cm *Unearthed at Lingjiatan, Hanshan County, Anhui Province in 1987*	新201589 **玉石料** **新石器时代** 高7厘米 宽10厘米 厚3厘米 备注：1987年安徽省含山县凌家滩出土 Xin 201589 Jade stone *Neolithic Age* Height: 7 cm Width: 10 cm Thickness: 3 cm *Unearthed at Lingjiatan, Hanshan County,* *Anhui Province in 1987*

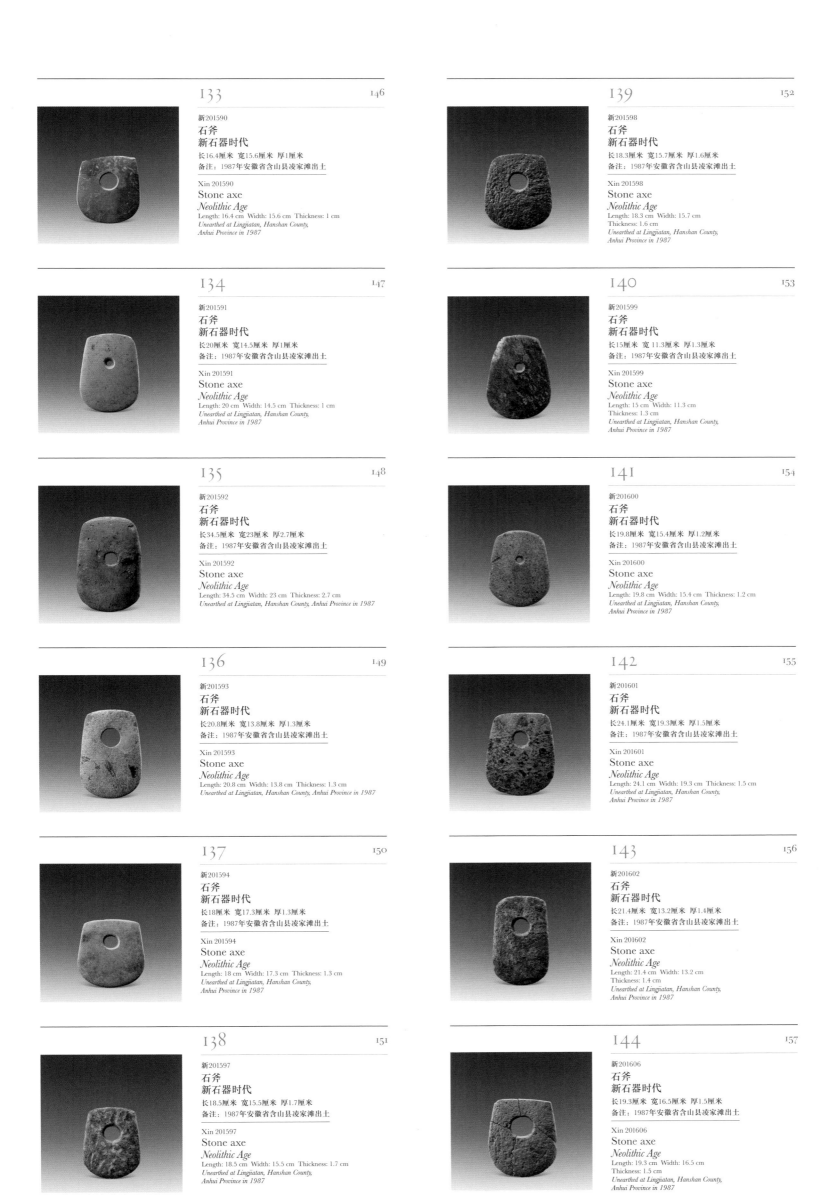

133 146

新201590
石斧
新石器时代
长16.4厘米　宽15.6厘米　厚1厘米
备注：1987年安徽省含山县凌家滩出土

Xin 201590
Stone axe
Neolithic Age
Length: 16.4 cm Width: 15.6 cm Thickness: 1 cm
Unearthed at Lingjiatan, Hanshan County,
Anhui Province in 1987

139 152

新201598
石斧
新石器时代
长18.3厘米　宽15.7厘米　厚1.6厘米
备注：1987年安徽省含山县凌家滩出土

Xin 201598
Stone axe
Neolithic Age
Length: 18.3 cm Width: 15.7 cm
Thickness: 1.6 cm
Unearthed at Lingjiatan, Hanshan County,
Anhui Province in 1987

134 147

新201591
石斧
新石器时代
长20厘米　宽14.5厘米　厚1厘米
备注：1987年安徽省含山县凌家滩出土

Xin 201591
Stone axe
Neolithic Age
Length: 20 cm Width: 14.5 cm Thickness: 1 cm
Unearthed at Lingjiatan, Hanshan County,
Anhui Province in 1987

140 153

新201599
石斧
新石器时代
长15厘米　宽11.3厘米　厚1.3厘米
备注：1987年安徽省含山县凌家滩出土

Xin 201599
Stone axe
Neolithic Age
Length: 15 cm Width: 11.3 cm
Thickness: 1.3 cm
Unearthed at Lingjiatan, Hanshan County,
Anhui Province in 1987

135 148

新201592
石斧
新石器时代
长34.5厘米　宽23厘米　厚2.7厘米
备注：1987年安徽省含山县凌家滩出土

Xin 201592
Stone axe
Neolithic Age
Length: 34.5 cm Width: 23 cm Thickness: 2.7 cm
Unearthed at Lingjiatan, Hanshan County, Anhui Province in 1987

141 154

新201600
石斧
新石器时代
长19.8厘米　宽15.4厘米　厚1.2厘米
备注：1987年安徽省含山县凌家滩出土

Xin 201600
Stone axe
Neolithic Age
Length: 19.8 cm Width: 15.4 cm Thickness: 1.2 cm
Unearthed at Lingjiatan, Hanshan County,
Anhui Province in 1987

136 149

新201593
石斧
新石器时代
长20.8厘米　宽13.8厘米　厚1.3厘米
备注：1987年安徽省含山县凌家滩出土

Xin 201593
Stone axe
Neolithic Age
Length: 20.8 cm Width: 13.8 cm Thickness: 1.3 cm
Unearthed at Lingjiatan, Hanshan County, Anhui Province in 1987

142 155

新201601
石斧
新石器时代
长24.1厘米　宽19.3厘米　厚1.5厘米
备注：1987年安徽省含山县凌家滩出土

Xin 201601
Stone axe
Neolithic Age
Length: 24.1 cm Width: 19.3 cm Thickness: 1.5 cm
Unearthed at Lingjiatan, Hanshan County,
Anhui Province in 1987

137 150

新201594
石斧
新石器时代
长18厘米　宽17.3厘米　厚1.3厘米
备注：1987年安徽省含山县凌家滩出土

Xin 201594
Stone axe
Neolithic Age
Length: 18 cm Width: 17.3 cm Thickness: 1.3 cm
Unearthed at Lingjiatan, Hanshan County,
Anhui Province in 1987

143 156

新201602
石斧
新石器时代
长21.4厘米　宽13.2厘米　厚1.4厘米
备注：1987年安徽省含山县凌家滩出土

Xin 201602
Stone axe
Neolithic Age
Length: 21.4 cm Width: 13.2 cm
Thickness: 1.4 cm
Unearthed at Lingjiatan, Hanshan County,
Anhui Province in 1987

138 151

新201597
石斧
新石器时代
长18.5厘米　宽15.5厘米　厚1.7厘米
备注：1987年安徽省含山县凌家滩出土

Xin 201597
Stone axe
Neolithic Age
Length: 18.5 cm Width: 15.5 cm Thickness: 1.7 cm
Unearthed at Lingjiatan, Hanshan County,
Anhui Province in 1987

144 157

新201606
石斧
新石器时代
长19.3厘米　宽16.5厘米　厚1.5厘米
备注：1987年安徽省含山县凌家滩出土

Xin 201606
Stone axe
Neolithic Age
Length: 19.3 cm Width: 16.5 cm
Thickness: 1.5 cm
Unearthed at Lingjiatan, Hanshan County,
Anhui Province in 1987

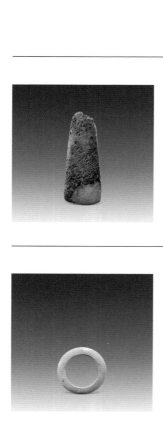

145

158

新201605

石斧
新石器时代

长22.8厘米 宽9厘米 厚0.8厘米

备注：1987年安徽省含山县凌家滩出土

Xin 201605

Stone axe
Neolithic Age

Length: 22.8 cm Width: 9 cm Thickness: 0.8 cm
Unearthed at Lingjiatan, Hanshan County,
Anhui Province in 1987

146

159

新201596

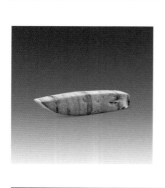

石环
新石器时代

径9.5厘米 孔径6.5厘米 厚2.3厘米

备注：1987年安徽省含山县凌家滩出土

Xin 201596

Stone ring
Neolithic Age

Diameter: 9.5 cm Internal diameter: 6.5 cm
Thickness: 2.3 cm
Unearthed at Lingjiatan, Hanshan County,
Anhui Province in 1987

147

160

新201607

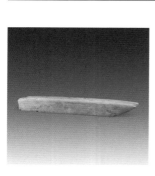

石凿
新石器时代

长14.3厘米 宽2.1厘米 厚3厘米

备注：1987年安徽省含山县凌家滩出土

Xin 201607

Stone chisel
Neolithic Age

Length: 14.3 cm Width: 2.1 cm
Thickness: 3 cm
Unearthed at Lingjiatan, Hanshan County,
Anhui Province in 1987

148

160

新201595

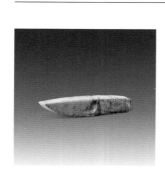

石凿
新石器时代

长30.5厘米 宽3.6厘米 厚3.8厘米

备注：1987年安徽省含山县凌家滩出土

Xin 201595

Stone chisel
Neolithic Age

Length: 30.5 cm Width: 3.6 cm
Thickness: 3.8 cm
Unearthed at Lingjiatan, Hanshan County,
Anhui Province in 1987

149

161

新201608

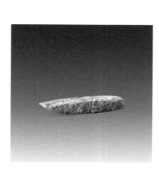

石凿
新石器时代

长13.8厘米 宽2厘米 厚2.6厘米

备注：1987年安徽省含山县凌家滩出土

Xin 201608

Stone chisel
Neolithic Age

Length: 13.8 cm Width: 2 cm
Thickness: 2.6 cm
Unearthed at Lingjiatan, Hanshan County,
Anhui Province in 1987

150

161

新201609

石凿
新石器时代

长12.6厘米 宽2.5厘米 厚2厘米

备注：1987年安徽省含山县凌家滩出土

Xin 201609

Stone chisel
Neolithic Age

Length: 12.6 cm Width: 2.5 cm
Thickness: 2 cm
Unearthed at Lingjiatan, Hanshan County,
Anhui Province in 1987

151

162

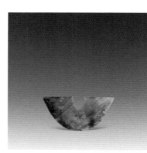

新130757

玉璜
崧泽文化

长10.6厘米 端宽4.4厘米 厚0.3厘米

Xin 130757

Jade Huang
Songze Culture

Length: 10.6 cm End width: 4.4 cm
Thickness: 0.3 cm

152

163

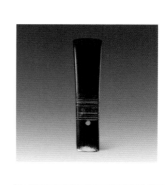

新67199

玉兽面纹圭
石家河文化

长21.8厘米 宽5.5厘米 厚1厘米

Xin 67199

Jade Gui with animal-face design
Shijiahe Culture

Length: 21.8 cm Width: 5.5 cm Thickness: 1 cm

153

164

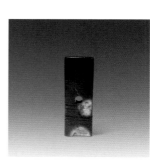

新116020

玉兽面纹圭
石家河文化

长9.9厘米 宽3.5厘米 厚0.9厘米

备注：残，青玉，表面染黑褐色

Xin 116020

Jade Gui with animal-face design
Shijiahe Culture

Length: 9.9 cm Width: 3.5 cm Thickness: 0.9 cm
This is a green jade incomplete object and the surface was dyed dark
brown

154

164

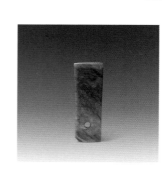

新116021

玉鸟纹圭
石家河文化

长10.4厘米 宽3.5厘米 厚0.8厘米

Xin 116021

Jade Gui with bird design
Shijiahe Culture

Length: 10.4 cm Width: 3.5 cm Thickness: 0.8 cm

155

165

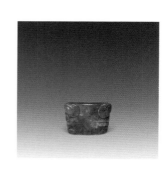

故83924

玉兽首
石家河文化

高2.5厘米 宽3.4厘米 厚1.4厘米

Gu 83924

Jade animal head
Shijiahe Culture

Height: 2.5 cm Width: 3.4 cm
Thickness: 1.4 cm

156

165

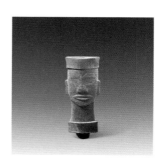

新141652

玉人首
石家河文化

高6.3厘米 宽2.6厘米 厚0.7厘米

Xin 141652

Jade human head
Shijiahe Culture

Height: 6.3 cm Width: 2.6 cm
Thickness: 0.7 cm

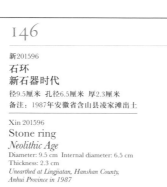

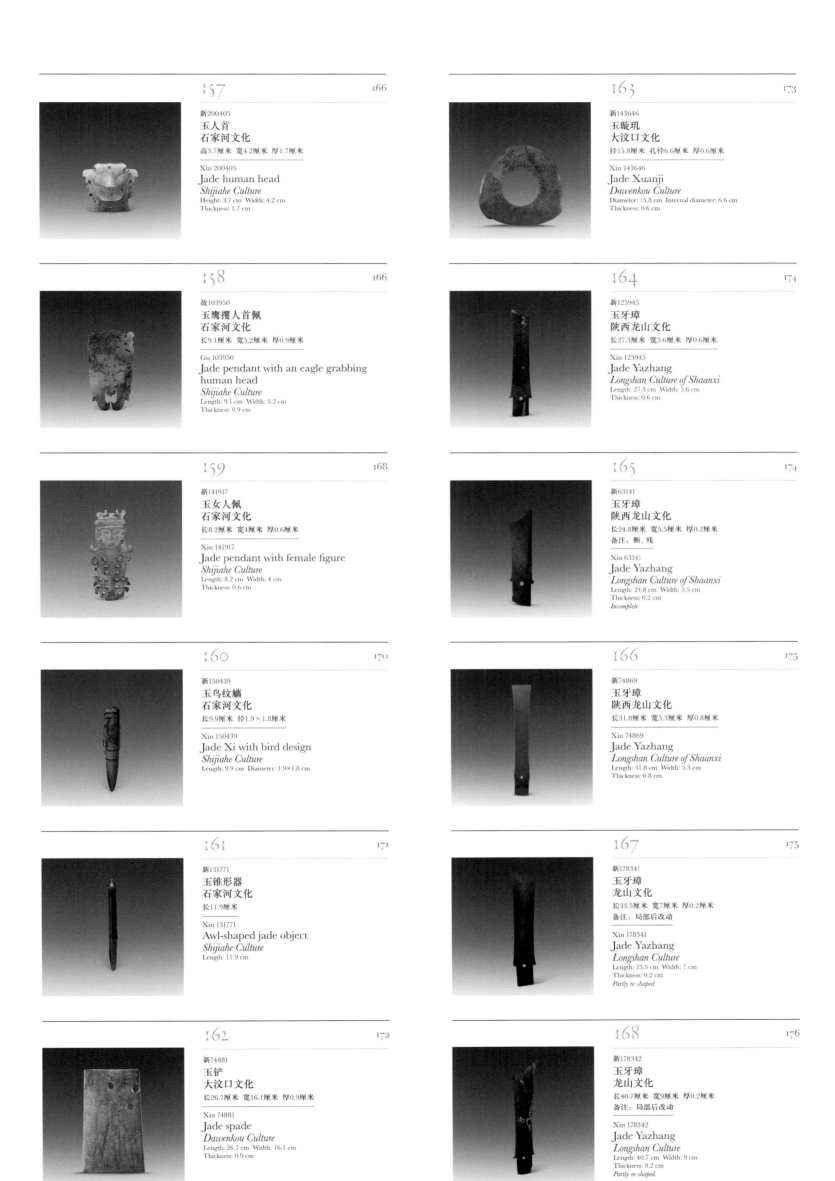

新200405
玉人首
石家河文化
高3.7厘米　宽4.2厘米　厚1.7厘米

Xin 200405
Jade human head
Shijiahe Culture
Height: 3.7 cm Width: 4.2 cm
Thickness: 1.7 cm

故103950
玉鹰攫人首佩
石家河文化
长9.1厘米　宽5.2厘米　厚0.9厘米

Gu 103950
Jade pendant with an eagle grabbing
human head
Shijiahe Culture
Length: 9.1 cm Width: 5.2 cm
Thickness: 0.9 cm

新141917
玉女人佩
石家河文化
长8.2厘米　宽4厘米　厚0.6厘米

Xin 141917
Jade pendant with female figure
Shijiahe Culture
Length: 8.2 cm Width: 4 cm
Thickness: 0.6 cm

新150439
玉鸟纹觿
石家河文化
长9.9厘米　径1.9×1.8厘米

Xin 150439
Jade Xi with bird design
Shijiahe Culture
Length: 9.9 cm Diameter: 1.9×1.8 cm

新131771
玉锥形器
石家河文化
长11.9厘米

Xin 131771
Awl-shaped jade object
Shijiahe Culture
Length: 11.9 cm

新74881
玉铲
大汶口文化
长26.7厘米　宽16.1厘米　厚0.9厘米

Xin 74881
Jade spade
Dawenkou Culture
Length: 26.7 cm Width: 16.1 cm
Thickness: 0.9 cm

新143646
玉璇玑
大汶口文化
径15.8厘米　孔径6.6厘米　厚0.6厘米

Xin 143646
Jade Xuanji
Dawenkou Culture
Diameter: 15.8 cm Internal diameter: 6.6 cm
Thickness: 0.6 cm

新125945
玉牙璋
陕西龙山文化
长27.3厘米　宽5.6厘米　厚0.6厘米

Xin 125945
Jade Yazhang
Longshan Culture of Shaanxi
Length: 27.3 cm Width: 5.6 cm
Thickness: 0.6 cm

新63141
玉牙璋
陕西龙山文化
长24.8厘米　宽5.5厘米　厚0.2厘米
备注：断、残

Xin 63141
Jade Yazhang
Longshan Culture of Shaanxi
Length: 24.8 cm Width: 5.5 cm
Thickness: 0.2 cm
Incomplete

新74869
玉牙璋
陕西龙山文化
长31.8厘米　宽5.3厘米　厚0.8厘米

Xin 74869
Jade Yazhang
Longshan Culture of Shaanxi
Length: 31.8 cm Width: 5.3 cm
Thickness: 0.8 cm

新178341
玉牙璋
龙山文化
长33.5厘米　宽7厘米　厚0.2厘米
备注：局部后改动

Xin 178341
Jade Yazhang
Longshan Culture
Length: 33.5 cm Width: 7 cm
Thickness: 0.2 cm
Partly re-shaped

新178342
玉牙璋
龙山文化
长40.7厘米　宽9厘米　厚0.2厘米
备注：局部后改动

Xin 178342
Jade Yazhang
Longshan Culture
Length: 40.7 cm Width: 9 cm
Thickness: 0.2 cm
Partly re-shaped

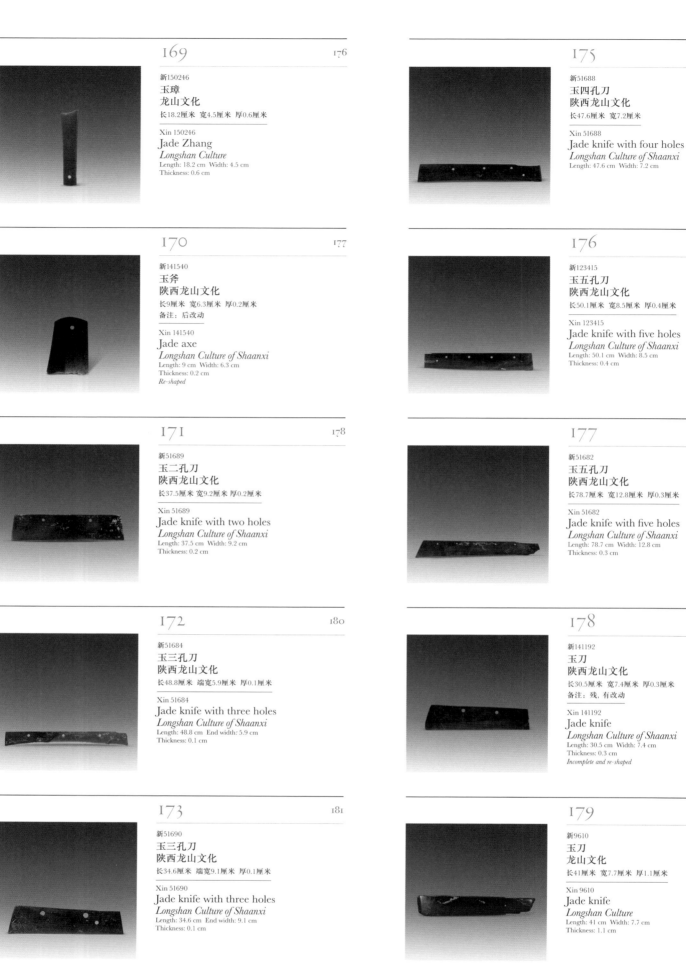

169 176	**175** 183

169 176

新150246
玉璋
龙山文化
长18.2厘米 宽4.5厘米 厚0.6厘米

Xin 150246
Jade Zhang
Longshan Culture
Length: 18.2 cm Width: 4.5 cm
Thickness: 0.6 cm

170 177

新141540
玉斧
陕西龙山文化
长9厘米 宽6.3厘米 厚0.2厘米
备注：后改动

Xin 141540
Jade axe
Longshan Culture of Shaanxi
Length: 9 cm Width: 6.3 cm
Thickness: 0.2 cm
Re-shaped

171 178

新51689
玉二孔刀
陕西龙山文化
长37.5厘米 宽9.2厘米 厚0.2厘米

Xin 51689
Jade knife with two holes
Longshan Culture of Shaanxi
Length: 37.5 cm Width: 9.2 cm
Thickness: 0.2 cm

172 180

新51684
玉三孔刀
陕西龙山文化
长48.8厘米 端宽5.9厘米 厚0.1厘米

Xin 51684
Jade knife with three holes
Longshan Culture of Shaanxi
Length: 48.8 cm End width: 5.9 cm
Thickness: 0.1 cm

173 181

新51690
玉三孔刀
陕西龙山文化
长34.6厘米 端宽9.1厘米 厚0.1厘米

Xin 51690
Jade knife with three holes
Longshan Culture of Shaanxi
Length: 34.6 cm End width: 9.1 cm
Thickness: 0.1 cm

174 182

新51685
玉四孔刀
陕西龙山文化
长32.3厘米 宽6.6厘米 厚0.1厘米

Xin 51685
Jade knife with four holes
Longshan Culture of Shaanxi
Length: 32.3 cm Width: 6.6 cm
Thickness: 0.1 cm

175 183

新51688
玉四孔刀
陕西龙山文化
长47.6厘米 宽7.2厘米

Xin 51688
Jade knife with four holes
Longshan Culture of Shaanxi
Length: 47.6 cm Width: 7.2 cm

176 184

新123415
玉五孔刀
陕西龙山文化
长50.1厘米 宽8.5厘米 厚0.4厘米

Xin 123415
Jade knife with five holes
Longshan Culture of Shaanxi
Length: 50.1 cm Width: 8.5 cm
Thickness: 0.4 cm

177 185

新51682
玉五孔刀
陕西龙山文化
长78.7厘米 宽12.8厘米 厚0.3厘米

Xin 51682
Jade knife with five holes
Longshan Culture of Shaanxi
Length: 78.7 cm Width: 12.8 cm
Thickness: 0.3 cm

178 186

新141192
玉刀
陕西龙山文化
长30.5厘米 宽7.4厘米 厚0.3厘米
备注：残，有改动

Xin 141192
Jade knife
Longshan Culture of Shaanxi
Length: 30.5 cm Width: 7.4 cm
Thickness: 0.3 cm
Incomplete and re-shaped

179 186

新9610
玉刀
龙山文化
长41厘米 宽7.7厘米 厚1.1厘米

Xin 9610
Jade knife
Longshan Culture
Length: 41 cm Width: 7.7 cm
Thickness: 1.1 cm

180 187

新99949
玉铲
龙山文化
长37.9厘米 宽18厘米 厚0.6厘米

Xin 99949
Jade spade
Longshan Culture
Length: 37.9 cm Width: 18 cm
Thickness: 0.6 cm

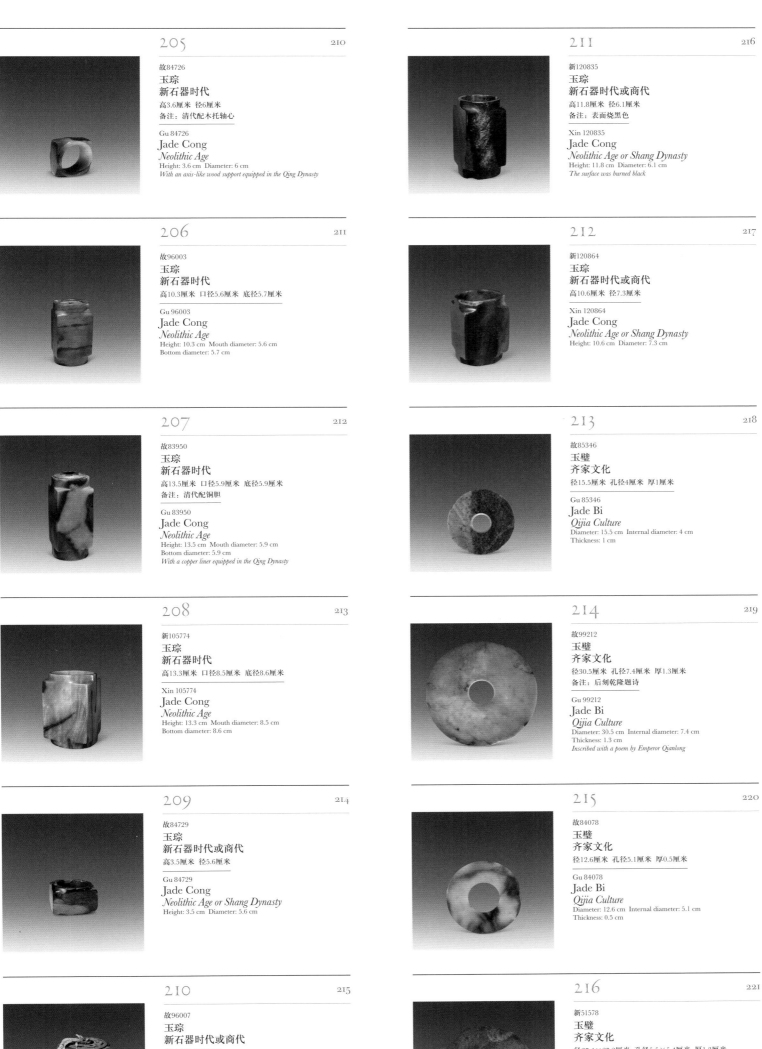

205

故84726
玉琮
新石器时代
高3.6厘米 径6厘米
备注：清代配木托轴心

Gu 84726
Jade Cong
Neolithic Age
Height: 3.6 cm Diameter: 6 cm
With an axis-like wood support equipped in the Qing Dynasty

206

故96003
玉琮
新石器时代
高10.3厘米 口径5.6厘米 底径5.7厘米

Gu 96003
Jade Cong
Neolithic Age
Height: 10.3 cm Mouth diameter: 5.6 cm
Bottom diameter: 5.7 cm

207

故83950
玉琮
新石器时代
高13.5厘米 口径5.9厘米 底径5.9厘米
备注：清代配铜胆

Gu 83950
Jade Cong
Neolithic Age
Height: 13.5 cm Mouth diameter: 5.9 cm
Bottom diameter: 5.9 cm
With a copper liner equipped in the Qing Dynasty

208

新105774
玉琮
新石器时代
高13.3厘米 口径8.5厘米 底径8.6厘米

Xin 105774
Jade Cong
Neolithic Age
Height: 13.3 cm Mouth diameter: 8.5 cm
Bottom diameter: 8.6 cm

209

故84729
玉琮
新石器时代或商代
高3.5厘米 径5.6厘米

Gu 84729
Jade Cong
Neolithic Age or Shang Dynasty
Height: 3.5 cm Diameter: 5.6 cm

210

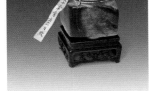

故96007
玉琮
新石器时代或商代
高5厘米 径6厘米
备注：附清代造木座、铜胆、黄笺

Gu 96007
Jade Cong
Neolithic Age or Shang Dynasty
Height: 5 cm Diameter: 6 cm
With a copper liner, a wooden base and a yellow piece of paper label in the Qing Dynasty

211

新120835
玉琮
新石器时代或商代
高11.8厘米 径6.1厘米
备注：表面烧黑色

Xin 120835
Jade Cong
Neolithic Age or Shang Dynasty
Height: 11.8 cm Diameter: 6.1 cm
The surface was burned black

212

新120864
玉琮
新石器时代或商代
高10.6厘米 径7.3厘米

Xin 120864
Jade Cong
Neolithic Age or Shang Dynasty
Height: 10.6 cm Diameter: 7.3 cm

213

故85346
玉璧
齐家文化
径15.5厘米 孔径4厘米 厚1厘米

Gu 85346
Jade Bi
Qijia Culture
Diameter: 15.5 cm Internal diameter: 4 cm
Thickness: 1 cm

214

故99212
玉璧
齐家文化
径30.5厘米 孔径7.4厘米 厚1.3厘米
备注：后刻乾隆题诗

Gu 99212
Jade Bi
Qijia Culture
Diameter: 30.5 cm Internal diameter: 7.4 cm
Thickness: 1.3 cm
Inscribed with a poem by Emperor Qianlong

215

故84078
玉璧
齐家文化
径12.6厘米 孔径5.1厘米 厚0.5厘米

Gu 84078
Jade Bi
Qijia Culture
Diameter: 12.6 cm Internal diameter: 5.1 cm
Thickness: 0.5 cm

216

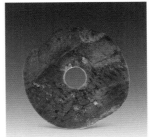

新51578
玉璧
齐家文化
径27.4×27.2厘米 孔径5.5×5.4厘米 厚1.3厘米

Xin 51578
Jade Bi
Qijia Culture
Diameter: 27.4×27.2 cm
Internal diameter: 5.5×5.4 cm Thickness: 1.3 cm

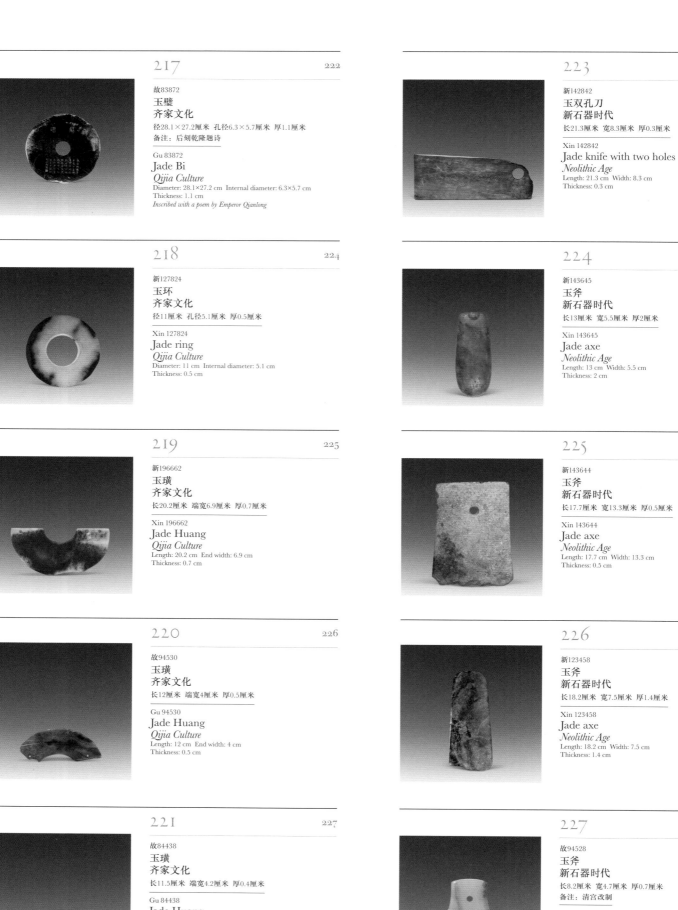

217

故83872

玉璧
齐家文化

径28.1×27.2厘米 孔径6.3×5.7厘米 厚1.1厘米
备注：后刻乾隆题诗

Gu 83872

Jade Bi
Qijia Culture
Diameter: 28.1×27.2 cm　Internal diameter: 6.3×5.7 cm
Thickness: 1.1 cm
Inscribed with a poem by Emperor Qianlong

218

新127824

玉环
齐家文化

径11厘米 孔径5.1厘米 厚0.5厘米

Xin 127824

Jade ring
Qijia Culture
Diameter: 11 cm　Internal diameter: 5.1 cm
Thickness: 0.5 cm

219

新196662

玉璜
齐家文化

长20.2厘米 端宽6.9厘米 厚0.7厘米

Xin 196662

Jade Huang
Qijia Culture
Length: 20.2 cm　End width: 6.9 cm
Thickness: 0.7 cm

220

故94530

玉璜
齐家文化

长12厘米 端宽4厘米 厚0.5厘米

Gu 94530

Jade Huang
Qijia Culture
Length: 12 cm　End width: 4 cm
Thickness: 0.5 cm

221

故84438

玉璜
齐家文化

长11.5厘米 端宽4.2厘米 厚0.4厘米

Gu 84438

Jade Huang
Qijia Culture
Length: 11.5 cm　End width: 4.2 cm
Thickness: 0.4 cm

222

新116053

玉弦纹刀
新石器时代

长4.6厘米 宽1.6厘米 厚1.4厘米

Xin 116053

Jade knife with bowstring design
Neolithic Age
Length: 4.6 cm　Width: 1.6 cm
Thickness: 1.4 cm

223

新142842

玉双孔刀
新石器时代

长21.3厘米 宽8.3厘米 厚0.3厘米

Xin 142842

Jade knife with two holes
Neolithic Age
Length: 21.3 cm　Width: 8.3 cm
Thickness: 0.3 cm

224

新143645

玉斧
新石器时代

长13厘米 宽5.5厘米 厚2厘米

Xin 143645

Jade axe
Neolithic Age
Length: 13 cm　Width: 5.5 cm
Thickness: 2 cm

225

新143644

玉斧
新石器时代

长17.7厘米 宽13.3厘米 厚0.5厘米

Xin 143644

Jade axe
Neolithic Age
Length: 17.7 cm　Width: 13.3 cm
Thickness: 0.5 cm

226

新123458

玉斧
新石器时代

长18.2厘米 宽7.5厘米 厚1.4厘米

Xin 123458

Jade axe
Neolithic Age
Length: 18.2 cm　Width: 7.5 cm
Thickness: 1.4 cm

227

故94528

玉斧
新石器时代

长8.2厘米 宽4.7厘米 厚0.7厘米
备注：清宫改制

Gu 94528

Jade axe
Neolithic Age
Length: 8.2 cm　Width: 4.7 cm
Thickness: 0.7 cm
Re-shaped in the Qing court

228

故95137

玉斧
新石器时代

长10厘米 宽6.7厘米 厚0.7厘米

Gu 95137

Jade axe
Neolithic Age
Length: 10 cm　Width: 6.7 cm
Thickness: 0.7 cm

229

233

新116009

玉斧
新石器时代

长12.1厘米 宽4.3厘米 厚1厘米

Xin 116009

Jade axe
Neolithic Age
Length: 12.1 cm Width: 4.3 cm
Thickness: 1 cm

230

234

新112681

玉斧
新石器时代

长11.6厘米 宽6.8厘米 厚0.5厘米

Xin 112681

Jade axe
Neolithic Age
Length: 11.6 cm Width: 6.8 cm
Thickness: 0.5 cm

231

234

新123832

玉斧
新石器时代

长16.1厘米 宽6.7厘米 厚0.8厘米

Xin 123832

Jade axe
Neolithic Age
Length: 16.1 cm Width: 6.7 cm
Thickness: 0.8 cm

232

235

新18911

玉斧
新石器时代

长13.7厘米 宽8.3厘米 厚0.5厘米

Xin 18911

Jade axe
Neolithic Age
Length: 13.7 cm Width: 8.3 cm
Thickness: 0.5 cm

233

236

故89412

玉斧
新石器时代

长23.5厘米 宽5.2厘米 厚1.1厘米

备注：后刻字

Gu 89412

Jade axe
Neolithic Age
Length: 23.5 cm Width: 5.2 cm
Thickness: 1.1 cm
With characters inscribed later

234

237

新14160

玉斧
新石器时代

长22.5厘米 宽7.2厘米 厚1.2厘米

Xin 14160

Jade axe
Neolithic Age
Length: 22.5 cm Width: 7.2 cm
Thickness: 1.2 cm

235

238

故83953

玉斧
新石器时代

长13.3厘米 宽5.9厘米 厚0.5厘米

备注：后刻乾隆题诗，附"含章比德"木函

Gu 83953

Jade axe
Neolithic Age
Length: 13.3 cm Width: 5.9 cm
Thickness: 0.5 cm
With a poem by Emperor Qianlong and a wood box inscribed with "Han Zhang Bi De"

236

240

故84632

玉斧
新石器时代或商代

长9.6厘米 宽5.5厘米 厚0.5厘米

备注：清代刻纹，附乾隆年制款"表德含辉"木函

Gu 84632

Jade axe
Neolithic Age or Shang Dynasty
Length: 9.6 cm Width: 5.5 cm Thickness: 0.5 cm
With designs engraved in the Qing Dynasty and a wood box "Biao De Han Hui" made in Emperor Qianlong's regin

237

242

故94565

玉斧
新石器时代或商代

长9.2厘米 宽6.5厘米 厚0.6厘米

备注：清代刻纹

Gu 94565

Jade axe
Neolithic Age or Shang Dynasty
Length: 9.2 cm Width: 6.5 cm
Thickness: 0.6 cm
With designs engraved in the Qing Dynasty

238

242

新141434

玉斧
新石器时代或商代

长11.6厘米 宽7.1厘米 厚0.8厘米

Xin 141434

Jade axe
Neolithic Age or Shang Dynasty
Length: 11.6 cm Width: 7.1 cm
Thickness: 0.8 cm

239

243

新74517

玉戚
新石器时代

长9.5厘米 宽6.5厘米 厚0.8厘米

Xin 74517

Jade Qi
Neolithic Age
Length: 9.5 cm Width: 6.5 cm
Thickness: 0.8 cm

240

243

新72893

玉钺
新石器时代

长14厘米 宽5.7厘米 厚0.4厘米

Xin 72893

Jade Yue
Neolithic Age
Length: 14 cm Width: 5.7 cm
Thickness: 0.4 cm

新51683
玉铲
新石器时代
长17厘米　宽14.8厘米　厚0.4厘米

Xin 51683
Jade spade
Neolithic Age
Length: 17 cm Width: 14.8 cm
Thickness: 0.4 cm

新106313
玉铲
新石器时代
长22.5厘米　宽16.3厘米　厚0.7厘米

Xin 106313
Jade spade
Neolithic Age
Length: 22.5 cm Width: 16.3 cm
Thickness: 0.7 cm

新116152
玉铲
新石器时代
长18厘米　宽8.9厘米　厚0.7厘米

Xin 116152
Jade spade
Neolithic Age
Length: 18 cm Width: 8.9 cm
Thickness: 0.7 cm

新98982
玉铲
新石器时代
长24.8厘米　宽7厘米　厚1.1厘米
备注：边及表面有改动

Xin 98982
Jade spade
Neolithic Age
Length: 24.8 cm Width: 7 cm
Thickness: 1.1 cm
With the edge and surface re-shaped

新105778
玉圭
新石器时代
长14.7厘米　宽5.2厘米　厚0.5厘米

Xin 105778
Jade Gui
Neolithic Age
Length: 14.7 cm Width: 5.2 cm
Thickness: 0.5 cm

新151152
玉圭
新石器时代
长26.3厘米　宽5.2厘米　厚1厘米

Xin 151152
Jade Gui
Neolithic Age
Length: 26.3 cm Width: 5.2 cm
Thickness: 1 cm

新115426
玉圭
新石器时代
长18厘米　宽4.9厘米　厚0.8厘米

Xin 115426
Jade Gui
Neolithic Age
Length: 18 cm Width: 4.9 cm
Thickness: 0.8 cm

故95071
玉圭
新石器时代
长14.5厘米　宽4.4厘米　厚0.7厘米

Gu 95071
Jade Gui
Neolithic Age
Length: 14.5 cm Width: 4.4 cm
Thickness: 0.7 cm

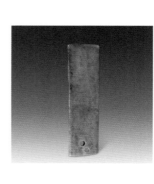

新127861
玉圭
新石器时代
长17.2厘米　宽4.6厘米　厚0.9厘米

Xin 127861
Jade Gui
Neolithic Age
Length: 17.2 cm Width: 4.6 cm
Thickness: 0.9 cm

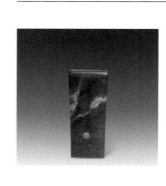

新105779
玉圭
新石器时代
长13.6厘米　宽5.8厘米　厚0.4厘米

Xin 105779
Jade Gui
Neolithic Age
Length: 13.6 cm Width: 5.8 cm
Thickness: 0.4 cm

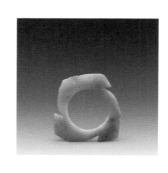

新156500
玉璇玑
新石器时代
径10.4厘米　孔径6.4厘米　厚0.8厘米

Xin 156500
Jade Xuanji
Neolithic Age
Diameter: 10.4 cm Internal diameter: 6.4 cm
Thickness: 0.8 cm

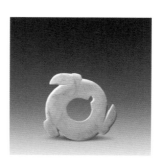

新110038
玉璇玑
新石器时代或商代
径10.5厘米　孔径3.3厘米　厚0.4厘米

Xin 110038
Jade Xuanji
Neolithic Age or Shang Dynasty
Diameter: 10.5 cm Internal diameter: 3.3 cm
Thickness: 0.4 cm

253 252

新116223
玉人首
新石器时代或商
高4.5厘米 宽3.5厘米 厚1.1厘米

Xin 116223
Jade human head
Neolithic Age or Shang Dynasty
Height: 4.5 cm Width: 3.5 cm
Thickness: 1.1 cm

254 252

新93128
玉笄
新石器时代
长17.4厘米 宽1.3厘米

Xin 93128
Jade hairpin
Neolithic Age
Length: 17.4 cm Width: 1.3 cm

255 253

故83909
玉璧
新石器时代
径15.2厘米 孔径6.3厘米 厚0.6厘米
备注：后刻乾隆题诗

Gu 83909
Jade Bi
Neolithic Age
Diameter: 15.2 cm Internal diameter: 6.3 cm
Thickness: 0.6 cm
Inscribed with a poem by Emperor Qianlong

256 254

故84930
玉璧
新石器时代
径6.8厘米 孔径3厘米
备注：附清代紫檀容镜盒

Gu 84930
Jade Bi
Neolithic Age
Diameter: 6.8 cm Internal diameter: 3 cm
With a red sandalwood box for mirror of the Qing Dynasty

257 254

故84925
玉璧
新石器时代
径7.8厘米 孔径3.5厘米
备注：附清代紫檀容镜盒

Gu 84925
Jade Bi
Neolithic Age
Diameter: 7.8 cm Internal diameter: 3.5 cm
With a red sandalwood box for mirror of the Qing Dynasty

258 255

故84929
玉璧
新石器时代
径8.9厘米 孔径2.4厘米
备注：附清代木座

Gu 84929
Jade Bi
Neolithic Age
Diameter: 8.9 cm Internal diameter: 2.4 cm
With a wood base equipped in the Qing Dynasty

259 256

故100541
玉璧
新石器时代
径23.1厘米 孔径7.5厘米 厚0.9厘米
备注：后配乾隆题诗紫檀框座

Gu 100541
Jade Bi
Neolithic Age
Diameter: 23.1 cm Internal diameter: 7.5 cm
Thickness: 0.9 cm
With a red sandalwood stand and inscribed with a poem by Emperor Qianlong

260 258

故95744
玉璧
新石器时代
径18.3厘米 孔径4.4厘米 厚1.3厘米

Gu 95744
Jade Bi
Neolithic Age
Diameter: 18.3 cm Internal diameter: 4.4 cm
Thickness: 1.3 cm

261 259

新117155
玉璧
新石器时代
径15厘米 孔径4.6厘米 厚1.1厘米

Xin 117155
Jade Bi
Neolithic Age
Diameter: 15 cm Internal diameter: 4.6 cm
Thickness: 1.1 cm

262 260

新99032
玉璧
新石器时代
径18.8厘米 孔径5.5厘米 厚0.6厘米

Xin 99032
Jade Bi
Neolithic Age
Diameter: 18.8 cm Internal diameter: 5.5 cm
Thickness: 0.6 cm

263 261

故83908
玉璧
新石器时代
径15.9厘米 孔径4.5厘米 厚1.1厘米
备注：后刻乾隆《题汉玉璧》诗

Gu 83908
Jade Bi
Neolithic Age
Diameter: 15.9 cm Internal diameter: 4.5 cm
Thickness: 1.1 cm
With a poem "Ti Han Yu Bi"(Inscribed to Han jade Bi) by Emperor Qianlong

264 262

新123894
玉璧
新石器时代
径17.6厘米 孔径4.5厘米 厚0.8厘米

Xin 123894
Jade Bi
Neolithic Age
Diameter: 17.6 cm Internal diameter: 4.5 cm
Thickness: 0.8 cm

265 263

新123357
玉镯
新石器时代
径7.6厘米 孔径5.7厘米

Xin 123357
Jade bracelet
Neolithic Age
Diameter: 7.6 cm
Internal diameter: 5.7 cm

266 264

新143912
玉人面纹环
新石器时代
径9.1厘米 孔径6.5厘米

Xin 143912
Jade ring with human-face design
Neolithic Age
Diameter: 9.1 cm
Internal diameter: 6.5 cm

267 265

新78657
玉弦纹环
新石器时代
径7.1厘米 孔径6.2厘米

Xin 78657
Jade ring with bowstring design
Neolithic Age
Diameter: 7.1 cm Internal diameter: 6.2 cm

268 266

故84927
玉环
新石器时代
径9.3厘米 孔径4.4厘米 厚0.6厘米
备注：附清代木盒

Gu 84927
Jade ring
Neolithic Age
Diameter: 9.3 cm Internal diameter: 4.4 cm
Thickness: 0.6 cm
With a wood box of the Qing Dynasty

269 267

故83871
玉环
新石器时代
径11.5厘米 孔径6.2厘米 厚0.8厘米

Gu 83871
Jade ring
Neolithic Age
Diameter: 11.5 cm Internal diameter: 6.2 cm
Thickness: 0.8 cm

270 268

新112682
玉环
新石器时代
径11.9厘米 孔径6.1厘米 厚0.7厘米

Xin 112682
Jade ring
Neolithic Age
Diameter: 11.9 cm Internal diameter: 6.1 cm
Thickness: 0.7 cm

271 269

故84909
玉环
新石器时代
径10.9厘米 孔径4.6厘米 厚0.7×0.5厘米
备注：清代刻花纹

Gu 84909
Jade ring
Neolithic Age
Diameter: 10.9 cm Internal diameter: 4.6 cm
Thickness: 0.7×0.5 cm
With designs engraved in the Qing Dynasty

272 270

新123876
玉环
新石器时代
径8.8厘米 孔径3.7厘米 厚0.4厘米

Xin 123876
Jade ring
Neolithic Age
Diameter: 8.8 cm Internal diameter: 3.7 cm
Thickness: 0.4 cm

273 271

新112683
玉环
新石器时代
径9.9厘米 孔径6厘米 厚0.7厘米

Xin 112683
Jade ring
Neolithic Age
Diameter: 9.9 cm Internal diameter: 6 cm
Thickness: 0.7 cm

274 272

故94302
玉环
新石器时代
径4厘米 孔径1.6厘米
备注：附清宫配匣诗册

Gu 94302
Jade ring
Neolithic Age
Diameter: 4 cm Internal diameter: 1.6 cm
With a box for poem album equipped in the Qing court

275 273

新196150
玉环
新石器时代
径4.4厘米 孔径1.9厘米 厚0.3厘米

Xin 196150
Jade ring
Neolithic Age
Diameter: 4.4 cm Internal diameter: 1.9 cm
Thickness: 0.3 cm

276 273

新196151
玉环
新石器时代
径4.3厘米 孔径1.8厘米 厚0.2厘米

Xin 196151
Jade ring
Neolithic Age
Diameter: 4.3 cm Internal diameter: 1.8 cm
Thickness: 0.2 cm

277

新196152
玉环
新石器时代
径3.9厘米 孔径1.5厘米 厚0.2厘米

Xin 196152
Jade ring
Neolithic Age
Diameter: 3.9 cm Internal diameter: 1.5 cm
Thickness: 0.2 cm

278 274

新196153
玉环
新石器时代
径3.6厘米 孔径1.5厘米 厚0.2厘米

Xin 196153
Jade ring
Neolithic Age
Diameter: 3.6 cm Internal diameter: 1.5 cm
Thickness: 0.2 cm

279 274

新196154
玉环
新石器时代
径3.5厘米 孔径1.3厘米 厚0.2厘米

Xin 196154
Jade ring
Neolithic Age
Diameter: 3.5 cm Internal diameter: 1.3 cm
Thickness: 0.2 cm

280 274

新196155
玉环
新石器时代
径3.6厘米 孔径1.6厘米 厚0.2厘米

Xin 196155
Jade ring
Neolithic Age
Diameter: 3.6 cm Internal diameter: 1.6 cm
Thickness: 0.2 cm

281 274

新196156
玉环
新石器时代
径3.4厘米 孔径1.2厘米 厚0.2厘米

Xin 196156
Jade ring
Neolithic Age
Diameter: 3.4 cm Internal diameter: 1.2 cm
Thickness: 0.2 cm

282 275

新196157
玉环
新石器时代
径3厘米 孔径1.4厘米 厚0.2厘米

Xin 196157
Jade ring
Neolithic Age
Diameter: 3 cm Internal diameter: 1.4 cm
Thickness: 0.2 cm

283 275

新196158
玉环
新石器时代
径3厘米 孔径1厘米 厚0.2厘米

Xin 196158
Jade ring
Neolithic Age
Diameter: 3 cm Internal diameter: 1 cm
Thickness: 0.2 cm

284 275

新196159
玉环
新石器时代
径2.7厘米 孔径1.2厘米 厚0.2厘米

Xin 196159
Jade ring
Neolithic Age
Diameter: 2.7 cm Internal diameter: 1.2 cm
Thickness: 0.2 cm

285 275

新196160
玉环
新石器时代
径2.5厘米 孔径0.9厘米 厚0.2厘米

Xin 196160
Jade ring
Neolithic Age
Diameter: 2.5 cm Internal diameter: 0.9 cm
Thickness: 0.2 cm

286 276

新176284
玉箍
新石器时代或商代
高3.6厘米 口径5.5厘米

Xin 176284
Jade hoop
Neolithic Age or Shang Dynasty
Height: 3.6 cm Mouth diameter: 5.5 cm

287 276

故84749
玉带槽条形器
新石器时代
长7.7厘米 宽2.3厘米 厚1.2厘米

Gu 84749
Fluted jade object
Neolithic Age
Length: 7.7 cm Width: 2.3 cm
Thickness: 1.2 cm

288 277

新93136
玉锥形器
新石器时代
长4.4厘米 宽0.8厘米 厚0.8厘米

Xin 93136
Awl-shaped jade object
Neolithic Age
Length: 4.4 cm Width: 0.8 cm
Thickness: 0.8 cm

289 277

新116115
玉锥形器
新石器时代
长6.6厘米　宽1.6厘米　厚0.7厘米

Xin 116115
Awl-shaped jade object
Neolithic Age
Length: 6.6 cm Width: 1.6 cm
Thickness: 0.7 cm

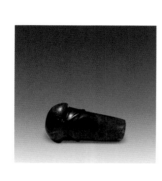

290 277

故95637
玉锥形器
新石器时代
长7.5厘米　宽1.2厘米　厚1.2厘米

Gu 95637
Awl-shaped jade object
Neolithic Age
Length: 7.5 cm Width: 1.2 cm
Thickness:1.2 cm

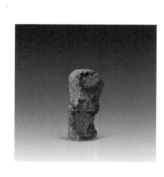

291 278

新166040
玉杵
新石器时代
长12.1厘米　首宽6.4厘米　厚4厘米

Xin 166040
Jade pestle
Neolithic Age
Length: 12.1 cm Head width: 6.4 cm
Thickness: 4 cm

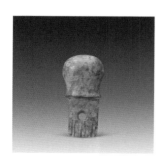

292 279

新115940
玉柄
新石器时代
长7.2厘米　宽3.2厘米　厚2.4厘米

Xin 115940
Jade handle
Neolithic Age
Length: 7.2 cm Width: 3.2 cm
Thickness: 2.4 cm

293 279

新141588
玉柄
新石器时代
长10.6厘米　宽5厘米　厚4厘米

Xin 141588
Jade handle
Neolithic Age
Length: 10.6 cm Width: 5 cm
Thickness: 4 cm

294 280

故95163
玉凿
新石器时代
长3厘米　宽2.5厘米　厚0.5厘米

Gu 95163
Jade chisel
Neolithic Age
Length: 3 cm Width: 2.5 cm
Thickness: 0.5 cm

295 280

故83963
玉凿
新石器时代
长11.3厘米　宽3.4厘米　厚2.3厘米
备注：后配红木座

Gu 83963
Jade chisel
Neolithic Age
Length: 11.3 cm Width: 3.4 cm
Thickness: 2.3 cm
With an amahogany base equipped later

296 281

新141592
玉凿
新石器时代
长13.1厘米　宽3.1厘米　厚2.5厘米

Xin 141592
Jade chisel
Neolithic Age
Length: 13.1 cm Width: 3.1 cm
Thickness: 2.5 cm

297 282

新143640
玉凿
新石器时代
长21.4厘米　宽4.5厘米　厚0.8厘米

Xin 143640
Jade chisel
Neolithic Age
Length: 21.4 cm Width: 4.5 cm
Thickness: 0.8 cm

298 283

新115425
玉凿
新石器时代
长11厘米　宽2.9厘米　厚2.5厘米

Xin 115425
Jade chisel
Neolithic Age
Length: 11 cm Width: 2.9 cm
Thickness: 2.5 cm

299 284

新110053
玉凿
新石器时代
长14.5厘米　宽3.1厘米　厚2.4厘米

Xin 110053
Jade chisel
Neolithic Age
Length: 14.5 cm Width: 3.1 cm
Thickness: 2.4 cm